Documentary Expression
and Thirties America

Documentary
Expression and
Thirties America

WILLIAM STOTT

THE UNIVERSITY OF CHICAGO PRESS
Chicago and London

The University of Chicago Press, Chicago 60637
The University of Chicago Press, Ltd., London

95 94 93 92 91 90 89 88 87 5 4 3 2

Library of Congress Cataloging in Publication Data

Stott, William, 1940–
 Documentary expression and thirties America.

 Reprint. Originally published: New York : Oxford
University Press, 1973. With new afterword.
 Bibliography: p.
 Includes index.
 1. Documentary mass media—United States.
2. United States—Popular culture. I. Title.
[P96.D622U67 1986] 302.2'34'0973 85–31819
ISBN 0–226–77559–3 (pbk.)

For my wife,
Molly and Gordon

(small recompense)

Whatever may have been the case in years gone by, the true use for the imaginative faculty of modern times is to give ultimate vivification to facts, to science, and to common lives, endowing them with the glows and glories and final illustriousness which belong to every real thing, and to real things only.

<div align="right">WALT WHITMAN</div>

Preface

Let Us Now Praise Famous Men, James Agee and Walker Evans' documentary report on Southern tenant farming, has come to be acknowledged a classic of its kind. This is a book about its kind. This is also a book about the time and place in which their report was made, the 1930s in America. It is thus part literary analysis, part cultural history.

As literary analysis, this book seeks to prove that documentary —whether in film, photograph, writing, broadcast, or art—is a genre as distinct as tragedy, epic, or satire, but a genre unlike these traditional ones in that its content is, or is assumed to be, actually true.

As cultural history, this book surveys the documentary expression of the 1930s and early 1940s, and suggests not only that a documentary movement existed then but that recognition of it is essential to an understanding of American life at the time.

I wrote the book because I think these topics deserve closer attention than they have received. There has never been a study of what Roy Stryker, the head of the Farm Security Administration's documentary photographic project, once called "the philosophy of the documentary approach." I analyze this philosophy

here, as well as the journalistic and artistic "approaches" that commonly embody it. Though critics and historians who treat the culture of the thirties have remarked on "the 'documentary' techniques characteristic of the period," they haven't examined the literature the techniques brought into being. Here this literature is studied in detail.[1] °

I establish the literary and social context of thirties documentary—then, in the book's last section, put the work of Agee and Evans against it. I argue that *Let Us Now Praise Famous Men* is a classic of documentary and the 1930s because it culminates the central rhetoric of the time, and explodes it, surpasses it, shows it up.

I mean this book to be useful to readers with differing interests. It is a work of mass communication theory. It is a cultural history concentrating on the "feel" of a particular era. It is a study of persuasion. It is a catalogue of ways of looking at the poor, the damaged, the inconspicuous, and the ordinary. But it also discusses such narrower concerns as the strategy of documentary photographs, the rationale behind "human interest" reporting, the ballets of Martha Graham's "American theme" period, Edward Murrow's wartime broadcasts, Franklin Roosevelt's use of allusion, Walker Evans' aesthetics, the world view in a "true confession" story, and the techniques of documentary reportage (which is currently called "new" or "personal" journalism).

There are, however, two relevant topics I neglect. Though John Grierson and Pare Lorentz, the leading documentary filmmakers of the 1930s, appear often in this narrative, little is said about the decade's films. I regret the omission, but chose to talk about the documentary media of the time that had not previously been discussed. Similarly I spend only a few pages on "Proletarian fiction." These radical novels have been heavily studied—studied quite out of proportion to their influence, authenticity, and imaginative vigor. But there is a more basic reason for my treating them in short

° Notes begin on page 315.

order. I believe—though I never again put the belief so boldly—
that the primary expression of thirties America was not fiction but
fiction's opposite. This genre of actuality I call by the name given
it then: documentary. And I see its essence as the communication,
not of imagined things, but of real things only.

I wish to thank the following people for information, advice,
and encouragement they gave me in the writing of this book:
Daniel Aaron, Ann Adams, Benjamin Bradlee, Cleanth Brooks,
Paul Brooks, John Morton Blum, Erskine Caldwell, Cass Canfield,
William Christenberry, James M. Cox, Robert Crunden, Benjamin
DeMott, F. W. Dupee, Robert Elson, Charles Feidelson, Father
J. H. Flye, William Goetzmann, Donald J. Gray, John Fischer,
Robert Fitzgerald, Beulah Hagen, Ida Hernandez, John Hersey,
F. Jack Hurley, Ralph Ingersoll, Victor A. Kramer, Alvin Kernan,
Frank Kingdon, Louis Kronenberger, Charles Kuralt, Dan A. Lacy,
Russell Lee, Harold Leventhal, R. W. B. Lewis, Jay Leyda, Dwight
Macdonald, James McIntosch, Archibald MacLeish, Robert Man-
ning, Barbara Marrs, Vivian Marsalisi, Louis Martz, Raymond
Moley, Carl Mydans, Norman Holmes Pearson, Richard Pells,
Leo Ribuffo, Elspeth Rostow, Joan Rubin, Nancy Ryan, Carl
Smith, John L. Spivak, William A. Sutton, Paul S. Taylor, James
Treece, Robert Thorpe, Helen Thurber, Rexford G. Tugwell,
Richard Warch, Joseph L. Wertzberger. I am particularly in-
debted to Walker Evans, James Raimes, and Alan Trachtenberg.
 The staffs of Yale University Library and the library and inter-
library loan service of the University of Texas at Austin patiently
obtained the materials I wanted for this book. I tracked down the
illustrations and had them copied with the assistance of Brandeis
University Library; Joe Coltharp, director of the Photography Col-
lections of the Humanities Research Center of the University of
Texas at Austin; Dennis East, labor archivist of the Wayne State
University Library; Walker Evans; Barbara Morgan; Jeanne
Smith of the University of North Carolina Press; T. E. Theisen
III and Sean Callahan of Time Inc.; and the staff of the Visual

Instruction Bureau of the University of Texas at Austin. I am especially grateful to Jerry Kearns and Alan Fern of the Reference Department in the Library of Congress' Division of Prints and Photographs for locating the FSA photographs and to the Photoduplication Service of that Library for superbly reproducing them.

The quotations from James Agee's unpublished notes and draft manuscripts to *Let Us Now Praise Famous Men* are used by permission of the Humanities Research Center of the University of Texas at Austin and the James Agee Trust, David McDowell, Trustee. The quotations from *Let Us Now Praise Famous Men* are used by permission of Houghton Mifflin. Permission to publish copyrighted photographs and advertisements was granted by William Christenberry; Walker Evans; the General Electric Company; Frances C. Macgregor; Barbara Morgan; the University of North Carolina Press; the Save the Children Federation and its advertising agency, Waterman, Getz, Niedelman; John L. Spivak; Paul S. Taylor and the Dorothea Lange Collection of the Oakland Museum; Time-Life Syndication Service and the Estate of Margaret Bourke-White.

To these people and organizations, and to the members of the American Studies programs at Yale and the University of Texas at Austin, I express my gratitude and good wishes.

W.S.

Austin, Texas
January 1973

Illustration Credits

Margaret Bourke-White, three photographs: courtesy the Estate of Margaret Bourke-White and Time-Life Syndication Service

William Christenberry, photographs: courtesy William Christenberry

Walker Evans, "Trash Can, New York, ca. 1968," "Sharecropper (Bud Woods)" (second version), "Sharecropper family (the Gudgers and Emma)": courtesy Walker Evans

G.E. Radio advertisement: courtesy General Electric Corp.

Rockwell Kent, commemorative stamp: from the Workers Defense League Archives, Wayne State University

Dorothea Lange, "Westward to the Pacific Coast on U.S. 80," "On U.S. 66 near Weatherford, western Oklahoma," "On U.S. 80 near El Paso, Texas," "Woman of the High Plains, Texas Panhandle" (two versions): courtesy Paul S. Taylor and the Dorothea Lange Collection, the Oakland Museum

Frances Cooke Macgregor, photograph: courtesy Frances Cooke Macgregor

Barbara Morgan, two photographs from Martha Graham's ballet *American Document:* courtesy Barbara Morgan

Co Rentmeester, photograph: courtesy Time-Life Syndication Service

Save the Children Federation advertisement: courtesy Save the Children Federation and Waterman, Getz, Niedelman Advertising

John L. Spivak, photograph: courtesy John L. Spivak

Bayard Wootten, photograph: courtesy the University of North Carolina Press

Photographs by Walker Evans, Dorothea Lange, Russell Lee, Marion Post, and Arthur Rothstein not cited above are from the Farm Security Administration Photograph Collection in the Library of Congress

Contents

PART ONE

Documentary

When Hallie Flanagan, director of the Federal Theatre during its brief and stormy life, looked back on her work in the thirties, she remembered with special pride a play she did at Vassar in the spring of 1931. She had adapted the play, *Can You Hear Their Voices?*, from a recent story in *New Masses* by the young communist writer Whittaker Chambers. The story, though inspired by *New York Times* dispatches about a revolt of Arkansas tenant farmers, did not have what Flanagan, in 1943, most valued in the play: "factual material, charts, statistics." She was amazed the play had this dimension because, she said,

> it must be remembered that *Can You Hear Their Voices?* preceded the many documentary books such as *You Have Seen Their Faces* by Erskine Caldwell and Margaret Bourke-White, and *An American Exodus* by Dorothea Lange and Paul Taylor. It preceded John Steinbeck's *Grapes of Wrath*, and *These Are Our Lives* by the Federal Writers' Project, and the wealth of such Americana now available. Theatrically it preceded the documentary films of Pare Lorentz, *The Plow That Broke the Plains*, *The River*, and the *Fight for Life*. It antedated the Federal Theatre Living Newspapers.

In these sentences Flanagan took for granted that the thirties had what is examined here: a documentary movement. She offered a perceptive sample of things in that movement. She did not suggest everything, despite the large implication of the word "Americana"; but hers was the best catalogue made at the time because it gathered the most varieties of expression.[1]

To date, the documentary movement of the 1930s and early 1940s has received little attention. This is odd, since the earliest and one of the shrewdest appraisals of the period's culture—Alfred Kazin's, in *On Native Grounds* (1942)—declares that among the vital work at the time there was a "preponderance of descriptive nonfiction" and "documentary literature." Ever since Kazin proposed the idea, historians have acknowledged that the thirties had a documentary literature complementing its well-known documentary cinema. For Kazin and the others, however, this literature consists of "documentary books": that is, books combining words and photographs; books like Caldwell and Bourke-White's *You Have Seen Their Faces*, Lange and Taylor's *American Exodus*, Agee and Evans' *Let Us Now Praise Famous Men*. What Hallie Flanagan did, what this study does in part, is expand the idea of documentary literature.[2]

The books with photographs and the documentary films are of

course important—but they typify the genre, they do not exhaust it. The documentary literature of the thirties was more diverse in medium and far broader in imaginative consequence. The second part of this book argues that a documentary motive was at work throughout the culture of the time: in the rhetoric of the New Deal and the WPA arts projects; in painting, dance, fiction, and theater; in the new media of radio and picture magazines; in popular thought, education, and advertising. Part Three examines a wide spectrum of the period's documentary nonfiction: case-worker reports written to acquaint the general public with the unemployed; social science writing in the documentary mode; angry exposés of the human cost of capitalism; "worker narratives" and other vernacular literature, like *These Are Our Lives,* that tried to get the common man to tell his own story; the "documentary books" themselves; and first-person quests to find and document America.

The rest of Part One explores documentary: what it is, how it works, what it treats, and what influences shaped it in the 1930s.

What Is
Documentary?

Documentary . . . pertaining to, consisting of, or derived from documents.
—a 1967 definition

During the controversy over the 1971 television documentary "The Selling of the Pentagon," a troubled viewer wrote *Harper's Magazine* to ask: "What is a 'documentary'? Is it an honest and reasonably objective report or is it a case for the prosecution? Most viewers, I guess, think the former." The viewer himself thought the former, but in fact it could be either. For the "documentary" in "documentary film" or "documentary journalism" or "television documentary," though of recent vintage, is a complex, even contradictory, word. Like "document," from which it derives, it has *two* meanings, only one of which is in the dictionary. These meanings are not mutually exclusive: a film or article that is a document in one sense may be a document in the other; nevertheless, the meanings are distinct and usefully separated.[1]

The first, the dictionary meaning, we use when we speak of "documentary proof" and "legal documents," of "documentary history" and "historical documents." This "documentary" has been defined as "presenting facts objectively and without edito-

rializing and inserting fictional matter, as in a book, newspaper account or film." As for "document," its first meaning is even plainer. Saunders Redding said that he would call his 1951 autobiography "a 'document' except that the word has overtones of something official, vested and final," and his book, on the contrary, was "personal." Impersonal documents we have always with us—Social Security cards, newspapers, bills: "written or printed paper bearing the original, official, or legal form of something, and which can be used to furnish decisive evidence or information." In 1938 Benjamin Glassberg, a Chicago relief administrator, allowed parts of the journal he kept on the job to be published "as an objective document . . . useful to others" in the trade. Documents of this sort give information about public events and social conditions.[2]

There is, however, a second kind of document and, thus, of documentary. Elizabeth Janeway recently reviewed Winthrop Sargeant's account of his fight with mental illness, *In Spite of Myself: A Personal Memoir*, and called it a "courageous exploration of his own soul by an intelligent man who is aware of his emotional flaws. It is a document from a private battlefield which is relevant to many other struggles." This "document" is an abbreviation of a phrase still used but especially frequent in the thirties, "human document." ° John Crowe Ransom, writing in the mid-thirties, compared Wallace Stevens' "Sea Surface Full of Clouds" with Allen Tate's "Death of Little Boys" and said that although the first poem's technique was superb, he personally preferred the second because it "is a human document, with a contagious fury about it. . . . The deaths of little boys are more exciting than the sea surfaces." °° Thirty years ago Marquis

° Judith Crist praised a 1970 film "as a social study, a human document and a fascinating and absorbing entertainment." As human document, it captured "a sense of small people sharing the universal burden of existence."
°° The adjective "human" recurs throughout thirties literature as a synonym for emotional or touching or heartfelt. A critic praised Virgil Thomson's score to *The River* because it borrowed folk melodies and hence was "full of the emotional content inherent in anything essentially human." The doc-

Childs confessed in print that he envied playwrights fifty years hence who would

> inevitably draw on this family [the Franklin Roosevelts] for the raw material of drama to compare with the Lincoln story. Take, for example, Eleanor Roosevelt's autobiography. That is an extraordinary human document. If it does not tell all, it tells nearly all with a frankness and a sincerity such as few personal narratives ever attain.[3]

A document, when human, is the opposite of the official kind; it is not objective but thoroughly personal.° Far from being dispassionate, it may be "a document that is shattering in its impact and infinitely moving," as Arthur Knight said of a 1971 film. Even when temperate, a human document carries and communicates feeling, the raw material of drama. Such a document gives some information that would be found in an impersonal document. One learns, for example, when Mrs. Roosevelt married, the names of her offspring, the work she did. Indeed, a human document may be read as a historical document is—for the facts it gives about public events and social customs. Malcolm Cowley read Harry Crosby's suicide diary this way and praised it as "a valuable record of behavior and a great source document for the manners of the age that was ours" in the 1920s. But to read a human document thus overlooks what is unique and primary: the glimpse it offers of an inner existence, a private self.[4]

umentary photographer Arthur Rothstein gave tips to amateurs on how to capture on film "the human aspects of an otherwise unemotional [social] problem." This use of the word is significant; it suggests that despite the elaborate intellectuality of some Marxist sympathizers, most Americans in the thirties felt the essential human faculty wasn't reason. Popular wisdom at the time, as Dale Carnegie expressed it in *How To Win Friends and Influence People* (1936), was that men were not "creatures of logic" but "creatures of emotion." The artist George Biddle estimated in 1939 that the human being was 98 parts feeling and 2 parts mind.

° One writer who made a book about his home town in the late thirties, Herman Clarence Nixon, not only took as his source such "human documents" as clippings from the village paper, but went so far as to proclaim, "I myself am a document."

One who considers a certain work a human document identi-
fies with the self it reveals; otherwise, he would not call it
human. Marquis Childs knew that Mrs. Roosevelt was telling
nearly all only because he knew himself. Yet insofar as Mrs. Roo-
sevelt revealed what is common and constant in man, it was no
wonder that Childs empathized—most readers would be drawn
to. Her story was ennobling:

> It is the story of the ugly duckling who at last came into the
> life of a swan and yet remembered what it was like to be an
> ugly duckling. For all the ugly ducklings of this world Eleanor
> Roosevelt will fight with a fury that grows out of the secret
> roots of her own experience.

It was ennobling, but one would read it as avidly were it base.
For the perennial truths of man's spirit and existence, the subject
of a human document, are by no means all ennobling; and it is
those truths a reader wants, for better or worse.[5]

How does a document convey spirit? How does it reveal the
secret roots of experience? Childs' tone tells us: through sensibil-
ity. We understand a historical document intellectually, but we
understand a human document emotionally. In the second kind
of document, as in documentary and the thirties' documentary
movement as a whole, feeling comes first.

Documentary: The Primacy of Feeling

Recent historians have all but acknowledged this. In his *History of
Photography* (1964), Beaumont Newhall stated that the impor-
tance of documentary photographs "lies in their power not only
to inform us, but to move us." Warren Susman, in his excellent
article "The Thirties" (1970), affirmed that "the whole idea of
documentary—not with words alone but with sight and sound—
makes it possible to see, know, and feel the details of life, to feel
oneself part of some other's experience." Susman didn't say that
documentary trades chiefly in emotion, but he implied as much:

one knows another's life because one feels it; one is informed—one sees—through one's feelings. The practitioners of the documentary genre in the thirties realized, if dimly, the same thing: emotion counted more than fact.[6]

Among the first to come to this conclusion was John Grierson, the British film producer who named documentary—and then repented of the name he chose. He chose it thinking he was dealing with documents of the first sort, in which facts, not feelings, were paramount. A trained sociologist, he had come to America in 1924 to study the effect of mass media on public opinion. At the time, he later recalled,

> Many of us . . . (particularly in the United States) were impressed by the pessimism that had settled on Liberal theory. We noted the conclusions of such men as Walter Lippmann, that because the citizen, under modern conditions, could not know everything about everything all the time, democratic citizenship was therefore impossible.

Grierson became interested in the factual film as a means of conveying "the information necessary to organized and harmonious living." He called such film "documentary," first using the word in a 1926 New York *Sun* review of Robert Flaherty's *Moana*, which, he said, "being a visual account of events in the daily life of a Polynesian youth, has documentary value." He may have chosen the word because the French then used *documentaire* to mean travelogue. It seems more likely, however, that, writing with characteristic haste, he took the entire phrase "documentary value," perhaps without realizing it, from the lips of his fellow sociologists. In either case, he used "documentary" in its dictionary sense of a presentation of facts without fictional matter.

Grierson detested the "false excitements" of Hollywood's fictions, so it is easy to understand why, in advocating films based on life, he would play up the impassivity of their "public observation." He described a sequence from *Drifters*, his 1929 film about the British herring industry:

I ran in detail of furnace and engine-room for image of force,
and seas over a headland for image of the open. I took the ships
out and cast the nets in detail: as to the rope over the cradle,
the boy below, the men on deck against the sea; as to the
rhythm of the heaving, the run on the rollers, the knotted haul
of each float and net; as to the day and approaching night; as to
the monotony of long labour.

But even in his words one hears that the monotony is too ener-
getic to be monotonous. The information, though prosaic, is
charged with feeling. As Grierson said, a documentary's subject
must always be "the blazing fact of the matter"; but the fact is
important because it is shown to blaze. None was too humble. He
later praised Basil Wright's *Cargo from Jamaica* because it "con-
veyed emotion in a thousand variations on a theme so simple as
the portage of bananas." He felt that documentary accomplished "a
unique achievement when, in *Big Money*, it made a fine, exciting
story of the Account-General's Department of the [British] Post
Office—surely, on the face of it, one of the dullest subjects on
earth." Here, we notice, the achievement belongs to the genre: *it*
made the exciting story, not Alberto Cavalcanti, the film's maker.
If the facts blaze, the form itself started the fire.

By the mid-thirties Grierson had decided that perhaps it did.
Perhaps communication of the kind needed to make a better
world wasn't chiefly informational, as Lippmann thought; maybe
it wasn't even rational. Instead, Grierson favored an approach he
called "dramatic," by which he plainly meant "emotional."

The way of information will not serve; it is too discursive. And
the way of rational explanation will not serve, because it misses
the corporate life we are dealing with. The new language of ap-
prehension which must communicate the corporate nature of
community life must in fact be something more in the nature of
a dramatic language than a rational one. . . . The quintessence
will be more important than the aggregate.

Since all the facts could not be given, he believed that education
would turn to a "shorthand method" that dramatized the human

consequences of a few facts. This method was of course documentary—a word Grierson now found "a clumsy description" of what he wanted, but the word he and the world were stuck with. For by that time it had achieved a life of its own.[7]

In 1938 Edward Steichen remarked that "one of the favored words . . . today is 'documentary.'" Then, without saying he was going to, he set about defining the word. Ostensibly he was writing a review of the work of the Farm Security Administration's Photography Unit run by Roy Stryker. He said that Stryker had put his photographers—Walker Evans, Dorothea Lange, Russell Lee, Carl Mydans, Marion Post, Arthur Rothstein, Ben Shahn—to work photographing "piles of this, stacks of that, yards of this, miles of that, boxes, bales, and timber." The FSA photographers were compiling a "picture record of rural America," tens of thousands of images of the implements and methods of farm labor at the time. But, Steichen added, while the photographers

> were busily engaged in producing this kind of "tweedle dum" and "tweedle dee" document, they also found time to produce a series of the most remarkable human documents that were ever rendered in pictures. . . . These documents told stories and told them with such simple and blunt directness that they made many a citizen wince. . . . Have a look into the faces of the men and the women in these pages. Listen to the story they tell and they will leave with you a feeling of a living experience you won't forget.

For Steichen also, then, there were two sorts of documents: one gave factual information; one gave human, made citizens wince, conveyed the feeling of lived experience.[8]

The essence of documentary is not information, as Grierson first thought. If it were, the classics of documentary cinema would be tweedle-dum "industrials," the worker-education films turned out by the hundreds. The essence, rather, is the same power to move that Grierson had all along sought in Hollywood's films; in them, he early wrote, "I look to register what actually moves: what hits the spectator at the midriff: what yanks him up

by the hair of the head or the plain bootstraps to the plane of decent seeing." For he believed that emotion, properly felt and understood, *does* engender decent seeing; *is* intelligence.[9]

Such a view, commonplace among artists from Sophocles to Tolstoy, has yet to gain philosophical standing, and perhaps never can. As intellectual a man as Henry Adams has spoken for it, though. Because he believed that one must "learn to feel," Adams spends *Mont Saint-Michel and Chartres* "trying only to feel Gothic art." He seeks emotion not as a means to rational comprehension but for its own sake; understanding is, he says, "not a fact but a feeling." He argues that learning to feel intelligently is authentic education. Intelligent feelings have little to do with intellect per se: any peasant woman in the medieval church knew more than Adams ever could because she was inside the religious experience. Intellect is a thing inferior, trivial: "one loses temper in reasoning about what can only be felt"; Adams teasingly suggests that he would cultivate ignorance "if only ignorance would help us to feel what we cannot understand." His greatest sorrow comes when he considers that perhaps, unlike artists, "the rest of us cannot feel; we can only study." [10]

Those who practice documentary tend to be skeptical of the intellect and the abstractions through which it works. Like artists, they believe that a fact to be true and important must be felt.

The Two Documents and How They Work

There are two kinds of documents, or two tendencies within the documentary genre. The first, the more common, gives information to the intellect. The second informs the emotions.

If we were to ask for proof that each existed, our question itself would prove the first kind. For it assumes that intellectual verification of some sort is possible. It asks for concrete examples, for documentation. It seeks what one social scientist has called "the ultimate in evidence": a fact or a firsthand impression; the refer-

ence to an objective authority or the personal observation; a foot-note or "Now I know a fellow. . . ." But let us notice how such documentation works. Say two people dispute when something happened. One says, June. The other, July. The first insists. The second says, prove it. The first offers documentary evidence: a citation from an almanac for the last week in June; a direct reference to a body of information open to all inquirers and of generally accepted validity. Their dispute may have been quite emotional; each may want passionately to be right. But the facts are simply there to be rationally understood. Emotions in no way affect their value, documentary value, as information. Only intellect is needed to weigh this value.[11]

To prove that there are documents of the second sort, documents the understanding of which requires the emotions, one does not need to turn to the work of Shakespeare or Beethoven or Van Gogh. Any newspaper, magazine, or TV news program will do, for all are larded with them. "There are events," W. H. Auden has written, "which arouse such simple and obvious emotions that an AP cable or a photograph in *Life* magazine are enough and poetic comment is impossible." Such cables and photographs are human documents and belong to the documentary genre. Consider the following from the *New York Times:*

DOGS KILL BROTHERS, 4 AND 3, AS FATHER'S HELP IS FUTILE

Lynchburg, Va., Dec. 17 [1967] (AP)—

A pack of dogs attacked and killed two young brothers today in Madison Heights, about a mile and a half north of this west Virginia city, the police said.

The police said the dogs, four German Shepherds from a near-by home, attacked the children while their father flailed at the animals with a rake.

Two of the dogs were shot to death by the state and Amherst County police. The other two were impounded on the property on their owner, the police said.

The victims were identified as Eugene H. Goodman Jr., 4 years old, and Kenneth Goodman, 3, children of Mr. and Mrs. Eugene H. Goodman of Rt. 1, Madison Heights.

> Mr. Goodman and his wife were hospitalized in acute shock
> at Lynchburg General Hospital.

Not only is *poetic* comment impossible, any human comment is.[12]

This is how documentary—of both kinds—works. It defies comment; it imposes its meaning. It confronts us, the audience, with empirical evidence of such nature as to render dispute impossible and interpretation superfluous. All emphasis is on the evidence; the facts themselves speak: the date was at the end of June; the Goodman boys are horribly dead, their family broken.

Documentary is the presentation or representation of actual fact in a way that makes it credible and vivid to people at the time. Since all emphasis is on the fact, its validity must be unquestionable as possible ("Truth," Roy Stryker said, "is the objective of the documentary attitude"). Since just the fact matters, it can be transmitted in any plausible medium. John Grierson realized that "the documentary idea is not basically a film idea at all" and that the documentary movement of the thirties might have occurred in media other than film. The heart of documentary is not form or style or medium, but always content. The theater historian Mordecai Gorelik observed that the documentary plays of the thirties owed whatever strength they had to the "undisputed newspaper accounts and public statements" upon which they were based. The accounts were undisputed because they were indisputable. The actual facts. The truth.[13]

One sees immediately the truth of a documented fact—the date was at the end of June—but may have trouble grasping the truth of a human document like that AP dispatch. It *is* difficult; as Auden said, there is nothing to say. One knows why such things get published, why in fact they are a mainstay of all journalism; it is because they are read. But why are they? Thoreau thought them a waste of time; he argued in *Walden* that

> if we read of one man robbed, or murdered, or killed by accident, or one house burned, or one vessel wrecked or one steamboat blown up, or one cow run over on the Western Railroad,

or one mad dog killed, or one lot of grasshoppers in winter—we never need read of another. One is enough. If you are acquainted with the principle, what do you care for a myriad instances and applications?

Obviously many people don't feel as Thoreau claimed to; they care about fresh instances. No doubt part of the reason men read about present calamity is to find whether they can avoid future ones. There is a large subspecies of documentary, the exposé, which uses emotional reportage to persuade the audience to take action against men and evils that cause unnecessary suffering in the world. But the quoted dispatch isn't exposé: there was no one to blame for the little boys' death and no social lesson to be learned. The article gives no practical information to help with life, and yet is published and read. Why? [14]

Because it happened, one may answer. This would be the answer of the *New York Times,* journal of record. It is a devious answer. For according to this view an event is newsworthy not because it happened but because it *seldom* happens. On the day the young Goodmans were killed, a Sunday, more than one hundred Americans died in car accidents, some presumably as pointless and gory and heartrending as what happened in Madison Heights, Virginia. These accidents didn't make the *Times* because cars are always killing people, whereas dogs almost never do. The *Times* carried the dispatch in the journalistic conviction that the record of a day is built of rarities.

In fact, the Goodman story matters very little as an intellectual document, a paragraph in the public record. Its importance, insofar as it has any, is due to its special emotional value. This value is hard to put one's finger on in the dispatch quoted because the *Times,* as one would trust, played emotion down. It ran no photos; it buried the story deep in the extraneous dry pages of its second section. Nonetheless, the emotion is there and is why the story was read.[15]

By "emotion" one doesn't mean a ghoulish thrill, a *frisson* at the abominable. One probably does feel this, as well as a

wretched kind of relief that someone else has suffered and died. These unhappy emotions are accompanied by others one is less apt to deny: shock, pity, compassion. And rage; one wishes (pointlessly) that he had been there with shotgun and axe.° All these emotions, however, are part, become part, of a more general and wiser emotion that tries to learn from the experience. This, surely, the reader is always struggling to do: learn something that may help him. When an article has no information of intellectual use, he can sometimes still learn from it. It may provide him what the psychologist Ernest Dichter calls "a lesson in living." Dichter believes that because reality is unknowably complex, men seek clues to it in the life around them; most men, he argues, shun the equivocal (and profoundly lifelike) versions of reality given in the greatest art, preferring the simpler lessons of the mass media.[16]

A lesson in living, whether one has it firsthand or via Tolstoy or the crassest Hollywood film, is just that: an event that shows one what life is like; an epiphany that strips reality bare. The AP dispatch from Virginia may do this. It may impress a reader as a human document and suggest to him—for a moment or longer, faintly or stronger—that life is like this, that this is a reality he must face: dogs destroying children. The reader immediately rejects the idea; "that's not life," he says to himself, and he is relieved to be able to say it. He has faced up to the worst catastrophe December 17, 1967, brought forth—one perhaps hitherto unconceived, which is to say inconceivable.

This is the reason the human documents in the news are read:

° In his last letter to Father Flye, James Agee commented on a newspaper clipping his friend had sent him. The clipping from a Wichita paper told, in Flye's words, "how a group of men who owned racing dogs had been gathered on the outskirts of the city for practice running. They would collect cats (under the pretext of finding good homes for them) and then take them out to be chased by the ravenous dogs who would tear them to pieces and devour them." Agee said: "The clip you sent about dogs and cats is beyond comment: except my wish to be present, not with an A.S.P.C.A. badge, but with a machine gun." To which Father Flye added in a footnote: "I knew what Jim's feeling would be, as mine was; and he expressed it."

they offer safe exercise for the reader's feelings; they test—but gently—his emotional competence to live in the great world that day. Does he know the latest cause for outrage, alarm, pity, disgust, laughter, warm tears? Can he face up to it? And the answer is always yes. The reader cannot lose. It is a test he may refuse to take, but he cannot—short of madness—fail it. He can face up to human documents, to whatever they put before him, however it strain his emotions. He can face up to them as he cannot be sure he will always face up to his own life, because they treat of someone else's.

A final word about human documents. They do not have to deal with death or dismemberment, though such topics are unfailingly popular. Violence is just one of the staples of human-interest reportage. Two others are staggering coincidence (a man finds in a fish the wedding ring his wife lost twenty years before on their honeymoon) and extreme kindness or self-sacrifice (a man returns a purse with $1000 in it).° Each of these has a view of life in tow, both sentimental. The first would have us believe that everything is ruled by a providence that likes playing cheerful jokes; the second, that men, that we, are better—nobler—than we know ourselves to be. These sentimental fallacies or the easy nihilism of random violence (another sort of sentimentality) underlie most of the human documents the media put out.

By and large the emotions in these documents are as crude or, to use Auden's more charitable words, as simple and obvious as their philosophy. Worse, the emotions are inflated, exacerbated, by much of the press; the result tends, in the words of Ronald Berman, "not to discipline feeling but to express it with as much moral damage as possible." Not to inform feeling, but to ensure that it will be unformed, directionless, self-indulgent.[17]

° The sacrifice is heightened if the event involves violence (a sergeant saves his platoon by throwing himself on a grenade; a man drowns trying to rescue a drowning child). Here, however, it is the fine sentiment that is to move us more than the violence.

CHAPTER 2

Social
Documentary

Some documents inform the intellect, some the emotions. Both
sorts are too simple to analyze further. They are extreme tenden-
cies within the documentary genre and share just one character-
istic, the one they must to belong to the genre at all: both report
actual fact. Documents at the extremes—timetables, hard-news
dispatches, almanacs, encyclopedias, industrial films, legal paper,
on the one hand, and human-interest journalism, on the other—
are most often rhetorically dull and, in the case of the human
documents, philosophically puerile. There are, however, interme-
diate documents that try to combine the virtues of the extremes.
These intermediate documents increase our knowledge of public
facts, but sharpen it with feeling; put us in touch with the per-
ennial human spirit, but show it struggling in a particular social
context at a specific historical moment. They sensitize our intel-
lect (or educate our emotions) about actual life. They are social
documents, their use is social documentary, and they are the sub-
ject of the rest of this book.

In Luis Buñuel's documentary film *Land Without Bread*
(1932), there is a sequence where the camera, having come from
a dim and stinking hut, finds a child, a girl of perhaps seven, sit-

ting in the sunny lane outside. She sits on a rock or a step, her feet bare, her body heavily clothed. The scene is the Hurdes region of Spain, whose people have dark hair and dark complexions. But this girl is fair; her hair looks russet. For an instant the viewer thinks that her life, too, is unusual—happier than those he has just been seeing. But then he notices the odd angle she holds her head at, as though her neck were broken; he sees her twisted face. The film's narrator says that one day "we," the people making the film, came upon a girl with a sore throat. Now a member of the film crew is holding her chin in his hand, and the camera, trembling slightly, peers into her mouth. And though the film is black and white, and pale with age, the viewer sees how inflamed that throat is. He sees it in the way the girl has to strain to open her mouth, in the way she tries to ease free of the hand. The narrator says that the girl had been in the street for several days, unable to eat, rejected by her family. But, he continues, we had no sulfa, we could do nothing for her, and three days later we heard she was dead. As he says this, the girl sits down again in the street, her head rocking slightly to and fro.[1]

This is social documentary. Morley Safer ad-libs excitedly into the microphone that there is no reason for the Marines to set these Vietnamese huts afire, while the viewer sees them doing it with flamethrowers and cigarette lighters. Other Marines, of another generation and war, strain endlessly in a still photograph to plant and raise a flagpole on Iwo Jima's highest mountain. Friends of Israel distribute on American campuses leaflets with atrocity photos of children killed when Palestinian terrorists blew up their school bus; the front page is a close-up of the driver's face: the flesh is mottled by fire and blood; the eyes are gray, exploded, and soft and lifeless as tar. "He was an Israeli bus driver. Every morning he drove village children to school . . . Until May 22nd. . . ."[2]

When people in the thirties spoke of documentary, they usually meant *social* documentary—and so do we today. Social documentary educates one's feelings as human documents do,

but with this difference. Human documents show man undergo-
ing the perennial and unpreventable in experience, what hap-
pens to all men everywhere: death, work, chance, rapture, hurri-
cane, and maddened dogs; as John Grierson said, the theme of
such documents is "la condition humaine." Social documentary,
on the other hand, shows man at grips with conditions neither
permanent nor necessary, conditions of a certain time and place :
racial discrimination, police brutality, unemployment, the De-
pression, the planned environment of the TVA, pollution, terror-
ism.° One might say briefly that a human document deals with
natural phenomena, and social documentary with man-made.[3]

The line between the natural and the man-made is often un-
clear; people disagree in which category a given phenomenon
belongs. Is crime caused by human vice, the inherent depravity
of man; or is it caused by social injustice? Is war an act of God,
or merely the result of foolish political systems? No definite an-
swer is possible, and when one is given, it is for polemical rea-
sons. Herbert Hoover spoke of the Depression as a natural phe-
nomenon, unappeasable as drought, something that could only
be endured; Franklin Roosevelt most often pictured it as man-
made, correctable by social modification. Hoover asked God to
grant the American people the self-reliance and steadfastness of
Washington and his men at Valley Forge; Roosevelt asked his
countrymen for war-time enthusiasm to lick the enemy. For Hoo-
ver, the crisis was sufferable but unalterable; °° for Roosevelt,
just the opposite. Accepting the Democratic nomination in 1932,
Roosevelt declared, "Our Republican leaders tell us economic
laws—sacred, inviolable, unchangeable—that these laws cause

° In 1970 the *New York Times* advertised its book *Great Songs of the Six-
ties* as "a social document you can play on the piano." This document re-
printed popular music reflecting "America's generational, technological and
racial crisis" in the 1960s. The music, according to the ad, "not only sings
of change; it has somehow made changes happen!"
°° A Hoover sympathizer, Dwight Morrow of J. P. Morgan and Company,
said in 1931: "I think the best way to get rid of business cycles would be to
prove that they are inevitable."

panics which no one could prevent. . . . We must lay hold of the fact that economic laws are not made by nature. They are made by human beings." Roosevelt's argument had the sympathy of most Americans. "The people of the United States have not failed," he said in his first inaugural address—and the people generally agreed. The fault lay not in themselves, human and irremediable, but rather in a social order men had made and might improve.[4]

Social documentary encourages social improvement. Its mildest goal is the "public education" Walter Lippmann sought. Usually its purpose is not so altruistic and indefinite; it has an axe to grind. It works through the emotions of the members of its audience to shape their attitude toward certain public facts. It wanted to move them to help those in Spain's neglected hinterland; to ask themselves just what, and whom, they thought they were defending in Vietnam; to redouble their efforts to crush Imperial Japan; to support Israel against the barbarous Arabs. It is that maligned thing, propaganda. The photographer Arthur Siegel suggests that Lewis Hine "defined very simply the documentary attitude when he said, 'I wanted to show the things that had to be corrected. I wanted to show the things that had to be appreciated.'" The definition is a good one, and the things to be corrected—always more telling than the others—are the staple of social documentary.[5]

In such documentary, as Grierson conceded, "there is hardly any avoiding [the] accusation of propaganda." There is not because social documentary deals with conditions that can be changed by human initiative. "We got the food, we got the clothing, we got the man power, we got the brains," says a Texan at the end of one of John Dos Passos' eyewitness reports on the unemployed in 1932; the Texan concludes: "There must be some remedy." *The Grapes of Wrath* is documentary in that, as Granville Hicks observed in the mid-sixties, "the situation it portrays is remediable, and was largely remedied, in part because of Steinbeck's novel."[6]

Many people would now acknowledge that a work of social documentary, whether or not they agree with its message, is, or originally was, propaganda. They might not like the word— Alexander Kendrick thinks that it will never be a polite word in America—but they wouldn't condemn out of hand everything to which it was applied. Most people in the thirties did. An accusation of propaganda then was deadly censure; then, as Edward Steichen wrote, "indignant condemnation ran high [at] the idea of propaganda." In 1937 Charles A. Beard, Paul Douglas, and Robert Lynd formed the Institute for Propaganda Analysis which sent out "Propaganda Analysis: A Monthly Letter To Help the Intelligent Citizen Detect and Analyze Propaganda" of all colors, from all sources. The propaganda detected was uniformly deplored and discounted. In thirties America this sort of propaganda against propaganda enjoyed wide popularity for at least two reasons. First, the Fascists and the Soviets had given propaganda a bad name by praising it and by exploiting it in gross and deceptive forms. Second, many Americans felt that propaganda had tricked the nation into a loathsome, pointless world war. In 1933 Malcolm Cowley put the popular case against propaganda thus: "Propaganda is false and misleading and was used to sell us Liberty Bonds during the War and to make us believe that Germans roasted little Belgian babies on the tips of their bayonets over a slow fire." Franklin Roosevelt defined propaganda the same way. During the 1936 campaign, he criticized employers who put political handbills in their workers' pay envelopes, but was even angrier at the untruths the handbills spread about Social Security: "Every message in a pay envelope . . . is a command to vote according to the will of the employer. But this propaganda [about Social Security] is worse—it is deceit." The notion that propaganda was deceit grew so ingrained that Archibald MacLeish in 1940 could call the film *The Grapes of Wrath* and Joris Ivens' documentary *The Spanish Earth*

> no more "propaganda pictures" than the most illusory of the Hollywood contraptions which conceal the actualities of a

tragic and endangered generation behind forests of pretty legs and acres of gaudy faces. If anything, the legs and gaudy faces are the more surely and more precisely "propaganda" . . .

—i.e., that which misleads.[7]

Some propaganda did mislead: the German and Italian Fascists boasted that their propaganda was built of big lies. But there was honest propaganda, too: *The Grapes of Wrath* and *The Spanish Earth* are examples, as is what this book treats. Today we recognize the truth advanced by a handful of social scientists —chiefly Harold Lasswell and Leonard Doob—in the 1920s and 1930s: almost all social utterances involve propaganda because almost all seek to influence opinion. At the very least we now admit that some propagandas are less reprehensible than others. We understand that propaganda has a "double face." There is black propaganda, put forward by a covert source, using vilification and lies to spread dissention among the group it addresses. There is white propaganda, put forward from an overt source, using actual fact to educate its audience. And there are all shades of gray between (the pamphlet with the dead Israeli bus driver had no attribution and distorted the Palestinian cause; it was gray propaganda). Few people in the thirties made these distinctions; then propaganda per se was evil.[8]

Lewis Mumford argued at the time that the American people's indiscriminate hostility to all propaganda betrayed "a pathological resistance to rational persuasion" of any sort. He suggested that when analysts of propaganda (he named Beard specifically) condemned not only everything deceptive but everything "self-interested," they "themselves put over one of the biggest propaganda frauds of our time. . . . Such analysts held in effect that the mere desire to persuade is a sufficient ground for rejecting a statement: hence any unwelcome truth could be dismissed out of hand as 'propaganda.'" For just this reason *The River* and *The Plow That Broke the Plains* were stripped of the honorific "documentary." Pare Lorentz had made the films for the government; the films showed the wisdom of the government agricultural pol-

icy; thus they were widely condemned as "propaganda." A film distributor who refused to handle *The River* said that had it been made by a private company "it would be a documentary film. When the government makes it, it automatically becomes a propaganda picture." [9]

If propaganda in the thirties was too readily despised by its legion of enemies, it was also too esteemed by its few friends, who were intellectuals and artists. The radicals who believed in agit-prop, and some moderates who favored documentary, claimed that propaganda, because it helped change society, was the highest form of expression, was art.° The communist editor Joseph North wrote in 1935 that great reporters, like Egon Erwin Kisch and John L. Spivak, whose work provided "an analysis and an experience, culminating in an implicit course of action," were "artists in the fullest sense of the term." Norman Cousins and Malcolm Cowley hailed the appearance of *You Have Seen Their Faces* in 1937 and agreed that the book belonged to a new art. In 1940 Lorentz declared that Dorothea Lange's photographs and John Steinbeck's fiction had done more for the Okies than all the politicians in the country, and claimed that this was "proof that good art is good propaganda." As Murray Kempton has observed, art versus propaganda provided the thirties' favorite aesthetic debate, the usual resolution of which was to blur the two together. Most artists of the time accepted the communist dictum that "Art Is a Weapon!" and many intellectuals, like Cowley himself, went so far as to assert that Kant's "eternal opposition" of art and propaganda, like a whole series of similar oppositions—form against matter, poetry against science, contemplation against action—could safely be swept aside. [10]

Such a confounding of art and propaganda now seems as simplistic as a prejudice against *all* propaganda. Those who com-

° The Nazis were the leading exponents of this idea. Goebbels, Hitler's chief of propaganda, taught those entering his service that "propaganda is an art, and the propagandist is an artist as much as the painter, sculptor, or writer."

ment on the 1930s generally agree that much of the period's
literature and thought exhibits this kind of sentimentality and in-
tellectual softness. The social critic Robert Warshow wrote in
1947 that the "organized mass disingenuousness" of the thirties'
intelligentsia, their pretense that good propaganda was good art,
lowered "the whole level of thought and discussion, the level of
culture itself," to the point where *The Grapes of Wrath* appeared
a great novel and John LaTouche's "Ballad for Americans" an in-
spired song. The critics and aestheticians most influential since
the thirties have defined art and propaganda in such a way that
the values of each are again understood as separate, even oppo-
site, with all prestige pertaining to the former.[11]

Nonetheless, there is no point scanting the fact that the docu-
mentary literature characteristic of the thirties was propaganda,
not art. Though the people of the time hated the idea of propa-
ganda, propaganda was in fact their common mode of expression.
This propaganda was timely then and, the timely being timely
for a little while only, it no longer is: thirties social documentary
in general is now as dead as the sermons of the Social Gospel.
The few exceptions, the works still live and pertinent, are those
that transcend the documentary genre. The most remarkable of
these is *Let Us Now Praise Famous Men*, and in discussing this
book later, we will notice how Agee and Evans "corrected" docu-
mentary, transformed a strategy of social polemic, of propaganda,
into something—"call it art if you must," sneered Agee—capable
of permanent revelations of the spirit.[12]

CHAPTER 3

The Two
Persuasions

Social documentary deals with facts that are alterable. It has an intellectual dimension to make clear what the facts are, why they came about, and how they can be changed for the better. Its more important dimension, however, is usually the emotional: feeling the fact may move the audience to wish to change it. "You can right a lot of wrongs with 'pitiless publicity,'" Franklin Roosevelt said, and he advocated such "publicity" (though he avoided its tainted name "propaganda") because he knew that social change "is a difficult thing in our civilization unless you have sentiment." [1]

To right wrongs, to promote social action, documentary tries to influence its audience's intellect and feelings. It persuades in either or both of two ways, directly and by example.

Direct

The direct method, the more usual, puts the facts before the audience as irrefutably as possible and solicits a commitment to change them. A 1972 magazine advertisement for the Save the Children Federation has a blurred photograph of the face of a

Korean boy, his brow furrowed, eyes fearful, and mouth tight. The ad says: "You Can Help Save Bo Suk for $15.00 a Month. Or You Can Turn the Page." In Buñuel's *Land Without Bread*, a classic of the direct method, the audience sees an evil, a preventable suffering, and sees it, unprevented, kill. The girl is dead, the narrator says in passing; yet even as he says it, there she is, throbbing with pain and life on the screen. And one feels somehow accomplice to her fate, as though sitting in a theater watching her were part of the social passivity that killed her. The viewer feels an impulse toward the screen, almost as though he would halt the image, hold it there, and correct the narrator, saying, "No, no, you see? She's alive." ° One feels this even seeing the film today, forty years after it was made. One probably doesn't feel responsible for her death: she died long ago. But one feels implicated. The casual dying of a child, when it happens as close to us as film can make it happen, with none of the consolations of fiction, not even sentiment, is an extreme violation of what we feel to be natural and right.°° However briefly, it calls *us* into question—our world, our humanity, our living, our death. We want the girl alive in part, then, to protect ourselves.[2]

To make us feel implicated is the purpose of the direct method. The facts are given us: how do we feel about them? what are we going to do about them? If we feel nothing and will do nothing, the documentary has failed of its aim. Shortly before Pearl Harbor, Archibald MacLeish praised Edward Murrow for

° Thorton Wilder creates the same effect in *Our Town* (1938) when the narrator remarks off-handedly on the deaths of people the audience sees in the fullness of life. Like Emily in the last act of the play, the spectator wants to cry out and keep them as they are, make them realize how precious their living is.

°° Children figure so often in propaganda because they are par excellence the blameless victims of social circumstance. In 1931 the American Red Cross refused to feed striking West Virginia miners and their families, explaining that their suffering was not an act of God; Heywood Broun, who supported the strike, said that even were the miners in the wrong, "is that sufficient reason for allowing their children, the innocent victims of these prolonged bickerings, to go hungry?"

his broadcasts from London during the Blitz. In two sentences MacLeish caught just what made these broadcasts such trenchant documentary; he said to Murrow, "You burned the city of London in our homes and we felt the flames that burned it. You laid the dead of London at our doors and we knew the dead were our dead." This is what documentary must do if it is to work social change: talk to us, and convince us that we, our deepest interests, are engaged.

Thirties documentary constantly addresses "you," the "you" who is we the audience, and exhorts, wheedles, begs us to identify, pity, participate. Richard Wright, in his documentary book *12 Million Black Voices* (1941), implores the white reader, "Look at us [the black Americans], and know us and you will know yourselves, for *we* are *you*, looking back at you from the dark mirror of our lives!" Dorothy Parker, an eyewitness to the Spanish Civil War, explained the people of Madrid to her readers; she said that even after the rebels' bombardment of the city,

> there are still nearly a million people here. Some of them—you may be like that yourself—won't leave their homes and possessions, all the things they have gathered together through the years. They are not at all dramatic about it. . . . They want the same thing you have—they want to live in a democracy. And they will fight for it,

resolutely, as no doubt "you" would. At the end of the important documentary film *The City* (1939), Willard Van Dyke and Ralph Steiner intercut shots contrasting big-city filth and confusion with the tidy calm of a Greenbelt town; the narrator intoned: "You take your choice. . . . You and your children, the choice is yours." In his social-conscious phase, Ernest Hemingway wrote for *New Masses* a curious piece of propaganda and self-exposure, a "First-Hand Report on the Florida Hurricane" of 1935 that killed 450 World War I veterans working on a WPA highway in the Keys. The heart of this outraged, prurient report is a strange conversation between "you" and "I" while hunting corpses in a mangrove swamp:

Hey, there's another one. He's got low shoes, put him down, man. . . . Turn him over. Face tumefied beyond recognition. Hell, he don't look like a veteran. He's too old. He's got grey hair. You'll have grey hair yourself this time next week. And across his back there was a great big blister as wide as his back and all ready to burst. . . . Sure he's a veteran. I know him. What's he got low shoes on for then? Maybe he made some money shooting craps and bought them. You don't know that guy. You can't tell him now. I know him, he hasn't got any thumb. That's how I know him. The land crabs ate his thumb. You think you know everybody. Well you waited a long time to get sick brother. Sixty-seven of them and you get sick at the six-ty-eighth.

Not content with making "you," the spectator, turn gray and vomit, Hemingway at the end of the article has you die as the veterans did: "The high wall of water rolls you over and over and then, whatever it is, you get it and we find you, now of no impor-tance, stinking in the mangroves. You're dead now, brother." But presumably if you had survived the experience, this imagined death, as Hemingway did, you would try to do what he was trying to do with his article: bring to justice those "who left you there in the hurricane months on the Keys." [3]

The direct method strives to give the audience the experience —and this as forcefully as possible. "A good documentary," said Roy Stryker, "should tell not only what a place or a thing or a person *looks* like, but it must also tell the audience what it would *feel* like to be an actual witness to the scene." Stryker was refer-ring to documentary photographs, and the still- or motion-pic-ture or TV camera provides the ideal instrument for the direct method. John Huston once remarked that "on paper all you can do is to say something happened, and if you say it well enough the reader believes you. In pictures, if you do it right, *the* thing happens right there on the screen." The spectator sees it happen, firsthand. As Arthur Rothstein observed, "The lens of the camera is, in effect, the eye of the person looking at the print." The two being interchangeable, the person looking at the print is, in ef-fect, present when the shutter snapped. He meets the subject as

Lange and Taylor wished "you" to meet the people in *An American Exodus:* "face to face." [4]

It is no wonder then that a photograph has, in Beaumont Newhall's words, "special value as evidence or proof." We believe it because we believe our eyes. A historian of photography, Newhall agrees that a photographer who uses a documentary strategy "seeks to do more than convey information. . . . His aim is to persuade and convince." The first documentary photos in America were made, Newhall says, in the 1870s of the geysers at Yellowstone by W. H. Jackson.° Jackson's pictures gave such convincing evidence of natural wonders formerly thought the tall tales of travelers that Congress declared the Yellowstone region a national park. Helmut and Alison Gernsheim have argued that the "first photographic social documentation" occurred in John Thompson's pictures for *Street Life in London,* an 1877 book portraying London's poor. But most historians agree with Michel Braive that "socially committed photography" began in the United States with Jacob Riis and Lewis Hine. Their work—Riis in the 1880s and 1890s, Hine in the first decades of this century —is well known. What has not been properly emphasized, however, is that in order to effect social reform, both *became* photographers. Riis was a police reporter, and Hine a sociologist; each taught himself to take pictures because he believed the camera would be a mightier weapon than the pen against poverty. Word-men both, they nonetheless felt images more telling than words. Said Hine with typical plainness, "If I could tell the story in words, I wouldn't need to lug a camera." [5]

Riis and Hine were a generation ahead of time. Despite their example, the most influential journalism of the Progressive era, the work of the Muckrakers, relied on the written word. The Progressives were, as Warren Susman says, people of the book. People in the 1930s—"people of the picture and the radio," Susman

° The Civil War photographs of Brady and O'Sullivan? Few historians call them documentary, though they are. They are human documents, however; they had no propagandistic use.

calls them—approached experience more as Riis and Hine did, and as we do now. In 1970, when *Life* magazine accused the Veterans' Administration hospitals of failing to provide decent care for American soldiers wounded in Vietnam, it didn't argue its case primarily on its reporters' accounts nor on the shocking statistics that "a Senate subcommittee chaired by California's Alan Cranston has documented." Instead, it presented photographs of rats captured in a hospital ward; of a man paralyzed from the neck down, sitting naked and unattended after his shower; of paraplegics changing the sheets of those unable to move their arms. Similarly, in 1930, the reporter who broke the story of slave labor on the Southern chain gangs, John Spivak, even while reading the Georgia State Prison records that laid the dreadful facts bare, "knew there were two things I had to do—get photographs of [the records] and visit the prison camps. America would not believe what I would say unless I could prove it with visual evidence." The truth would be vitiated, deniable, unless he could present it to his audience, via photographs, as it came to him: present it directly.[6]

The truth Spivak brought America, the truth *Life* brought, the truths Riis and Hine brought, were all new and repellent. To convince people of what they don't wish to be true demands the strongest documentation. If only seeing will make them believe, they must be given a picture. Exposé documentation relies so often on photographs and films not, as the historian Leo Gurko suggests, because a single picture communicates what formerly required a whole essay: one photo is not worth a thousand words if the words are doing their proper job. Rather, exposé uses the evidence of cameras—and more recently, of tape recorders—because machines communicate facts passively, transparently, with an almost pure impersonality. Hine and Lange both felt the camera "a powerful tool for research." And so it is, because it is a *tool*. It mechanically re-creates reality, as writing or painting—crafts, not tools—never can.[7]

"With a camera," explained Margaret Bourke-White, "the shut-

ter opens and closes and the only rays that come in to be regis-
tered come directly from the object in front." Writing is not so
direct, so mechanical: as Bourke-White said, "Whatever facts a
person writes have to be colored by his prejudice and bias." Ac-
tually, there is bias in most photographs, especially documentary
photographs, and Bourke-White's among them. She exaggerated
the impersonality of the medium; because the process that makes
a photo is mechanical, she claimed that the results are wholly
objective, an error common in the thirties.° Still, she was correct
about writing: it *is* more obviously prejudiced. A photograph is
made from ingredients in the world; writing is made of words.
Actuality vouches for part of any photo; one may have what a
writer says just on his say-so. And his word, or his words, may
not be sufficiently impartial.[8]

In 1931 Edmund Wilson reported a congressional hearing on
communist activities in the U.S. He described the participants in
vigorous detail. The only anti-communist witness before the com-
mittee was, he wrote, "one of the most untrustworthy-looking
characters who have surely ever been called upon to testify—a
pale-eyed, shifty-eyed, shaved-headed man, represented as an
honest Russian farmer sent to prison for criticizing the Soviets."
In the fifties Wilson republished his thirties reportage, much re-
vised; the "Marxist morals" he had drawn too eagerly from the
phenomena he went out to explore he now toned down or ex-
punged. But he let stand his description of the farmer, appending
to it an apologetic footnote:

> This represents a kind of thing that is to be sedulously avoided
> by honest reporters. On the strength of a physical impression
> and solely out of a sympathy toward the Soviet Union, about
> which at first hand I knew nothing, I assumed that this man was
> lying. . . . I leave my report of the incident as an example of
> the capacity of partisanship to fabricate favorable evidence.

° Laurence Stallings dedicated his picture book *The First World War*, a
best seller of 1933, to "The Camera Eye," the time's equivalent of ideal
truth.

A camera, however partisan, would not have been able to fabricate so completely. It would have showed the farmer in the flesh, and, as George Orwell observed in 1938, "when you meet anyone in the flesh you realise immediately that he is a human being and not a sort of caricature embodying certain ideas." A camera would at least have showed the farmer to be a man, not a perambulating deceit.[9]

Vicarious

Photographs and most writing, like Wilson's word-portrait, use direct persuasion. They present evidence and let it work upon the audience if it will. There is, however, a second method of persuasion common in documentary and particularly thirties documentary. This method gives the facts indirectly, through an intermediary. A member of the audience isn't put in the place of the firsthand experiencer; this role is taken by someone else, whose reactions to the facts are often as influential as the facts themselves.

John Spivak's report on Southern chain gangs used photographs to persuade his audience directly that convicts were kept in shackles and forced to suffer cruel and unusual punishment. But the photos, though they made the exposé credible, did not give it its passion; they documented facts rather than feelings. The prisoners, suspicious of the camera and of Spivak, who was accompanied by the warden and guards, hid their emotions in enigmatic stares. The one man photographed while undergoing punishment—a Negro fallen in the sun, his knees bent sharply around an iron pipe and his wrists bound to ankles—showed little of his pain. His face was bright with sweat, but his mouth was closed, not raggedly open; his jaw was relaxed, not clenched. He frowned lightly, as though he tasted an unexpected flavor.

If the prisoners managed to feign indifference, Spivak, who seemed to a dispassionate critic in the mid-thirties "one of the

very best writers of *reportage* in America," did not.° To make sure his readers understood the human abomination of the chain gang, he coached their emotions by exposing his own. He began the report:

> I saw the Spanish Inquisition of 300 years ago. I saw men chained by the neck like galley slaves. I saw men with monstrous bayonets riveted around their feet so that they could not sleep without waking up when they turned. I saw men trussed up like cattle ready for slaughter and ants crawling over their helpless bodies. I saw men hanging in stocks such as the Puritans used in their cruelest days. I saw men broken on the rack as they broke them under the Spanish Inquisition.
>
> I saw these things and I photographed them—not in a forgotten dungeon in ancient Spain but in the United States—in Georgia—in this year of our "civilization" 1932! [10]

The tone of incredulity and outrage recurs throughout the article, and if the reader puts up with it, he does so not least because he wants to assure himself that it cannot be justified. Spivak documents what he saw in matter-of-fact, first-person vignettes,°° and with several crucial photos. He is the reader's eyes and ears:

° A word about Spivak, who figures again in this study. His writing is ignored today, but from 1934 to the end of the decade he enjoyed the reputation of "America's greatest reporter." This appraisal came from *Time* magazine in 1936—and despite the fact that most of Spivak's recent work had appeared in communist publications. In 1938 Ernest Hemingway, George Seldes, Paul DeKruif, Spivak, and Raymond Gram Swing were announced as editors—in that order—of the new liberal magazine *Ken: The Insider's World*, which called Spivak "America's best reporter . . . no man more respected by those who are interested in pure journalism." Spivak was a reporter in the romantic, *Front Page* mold: "Spivak, Star Reporter," one admirer called him. Brash, bullying, fearless, a hunter for the scoop behind the news, he usually put his search for the facts into his articles—"Spivak is part of his story," Joseph North, the *New Masses* editor, remarked in 1936—and thus dramatized his findings. But he *had* findings. His articles were the best reportage in *New Masses* and brought the magazine many new readers. A large share of the period's exposés were his. Spivak's involvement in communist causes in the thirties prevented him from getting published under his own name in the forties and fifties, and he wrote for national and pulp magazines under pseudonyms. A spirited autobiography of his work in the thirties, *A Man in His Time*, appeared in 1967.
°° In 1936 Spivak toured the United States as a *New Masses* lecturer on European Fascism. His lecture was entitled "I Saw."

> I saw a man working in a group of convicts and as he shovelled the sun caught the glint of bayonets on his feet.
>
> As I walked through the white-washed cages the sounds of a hymn reached my ears.

The reader's mind and voice:

> I remember those death certificates, the neat little batches with rubber bands around them, each telling a story of one dead of apoplexy, tuberculosis, heart failure, sunstroke.
>
> "How long do you keep him in the stocks?" I asked.

The audience participates in his quest for the facts, gains some respect for his guile and more for his daring. Spivak is, simply, the reader's stand-in. And insofar as the reader takes Spivak's word for what happened, he is led to accept also his emotional response. It seemed at first exaggerated, but the reader learns that it had some justification. One accepts, to some degree, the validity of Spivak's emotions—and thus Spivak forces him to feel what the prisoners felt.

At the end of the article, Spivak tells of seeing a convict stretched by ropes between two posts and makes this torture real to the reader by describing how it affected him, Spivak. "As beads of sweat broke out on [the prisoner's] arms and neck and face a cold sweat broke out on me. I doubted my sanity. They were tearing this convict's arms out." The horror of it threatens the mind that has given the entire report. It is such horror that Spivak cannot face it, and in consequence neither can the reader. The article ends without summary or peroration. Spivak runs from the scene, "the convict's groans ringing in my ears." And the reader, perforce, is running with him, hearing what he hears and what has finally broken his emotional command.[11]

Spivak's *example* was meant to influence his audience. The emotion he felt at going through the experience they were to share. This method of persuasion, which is called here vicarious or confessional, was much used in the thirties and throughout

the war.° Readers were encouraged to feel John Steinbeck's angry pity for the migrants in California because he "told his story . . . at first hand," having "followed the people who followed the crops" and partaken of their working and living conditions. In his last speech to Congress, Franklin Roosevelt, who had just returned from the Crimea, condemned "the kind of reckless, senseless fury, the terrible destruction that comes out of German militarism," and did so in a way that asked his audience to share his emotion and the specific experience that caused it: "I had read about Warsaw and Lidice and Rotterdam and Coventry —but I *saw* Sevastopol and Yalta! And I know that there is not room enough on earth for both German militarism and Christian democracy." He was an eyewitness; he had been there, seen the facts, and knew.[12]

Murray Kempton has said of the thirties that no other period in our literature produced so many counterfeit Walt Whitmans. This was in part because no other time so prized the Whitmanian "I"—able to see, incorporate, and give voice to all human experience. Several critics singled out for particular praise Whitman's line "I am the man, I suffer'd, I was there." And Whitman's stance of *being there* was a criterion of authenticity in expression at the time.°° To be trustworthy, a speaker needed to be the man or a firsthand witness; if he had suffered also, it would help. Tom

° It is a chief strategy of the "new journalism" of our day, in which the reporter seeks, as Benjamin DeMott has said, "to change his relation to his work by crossing his objective function as a noter of external events with an enterprise in self-analysis—scrutiny of . . . his own response to the occurrences 'covered.'" Vicarious techniques are increasingly used in hard-news reporting. A *Time* stringer toured a portion of East Pakistan decimated by the 1970 cyclone and wrote: "I could not walk 200 yards without passing heaps of bloated bodies. For miles, animal carcasses littered the landscape. The stench was appalling, the sight of parents hovering over their dead children staggering. My legs shook."

°° "Vas you dere, Sharlie?", Jack Pearl's vaudeville refrain, became, thanks to radio, perhaps the decade's most popular tag line. The reporter James Rorty heard the phrase shrilled among the teenagers of South Dakota, "some of whom seemed to have more than a trace of Indian blood in their veins."

Kromer's book about his life on the bum managed to imply in its first two pages that he was a man who had been there and suffered plenty: its title was *Waiting for Nothing*, and it was dedicated "To Jolene who turned off the gas." Doubleday offered Edward Anderson's *Hungry Men*, a novel about the unemployed roaming the country, with a prefatory note explaining that "Mr. Anderson himself rode the blinds of crack passenger trains, freight manifests and slow locals, in gondolas and cattle cars; slept in welfare flops, ten-cent hotels, parks and darkened churches." Clara Weatherwax's *Marching! Marching!*, which won the only *New Masses* award for a novel on an American proletarian theme, was published with a biographical sketch of the author preceding the text; the sketch is a gem of its kind, rapidly proving Weatherwax a genuine American, a revolutionary, and a person acquainted with work and those who do it:

About the Author

Clara Weatherwax stems from pre-Mayflower New England stock, which has pioneered across the American continent. . . . One of her outstanding forbears was Roger Williams. Fourteen of her direct ancestors fought in the first American revolution. . . .

Miss Weatherwax was born and schooled in Aberdeen, with the sound of sawmills in her ears. Her earliest days were spent in a papoose blanket which her mother got from Indians at the Quinault Indian Reservation. . . .

Since high-school days Miss Weatherwax has had a variety of jobs—both white-collar and proletarian, mostly for fifty dollars a month or less, and the kind of work mentioned or described in this book she knows through experience or close contact.[13]

Readers were to trust the information Weatherwax gave because of who she was and what she had done: this is vicarious persuasion. The characteristic fiction of the thirties, the Proletarian, is full of it. Each novel carries its author's blue-collar pedigree.* More important, the novels all have the conversion-end-

* James Thurber made up one for himself which read, in part: "Mr. Thurber has not worked as a cow-puncher, ranch-hand, stevedore, short-order cook, lumberjack, or preliminary prize-fighter."

ing notorious in this fiction. John Gassner has said that "Leftish orthodoxy" required this final turn of the plot in which the principal characters discovered the class struggle and resolved to participate in it. Such endings were requisite because they offered barefaced exempla for the reader. The principal characters had undergone experiences which led them to conclude they must shoulder arms in the class war; the reader had been vicarious participant of their experience; was he not thus led also to the same conclusion? [14]

The nonfiction of the time put the same premium on the author's experience. Reliability of insight was conferred not, as in fiction, by fitful employment at many jobs, especially menial ones,° but rather by prolonged wandering about. To compose a portrait of American youth in 1935, Maxine Davis "gathered the material as any reporter covers a story: I went about the country and collected it. . . . In a cheap second-hand car I travelled almost four months, alone, over 10,038 miles of the United States, talking with boys and girls every time I could." James Rorty prefaced his attack on American optimism, *Where Life Is Better* (1936), with proof that he knew whereof he spoke: he had just made a "seven months' automobile trip, covering about fifteen thousand miles." Louis Adamic sought to persuade the reading public of the validity of *My America* (1938) by confessing that while writing it "I have travelled perhaps 100,000 miles in America, by train, by automobile, by plane, as well as afoot, pausing here and there to look and listen, to ask questions, to get 'the feel of things.' " [15]

Experience per se became a good. A 1940 gathering of students and New Dealers would be impressed, not alienated, by Franklin Roosevelt's boast that "Frankly, I have seen a good deal of the world, probably more than anybody in this room, first and last, and a war." That same year Philip Rahv coined a phrase to

° An exception. While chief book reviewer of the *New York Times* in the early thirties, John Chamberlain characterized himself as an "ex-fruit tramp."

describe this tendency in the American character: he called it "the cult of experience." Americans, he said, had "an intense predilection for the real: and the real appears as a vast phenomenology swept by waves of sensation and feeling." So strong was this "urge toward and immersion in experience" that Americans were disinclined to thought, indifferent to ideas in general, and, at times, outright contemptuous of the intellect, "which in the unconscious belief of many imaginative Americans is naturally impervious, if not wholly inimical, to reality."

Rahv examined this tendency in thirties fiction, but it is evident in all the arts. Flagrant examples are to be found in the government-sponsored murals of the period. James Michael Newell's monumental "Evolution of Western Civilization" shows slaves picking cotton, a farmer grafting fruit twigs, miners entering the pit, cowboys herding cattle, welders welding, a (Frankensteinish) scientist heating a test tube, surgeons operating, a jury listening to a pretty witness—but nobody *thinking*, nobody laboring with just pen and paper. When education is portrayed, as it often was in WPA murals, it is singularly experiential, not to say athletic. Emanuel Jacobsen painted an "Early Schoolroom" with dignified idle Indians to the left of it and whites in a sleigh—a fur blanket being draped across them—to the right. The teacher, a woman, stands on the school threshold, watching the sleigh depart. Inside the school, two girls are dancing while a third, book in lap, smiles at them; two boys are wrestling (one has the other in a choke-hold); a girl stands on a bench, evidently getting something down from a cupboard. In the far corner, alone, sits a stoop-shouldered drudge reading a book. The book is propped on his desk, his arms hang limply between his knees, his heavy head bows almost to the page. Happily his suffering will soon be over, for the final student, a handsome girl, is walking briskly toward him to turn his attention from such dismal fare. In Edgar Britton's "Classroom Studies and Their Application," there is no classroom and no "study" but plenty of application. A farmer rides a tractor; two young people graft a sapling as chickens swagger

about their feet; a boy looks through a microscope while a girl, who holds a stop-watch in one hand, marks down his observations; a novice carpenter chisels a piece of wood; three young men casually check a measurement in a blueprint; other young men make industrial designs; workers hoist a girder into place. The only piece of paper in the series that may have words on it belongs to a woman who holds it negligently at her side, indeed behind her back, while she turns her attention to what her other hand is doing: putting the final touches on a painting of a decorative shrub. Like everyone else, she shuns words for deeds, the merely mental for the lived experience.[16]

The promise of such experience led Helen and Lillian Ross and three college friends to quit school in the late 1930s "to taste in real life what we knew only from books." They wandered around the United States in a car, seeking "the America that could not be found in textbooks." They gayly jeopardized their academic futures, so certain were they that only life at firsthand mattered: "We withdrew the last of our scholarship money—for a *real* education!" When these young people got home, they wrote a book about what they had learned at large that couldn't be learned from books. This book, *The "Argonauts"* (the bookish name by which they called themselves), was derivative and little read, but it followed the approved formula. Like much of the literature of the time, it offered a first-person account of lived experience. It was, in the broadest sense, confessional.[17]

Confession literature greatly influenced documentary using the vicarious method. Pulp confessions—*True Story, True Confessions, True Romance, True Detective,* and a host of similar magazines—were enormously popular in the 1920s and 1930s, and actually reached their peak market in the latter decade. The strategy of the "true confession" is exactly that of the vicarious method: "I am the man, I suffer'd, I was there." The pulps showed the formula to be so successful that genteel magazines picked it up.° In the mid-thirties it was a rare issue of *Harper's*

° As did advertising. These decades were the heyday of the "testimonial" ad. In the twenties, more than a hundred distinguished women including

or *The Atlantic Monthly* that didn't have several articles like
Charlotte Muret's "On Becoming French," which began:

> Can an American adapt herself so thoroughly to the French as
> to become one of them? This question became vital to me when
> I married a Parisian who spoke almost no English.°

Or like "The Aftermath of Divorce," by Anonymous:

> I have had a great deal of happiness out of life, but I have also
> had a great deal of unhappiness. My main slice of unhappiness
> was due to the mistake I made in marrying at the age of twenty
> a man more than twenty years older than myself, who in his pri-
> vate relationships was for all practical purposes a lunatic.

In the pulp magazines, and often in the genteel, a true confession
dealt with the passions: romance, rape, hate, murder, and re-
venge. But occasionally the pulps would handle something that
had social as well as human interest. A prime example of such a
confession is Robert E. Burns' *I Am a Fugitive from a Georgia
Chain Gang!*, which, though it first appeared as a serial in *True
Detective Mysteries* from January to June 1931, was in part au-
thentic documentary.[18]

Burns' book is awful and lurid, and a treasure trove for the cul-
tural historian. As true confession, it has everything: "Success,
Romance and—Betrayal" (the title of Chapter Nine), "the marvel-
ous human interest of a first-hand prison document" (one of the

Gloria Vanderbilt, Lady Diana Manners, and Her Royal Highness Eulalia,
Infanta of Spain, testified that they owed their beauty to Pond's Cream. In
the thirties, tobacco auctioneers, weighing-clerks, farmers, and warehouse-
men appeared in Lucky Strike's "Witnessed Statement Series" to strengthen
the claim that "with men who know tobacco best—it's Luckies 2 to 1." In
1928 the head of the J. Walter Thompson Agency defended the testimonial
ad, saying that "tabloid readers seek to live vicariously" and that "testimoni-
als merely offer the [same] sort of personality satisfaction."

° Compare the opening of the radio soap opera *Our Gal Sunday:* "The story
that asks the question: can a girl from a little town in the West find happi-
ness as the wife of a wealthy and titled Englishman?" The soap operas,
which began in the thirties, were simply true confessions chopped into epi-
sodes. The potential of radio confessions was demonstrated when the Mac-
fadden Publications' weekly *True Story* on C.B.S. became a surprise hit of
the 1928–29 season.

come-ons in the introduction by Burns' brother), and moralism as heavy as a De Mille film. *True Detective Mysteries* was one of Bernarr Macfadden's stable of confession magazines, and Macfadden kept an ordained clergyman on the payroll full time, reading every article to make sure that the participants never got any enjoyment from their seductions or rapes and to put in a final uplifting paragraph on how crime didn't pay. Thus, late in his agonies, Robert Burns counsels a man who had once forced him to attempt a robbery: "Moore, don't ever get in trouble again—obey the law at all times, no matter how unreasonable it may seem." And of course Moore wouldn't; like all bad men in these stories, he has "learned a bitter lesson" and become honest and penitent.[19]

As social history, *I Am a Fugitive*—which has little in common with the excellent social-protest film that derived from it—is interesting because it exploits stereotypes from both the 1920s and 1930s. Before he was betrayed and sent back to the chain gang, Burns started a lucrative advertising firm, and the audience was meant to admire his "rise from fugitive to business executive" occupying a "modern suite of offices in one of the finest buildings in Chicago." Indeed, according to his brother, "one must recognize in him those qualities of courage, perseverance, industry and honesty which lie close to the bed-rock of American life." This Robert Burns was a twenties hero, an Hooverian individualist. By the end of the serial, though, Horatio Alger has vanished, and in his place is a paragon of social conscience who no longer seeks to attain personal success but rather to improve the world. This new man declares, "It's now my life's ambition to destroy the chain-gang system in Georgia." Unmistakably, a thirties hero.

How was this profound change in character justified? It wasn't. The hero *has* no character. He shifts from one stereotype to the other for no reason. Or rather, he shifts for a very good reason: the society was shifting and the pulps were keeping pace. For of course Burns' story wasn't really by Burns. He provided the facts, the details, perhaps some of the words; but *True Detective* made

a true confession of them. According to John Spivak, who worked for Macfadden Publications in the mid-twenties, Macfadden had a squad of writers rewrite whatever came in that had the germ of a story and make up confessions wholecloth. This "true story factory" ground out confessions on a "literary assembly line," with many of the writers specializing, like the clergyman, in one or two effects (Spivak was particularly adept at getting raped and giving birth). But in this instance the facts, the germ of the story, overturned the formulas.

Macfadden's writers began *I Am a Fugitive* as a twenties story: good weak man makes small misstep, is terribly punished, will risk death to be free, escapes "the bottomless depths of Hell," proves strong character in business and romance, is betrayed and returned to the chain gang, and then. . . . But by this time *True Detective* had learned that the rules were changed. The serial was selling out but not for the expected reason. Readers didn't care much about Burns, the heroic individual made society's captive, but they were greatly exercised about the chain gang. The South was up in arms, denying, apologizing, mounting investigations. The truth was that no one before had documented (or much bothered) what went on in this penal system, and though Burns' confession was—to say the least—highly colored, it did offer a picture of the sort of thing people in the early thirties had begun to care about: a social evil.

Realizing this, Macfadden's writers mimicked the tone of social concern the serial had aroused and stirred it into the last installment as though it had been there all along. "It's now my life's ambition to destroy the chain gang system," says the hero—but in fact only "now," at the end, was the propaganda motive noticed. (The actual Robert E. Burns became a tax consultant in Newark.) What had happened is clear: the serial, as it ran its course, adapted to changes in public sentiment; it dropped the clichés of the twenties and picked up those of the thirties. This was no great feat. The hired clergyman, for example, easily adapted: guilt was no longer personal; morality now meant the condemna-

tion of social evils and the social order that allowed them. The clergyman found one text would do the whole job. On the book's last page the hero wonders whether jails are for punishment or rehabilitation:

> In a sane, intelligent and loving society, justice would be wide-awake and ready to help those who by virtue of their environment have become mentally and spiritually sick. Simple justice should be happy when the weak one is strong again—and should say as the Master said, "Go—and sin no more." *That* was the Son of God's command; *that* is the very essence of justice. . . .
>
> Perhaps I am wrong. Perhaps men and women are sent to prison solely for brutal punishment, and a warden's duty is to inflict that punishment—and then let the helpless convict leave the prison with a scar on his heart—a tortured brain—and hope forever gone. What do you think? [20]

The true confession provided the rhetoric for much of the thirties' "common man" vernacular literature. Indeed, the difference between such a confession and first-person documentary (as, for example, a "worker narrative") seems to have been difficult for many people to catch. In her list of documentary literature in the thirties, Hallie Flanagan mentioned the WPA's *These Are Our Lives;* a sharecropper wife who tells her history in this book believed that what she said was no different, no truer, than a true confession—or, in fact, than a soap opera. She said:"I used to tell Morrison [her runaway husband] our lives would make a good true story—like you read in the magazines and hear on the radio —Ma Perkins and the others." [21]

The confession influenced most the *style* of vicarious documentary. Since both genres sought to communicate emotion to the reader through the narrator's reactions, these tended to be exaggerated. The hero of *I Am a Fugitive* has no character because he has no mind. He is a raw tissue of nerves responding to stimuli. A policeman enters the barber shop where he is getting a shave: "A nervous tremor ran through my body, beads of perspiration started to roll down me. . . . Fear clutched every nerve

and muscle." His body expresses his mental state.° His thinking is all reflex; it occurs—as with an animal—in the nervous system, the brain, not in the mind. Burns fears he has been pursued onto a train: "Another shock hit my nerves. Trapped! This idea flashed through my brain—trapped! . . . I must think! I must act!" (The two are of course identical in this rhetoric.) "Oh! where was that quick thinking brain power now? Now when I needed it most, my brain failed even to direct a muscle." The train conductor appears.

> He punched the ticket, gave me a colored slip, and looked worried. So was I. Plenty worried! . . . Good God! Would I ever get away? Could a nervous system stand any more shocks and still survive and function? Would this fearful suspense never let up?

Not in this genre. Emotions here come fast and heavy. And so do they in the documentaries that borrow, consciously or not, the method of the confession.[22]

° It was not only T. S. Eliot and the intellectuals who sought "objective correlatives" for emotion. Some of the freshest correlatives of the thirties were coined by James Cain, who borrowed the true confession rhetoric—including, alas, the moralism—and raised it almost to reputability. In *The Postman Always Rings Twice*, the hero-heel gets ready to seduce Cora: "I locked the front door. I picked up a plate that a guy had left there, and went back to the kitchen with it. She was there.
'Here's a plate that was out there.'
'Oh, thanks.'
I set it down. The fork was rattling like a tambourine."

What
Documentary
Treats

In 1970 Doubleday published a novel about contemporary life on an Indian reservation in British Columbia. The book, *How a People Die*, was written by a white man working for the Canadian Department of Indian Affairs, and Doubleday advertised it as "a documentary novel about the tragedy of the North American Indian." N. Scott Momaday, who reviewed the book in the *New York Times*, didn't feel comfortable with the phrase "documentary novel"; he didn't understand its meaning. The term was oddly applied, since unlike Michael Crichton's *Andromeda Strain* or John Hersey's *Child Buyer, How a People Die* contained no supposed documents. Nevertheless, when Momaday said, "I don't know what is meant by that term 'documentary novel,'" he was not quite candid—he assumed he did know. "Presumably," he continued, "the story is based upon one or more actual incidents in the author's experience." This surely is the basic assumption about documentary: that it treats, at firsthand, of actual experience.

What kind of experience? Momaday thought *How a People Die* sensitive and incisive: "As a document reflecting a particular human and intercultural relationship, the book is remarkably

thoughtful and provocative. It is an attempt by a writer to treat
—with honesty and intelligence—a problem that is at once im-
mediate and all but unimaginable." The problems social docu-
mentary treats, in addition to being actual, are immediate and
yet all but unimaginable.[1]

They are immediate because they touch us, the audience,
closely; they touch us closely because they are problems of our
society. Sometimes "our society" is taken in the largest sense and
means "human society"; we are then to be concerned about cy-
clones in Pakistan and terrorism in the Middle East. More often,
though, documentary shows us realities nearer home; the histo-
rian Howard Zinn credits Michael Harrington's *The Other Amer-
ica* (1962) with "supplying a periscope so that we could see
around the corner" and notice poverty just down the road.[2]

Though poverty was an immediate problem in American so-
ciety, it had been generally overlooked during the 1950s. It had
become, as James Agee said of the sharecropper's plight in the
1930s, "a portion of unimagined existence." Documentary treats
just such existence and makes it real to people at the time. The
editor of *These Are Our Lives*, W. T. Couch, wrote that the doc-
umentary life histories in the book portray the structure of
Southern society and "the quality of life" of its members: such
representations had high value, he felt, because "the life of a
community or of a people is, of course, made up of the life of in-
dividuals" so different from one another "as to be almost unimag-
inable." Documentary deals with the almost unimaginable, the
all but unimaginable—in short, the still unimagined.[3]

Experience that is both immediate and still unimagined varies
from society to society, and time to time. Nonetheless, the way
documentary handles it is always the same. Couch warned that
These Are Our Lives would have no meaning "to those who are
not genuinely interested in the rich variety of human experience,
to those who cannot for a moment look at the world and people
as if they were seeing them for the first time, pushing aside all
patterns and doctrines that might be obstructive." The sentence

not only patronizes, it greatly overstates the case; yet there is a truth in it. Although documentary most often has doctrines in tow, it does argue them in terms of particular human experience. It looks at the world and its people as though seeing them for the first time—that is, it sees each thing and person as individual.

There is a polemical reason for emphasis on the particular, of course. In *We Too Are the People* (1938), Louise Armstrong, a federal relief administrator in northern Michigan, told of a tough Chicago businessman who did a stint in her rural office, reorganizing the bookkeeping of its food distribution. While there, he heard a poignant hardship case involving a little girl whom he met. Several years later he came through town again and stopped by the office. Armstrong found that he had forgotten everything about the food relief, but that he remembered "little Nita. Many thousands of decent, kindly American citizens would also have remembered her, had they known about her." No doubt they would remember her better than the food accounts. The Cranston committee's disclosure that VA hospitals got less money in 1970 than before the Vietnam war didn't stir much indignation; but *Life's* picture of Marke Dumpert, a quadriplegic, waiting naked in a shower stall because there were too few attendants to provide adequate care, did. The magazine reported in May 1971 that "the shock of the photographs" prompted more letters than any other article published that year, and that the old, overloaded ward where Dumpert received treatment had been renovated and enlarged. The head of the Eastern Paralyzed Veterans Association praised *Life* as "the moving force behind this action." [4]

Nita and Marke Dumpert and the dead Israeli bus driver give human dimension to social problems. This dimension is always the subject of documentary. When someone asks, as people in the thirties often did, what a social reality means "in human terms," he is asking for documentary; he wants particular facts—an image, an anecdote—to sum the reality up and, so doing, to express the speaker's attitude toward it. During her long service

with Franklin Roosevelt, Frances Perkins said she learned to describe a problem to him "in human terms," because he would grasp it "infinitely better when he had a vicarious experience through a vivid description of a typical case." Herbert Agar suggested in 1936 that "those who try to build a better world should make a picture, in human terms, of what they want that world to be"; he felt that such a picture, unlike abstract theory, could "stir the human heart."[5]

The social realities that documentary treats in human terms are much of a kind. One sees this clearly in the thirties when the word "human," like documentary itself, had a class bias. As Roosevelt's Secretary of Labor, Frances Perkins traveled to Duquesne in the early days of the New Deal to find how the NRA codes were working in the steel mills. She followed her standard practice and spoke first with the company brass: "Again I asked my questions of these managers. But I had come down to get the human side of the situation and I wanted to see some of the men alone." The "men" are of course the workers, and to understand "the human side," one spoke to them, not the managers.[6]

Documentary is a radically democratic genre. It dignifies the usual and levels the extraordinary. Most often its subject is the common man, and when it is not, the subject, however exalted he be, is looked at from the common man's point of view. In the thirties there were quite a few documentary exposés of the inhumanity of the very rich, but it was far more frequent then (as now) for documentary to show the rich, the powerful, the renowned as just regular guys. Alfred Kazin remembers that during the Depression "*Time* was always documenting some great and successful and unparalleled American career with a show of inside knowledge. You saw the great man on his living room sofa, with his dogs; you heard the nickname by which only his fellow ambassadors or corporation executives knew him." Documentary made almost common men of the remarkable.[7]

And vice versa. In his broadcasts during the dark days of the Battle of Britain, Edward Murrow constantly answered the ques-

tion "how does Commonman feel?" because it was the common man that mattered. As Murrow said, "evidence that the little people of Britain were losing their curious sense of humor, their fondness for grumbling at their government, their arrogant but well-mannered pride, would be much more important than news of a battle won or lost." Dorothea Lange practiced documentary photography because, unlike most photography, it sought not the spectacular or the bizarre but the ordinary and the meaningful. Roy Stryker admonished the FSA photographers to document "not the America of the unique, odd or unusual happening, but the America of how to mine a piece of coal, grow a wheat field or make an apple pie," the crucial everyday America.[8]

The contours of this America are well defined in a 1937 anthology of free-time writing by members of the WPA Federal Writers' Project. It is revealing to see what the professional writer in the thirties did on his own, for his pleasure and the advancement of his career. Henry Alsberg, director of the project, complained in the anthology's foreword: "The impression persists that our writers are incapable of producing anything but guides and the other less creative types of publications." One would assume then that the free-time writing was quite unlike the literal reporting the WPA required—more introspective, more "creative." And in fact there are four Proletarian sonnets ("O honored folk, do not begrudge the sight / and rumor of reality"); a good poem about guppies; two love poems in the manner of Donne; an antiwar fairy tale; several contorted, inexplicable poems in the manner of Hart Crane ("I must in my inch of ghetto / still constringe!"); and some windy anthems—one to Omaha—in the manner of Walt Whitman. But the heart of the book is elsewhere. For the anthology includes: the text of "Twenty-one Negro Spirituals" collected in South Carolina ("If 'ligion was a thing money could buy / Well, de rich would live, en de po' would die / But I'm so glad God fixed it so / Dat de rich must die as well as de po'"); "A Gullah Story" in Gullah dialect; tall tales from West Virginia; Richard Wright's fine essay "The Ethics of Living Jim Crow";

square dance calls, "Four Traditional Stories," and a white spiritual—all from Arkansas; "Six Negro Market Songs of Harlem"; "Mutiny: Being a Series of Excerpts from Ships' Logs and Diaries, Concerning Strikes or Revolt on the High Seas"; six stories or sketches about workers, immigrants, unemployed vagrants, and "the *poor, those who suffer!*"; "Seven Negro Convict Songs"; "Romances and Corridos of New Mexico" (songs, with English translation following the Spanish originals); "Phrases of the People" (the people being Mississippi and Arkansas Negroes); the folk history—"related by Dame Rumor"—of a collapsed chapel in Sharon, Connecticut, built by Maria Monk's bastard daughter, who absconded with most of the funds; and an Alabama Negro's lively tale of how John Spencer met so many fools he decided to marry Tildy Moore.[9]

Contrary to what Alsberg implied, his writers in their free time seem to have done what they did on the job: they documented American life, past and present; they collected and wrote up *American Stuff*, as the anthology was called. It is an ugly, funny phrase, "American stuff"—but meaningful. Nothing could be commoner, or more essential, than stuff. "Stuff," says a dictionary, is "the material out of which anything is made." Since it is material, one can pick it up, feel it, turn it in his hand. As a matter of fact, to make sure that it is "good stuff" and not "just stuff," one must get close to it, handle it. This the artists and intellectuals of the thirties tried to do with America: touch its substance, find and lay hands on whatever would give them, and help them give, "the impression and the feel of America" (Margaret Bourke-White), "the 'feel' of the country" (James Rorty), "the feel of things" (Sherwood Anderson in *Puzzled America*), " 'the feel of things' " (Louis Adamic in *My America*), "The Feel of America" (Stuart Chase).[10]

The American stuff the artists of the time wanted to feel and document was not just *anything* American. To be sure, they usually pretended that it was. The novelist Nathan Asch began his book of documentary reportage, *The Road: In Search of Amer-*

ica (1937): "When you decide to try to see America, you start out from a point by train or car or freight or bus and go in any possible direction—all of it is America—and stop off anywhere at all and watch people and talk to people." It all may have been America, but parts of it were more America than others, apparently; for some were hardly treated, and never with respect. Consider the America celebrated in the twenties—white, Anglo-Saxon, Protestant, success- and business-oriented. This America appears once in the fifty selections in *American Stuff*, the book has one character who would have been a twenties hero—Leslie Squires, a bright young man with great wealth (in manufacturing) and a Harvard law degree; here he finds his "Heart's Desire" (the story's title) in committing murder and suicide for reasons unclear.[11]

The intellectuals and artists of the thirties paid attention to an America few had noticed in the twenties. This America existed then of course, but the country's leaders and its media celebrated an "Age of Prosperity" and overlooked the literally uncounted millions unemployed and the tens of millions living in hardship. Fiorello LaGuardia was one of the few men in public life who recognized the existence of this other America; though he spoke constantly on its behalf, trying to make it visible and real, he was little heard. The society of the time drowned him out. Howard Zinn has cited a typical instance:

> As 1928 drew to a close, LaGuardia accompanied a reporter on a tour of homes in the poorer districts of the city in connection with the newspaper's annual relief fund, and reported: "I confess I was not prepared for what I actually saw. It seemed almost incredible that such conditions of poverty could really exist." The article was lost amid reports of a city dancing, singing, and shouting with joy to usher in the year 1929.

It was an unimagined America of almost incredible poverty that moved to the front of public consciousness in the thirties. As was typical, Harold Stearns, the best known intellectual among the exiles of the twenties, by 1934 had set about "rediscovering America" and had, in fact, published a book of that title. For

Stearns, as for most writers and artists, however, America of the 1930s was less a land "rediscovered" than—as Archibald Mac-Leish called it—a "New Found Land." [12]

This New Found Land had as its heroes people largely ignored in the twenties: the worker, the poor, the jobless, the ethnic minorities, the farmer, the sharecropper, the Negro, the immigrant, the Indian, the oppressed and the outlaw.° Of the selections in *American Stuff* more than a fifth were created by Negroes. The main characters in the anthology's sketches and fiction provide a cross section of thirties America; the characters, in addition to Leslie Squires, are Mrs. Pontowski, Mr. Lazar Feinkucken, the Dalcassians and O'Briens, Salvatore Attansio, Eluard Luchell McDaniel (boy on the bum), Old Barnham (farmer-sage speaking on democracy), Martha (unwed, unemployed mother), Louie the barkeep in the dented derby, Tom Wilson (unemployed man on the bum), Mr. Walter Demetrius, Mr. McWebb (timid clerk, terrified he will lose his job), The Man Standing There (swarthy, unemployed "Mexican or something" with no place to go), Thoke Sitwell (lovable Jewish huckster), Lester Cummings (unemployed man on the bum). The salt of the earth.[13]

When an artist of the thirties wanted to present a fact in human terms, these are the kind of humans he chose. Documentary then (as now) was populist—or to use the word of the thirties, "proletarian." It is no doubt true that this emphasis in thirties documentary was influenced by the Russian example in letters and movies, and by the German example as well. The worker, the peasantry (or "folk"), and the land were the key themes of Russian and German expression at the time. Furthermore, certain artistic and reportorial techniques developed in

° "Individuals make up a people," Roy Stryker wrote in 1940; "their photographs are important in any documentary coverage." He offered eight FSA portraits of individuals who made up the American people: a Nevada gold dredger, a migrant worker in Visalia, California, a Louisiana muskrat trapper, the brakeman on the *Challenger*, the sheriff of Duncan, Arizona, a Salvation Army worker, a Mexican family in San Antonio, and Postmaster Brown of Old Rag, Virginia.

these countries that became part of the American documentary movement.° The Federal Theatre's documentary play, the "Living Newspaper," was an adaptation of German Epic theater. Some Russian experiments with new sorts of reporting preceded and seem to have influenced documentary journalism in this country. Speaking to the 1935 American Writers' Congress, Joseph North and Matthew Josephson explained "reportage," a word that came to the U.S. from Europe, "particularly from the Soviet Union." Reportage, said North, was "three-dimensional reporting" that "helps the reader *experience* the event recorded." Although the word was of foreign origin, he suggested that some of the most effective early reportage had been done by Americans: Stephen Crane, Richard Harding Davis, Lincoln Steffens, John Reed. He argued also that if the current best known practitioners of reportage were European—the Czech Communist Egon Erwin Kisch ("probably the greatest reporter in the world to-day") and the Russian Sergei Tretiakov—nevertheless "America has its Agnes Smedley, its Spivak," and had reason to be proud.°° Josephson explained how Soviet writers used reportage

° The visual arts of the three countries had obvious correspondences. Before the Soviet pavilion at the 1939 World's Fair there stood a gigantic statue of a worker holding aloft a red star; the worker, as many people remarked, was just like those in WPA murals. The photographs that made Bourke-White's fame, her monumentalized machines done for *Fortune* in the early thirties, paralleled photos done in the U.S.S.R., which country Bourke-White had visited. Russian painters exploited the theme of machinery bringing the better life and influenced what artists in the Resettlement Administration's Special Skills Division hung on the walls of the first Greenbelt town: rhapsodic works like "Constructing Sewers," "Concrete Mixer," and "Shovel at Work." The WPA's *Inventory,* published in 1938 to promote the WPA, used heavy, sharp-edged, black-and-white graphics, a style popularized by the Nazis.

°° John Spivak relates an anecdote that suggests how well these Left reporters knew one another and one another's work. When he and Kisch met in Paris in the later thirties and became good friends, he gave the Czech a book inscribed "To the Greatest Living Reporter." Kisch laughed at the inscription and said it meant the book didn't belong to him but to the Soviet writer Ilya Ehrenburg. Kisch reinscribed the book under Spivak's inscription, and the two took it around to Ehrenburg, who was in Paris on a visit. The Russian read the inscriptions and said, "No, this does not

to make the common people understand their own lives and work. He told of a collective "documentary history" that recorded the digging of the Bielnostroy Canal, Leningrad to the White Sea, by 100,000 men and women. This "novel form" of journalism grew from on-the-spot scrutiny of the canal and the construction camps, interviews with hundreds of workers, and access to their records and biographies. The result was a factual "romance of the masses." Josephson said that Tretiakov, the leading Russian exponent of reportage, had renounced the career of novelist to write about a collective farm because he felt conditions required that he write "facts, facts"—"nothing must be made up out of the writer's head." An English translation of Tretiakov's *Chinese Testament*, the "autobiography" he wrote of a young Chinese who had been his student, was published in the U.S. in 1934; true in every detail, episodic, and anticlimactic, the book no doubt had some influence on vernacular or "worker narrative" documentary, which to that time had usually been cast as fiction.[14]

But one should not exaggerate foreign influences on American documentary. A few intellectuals tried to see the people of America in European terms, as a folk; Waldo Frank was one, and he found his countrymen severely wanting: "We Americans are weak—infinitely weaker than the peasants of China, America Hispana, or old Russia—in that intuitive connection with soil and self and human past, which makes of a folk an effective medium for creative action." But most writers and intellectuals were interested in the new-found America for a reason that had little to do with European standards, a quite American reason in fact. They preferred the thirties' proletarian America to the twenties' business America for the same reason that Jane Addams, say, had

belong to me. It belongs to Agnes Smedley." He signed the book, and Spivak sent it off to Smedley, who was then recuperating in Seattle after making the Long March with Mao Tse-tung's forces. Smedley decided the book didn't belong to her either and signed it over to her friend Anna Louise Strong. Strong read all the inscriptions, said "Oh, thank you," and kept the book.

preferred the struggling poor to the genteel affluent: the former were more "real." Henry Hart claimed in 1935 that "the day in the life of a man who spends nine hours in front of a punch press or on a ship has more reality, more beauty and more harmony than you will find in all of Park Avenue." For that reason Sherwood Anderson envied the lot of the worker:

> I was a common laborer until I was 24 or 25 years old. I swear I would have been a better artist, a better story-teller now if I had stayed there. I might then have had something to say here as coming up out of the mass of people, out of the hearts of common everyday people. . . . I say that if I had stayed down there, never tried to rise, had earned my bread and butter always with the same hands with which I wrote words I might have had something real to say with the words I write.

For that reason also Granville Hicks warned his students that an intellectual had to study hard to raise himself to the level of the proletariat. In 1934 William Saroyan wrote a story about a low-class genius of a composer who, as he gets drunk on their liquor, reviles the rich people fawning on him: "He came from the street and didn't care if he did because the street was a damn sight realer than they'd ever be." [15]

Documentary deals with people "a damn sight realer" than the celebrities that crowd the media. These people, far from being the society's rulers, are often its most deprived and powerless subjects. They often feel (often with reason) overlooked, unheard, or—the word Franklin Roosevelt chose—"forgotten." In 1939 George Orwell remarked that all workers, "all people who work with their hands are partly invisible, and the more important the work they do, the less visible they are." Documentary, which makes vivid the unimagined existence of a group of people by picturing in detail the activities of one or a few of its number, documentary makes them visible, gives the inarticulate a voice.°

° Documentary reporters often mention their subjects' eagerness to tell their stories. Lange and Taylor wrote that many of the migrants in *American Exodus* "regarded conversation with us as an opportunity to tell what they

So doing, it provides "a picture of society given by its victims," which is the basis of "instrumental history" of the kind that social activists like Howard Zinn seek.[16]

The people documentary treats are felt to be more real than those on top of society, but that is not all. Social documentary is instrumental, and its people tend, like the innocent victims in most propaganda, to be simplified and ennobled—sentimentalized, in a word. Frances Perkins, while looking for the human side of conditions in the Duquesne steel mill, spoke with workers, one by one, in the rectory of a church near by. The first man began by saying, "Miss Secretary, we are poor but we want you to know we are honest." Perkins thought this a telling characterization of them. So highly did she value the common wage-earner and his "unique experience and wisdom" that in a whole book about *People at Work* (1934) she never showed a worker with a vice. Not one was sly, lazy, stupid, lewd, or cruel. The worst she would say about a member of the working class is that he might have the shortcoming of many of his betters: poor taste.

> "How I hate good music!" said a young girl to her escort in a subway.
> "So do I. But I can bear a band!" he answered.
> Many good and even cultivated people feel the same way.

The 100,000 men and women who dug the Bielnostroy Canal were, Matthew Josephson said, "former thieves, vagabonds, re-

were up against to their government and to their countrymen at large." Oscar Lewis found that his informants in *The Children of Sanchez* (1961) got satisfaction from telling their life histories in "a scientific research project" that might help other people. The *Life* reporter who accompanied a photographer through parts of East Pakistan devastated by the 1970 cyclone wrote that "people called out to us, to come in, to see their personal tragedy, to be witness to this thing which had destroyed their lives. 'Come, see this old man who has lost his four sons,' one neighbor begged us. 'Talk with my sister. She lost her husband and three boys,' said a teenage youngster. They did not plead with us for food or medicine, for we obviously carried none, but they did want us to record their loss. There was almost a fear that unless someone did, their tragedy would be ignored."

bellious kulaks, saboteurs." (They were also prisoners, though Josephson obscured this fact.) Through summer and winter, despite hundreds of lives lost, they labored, and their labor redeemed them. "Great numbers of the former rebels and thieves were converted, honored, decorated, restored to citizenship," because they "had been infected by their teachers with the conquering spirit of the whole socialist army." (These teachers were the Soviet secret police, best known by their dread initials: G.P.U.) According to the documentary history of the canal, then, the captives who built it were glad of their labor and made worthy to have done it on Russia's behalf. A "romance of the masses," indeed.[17]

American documentary photographs of the thirties had a similar romantic view. Edward Steichen challenged people of the time to "look into the faces of the men and women" in the FSA photographs: "listen to the story they tell and they will leave you with a living experience you won't forget; and the babies here, and the children; weird, hungry, dirty, lovable, heart-breaking images; and then there are the fierce stories of strong, gaunt men and women in time of flood and drought." "Lovable," perhaps; pitiable, certainly. Yet how little of these people one sees. They come to us only in images meant to break our heart. They come helpless, guiltless as children and, though helpless, yet still unvanquished by the implacable wrath of nature—flood, drought—and the indifference of their society. They come, Pare Lorentz said, "group after group of wretched human beings, starkly asking for so little, and wondering what they will get." Never are they vicious, never depraved, never responsible for their misery. And this, of course, was intentional.[18]

Lorentz noted that although Lange had photographed only poor people from 1935 to 1940, "she has selected with an unerring eye. You do not find in her portrait gallery the bindle-stiffs, the drifters, the tramps, the unfortunate, aimless dregs of a country." One does not, because hers—as Lorentz announced in his title—was a "Camera with a Purpose." The poor in the documentary photographs of the thirties simply do not include those who

are poor through laziness or moral dereliction.° The people shown have "simple dignity"; they have "leaned against the wind and worked in the sun and owned their own land." They are honest, straight-standing, and decent.[19]

Or at least when the audience sees them they are. For we see even these fine types of poor only in selected, sentimental poses. On the cover of "Their Blood Is Strong," John Steinbeck's 1938 pamphlet about migrant workers in California, is a Lange photo of an Okie woman seated in the shade of a tent flap, nursing her two-year-old son. The woman is young and beautiful, her bare breast shapely, her eyes the innocent trapped eyes of a deer. She stares with impassive pleading at the camera, and her son stares, too, rather more skeptically. Their look, half frown, half appeal; a look vacant but despairing; a look that expects rebuff yet *asks* anyway—this look appears on the face of more than half the subjects of documentary portraits in the thirties. And again there was a reason. The photographers sought it out.[20]

While taking pictures for the documentary book *You Have Seen Their Faces*, Bourke-White, like any photographer, looked for "faces that would express what we [Erskine Caldwell and she] wanted to tell." But it was not just certain faces she sought —the faces of the worthy poor, one might say—it was a certain expression. She and Caldwell would come upon a sharecropper family with likely faces. He would talk to them and while he did she "lurked in the background with a small camera, not stealing pictures exactly, which I seldom do," but inconspicuously taking them. If the people proved friendly, Caldwell and Bourke-White would sit down for a chat. After a time, while he continued the talk, she set up a large camera, on tripod, with flashes; she framed the picture, focused, then went back to her chair, a re-

° Consider a partial exception. *U.S. Camera 1939* ran a photo by Lusha Nelson of a Bowery wino with thick stubble and an obscene and blazing eye who is thumbing his nose at the camera. But the picture has the maudlin title "Friendless," and the wino is not menacing—in fact, he smiles with wry whimsy to take the nastiness from the gesture.

mote control in her hand. Now she waited and "watched our people while Mr. Caldwell talked. It might take an hour before their faces or gestures gave us what we were trying to express, but the instant it occurred the scene was imprisoned on a sheet of film before they knew what had happened." Bourke-White's thumb moved, the flashbulbs burst, the shutter fell—and she got from her subjects the look she wanted. *The* look: mournful, plaintive, nakedly near tears.[21]

You Have Seen Their Faces is discussed later in this study, and it is suggested then that Bourke-White overemotionalized the look. If so, this is a fault in her taste and insight. It is not, however, a fault in her intent. When documenting the victims of society, photographers (and other artists) try to make them poignant. Nor is it necessarily a fault in her technique, devious though the technique was. Ever since Paul Strand put gold foil and a glittering false lens on the side of his camera to divert people's attention while he took the first candids, many photographers have found that they must surprise, even trick, subjects into giving them a natural pose.[22]

Arthur Rothstein, an FSA photographer in the thirties and later *Look's* Director of Photography, wrote in the early forties that most people, unaccustomed to being before a camera, respond with a posed smile and self-conscious air. To overcome this, he recommended that their attention be distracted and offered an example of how he took a portrait that Archibald Mac-Leish had included in his documentary book *The Land of the Free* (1937). The picture shows a handsome, very pregnant sharecropper woman in a ragged print dress, standing at the doorway of a cabin. She has her hand on her side to ease the pressure in her swollen abdomen and fixes her eyes on something before her. She frowns with incredulity and concern, her mouth slightly open. Next to her, a tow-headed child of perhaps six years, with darkly smudged eyesockets, gazes bitterly at the ground, rubbing a thumb with the fingers of her other hand. Their sad faces and worried expressions were just what Rothstein wanted, but when

he asked to take their pictures, he found that "their forlorn attitudes gave way to . . . Sunday-snapshot smiles." To get a "truly candid photograph," then, he had to plan carefully. He got someone from the region to go up to the woman and talk to her while, with his Leica, he stood unobtrusively in the background. The local person questioned the woman, and when she answered "with anxiety or concern, completely unaware of the camera," Rothstein stepped forward and snapped the picture. For him, as for Bourke-White, this was standard procedure. "This method gave me what I wanted," he said, "a factual and true scene." [23]

Having learned Rothstein's method, one understands why the picture looks less factual than it might: the woman's concern is too focused, too energetic to be the result of her social condition. Similar artifices were behind many documentary pictures in the thirties—though not, as we will see, all of them. In the most notorious instance, Rothstein himself, while recording the Dust Bowl for the FSA, was found to have moved a cow's skull and photographed it against two different backgrounds, one of grass, the other parched earth. The resulting uproar almost put an end to the Photography Unit. Making a moveable prop of the skull was manipulation of a kind that violated the spirit of documentary, some people felt. [24]

We must realize, though, that all documentary photographs, like all propaganda and indeed all exposition, are to some extent biased communication. Most documentary photos of the thirties were not intentionally deceptive, as the skull picture was; but all prejudiced their evidence in selecting it. In Lange's photograph the Okie girl nurses her son. Why doesn't she spank him or yell at him for having thrown his food on the ground? She must discipline him as well as give him suck.° And she must laugh enor-

° Among the photographs Walker Evans prepared for the first (1941) edition of *Let Us Now Praise Famous Men* was one he included in the second (1960) edition. It shows a sharecropper wife, Ivy Woods, seated in a chair, gently reprimanding her cranky daughter, whom she cuddles in her lap. Evans, more than any other photographer, broke the clichés of thirties documentary.

mously too, hug her son roughly and dance him about, her face distorted with joy. No doubt she flirts, at least with her husband, and she must get mad at him, nag him, call him names, weep murderously, maybe throw things (maybe he punches her). And she yawns and scratches and giggles and cleans her nose. But these things are not shown. All her life, everything she is, gets reduced to the instrumental, to the pitiable, to a poignant helplessness and wan despair. When Lorentz claimed that Lange's one desire was to record poor people "as they are, not as they should be, not as some doctrine insists they should be," he exaggerated. Lange's people were treated according to a doctrine, and the doctrine was documentary.[25]

Simplifying, then: documentary treats the actual unimagined experience of individuals belonging to a group generally of low economic and social standing in the society (lower than the audience for whom the report is made) and treats this experience in such way as to try to render it vivid, "human," and—most often —poignant to the audience.

A qualification, though. Documentary—visual documentary, in particular—need not show the individual having the experience. Instead, the audience may itself be presented with his experience directly. Evans' photographs frequently have no one in them: the rooms are empty, the floor swept, the broom stands in the corner on its handle, and beside the empty washbasin a clean towel hangs from a nail. In many of his pictures it is when people are gone, leaving the signs of their lives for our unhurried contemplation, that we discover most about them and the group they represent. Malcolm Cowley said that Bourke-White's photos in *You Have Seen Their Faces* revealed drama in the gullied soil and sagging rooftree of sharecropper's house. Lange's noble pictures of the Dust Bowl—an abandoned tenant shack floating in a sea of tractor furrows that rise even to the porch—explain completely why no humans are to be seen and what has pushed them out. The FSA photographs by Lange and Rothstein of deserted Western roads running straight ahead through nowhere to the

blurred horizon make the viewer know, as Roy Stryker said, "what it would *feel* like to be an actual witness to the scene"; give "the feeling of a desert highway," and, faintly, of what the Okies must have felt, traveling from emptiness to emptiness toward a receding goal.[26]

The Documentary Motive and the Thirties

The documentary approach and the documentary genre were characteristic in the 1930s, and there are important historical reasons why they were. Not the least of these was the Great Depression itself.

Most Americans born since the Depression first approach it, if they do,° through documents of the kind treated here. Their image of it starts with documentary photographs, one of the few things vivid in high school history books. There the young American sees an emaciated dog, lame in one leg, prowling the dust before Hooverville huts made of rubbish and earth; a seven-year-old boy, bundled in adult clothes and cap, looking blankly up from the garbage can where he is scavengering; a man selling 5¢ apples, his shoulders hunched against the cold; a breadline, blocks long and black as soot; a pale landscape corrugated with erosion or a shattered wagon wheel half buried in the sand (stills from Pare Lorentz's films); Dorothea Lange's sullen unemployed, hands in pockets, eyes obscured, backs against the wall; the "Memorial Day Massacre" at Republic Steel, a policeman's truncheon raised and the shirt-sleeved crowd beneath him tangled together; Walker Evans' portrait of "Annie Mae Gudger," a sharecropper's wife, puzzled, not hostile, deeply skeptical. These are the young American's first images of the Depression, and he supposes that this is the way it must have looked to those who lived through it, that anguish and despair were everywhere apparent. Not at all, though.[1]

"One of the strangest things about the Depression," Frederick Lewis Allen wrote in 1947,

> was that it was so nearly invisible to the casual eye (and to the camera, for that matter). To be sure, the streets were less crowded with trucks than they had been, many shops stood vacant, . . . and chimneys which should have been smoking were not doing so. But these were all negative phenomena. There just didn't seem to be many people about.°°

° A central theme in Studs Terkel's excellent oral history of the Great Depression, *Hard Times* (1970), is that young Americans of the sixties know almost nothing of what their country went through in the thirties. A twenty-one-year-old Atlanta girl said she never heard about "the rough times" and criticized her parents' protectiveness, because "it's wanting you not to have to go through what is a very real experience, even though it is a very hard thing. Wanting to protect you from your own history, in a way."
°° Lewis echoed *Life* of a decade earlier. During the recession of 1937–38, the magazine remarked that "depressions are hard to see because they con-

"You could feel the Depression," Caroline Bird remembers,

> but you could not look out of the window and see it. Men who lost
> their jobs dropped out of sight. They were quiet, and you had to
> know just when and where to find them: at night, for instance, on the
> edge of town huddling for warmth around a bonfire, or even the mu-
> nicipal incinerator; at dawn, picking over the garbage dump for
> scraps of food or salvageable clothing.

Suffering there was and outright starvation as *Fortune* conceded in its
important September 1932 article " 'No One Has Starved,' " the subti-
tle of which was, ". . . which is not true." But if one had a job, he did
not have to confront such things. The previous winter *Fortune* had
noted that a visitor from out of town would

> be surprised to discover that, at first and even at second glance, New
> York City is much the same as it was in pre-depression days. . . .
> Wandering about the city looking for Disaster, the visitor will very
> likely find no more than he would have in New York in any other
> winter—the kind of Disaster, that is, which impinges on the eye.

The same disastrous winter the reporter Mauritz Hallgren wrote in
The Nation that Philadelphia's more fortunate residents, though they
knew there was unemployment, had no conception of its severity, be-
cause "the poverty and spreading destitution are not thrust under
one's nose as one walks along the street." To find them, Hallgren said,
one had to go behind the lace curtains which Philadelphia's mayor
said he saw hanging in the windows of "clean and comfortable
homes." In 1941 Marquis Childs acknowledged that during the De-
pression everyone knew that "horrors were just around the corner,
any corner, if you cared to look. Most people never looked." [2]
Not only was the Depression easy for the casual eye to miss, but
those who should have brought it to public attention—the Hoover
government, the business community, most of the media—overlooked
or minimized it, hoping thus to restore confidence. It was Hoover
himself who named the Depression, choosing the word because it
sounded, in 1929, less alarming than "panic" or "crisis," the tradi-
tional terms. His other efforts at morale-building proved as lugub-

sist of things not happening, of business not being done." To document the
recession, *Life* (typically) described the plight of one man who had just lost
his job and of the family that depended on him in "The Case of Robert
Simpson: An American Tragedy."

rious: he assured the American people that their hoboes were fed better than hoboes ever had been, that everyone would have a job once the current generation of workers died off, that adversity was good for the soul and prosperity just around the corner. Business and press echoed him; ° some of the hilarious, cruel results were collected in a 1931 book documenting what America's leaders had said about the brevity and mildness of the slump: the book's title was *Oh Yeah?* Throughout the early thirties, radio observed what Erik Barnouw, a historian of broadcasting, has called "a blackout on current problems." News reports were perfunctory recitations of wire-service bulletins; radio drama dealt always with "crime and love, always in a social vacuum." Far more common than news or drama were music, comedy, and variety shows. To the businessmen who controlled the airwaves, such gay fare seemed just what was needed in the bleakest hours of the Depression. Academics too did their best to cheer the country's spirit. The American Economic Association, meeting in Washington in December 1929, deliberately announced outdated forecasts indicating recovery by June 1930, because its members felt that to give out their current estimates would be against the public interest.[3]

A high point of bungling insensitivity was Walter Gifford's performance, in 1931, as head of the President's Organization on Unemployment Relief (POUR—the pun itself a taunt at the unfortunate). Hoover had named Gifford to the post because Gifford, the head of A.T.&T., had the facilities to stay in touch with local relief agencies all over the country. Gifford did his job as he understood it. In January 1932, after five months with POUR, he reported to a Senate subcommittee that he had no statistics on how many people were unemployed, how many on relief, or how much relief they got, and that he hadn't tried to obtain these figures. He considered such things none of his business. His job, as he saw it, was

> to stimulate the local organizations and keep them busy on the problem . . . and . . . to create a national sentiment, as far as possible to

° " 'No One Has Starved' " was, as William Leuchtenburg argues, a milestone in the nation's acceptance of the fact of the Depression: though published in a moderate magazine, it admitted that untold millions were suffering, unhelped, and that the Depression would continue as far ahead as anyone could see. The most significant thing about the article, however, is that it didn't appear until thirty-five months after the market broke; to that time, America's periodicals with few exceptions had done their utmost to ignore the Depression.

do so, in favor of everybody getting his shoulder behind the wheel to help and push this thing over to success this winter.

He was the drum major for greater confidence and greater sacrifice.[*4]

Gifford's testimony is pages of "I don't knows," spiced with pious assurances that the poor are better off for not being adequately cared for:

> It is only after nearly five months of intensive work on this problem that my sober and considered judgement is that at this stage, at least, of the proceeding, Federal aid would be a disservice to the unemployed, or might be a disservice to the unemployed.

Concrete evidence to the contrary did not shake him:

> THE CHAIRMAN [Robert La Follette, Jr.]: You do not think we should be concerned that people in Philadelphia are not receiving adequate relief?
>
> MR. GIFFORD: Of course, we are all concerned, as human beings, on that subject, but whether we should be concerned in the Federal Government officially with it, unless it is so bad it is obviously scandalous, and even then we would not be obliged to be concerned. I think there is a grave danger in taking the determination of these things into the Federal Government. I think the country is built up on a very different basis.

Part of Gifford's complacency was based on a census finding that more money had been spent on relief in the first three months of 1931 than in the same period of 1929. La Follette pointed out that the census showed welfare agencies' expenditures but not necessarily their need.

> MR. GIFFORD: You mean they may have needed more than they spent?
>
> THE CHAIRMAN: Precisely.
>
> MR. GIFFORD: I think that would be rather hopeless.

When the subcommittee insisted that he must have some idea, however imprecise, of how many Americans needed relief, Gifford re-

[*] The 1932 musical *Of Thee I Sing* makes sport of Gifford and his "booster" tone when a senator announces that "the Committee on Unemployment is gratified to report that due to its unremitting efforts there is now more unemployment in the United States than ever before," and the Senate cheers.

sponded with the following, a sentence of classic obtuseness: "Well, I will not say that I did not make any estimate for my own interest and amusement." [5]

Gifford's estimate was no better than anyone else's: it too was an impression, had little basis in fact. Facts like these, crucial facts on how many worked and how many went hungry, were just what was lacking throughout the Depression. The director of New York City's welfare council said in 1932 that relief agencies were "in the anomalous position of being without that comprehensive, up-to-date, continuous information which will enable us to see the problem" they were trying to treat. The Hoover government hadn't the enterprise to find out how bad things really were—and certainly not the inclination. When, at Senator Robert Wagner's insistence, the Census of 1930 counted the unemployed in the U.S. and found there to be 3,187,947, Hoover "corrected" this figure down to 1,900,000 by cutting out those whom he judged only seasonally unemployed and those whom he decided did not seriously want work. The New Deal was franker than the previous administration: it tried to run down the facts, not run from them (though it too refused to have a national census of the unemployed). It also failed. In May 1937 *Fortune* reported that "the Roosevelt Administration, after four years, knows no more about the actual number of unemployed than the Hoover Administration knew. . . . It *guesses*." Harry Hopkins, the New Deal's relief director, freely acknowledged as much. "A major obstacle in the path of meeting the problem of unemployment," he said late in 1936, "has been the absence of really adequate unemployment figures." Lest his audience think the problem solved, he said that the U.S. then had 8,000,000 or 11,000,000 unemployed, depending on which estimate one preferred. Not until 1940 did the government adopt an effective way to measure unemployment, monthly interviews of 35,000 households chosen as a cross section of the population. Until then, it was a commonplace that the United States had better statistics on its pigs than on its unemployed people. [6]

During the Depression the basic facts of the country's economic plight simply were not available. Those who claimed to know what was going on—business, press, government, reformers, radicals—all were suspected, and not always falsely, of arranging evidence to suit themselves, of prejudicing their estimates. How was one to find the truth then? "We cannot depend upon the public record," Mauritz Hallgren declared in 1933. He was giving up on law, government, and the media because they did not publish the particular ugly facts

he wanted them to. He had these facts from what he considered the only trustworthy sources: "social workers, trained journalists, neighborhood physicians, and other eye-witnesses." People on the scene, having facts firsthand. People with no axe to grind, or people who lied in public for the conservative press but who told the truth in private. If a man didn't trust the publicized facts and generalizations, the only way for him to approach the awful truths of a broken economy was to go out on his own and see what he could see with his own eyes; see what reliable witnesses had seen behind the lace curtains and beside the town dump; get the feel of how things were by gathering as many individual facts and impressions as he could. The Depression stimulated, even compelled, a documentary approach.[7]

Although Americans at the time were searching—as many of them remarked—for a "faith," a "way," ° ideologies satisfied very few. The way had to be plainer, its roadmarks tangible in common experience. Before his conversion on the book's last pages, the hero of Jack Conroy's Proletarian novel *The Disinherited* (1933) distrusted Communism, not because of its radical program, but because of its rhetoric's abstractness: "That's why them soap-boxers [street-corner agitators] never get anywheres. Why don't they talk about beans and potatoes, lard and bacon instead of 'ideology,' 'agrarian crisis,' and 'rationalization'?" Thomas Stokes, a Scripps-Howard correspondent, criticized Hoover for speaking "loftily of 'the imponderables,' of 'the ebb and flow of economic life,' when people were thinking of their bellies and of bread and meat." Stokes felt the President needed a ghost writer with "a flair for the common phrase, the lowly human impulse," because the American people weren't in the mood for abstruse thinking or fine phrases. In early 1937, as public concern over the sharecropper reached its zenith, Rexford Tugwell, head of the Resettlement Administration, announced that it would be impossible to provide the American standard of living for "all the underprivileged farmers" then or in the next generation, and that to pretend otherwise was cruel delusion. Rather than fantasize about "our slick advertised standards," he suggested that "the only practical course open to us is to . . . begin all over, in the kitchen and stables of real people rather than imaginary ones, working toward obvious small betterments—and

° Franklin Roosevelt's first collection of Presidential speeches and messages, published in 1934, had the optimistic title *On Our Way*. Conservative, radical, and "middle" ways (*Sweden: The Middle Way* was a best seller of 1936) were proposed for America in the thirties, and late in the decade all claimed the same encomium: "the American way."

they are terribly obvious; there is no chance to go wrong!" Tugwell spelled out the kind of betterments he meant: the RA's Alabama clients now plowed with mules, not bulls; many tenant wives had learned to raise and to can a variety of vegetables—formerly their families had eaten pickles throughout the winter, if they had any greens at all. David Lilienthal saw the TVA's first job as the bringing of hope to the people of a cheated region, but his method of persuasion had nothing ideological or hortatory about it:

> The first steps seemed to me (this was back in the hectic days of the fall of 1933) to revive Southern *morale* . . . by demonstrations, as many demonstrations as possible, but always ones that the average man who had to carry the job ahead could see and understand—if possible, those that he could not only see, but that he could touch and handle himself, so that his deep-seated skepticism would disappear.[8]

By the time the Great Depression entered its third (and worst) winter, most Americans had grown skeptical of abstract promises. More than ever they became worshippers in the cult of experience and believed just what they saw, touched, handled, and—the crucial word —felt. While driving through the Midwest in the early thirties, Louis Adamic picked up a girl tramp who had the "facks," as she said, about everything. Adamic, somewhat startled at her brazenness, asked, "How do you feel?", and the girl gave him the tag-answer of the time: "With my fingers." For skeptics such as these, communication, if possible at all, must be documentary. It need not be *called* documentary, of course. It may be a description "in human terms." It may be a New Deal "demonstration." It may be, as communist writers suggested, "reportage." It may be what Dale Carnegie called a "dramatization"—"this is the day of dramatization," he announced in 1936; "truth has to be made vivid, interesting." But whatever the name, documentary—the presentation of actual facts in a way that makes them credible and telling to people at the time—is what it must be.[9]

CHAPTER 5

The
Central
Media

Different media have at different times made the actual facts of
social life credible and vivid to people of the day. An example.
The first-person life histories in Henry Mayhew's *London Labour
and the London Poor* (1851–62) were illustrated with engravings
which intensified the reality of the poor for readers of the time,
but which, a century later, make the poor look almost as fabulous
as Cruikshank's caricatures. Though Mayhew's narratives retain a
great deal of their power, the illustrations do not. They are too
glib and sentimental; they certainly do not strike the twentieth-
century reader as authentic in the way John Thompson's 1870
photographs of London's street people do. The engraving is a
medium in which documentary would now seem to be impossi-
ble.[1]

A second example. Mary McCarthy has pointed out that the
literature that documented "the actual world" in the nineteenth-
century was usually fiction. Novels gave "explanations of the way
institutions and industries work, how art is collected, political of-
fice is bought"; they were "continuous with real life, made of the
same stuff," and performed "many of the functions of a newspa-
per." As late as the 1890s, American publishers' trade lists di-

vided fiction, far the largest seller, into subcategories like "Social" and "Economic" and "Reformative," and offered novels treating such "Present Day Problems" as "Alcoholism," "Poverty," "The Soldier of the North and the Soldier of the South," "The Latest Social Vision," "The Role of the Woman in the Modern World," "The Double Standard of Morals," "The Education of the Child." The way to explore such real-life matters then was generally in a fiction. Needless to say, it no longer is. Today if one wants to know how to raise a child, what to do about poverty, drugs, and alcoholism, why we are in Vietnam (Norman Mailer to the contrary), how Americans make love or money, the way we bury our dead, what the Blacks, hippies, and females want, one turns, customarily, not to a book of fiction but to one of fact, a nonfiction.° Indeed, a contemporary reader may get impatient when fiction speaks to him directly about actual social conditions. He reads Disraeli's *Sybil, or the Two Nations,* Zola's *Germinal,* Sinclair's *The Jungle,* or virtually any of the Proletarian novels of the 1930s, and he finds himself saying, "But if things are really that bad, why bother to make a fiction of them? Just give us the facts so we know whom to blame." Nonfiction increasingly appeases the reading public's hunger for the facts of the actual world, and fiction is no doubt a less viable medium for documentary than it once was.[2]

For Americans in the thirties, a crucial reporting tool—"the central instrument of our time," said James Agee in 1936—was the camera, because it makes the viewer almost an eyewitness. Agee felt that, properly used, "the camera can do what nothing else in the world can do: . . . perceive, record, and communicate, in full unaltered power, the peculiar kinds of poetic vitality which blaze in every real thing and which are in great degree . . . lost to every other kind of art." Alfred Kazin has written perceptively on the extent to which "the camera *as an idea*" affected thirties thought and expression. He believes the camera

° The trade statistics confirm this. In the 1920s, fiction outsold nonfiction by two to one; today fiction is outsold by better than one to three.

served as the "prime symbol of a certain enforced simplicity and passivity of mind." Christopher Isherwood's classic *Berlin Stories* (1938) portrayed just such a mind: "I am a camera with its shutter open, quite passive, recording, not thinking. Recording the man shaving at the window opposite and the woman in the kimono washing her hair. Some day, all this will have to be developed, carefully printed, fixed." Isherwood implied that the images recorded by the camera-mind, though clear and believable, did not "develop" a coherent picture of a society, much less of life. This, Kazin would argue, was exactly the point:

> If the accumulation of visual scenes seemed only a collection of "mutually repellent particles," as Emerson said of his sentences, was not *that* discontinuity, that havoc of pictorial sensations, just the truth of what the documentary mind saw before it in the thirties? [3]

In part, certainly, this was true. As Kazin said, the camera, still and motion-picture, "reproduced endless *fractions* of reality." But as we saw in Chapter 4, the reality documentary treats is, however fractioned, very much *one* reality, one vision of life. The camera is a prime symbol of the thirties' mind, then, less because the mind was endlessly fragmented than because the mind aspired to the quality of authenticity, of direct and immediate experience, that the camera captures in all it photographs.[4]

As we have noted, such immediacy, such direct rendering of actuality, cannot be achieved in print. It is significant that print media, and newspapers in particular, were widely distrusted in the 1930s. What the press published then was generally felt to be propaganda serving a special interest. In 1931 Robert Allen and Drew Pearson complained that "the business or partisan interest that owns a publication determines what shall and what shall not be written, and how." Seven years later Franklin Roosevelt told the Society of Newspaper Editors that 85 per cent of America's daily papers were "inculcating fear in this country" and suspicion of the New Deal. He said the problem traced back to the news-

paper owners, who tampered with the news to promote their interests. In 1941 Archibald MacLeish accused America's publishers of deliberately turning their "printing presses, like machine guns, on the people." [5]

Unlike movies and radio, newspapers were hard hit by the Depression. Many folded or were merged; many more fought back with their only easy weapons, exaggeration and sensationalism. Furthermore, as George Seldes demonstrated in *Freedom of the Press* (1935) and *Lords of the Press* (1938), newspapers of the day, with a handful of exceptions, colored, suppressed, and even concocted facts to fit their editorial bias. In his conference with the editors, Roosevelt gave an example which he said he could multiply a thousand times. The Sunday before there had been a radio debate on WOR between a Republican senator, Arthur Vandenberg, and a Democrat, Lister Hill. Each talked for fifteen minutes on the New Deal's program for economic recovery. Monday's New York *Sun*, an anti-Roosevelt paper, put the story on page one, right-hand column. Its headline read: "Huge Recovery Plan Attacked by Republicans; Vandenberg Denounces Roosevelt Relief Program; Says Pump Priming Means Bigger Deficits." The dispatch ran down the column, was continued inside, reported similar remarks made that Sunday on a C.B.S. program by the Republican National Committee chairman—and never once mentioned Senator Hill. Because Hill spoke on behalf of policies abhorrent to the *Sun*'s publishers, the paper's editors had cropped every reference to him and what he said from an AP dispatch. Roosevelt deplored the *Sun*'s leaving out "half the truth" and said there were hundreds of papers that did the same. [6]

There were. In no other decade was the American press so out of step with its audience. At no other time did it impress millions of Americans as "a rich man's property, conducted to curry to the rich man's favor, to spread the rich man's prejudices, to impose the rich man's will on the nation," as the liberal Protestant *Christian Century* said in 1936. *Time*'s head editor confided to Henry Luce in the mid-thirties that the magazine's news would be more

responsible were it not based on the U.S. press: "The U.S. press," he said, "is stupid and reactionary." Throughout the early thirties the press generally managed to ignore or belittle the evidence of a depression. In the 1936 Presidential campaign, more than 80 per cent of the press opposed Roosevelt, and he won by the highest percentage ever. During the campaign and for years after, many newspapers, including major syndicates, went beyond all legitimate bounds in an effort to disparage the President and the New Deal. And as Roosevelt warned the editors, the press lost by it. Public opinion polls in the late thirties suggested that 30 million Americans, nearly one adult in three, doubted the honesty of the American press.[7]

Unquestionably the crucial event in this "repudiation of the press by the public," as George Seldes thought it, was the 1936 election. When Roosevelt motored through Chicago at the height of the campaign, a reporter in the press car noticed that the enormous crowd was making "menacing cries of anger against the Chicago *Tribune* and the Hearst papers in Chicago which were fighting Roosevelt so bitterly. These people no longer had any respect for the press or confidence in it. The press had finally overreached itself . . . and was losing influence." After the election the *Christian Century* wrote the newspaper publishers of America a scathing open letter to tell them that "in the minds of hosts of your fellow Americans, you stand today indicted" for arrogance, tyranny, greed, and scorn of fair play. "Election day 1936 was judgement day for America's daily press," the letter said; "when the people voted, they voted against *you*." The *Century* tried to maintain a tone free of gloating and vituperation, but it could not. It assured the publishers that those who voted for Roosevelt

> obtained a deep emotional satisfaction from the fact that you had not merely been defeated, but that you had been smashed. A vendor selling election extras at a stand across the street from the building of a great city newspaper, cried to the crowd in a transport of ecstasy, "We showed the ---- -- -------!" While he

shook his fist at the newspaper office, the crowd cheered. Didn't you hear him, gentlemen? Then truly you have become isolated from the American public.

So low had the press fallen in public esteem that well-bred Christians would leave no doubt that they felt newspaper publishers sons-of-bitches.[8]

The press had lost credibility and influence, but the press was no longer all of journalism. By the late thirties, radio journalism, though only in its teens (the first scheduled newscast was in 1920), had come of age. In 1939 *Fortune* sponsored an Elmo Roper survey° on what the American people thought of the press; the people, it turned out, didn't think much and preferred radio. If presented with conflicting versions of the same story in two media, the respondents believed the radio (40.3 per cent) rather than the newspaper (26.9 per cent). When asked "Which of the two—radio or newspaper—give you news freer from prejudice?" 49.7 per cent answered radio, only 17.1 per cent answered newspaper (18.3 per cent said both were the same, 14.9 per cent said they didn't know). This stunning confidence in radio's credibility and impartiality made it already the "preferred source of news interpretation." Commentators like Lowell Thomas, H. V. Kaltenborn, Boake Carter, and Edwin C. Hill were more respected than editorials and columnists combined.[9]

Why was radio trusted and the newspaper not? *Fortune* suggested several reasons. The public doubted a newspaper's disinterestedness—and the doubt focused on "the publisher's office, where policy is made." The people interviewed believed, 65.8 per cent to 14.8 per cent, that the publisher managed news to his own benefit.°° Radio didn't excite this suspicion, and with

° Public opinion polling began in the 1930s and is an example of another way in which the nation then tried to discover itself and its people. Roper's was far the most accurate poll of the time, predicting the treacherous 1936 Presidential election to within a percentage point and the 1940 election to three-fifths of a point.
°° Consider how the films of the period portray the newspaper publisher: as sneaky villain (*Mr. Smith Goes to Washington*, 1939), as egomaniac (*Citizen Kane*, 1941), as protofascist (*Meet John Doe*, 1941).

some reason, *Fortune* argued. The magazine pointed out that there were three kinds of news on radio: on-the-spot news, bulletins, and commentary. "Spot-news coverage," instantaneous reporting of an event, was impossible in the written press. Bulletins were simply abbreviated versions of the wire-service dispatches the newspapers print. Though radio got them to the public quicker, it gave fewer facts; but actually this may have been to its benefit, *Fortune* implied, since radio confined itself to "the naked, irrefutable highlights of the news" and shunned interpretation. Radio commentaries, unlike newspaper editorials, expressed no opinion on issues that might stir controversy and get the station in trouble with the FCC. In short, according to *Fortune*, the radio's news might then have seemed more credible than the newspaper's because it did less: it said less, pled less, had fewer opinions and almost none that would upset anybody.[10]

Paul Lazarsfeld's *Radio and the Printed Page* (1940), which reported the media preferences of 5528 "representative" Americans, came to the same conclusions as the *Fortune* poll. It found radio preferred to the press as a source of news and overwhelmingly favored by people of lower income, by women, and by those in rural areas. Lazarsfeld and *Fortune* implied that radio was more trusted because it was less untrustworthy. While this may have been true, the media preference can be looked at from another angle. If in the late thirties and early forties radio was more readily accepted than the press, the content of each may have been only part of the reason; the *medium* of radio may then have seemed more credible.[11]

The difference between the two media is plain. Radio is people talking to us (or apparently us). Newspapers are articles in uniform typeface. Radio is direct: Vandenberg and Hill each has his say. Newspapers are unimaginably indirect: they are writing, to begin with—writing by someone the name of whom is rarely given, someone usually at great distance from where the article was, with such obvious labor, set in type, printed, and distributed. In a newspaper all the talking of Vandenberg and Hill gets flattened into 500 words by persons unknown; drastic simplifi-

cation and subordination of one fact, one man, to another turns an event into copy. Yet this "copy" exists in a wholly different form from the original: it is report of experience, not the experience. Radio provides experience; "coming instantaneously from the very scenes of events and entering directly into the home," it gives listeners, Lazarsfeld suggested, "a feeling of personal touch with the world." Direct, on-the-spot coverage, impossible in a newspaper, is in a sense perpetual on radio. We hear Vandenberg and Hill for ourselves, but we hear also newscasters, announcers, Mary Margaret McBrides, men in the street. The people on radio all have names (except those in the ads, whom we don't believe), and speak to us, without apparent intermediary, in voices of our kind.° However trivial and dull, radio offers human experience—the experience of another human. "People who weren't around in the twenties when radio exploded can't know what it meant," the sportscaster Red Barber has written. "Suddenly, with radio, there was instant human communication." [12]

Human communication is the lifeblood of the medium. Historians agree that Franklin Roosevelt's use of radio in his Fireside Chats made him, though President, a living human, an acquaintance, to millions in America. Roosevelt used the medium more as it should be used than other public men had dared to. He was personal, friendly, even a bit casual. He ad-libbed in the days before ad-libbing was allowed. During a 1933 broadcast he interrupted his talk to ask for a glass of water, paused while it was brought, took a swallow audible in living rooms across the country, and then told the listeners: "My friends, it's very hot here in Washington tonight." His simple gesture drew thousands of sympathetic letters. [13]

° Voice matters. Lazarsfeld remarked that "again and again in our case studies, respondents mentioned the human voice as if it were of especial importance." Respondents said, typically, "I like the voice. It is *nearer* to you"; "A voice to me has always been more *real* than words to be read." C.B.S.'s Paul Kesten claimed in a 1935 brochure promoting radio advertising that voices of affection and authority make people do what they are told seven times out of ten or better, even when the voice is on radio. A wild exaggeration, Kesten's argument was taken seriously at the time.

For many people in the thirties the newspaper form itself was apparently compromised, while the radio was not. The newspaper's indirectness—the gap between an event and the published report—left too much room for tampering. People didn't suspect the radio of tampering in part because it used direct and human communication. There was always, at the least, an announcer explaining things to them; and "the announcer," many people felt, "would not say something if it was not true." This sentence was the rationale of a listener misled into panic by Orson Welles' 1938 radio production "The War of the Worlds." The listener, like thousands in the audience of the day, accepted without reservation the news announcer's veracity. Said another: "I always feel the commentators bring the best possible news. Even after this I still will believe what I hear on the radio." Archibald MacLeish tried to coax poets to write for the radio because the medium's credibility was so high. "Only the ear is engaged," he said, "and the ear is already half poet. It believes at once; creates and believes." Chief cause of belief was "the commentator," an "integral part of radio technique" and the "most useful dramatic personage since the Greek Chorus." The commentator (or announcer) was the listener's surrogate—an eyewitness often, but at any rate one closer to the facts than he. In radio drama, where experimentation centered on the narrator and his possible uses, a commentator might prove a liar or, more frequently, a madman. But in general he was there to be trusted: his reactions vocalized the audience's own and influenced them. What he said was probably trite; it was also undeniable. Robert Warshow, writing in 1949, jeered at the American media's use of the commentator, yet had to admit that he couldn't finally dissociate himself from what the commentator said:

> A typical figure in our culture is the "commentator," whose accepted function is to make some "appropriate" statement about whatever is presented to his attention. "Grim evidence of man's inhumanity to man," he remarks of the corpses of Buchenwald. "The end of the road," he says as we stare at dead Mussolini on the newsreel screen. (And what can one do but agree?) Even in

its most solemn and pessimistic statements, this voice is still a
form of "affirmation" (its healthy tone betrays it); at bottom, it
is always saying the same thing: that one need never be entirely
passive, that for every experience there is some adequate re-
sponse.

Which response it thrusts upon its audience.[14]

Radio convinced people in the thirties, then, both directly and
by example. Indeed, it synthesized the two methods of persua-
sion discussed in Chapter 3: it presented the audience the facts
firsthand—on the spot or nearer the spot—yet did so usually
through an observer or commentator (and always framed by an
announcer). The facts and the observer reinforced each other's
credibility: if one was believed, it was hard not to believe the
other; if listeners accepted a report, they probably took over its
tone as well and echoed its observer's response. Radio was influ-
ential in the thirties because it was believed; it was believed be-
cause, as much as film or photograph, it was then a documentary
medium.

The "golden age" of radio reporting in the late thirties and
early forties added two phrases to the language. The two, signifi-
cantly, are expressive of the time's documentary bent. The first
was Edward Murrow's grim "This . . . is London," the salutation
with which he began his London broadcasts from September
1938 till the end of the war. "This is London": the direct method
could not be put more plainly. This is London: here it is, talking
right to you. The second phrase had a variety of forms: "We take
you now to Nuremberg, Germany"; "We take you to Paris"; "I
return you now to America"; "We return you to the studio." It
was the spoken signal announcers used to cue in and cue out live
remotes, and became an established technique during C.B.S.'s
coverage of the three-week Munich crisis of 1938, the event that
proved the value of radio journalism. Again we notice the direct
method. "You," the listener, are apparently hustled from place to
place in order to be an on-the-spot witness in each.[15]

Radio technology was still primitive in the late thirties, and

the role of the broadcast correspondent somewhat undefined. Yet these shortcomings oddly enhanced the medium's credibility. A listener would believe he heard Prague, Czechoslovakia, direct when it took luck to do so, and when exchanges such as the following occurred:

CBS ANNOUNCER: At this time . . . Maurice Hindus, prominent authority on central European affairs, will speak to you from Prague, Czechoslovakia. This is America calling. We take you now to Prague.

A long pause. Static. Silence.

CBS ANNOUNCER: Prague apparently is not prepared to transmit the voice of Maurice Hindus at this moment. We shall be in constant contact with Prague, however, and when the moment comes we shall switch to that capital. May we ask you to stand by.

Then, nearly six hours later:

CBS ANNOUNCER: That was London speaking. And now Maurice Hindus in Prague, Czechoslovakia, is to be interviewed by H. V. Kaltenborn. And here is Mr. Kaltenborn.

KALTENBORN: Hello is this Prague? Who is talking please?

HINDUS: Is this Columbia?

KALTENBORN: Maurice Hindus is that you?

HINDUS: Speaking.

KALTENBORN: Oh fine. See here, this is H. V. Kaltenborn. I am speaking from the Columbia office and I want to ask you a few questions about the situation in Prague. This is going to be an interview and I don't know whether they have it on the air. I know they intended to have it on. In any case, I'm going to fire ahead, and ask you whether Prague had any report of Litvinoff's speech at Geneva today. . . .

HINDUS: I haven't seen any of it in any of the papers.

KALTENBORN: I see. Have you had all of the evening papers?

HINDUS: I have all the evening papers.

KALTENBORN: And there is nothing about Litvinoff's speech?

HINDUS: Not a word that I have read.

KALTENBORN: I see. Well, he made a very important address in which he stated . . .

And the conversation, though carried on across thousands of miles of oceans, was unmistakably spontaneous.[16]

The spontaneity of radio remotes in the thirties encouraged audience participation: as the technicians sweated to get Prague on the line, the listener labored too, in his imagination. Frederick Lewis Allen remembered turning the dial to find

> a voice swelling forth in the midst of a sentence: . . . "attempt first to receive a broadcast direct from Prague, the capital of Czechoslovakia, where Maurice Hindus, well-known authority on Central European affairs, has been observing the day's happenings. We take you now to Prague." A pause, while the mind leapt the Atlantic in anticipation; then another voice: "Hello, America, this is Prague speaking."

The listener felt close to Europe because he put himself there.[17]

This was the object of documentary radio: to make the listener believe he was there. Ed Murrow, the most influential radio journalist, seems to have understood this instinctively. Even at the beginning of his career, during the Munich crisis, while experimenting with formats (debate, guest commentary) he later discarded, he told his audience: "Now, we're trying in these talks from London to really hold a mirror behind these very fast-moving events. We're trying to recite what you would see and hear if you were in London." During the Battle of Britain, he confided to his listeners that he spent hours collecting news and impressions, and "more hours wondering what you'd like to hear," what detail would make an event real to you because it was the sort of thing you would have noticed. Nothing was beneath regard.

> Perhaps you'd like to know what's being advertised in London's newspapers after forty days and forty nights of air raids. Here's a random selection taken from today's papers. On the front page is the old favorite—hair tonic, under the title "Why be gray? Gray hair makes you look old before your time."

His concern was not so much with relating the news to the listener as with relating the listener and the news. "You will want

to know how the British took last night's announcement of the creation of a new French government"; because you want to know, he tells. Always he spoke to what he thought the audience was thinking, often to qualify and sometimes to contradict:

> During the last week you have heard much of the bombing of Buckingham Palace and probably seen pictures of the damage. You have been told by certain editors and commentators who sit in New York that the bombing of the Palace, which has one of the best air-raid shelters in England, caused a great surge of determination—a feeling of unity—to sweep this island. The bombing was called a great psychological blunder. I do not find much support for that point of view amongst Londoners with whom I've talked. . . . It didn't require a bombing of Buckingham Palace to convince these people that they are all in this thing together.[18]

The quality of Murrow's broadcasts surprised veteran journalists; some were scandalized, Elmer Davis said in 1941, that such good reporting could be done by someone without any newspaper experience. But in fact Murrow was so good on radio exactly because he had never been a newspaperman and didn't approach the medium from this perspective. He hadn't trained as a writer. In college he majored in Speech, was an actor, campus politician, and debater; then and later, as Alexander Kendrick has observed, Murrow wasn't interested in the written word but in the spoken. Before joining C.B.S. he worked as lecturer and advance-man for the National Student Federation and the Institute of International Education. His forte was direct persuasion. In consequence, he put things more personally, less abstractly than the press. Unlike a newspaper reporter (and most radio commentators of the thirties), he constantly referred to himself, the "I" who spoke, and to the "you" who listened. Moreover, he was unremittingly particularistic. Kendrick has said that the Murrow style of broadcasting, which became the model for a generation of commentators, might be called "subjectively objective." It dealt with public fact in concrete and human terms. Murrow concentrated on what he called "the little picture," "the little incidents, the

things the mind retains"; and these he captured with a poet's eye:

> One night last week I stood in front of a smashed grocery store and heard a dripping inside. It was the only sound in all London. Two cans of peaches had been drilled clean through by flying glass and the juice was dripping down onto the floor.[19]

To make the war vivid to his listeners, to bring them what he called "the real thing," Murrow made ad-lib reports from bombers over Germany; from C-47s dropping paratroops in the Lowlands; from a London air-raid shelter; from the street outside where he lay on the sidewalk to capture the sound of the English walking, not running, to safety; and, most memorably, from a rooftop overlooking London in the Blitz. His first rooftop broadcast was drowned out by the sound of planes and antiaircraft fire. The second broadcast was on September 21, 1940, two weeks after the terror bombing began:

> I'm standing on a roof top looking out over London. At the moment everything is quiet. For reasons of national as well as personal security,° I'm unable to tell you the exact location from which I'm speaking. Off to my left, far away in the distance, I can see just the faint red angry snap of antiaircraft bursts against the steel-blue sky. . . . You may be able to hear the sound of guns off in the distance very faintly, like someone kicking a tub. . . .
> The lights are swinging over in this general direction now. You'll hear two explosions. There they are! That was the explosion overhead, not the guns. . . . Earlier this evening we could hear occasional—again, those were explosions overhead. Earlier this evening we heard a number of bombs go sliding and slithering across, to fall several blocks away. Just overhead now the burst of the antiaircraft fire. The searchlights now are feeling almost directly overhead. Now you'll hear two bursts a little nearer in a moment.
> There they are! That hard, stony sound.[20]

The one precept Murrow gave the staff of correspondents he recruited for C.B.S. was "Never sound excited," because an im-

° Note how completely Murrow identified with the British cause: the "national" security sounds like *his* nation's.

passioned observer isn't trusted. But during this rooftop broadcast, far from being dispassionate, he spoke in a trembling voice that once broke into sobs. His emotion was genuine, but during the Blitz—and indeed until America entered the war—Murrow consciously let it come out. He thought conditions demanded no less. As he explained in a note to his wife written shortly after he began the rooftop broadcasts:

> Have been doing some fair talking last few nights. Pulled out all the stops and let them [the listeners] have it. Now I think is the time. A thousand years of history and civilization are being smashed. Maybe the stuff I am doing is falling flat. Would be better if you could look at it, but have spent three years trying to make people believe me and am now using that for all tis worth.

By careful attention to his audience, Murrow had built up credibility; he now tried to use it to persuade America, as movingly as he could, of the evil of Fascism and the decency of the British. He told his wife in a later note that he had broken network rules and run the transcribed sound of a bomb falling nearly on mike, because he wanted "pretty strong meat" to "take the heart out of a few people" listening; he wanted to shake his audience, wake them up. He wished that his reportage were visual—it "would be better if you could look at it"—but actually he was more effective than any camera. For he communicated not only fact but emotion—and not only these but values. As Erik Barnouw has said, "Murrow and his colleagues offered something akin to drama: vicarious experience of what they were living and observing. It put the listener in another man's shoes. No better way to influence opinion has ever been found." [21]

None has. That Murrow's broadcasts during the Battle of Britain stirred the heart and conscience of America, all witnesses agree. Whether or not one calls this Murrow a propagandist depends on whether one thinks the word inherently disreputable. Beyond question, though, he was a practitioner of social documentary, which, in John Grierson's words, "is an instrument of human observation and judgement" concerned "with 'bringing

alive' every-day affairs, evidently with a view of altering old loyalties or . . . crystallizing new loyalties." Beyond question, too, Murrow helped crystallize new loyalties toward Great Britain, a nation many Americans hated in the thirties. Archibald MacLeish considered Murrow's persuading the American people that Britain's fight was their fight "one of the miracles of the world"; he wondered in passing, though, as he praised Murrow to his face, "how much of it was you and how much of it was the medium you used." [22]

It was both, and circumstance more than either. Murrow had the eye to describe the passing moment and a voice for final things. But perhaps the miracle belonged even more to radio. Radio was the ideal medium for putting the audience in another man's shoes. Unlike the written word, it offered a sense of intimate participation, the immediacy of the human voice and of spot-coverage. Such coverage had direct elements—the bombs bursting on mike—but background noise did not overwhelm the commentary as the video overwhelms the audio in a TV report. Furthermore, a remote reporter on radio could take more liberties than one on TV, because his audience had to rely on his word. Murrow's listeners accepted the fact that Londoners were "magnificent" with no more tangible proof than his saying, "I've seen them, talked with them, and I know." On TV, one would expect to see some magnificence face to face.

Radio was such an effective documentary medium, a central medium in the 1930s, because it inextricably joined the two methods of persuasion, direct and vicarious. The listener witnessed firsthand, yet through another's eyes. The relation of listener and speaker was paradoxical, and like all paradoxes instable and unresolvable. The listener never could get from the speaker just the information he wanted as he wanted it, because to believe entirely he needed it firsthand. The speaker never could give the information he wanted as he wanted to. Always an insuperable limitation remained: "It's one of language," Murrow said; "there are no words to describe the thing that is hap-

pening." To know it one had to be there: "These things must be experienced to be understood." The speaker really couldn't take the listener there via radio.[23]

And yet, paradoxically, not being able to, he could. Radio's limitation became its strength. For as the speaker acknowledged his limits, the listener grew less observant of them. As the speaker disclaimed the transparency of the camera, as he intruded between the experience and the listener, selecting what had to be said but telling what he had left out and why, the listener came to believe in the experience. He felt the pressure of reality on the speaker, endless and incommunicable. All that the speaker left unspoken—found unspeakable—testified to the reality of his experience. And though the listener did not have the experience firsthand, he had another: his experience of the speaker. Listener and speaker engaged in "something akin to drama." The report of one voice was a dialogue; the commentary itself had a commentary, in the listener's mind. And when the listener believed, it was because he had convinced himself through his own imaginative trial of the facts.

CHAPTER 6

The
New
Deal

During the early thirties the documentary approach was practiced by those who wished to embarrass the Hoover administration and upset the status quo: in particular by journalists of the Left and by social workers trying to inform the more fortunate classes about the hardship of the poor and unemployed. Such documentary, studied here in Part Three, exposed America's shortcomings: the government's mendacity, the brutal wastefulness of a capitalistic system. But when the New Deal came to power, it institutionalized documentary; it made the weapon that undermined the establishment part of the establishment.

A characteristic figure in the early New Deal, along with the worldly academic, was the social worker, because it was felt that social workers knew facts in the way facts had to be known, firsthand. Harry Hopkins, a social worker by trade and, according to Marquis Childs, "a sensitive device for recording in the briefest possible time a thousand things that were going on around him," recruited a network of people like himself as field representatives for the Federal Emergency Relief Administration (FERA) and, later, for the WPA. The representatives included not only social workers but another brand of New Deal hero: ace reporters like

Lorena Hickok and Martha Gellhorn. They served Hopkins as his eyes and ears, capturing "the human side of relief" in graphic phrases and anecdotes that frequently found their way into the President's speeches and press conferences.[1]

Hopkins' network, though it became the best known, was but one of several. Indeed, the New Deal was honeycombed with rival spy systems, each trying to bring back to Washington concrete evidence of something the administration knew dimly or not at all. The New Deal pragmatists realized they could not get by on information made to serve their ends, though their ends began with restoration of the country's morale; they had to have actual, documented fact. And they tried to give each fact, when found, full measure of value. Ideologues of the Left and Right won every argument in the abstract; the New Dealers seldom lost one in the particular. Thus in the following exchange, written in 1934 by the communist satirist Robert Forsythe, it was the New Dealer, the "Secretary of Whatzis" as Secretary of Agriculture Henry Wallace is here called, who actually came out ahead:

> There is nothing so baffling as the discovery that the Secretary of Whatzis, to whom you are addressing your remarks, is not present mentally at all. When you venture the opinion that the purposes of the NRA and the AAA are diametrically opposed, he will answer that business, on the contrary, is excellent in South Bend.

The National Recovery Administration and the Agricultural Adjustment Administration may have been antithetical, but a city that depended on both industry and farm was doing very well.[2]

FDR

The chief client for these intelligence networks was the Chief Executive himself, Franklin Roosevelt. The New Deal's curiosity about what went on in America was endlessly goaded by his own. A reporter noted in 1934 that Roosevelt kept always at hand a stack of blank slips of paper about the size of catalogue

cards which he called "chits." Whenever he wanted information, on a remarkable variety of topics, he scribbled down a question and had it sent to an appropriate official. On some days he wrote more than a score of chits. Roosevelt's inquisitiveness was in part human concern, in part political caution. It also was in part vanity, the braggadocio of a gossip who had seen more of the world than anybody else in the room and who would warn the American Society of Newspaper Editors, "Mind you, I am more closely in touch with public opinion in the United States than any individual in this room. I have a closer contact with more people than any man in this room." But whatever its origin, Roosevelt's determination to know more about America than anyone else had rich rewards.° The documentary approach was characteristic in the thirties, and Roosevelt, "the man of the decade," "the symbol of the New Deal," epitomized it.[3]

Roosevelt had a documentary imagination: he grasped a social reality best through the details of a particular case. We have seen that Frances Perkins gave him information "in human terms," in small case histories like those she prepared while a social worker, her original career. Whereas the abstract description of a problem, "no matter how logical, never seemed solid to him," Perkins found "his vivid imagination helped him 'see' from a word picture." She felt the attack of polio that crippled him for life intensified his sympathy and imagination, because he had "to learn to take vicarious instead of direct personal experience. The friends who became most useful to him were those who reported truthfully, colorfully, on what they saw and heard."[4]

The reports Roosevelt depended on most were those of his wife, Eleanor, who served, correspondents noted, as the President's eyes and ears. Since his polio attack, she had described for him what he could not experience; "he trained her," a family

° George Reedy, one of Lyndon Johnson's press secretaries, has argued that only Roosevelt among modern Presidents was able to keep himself adequately in touch with the country he governed. Roosevelt succeeded, Reedy thinks, because he maintained sources of information outside his immediate staff and rewarded bad news with the good.

friend said, "to be a good reporter who knew how to look for
what he would have seen if he had been with her." In August
1933 he sent her on a trip into southern Appalachia from which
he had received disturbing letters. On this first inspection trip, as
on the later ones, she was confronted by appalling poverty ("Mrs.
Roosevelt might be described," said Drew Pearson, "as the Presi-
dent's private case-worker"). Many Americans felt it improper for
the President's wife to see such things because she called atten-
tion to them. Not only the President's attention, which might
have been all right—everyone's attention. For where the First
Lady went, the press was sure to follow (in 1936 Mrs. Roosevelt
actually joined the press as a daily columnist). The President,
however, was quite willing to have her travels publicize misery
in the U.S., since this stirred sentiment for New Deal reforms.
Between them, the Roosevelts had elaborated the whole docu-
mentary method: as Frances Perkins said, "they got the idea that
while you might not be able to see every family [who com-
plained to the White House], you could find out about their
plight by seeing some." Mrs. Roosevelt saw, felt, and reported;
her husband felt and understood.[5]

And then he reported. He documented facts for his Cabinet
(often beginning, "You know my Missus gets around a lot"); for
members of Congress (when Senator Carter Glass insisted that
Virginia needed no relief, Roosevelt suggested they take a drive
and visit some of the bad spots); for the press (he frequently
would tell a "story" to bring his point alive); ° and for those he

° In a 1933 press conference, Roosevelt announced that the government
would thenceforth give cotton cloth to those on relief and told the newsmen
why: "There is a story, off the record. You know Miss Hickok? She went
down, for Hopkins' department, I think it was somewhere around South-
eastern Kentucky. She got into one of those mining towns and came around
a corner of an alley and started to walk up the alley. There was a group of
miners sitting in front of the shacks, and they pulled down their caps over
their faces. As soon as she caught sight of that she walked up and said
'What is the matter? What are you pulling your caps down for?' They said,
'Oh, it is all right.' 'Why pull your caps down?' They said, 'It is sort of
custom to pull caps down because so many of the women have not enough
clothes to cover them.' "

greeted as "my friends," the American people. Here was what made Roosevelt's popularity possible: his extraordinary power to communicate. He impressed H. G. Wells as "the most effective transmitting instrument possible." Richard Hofstadter, echoing Wells, called him "a public instrument of the most delicate receptivity," and judged this "the secret of his political genius. He became an individual sounding-board for the grievances and remedies of the nation." [6]

Roosevelt was the first President to make of radio a means for direct, seemingly personal, contact with the people. He would deliver a Fireside Chat in a kind of trance, oblivious of the microphones, speaking naturally, with easy gestures, as though to friends. The "friends" whom Roosevelt addressed in every speech were people like himself, fair-minded and commonsensical. They too thought and talked as he did, "in the concrete." For them, Roosevelt took pains to make things "clear as crystal," "simple as ABC"—in short, vivid. According to Robert Sherwood, who drafted speeches for the President in the 1940s, Roosevelt was happiest when he could "reduce an enormous and even revolutionary issue to the familiar scope of a small town" by transforming a cloudy idea like Lend-Lease into the loan of a garden hose to a neighbor fighting a fire. Getting his point across, Roosevelt would use story, personal anecdote, a quotation from a letter written him by an anonymous citizen in Council Bluffs. If he felt an opinion rarefied, lacking in vigor and authority, he would sometimes invent people and put the opinion in their mouths. The following are two witnesses he used to dramatize his opinions; the people cited are almost certainly imaginary:

[From the 1937 "Quarantine the Aggressors" speech:]

Those who cherish their freedom . . . must work together for the triumph of law and moral principles in order that peace, justice and confidence may prevail throughout the world. There must be a return to a belief in the pledged word, in the value of a signed treaty. There must be recognition of the fact that national morality is as vital as private morality.

A bishop wrote to me the other day: "It seems to me that something greatly needs to be said in behalf of ordinary humanity against the present practice of carrying the horrors of war to helpless civilians, especially women and children. . . . Even though it may take twenty years, which God forbid, for civilization to make effective its corporate protest against this barbarism, surely strong voices may hasten the day." °

[From a 1937 letter to a woman who said that Boake Carter, the radio commentator, accused him of being a warmonger:]

Not only this Administration but this Nation want peace—but at the same time they do not want the kind of peace which means definite danger to us at home in the days to come.

I happen to know a very nice Chinese family which lives quite far in the interior. For years they have said that China wanted peace at any price and that they felt no possible harm could come to them back from the seacoast. The other day most of the family was wiped out by some Japanese bombing planes which wrecked their community and killed one thousand people. I got a message from one of the survivors which read "we are no longer for peace at any price." [7]

To Roosevelt, people appear to have counted more than ideas. As a politician, he many times had to sacrifice men for reasons of expediency, but he seldom sacrificed them—as Hoover had, as many radicals stood ready to do—in the interest of ideals, however sacred, inviolable, necessary, efficient, or rational these appeared.°° Values like these concerned him, Frances Perkins said, only insofar as they served to "make human life on this planet in this generation more decent. 'Decent' was the word he often used"; was the value that mattered most to him. In 1933 Adolf

° A "bishop" was a particularly useful witness since the American Catholic hierarchy generally opposed any help to the Spanish Loyalists and were the chief reason F.D.R. did not move to quarantine the aggressor in Spain.

°° Conservatives sacrificed the unemployed to the ideals of individualism and laissez-faire: Walter Gifford felt there was grave danger in the federal government's helping men without work because "the country is built up on a very different basis," which basis mattered more than men. Many radicals—and many "liberals" too—were disposed to sacrifice whatever was necessary, and certainly lives, to achieve their political ends. The idealist of the 1930s, on the both Right and the Left, was all too ready to have other people suffer for his ideals.

Berle defined the New Deal's philosophy as the belief that "human beings cannot indefinitely be sacrificed by millions" to the laws of classical economics, or any other law. Six years later Lewis Mumford wrote that "nothing is sacred but human life." Though he would seem to have reasoned less abstractly than these men, Roosevelt agreed with their ideas. And he intuitively knew that most Americans then felt as he did.[8]

So he spoke to his countrymen of what counted—of people, their lives—and he persuaded them in concrete and human terms. Here he speaks, ad-lib, during the 1932 campaign:

> I shall tell you what sold me on old age insurance—old age pensions. Not so long ago—about ten years—I received a great shock. I had been away from my home town of Hyde Park during the winter time and when I came back I found that a tragedy had occurred. I had had an old farm neighbor, who had been a splendid old fellow—Supervisor of his town, Highway Commissioner of his town, one of the best of our citizens. Before I had left, around Christmas time, I had seen the old man, who was eighty-nine, his old brother, who was eighty-seven, his other brother who was eighty-five, and his "kid" sister, who was eighty-three.
>
> They were living on a farm; I knew it was mortgaged to the hilt; but I assumed that everything was all right, for they still had a couple of cows and a few chickens. But when I came back in the spring, I found that in the severe winter that followed there had been a heavy fall of snow, and one of the old brothers had fallen down on his way out to the barn to milk the cow, and had perished in the snow drift. The town authorities had come along and had taken the two old men and had put them into the county poorhouse, and they had taken the old lady and had sent her down, for want of a better place, to the insane asylum, although she was not insane but just old.
>
> That sold me on the idea of trying to keep homes intact for old people.

Roosevelt has documented the reason he made a certain political decision: to support old-age insurance. The reason was his emotion, his great shock, on learning of a poignant incident. Whether this was his *real* reason, whether the incident actually happened,

is less important for our purposes than the strategy he used to persuade others. He assumed that his audience, hearing of the incident, would be moved to agree with his decision. A reader of the 1970s may find the appeal maudlin, even corny: today's politicians do not try to touch us with individual suffering; instead, they speak of mass calamities—loss of American credibility, population explosion, race war, ecological suicide. Nevertheless, one can respect the reason behind Roosevelt's decision; one accepts a man's being moved by particular experience.[9]

Many radicals in the early thirties did not. They ridiculed Roosevelt's use of documentary: his stories, his public confidences. They did so not because he sentimentalized—they were as sentimental as he, though about the proletariat, Communism, and a Soviet Union which stood, said Corliss Lamont at the 1935 American Writers' Congress, "as the hope and inspiration of all that is fine, intelligent and progressive in civilization." They ridiculed Roosevelt because they considered his reasoning callow and false. *Their* reasoning, on the other hand, was complex and, when properly done, infallible. It was based on science, historical necessity, the meticulous ramifications of Marxist theory, and the self-evident contradictions of capitalism. It was abstract, impersonal, and everywhere valid. Thus Mauritz Hallgren, though he favored the state's caring for aged workers, had outright contempt for the way Roosevelt came to this decision:

> At no time did he visualize the need for old-age security as the direct outgrowth of an industrial system that makes it increasingly difficult for workers to put away savings of their own against old age, that is constantly adding to the surplus of labor, and that is accustomed to discard workers still in their prime as being "too old." Instead, . . . he came around to what he calls old-age pensions in consequence of a personal experience.

Hallgren felt such a reason absurdly trivial.[10]

To most intellectuals of the thirties, everything personal was suspect. "There is no longer I," Dorothy Parker announced,

"there is WE. The day of the individual is dead." It was a period, Leslie Fiedler observes, which found it hard to believe in the person at all. Roosevelt moved cheerfully against this current of the time. Frances Perkins noted that he thought of those listening to his Fireside Chats "individually. He thought of them in family groups. He thought of them sitting around on a suburban porch after supper on a summer evening. . . . He never thought of them as 'the masses.' " He thought of the audience as people, and those listening felt it. Some apparently felt that he was talking to them as individuals. From New Orleans in 1934 Hickok wrote Hopkins: "People down here all seem to think they know the President personally! . . . They feel he is talking to each one of them." Americans wrote letters to this President in unprecedented numbers, and many of the letters confided personal woes, sought advice, as from one close and trusted. Roosevelt "came through to people," Arthur Schlesinger, Jr., thinks, "because they felt—correctly—that he liked them and cared about them." He called them "my friends," and they believed they were. Roosevelt's power to communicate won him an audience, but his gift for conveying empathy, his remarkable power to associate himself with others, won many of their hearts. And it would seem that the emotion he conveyed, an emotion much prized in the thirties, he genuinely felt.[11]

When Germany overran Denmark in April 1940, many Americans feared Hitler would try to gain entrance to the Western Hemisphere by seizing Greenland, then a Danish possession. Roosevelt, speaking three days after the Nazi invasion, said such fears were premature and chose to discuss Greenland with the press "more from a humanitarian point of view." (Not that he ignored the military; ten days before he had secretly ordered the construction of an army air field on Greenland.) He said there were about "17,000 human beings in Greenland," who received from Denmark every summer the necessities of life they couldn't raise. He had asked the American Red Cross to look into the provision of these necessities, in case the ships from Denmark were

cut off. A newswoman inquired whether "the possible relief of
the Eskimos" was his own idea or a suggestion from the Danish
government, and Roosevelt gave this amazing reply:

> No, no. I will tell you how it came about. Mrs. Ruth Bryan
> Owen, Mrs. Rhode, on her way back from Denmark four or five
> years ago, stopped off in Greenland and took a lot of pictures
> and showed them to us at the White House one evening and I
> got quite thrilled. I have been thinking a lot of those people up
> in Greenland the last few days, thinking in terms of these pic-
> tures, the very interesting life they are living. I invented it; it is
> all right; nobody else.

It took an unusual mind to invent the idea—to be thinking of
Greenland as the home of 17,000 people and not just a strategic
pawn three days after Denmark fell. But Roosevelt had seen doc-
uments that showed him Greenland's people as human beings,
and the fact of their existence "quite thrilled" his imagination.
We hear in his words how live those documents and Greenland-
ers were to him. He speaks of "*these* pictures," as though the
images were there in the room, in front of the whole White
House press corps and not his eyes alone. He speaks of "the very
interesting life they are living," as indeed they *are*—in his mind,
as he thinks of them.[12]

It would seem that people *lived* for Roosevelt and that their
existence, their just *being*, mattered more than anything one
might make of them or that they might do. When it was pointed
out that artists suffered especially during a depression and
needed work relief like other unemployed, his immediate re-
sponse was, "Why not? They are human beings. They have to
live." On this justification the arts projects of the WPA began.
They were not begun to encourage the arts (though the arts were
greatly encouraged). They were not begun to glorify America in
nationalistic propaganda like the German or Russian art of the
time (though their results *were* nationalistic, often guilty of what
Wallace Stevens called "factitious Americanism"). The arts proj-
ects began, like all WPA projects, less to do a job than to make

one. Like much that the New Deal did, the projects had no theoretical purpose; like Roosevelt, they had no "philosophy." °
Painters painted, writers wrote, teachers taught, actors acted, and musicians played because, as Frances Perkins said, they "were human beings and, like others, must earn a living." The living deserved no less.[13]

WPA

Historians tell us that the WPA has come to stand as a symbol of the New Deal, but we probably don't need to be told. For WPA —the Works Progress Administration, begun in 1935, renamed Work Projects Administration in 1939, liquidated in 1943—had the largest effect of any New Deal agency at the time and has the strongest hold on imagination now. A general history of the WPA has yet to be written, so that to get an idea of all it did one must turn to its *Final Report*, a funereal government booklet, printed on war-time flimsy, two columns to a page, with no photos and with type smaller than a newspaper's. It is a dismal memorial to a program that changed the face of the U.S. with 651,087 miles of road and 125,110 public buildings, that employed 8,-500,000 "different individuals" (who supported nearly one family in four), and that inaugurated the policy—ratified in the Employment Act of 1946—according to which the government is responsible for providing work when private enterprise fails. The WPA's monuments are all about: highways and streets, small dams, sewers, parks, power flumes, hospitals, airports, libraries, schools with cement and steel playgrounds; ironically, the "affluent society" lives on public capital a disproportionate share of which was produced by an era of hard times. But though these roads and buildings are used every day, they are not why WPA

° In a famous exchange, Roosevelt assured a pestering young reporter that he was not a communist, capitalist, or socialist. The young man said, "Well, what is your philosophy then?" "Philosophy?" said the President. "Philosophy? I am a Christian and a Democrat—that's all."

captures the imagination. WPA looms large in our thinking of the thirties thanks to projects that cost less than 7 per cent of its budget and that brought about what *Fortune* magazine called in 1937 "a sort of cultural revolution in America": the arts projects.[14]

This revolution was twofold. First, it was America's awakening to itself as a culture. Formerly "culture" had been what Matthew Arnold meant—the best that men have thought and expressed; such "culture" was synonymous with "art" and was considered strictly European in origin. But during the thirties the anthropologists' definition of culture as a society's pattern of organization gained currency in America; by the end of the decade, as Warren Susman says, the idea of culture had been domesticated. Americans learned that, like it or not, they had a culture and had had one all along—it had simply been overlooked. Now Americans tried to make up for lost time, track the culture down, record, restore, and celebrate it. They became intrigued with American art of all kinds, and particularly that least influenced by Europe: primitive, folk, or, as it was called most often, "popular" art. American artists turned their attention to their homeland; the intellectual exiles returned because, Malcolm Cowley explained, the twenties' view of art—"art for art's sake"—seemed as bankrupt as capitalism. Aaron Copland stopped composing avant-garde music to Schönberg's formulas and wrote "a good marching song for May Day" 1934,° *El Salón México, Billy the Kid, Appalachian Spring, A Lincoln Portrait, Fanfare for the Common Man,* overtures for high school bands, the incidental music for the Hall of Pharmacy puppets at the 1939 World's Fair, and the scores for documentary and feature films like *The City, Of Mice and Men,* and *Our Town.* Moses and Raphael Soyer, studio painters before the Depression and after, went into the streets to paint derelicts and breadlines. Robert Sherwood

° The song, whose words were by Alfred Hayes, included such lines as "Up with the sickle and hammer" and "Down with the bourgeoisie!"

stopped writing boulevardier comedies set in mythical European duchies and tried to do "what I most wanted to do with my work —express America." This cultural revolution would have happened without the WPA arts projects or indeed any government impetus. Its causes—the Depression, America's isolation in a menacing world, the Russian and German examples—were more compelling than any Washington could legislate. But without WPA, America's "cultural nationalism" in the thirties would have been thin and elitist. The arts projects kept the revolution honest: in touch with real facts about America rather than merely sentimental myths, and in touch with literally tens of millions of Americans.[15]

This was the second part of the revolution: the WPA brought the American artist and the American public face to face for the first time. It created a mass audience for what had been privileged entertainment: art galleries in thousands of towns that had never seen one; Federal Theatre productions for half a million spectators each week; WPA concerts with several million in attendance, nationwide, on a warm summer night. Formerly the American painter, composer, or performing artist addressed his work to a coterie—monied, urban, and European in taste. The painter had to make a reputation on the Continent before those among his countrymen rich enough to collect paintings would look at his work; the dancer and musician also had to prove themselves abroad. The composer had a even tougher fate: he had to contend with the American concert-goer, who had imbibed Walter Damrosch's prejudice against anything composed more recently than 1900 or nearer than France. American artists worked, then, in a kind of limbo, contemptuous of the audience they had and ignorant of any other. When the WPA subsidized another audience into being, the artists eagerly adapted to its taste as they imagined it. Copland began writing "music for the people, for as large an audience as possible," music "in the simplest possible terms," music based on folk melodies, music one could whistle, because he feared "that we composers were in

danger of working in a vacuum" at the same time that "an entirely new public for music had grown up." This new public was a healthy percentage of the American people, and as *Fortune* said, the arts projects—through teaching, information gathering, and performances—enjoyed "a more immediate contact with the people" and "a greater human response than anything the government has done in generations."[16]

The purpose of WPA art—to employ artists—was unique, but the artists' purpose was what it always is, to please and edify. Looking at the art they created, one finds that the way they did this was to record and clarify for the American people aspects of their experience, past or present, main-current or side-stream. In certain of the Projects (the American Guide Series and the Index of American Design, for example) this motive was explicit; in others (theater, painting) it was not. WPA headquarters imposed no restrictions on the subject matter its creative artists chose, though regional offices sometimes tried to, and though Harry Hopkins, the national director, made it known that he wouldn't stand by an artist if the community thought his work obscene. In 1939 George Biddle boasted that for the first time in history many thousands of government-sponsored artists were working "completely without censorship," and this seems to have been largely the case. The WPA artists were free to do what they wanted, but all they wanted to do was document America.[17]

As we saw in *American Stuff*, this documentation could take many shapes. The most influential at the time was done by the Federal Theatre, the project which, observers agree, "made by far the strongest impact on the public mind." The Federal Theatre's documentation was often as heavy-handed as the following. The Consumer, a "meek-looking little man," is seated at the corner of the stage, thumbing through his bills:

LOUDSPEAKER: What do you pay for electricity, Mister?
CONSUMER: Too much. Seventeen cents a kilowatt hour.
LOUDSPEAKER: What's a kilowatt hour?

CONSUMER: I don't know. That's what it says on the bill. . . .

LOUDSPEAKER: You're paying for it, but you don't know what a kilowatt hour is. How many ounces in a pound?

CONSUMER: Sixteen.

LOUDSPEAKER: How many quarts in a gallon?

CONSUMER: Four.

LOUDSPEAKER: How many inches in a yard?

CONSUMER: Thirty-six.

LOUDSPEAKER: But you don't know what a kilowatt hour is!

CONSUMER: No, I don't, what is it?

LOUDSPEAKER: Well—a kilowatt hour is—a kilowatt is a—eh—uh—

CONSUMER: Go on. I'm listening.

LOUDSPEAKER (desperately): Isn't there *anyone* who knows what a kilowatt hour is?

(Second front spotlight picks up ELECTRICIAN, up left, and follows him.)

ELECTRICIAN: I do.

CONSUMER: He's the electrician.

ELECTRICIAN: Yeah, I was up there in the prologue, pullin' them switches. Remember? . . .

LOUDSPEAKER: Well—what *is* a kilowatt hour?

ELECTRICIAN (calling, off): Hey, Mike! Drop that work light. (The work light comes down.) Now light it up. Now when this thousand-watt bulb burns for an hour that's a kilowatt hour.

LOUDSPEAKER (after a pause): Is that all?

ELECTRICIAN: That's all. The word comes from the Greek, *chilioi*, meaning thousand.

And the noble proletarian with a work light saves the day; he may use "them" as a demonstrative adjective, but he knows his job to the roots, even the Greek roots. This scene is from *Power* (1937) and is a fair sample of what went on in a WPA documentary play.[18]

The Federal Theatre called its documentary plays "Living Newspapers" and used the form to treat public questions of the day. A Living Newspaper sought to persuade its audience in the ways just seen. It quoted authority (here, an electrician). It con-

firmed what the audience already knew (36 inches to the yard) so that it might convince them of what they didn't (a kilowatt hour). And so far as it could, it presented or represented the evidence right before the audience (the burning bulb). Hallie Flanagan, the Federal Theatre's director, realized that if actors were going to "dramatize the news" and "current problems" to any effect, the information they used had to be authoritative. She therefore set up "a staff of the living newspaper" like that of a city daily with editors, reporters, and copy readers to get the facts straight. The Living Newspapers were group efforts, like a *Time* article, and one is tempted to say that they were created less by dramatists than by researchers. The plays take their facts, conflicts, and most of their characters from the real world and footnote their sources. Thus in *Power*, when the Consumer says that a kilowatt hour costs seventeen cents, a footnote reports that the figure comes from the "Edison Electric Institute *Bulletin* No. 3, June 3, 1936, p. 6"; Senator George Norris makes a statement for which the reference is the "*Congressional Record*, May 31 to June 14, 1935"; and a typical scene cites specific issues of *The Nation*, the *New York Times*, and *The New Republic*. When a fictional character like the Consumer appears, a footnote announces, "This character is fictional," or "Fictional characters. Incident from article by Fred Pasley, News Syndicate, August 21, 1936," or, most disparaging of all, "This entire scene is fictional." Indeed, *Power* itself ends with a footnote that points back to actuality: "The foregoing finale is subject to change when the TWA issue is finally decided by the United States Supreme Court." Surely, as John Gassner said, this theater went as far as any can "in the direction of an objective drama of fact rather than fiction." [19]

Gassner thought the urge toward factual truth a logical development of realism in American letters, but, as he recognized this urge—"the impulse to compose a documentary drama"—pushed the style *beyond* realism into "so-called epic theater." A documentary play's significance lay not in one character's fortune, good or ill: "the individual hero was purely incidental." Rather,

the significance lay in "masses or groups of people," in what they
do and how they fare in actual life. As Flanagan said, the Living
Newspapers focused on "a struggle hitherto infrequently stressed
in the drama of our country": "the struggle of many different
kinds of people to understand the natural, social, and economic
forces around them and to achieve through these forces a better
life for more people." By different kinds of people, she meant the
Colored Sharecropper and College Professor, the Financier and
Fruit Vendor, the Policeman and Barber and Clerk of the Senate
—all of whom appear in *Power* along with the Consumer. The
Living Newspapers were, quite simply, social allegories; and if,
like Alfred Kazin, one abominates these "gloomy editorials" with
their "social dummies parading the stage as 'First Man,' 'Second
Man,' 'Woman,' 'Line of Soldiers,'" it is the allegory one
loathes.[20]

The WPA documentary drama is easy to be contemptuous of
now when our theatrical conventions are so different. But for
what it was (white propaganda) and in what it was trying to do
(educate the audience of the time on social issues), it unquestion-
ably succeeded. The Living Newspapers were the biggest hits of
the most popular project. Even today, when this theater is only
words on a page, a reader finds scenes he can believe worked
well. Here is one, "Vicious Circle," scene three of the first Living
Newspaper, *Triple-A Plowed Under* (a footnote explains that it is
the "Digest of article 'A.A.A. Philosophy' by Rexford G. Tugwell,
Fortune Magazine, January 1934"):

(Blackout)

VOICE OF LIVING NEWSPAPER (over loudspeaker): In the troubled
fifteen years, 1920 to 1935, farm incomes fall five and a half bil-
lion dollars; unemployment rises seven million, five hundred
and seventy-five thousand. (Four spotlights illuminate a
FARMER, a DEALER, a MANUFACTURER, a WORKER. The FARMER,
at right, turns his head sharply to left, speaks to DEALER.)
FARMER (to DEALER): I can't buy that auto.
(There is a count of one, then light out. DEALER turns head
sharply left, speaks to MANUFACTURER.)

DEALER (to MANUFACTURER): I can't take that shipment.
(There is a count of one, then light out. MANUFACTURER
turns sharply left, speaks to WORKER.)
MANUFACTURER (to WORKER): I can't use you any more.
(Count of one, light out. WORKER speaks directly front.)
WORKER: I can't eat.
(Light goes out.)[21]

The Federal Theatre used documentary to inform and influ-
ence public opinion on contemporary issues; the issues died and
the plays with them. The WPA documentation of most value
today did not use facts to a specific social end: it just lay them
before the public, "raw cultural material—the raw material of
new creative work." They lie before us still in the WPA's pain-
stakingly plain records. For example: the music project's tran-
scriptions of Acadian and Creole songs from Louisiana, sea
chanteys down Maine, songs of African origin in the Mississippi
Delta, pioneer songs, cowboy songs, Indian songs, spirituals—
black and white, folk songs with Elizabethan roots from the foot-
hills of Appalachia, early Spanish music in the old Southwest; the
photographs and sketches of the Historical American Buildings
Survey; the endless (and unended) bibliographies of the Histori-
cal Records Survey, microfilms of federal and state archives, in-
dexes of American composers, architects, artists, authors, plays,
films—all of them prepared by the workers for whom Hopkins
had the hardest fight, white-collar relief, "Ph.D.'s who had pre-
viously been digging ditches"; the ethnic studies—*The Arme-
nians in Massachusetts, The Negroes of Nebraska, Jewish Fam-
ilies and Family Circles in New York* (in Yiddish)—and straight
scholarship—*Norwegian Word Studies, The Pattern of Internal
Mobility in Texas: A Subregional Analysis*—no one else could
afford; the life histories—sometimes verbatim, sometimes im-
pressionistic—of tenant farmers, farm-owners, textile workers,
bell hops, waitresses, messenger boys, clerks in five-and-ten-cent
stores, soda jerks, fishermen, lumbermen, miners, former slaves,
the old, the out of work, the migratory, the unwanted. The goal of

all these projects was the sublime fidelity to fact much com-
mended in the WPA Index of American Design, a collection of
some 10,000 paintings that record the decorative arts of America
from the time the country was settled to 1900. For the Index,
hundreds of skilled craftsmen, following what their director
called "a meticulous technique of documentary painting," origi-
nally devised to record the contents of Egyptian tombs, made
watercolor portraits of things men had made in America. "Under
the compulsion to reproduce truthfully and accurately, all arti-
ness, all redundance, has disappeared," critics agreed. What re-
mained was "a faithfulness, and an objective beauty which de-
serve the highest praise." [22]

Each WPA project documenting America became, as Grace
Overmyer said in 1939, "a sort of road map for the cultural redis-
covery of America from within." Yet the land and people redis-
covered proved a wealth of surprise; the record showed both to
be far subtler and odder than anyone had guessed. Paintings in
the Index of American Design suggested, for example, that "the
romantic debunkers of the twenties were all wrong about Puri-
tanism. Puritanism was not responsible for the lack of popular art
in America for two reasons: first, there was no lack of popular
art, and second, Puritanism was its best friend." The evidence,
when one troubled to consult it, showed the Puritans loved color,
sumptuous cloth, cheerful design, silver and brass. The same for
the myth of a "standardized America." If one pursued the docu-
mentary method and looked at facts in their full particularity, as
though for the first time, one found no entity to call America. In-
stead, there were regions,° though again if one looked hard

° According to Dixon Wecter, the thirties witnessed "the rise of the re-
gion" in American thought. The chief apostles of regional thinking were so-
cial scientists. The sociologist Howard Odum believed the groundwork had
been laid for "the new science of the region, a science descriptive of how all
societies grow." "Is there a regional history of America?" he asked himself.
"The historians answer that there is. 'Is there a regional psychology?' The
literary and government folks have found out that there is." As a matter of
fact, the government folks were cultivating it. The WPA sold the arts pro-
gram to Congress with the boast that it had "produced thousands of works

enough, the regions gave way and one had communities—which themselves became, on further scrutiny, classes, factions, groups. In short, documenting America turned up such an abundance of what one educator called "localized information" that no generalization with teeth or vigor held. Each town became so unique that the main thing that joined it with the next was the road.[23]

The best record of this localized America, and the WPA's finest monument, actually *is* a road guide—the American Guide Series of the Federal Writer's Project. The 378 books and pamphlets in this series include guides to each of the states; major cities (New York, San Francisco); many minor ones (Romney, West Virginia; Portage, Wisconsin); tourist areas (Berkshire Hills, Death Valley); federal highways (*U.S. One, Maine to Florida*); places of local pride (*The State Teachers College at Westfield, Private Burial Grounds in Schenectady County*); scenic waterways (*The Intercoastal Waterway, Norfolk to Key West*); and regional folklore (*Fish Are Fighters in Alabama, Idaho Lore*). The series represents, Lewis Mumford said, "the first attempt, on a comprehensive scale, to make the country itself worthily known to Americans." By "worthily," Mumford meant in adequate detail, and detail these guides furnish by the yard. The state guides, the heart of the series, follow a set pattern. Each surveys a state's history, geology, climate, racial makeup, industries, folklore, social life, arts, crafts, and culture, to begin with. It next describes every city at length, and then, mile by mile, every town and village on every major road, and every landmark in between. The very exhaustiveness of the program—"all towns and all country-

that truly reflect the vastness and variety of America rather than repetitions of themes from New York and Paris." Why had the artists avoided sophistication? Because WPA kept them down on the farm. As the WPA said mildly, "the constant drift of talent away from home communities toward the great cities has been counteracted." The Federal Theatre was quite literal about being "regionally centered": it counted on each region to find a way to expess its character. Hallie Flanagan regretted that the New England productions never offered "the illumination of the region which the *Swing Mikado* afforded Chicago, *Altars of Steel* the South, and the living newspapers New York."

side, attractive and unattractive"—sharpened the results; as Kath-
arine Kellock, the series' head editor, remarked, "the need to
find something to say about every community and the country
around it force [s] . . . close scrutiny . . . for what makes each
community differ from the others." The director of the Minnesota
guide, Mabel Ulrich, ridiculed this notion that one town or state
or region was "romantically different from any other in the coun-
try," but her editors in Washington corrected her. "What we
want," they repeated, "are the customs and characteristics that
differ sharply from those of any other State. . . . You say you
have no folklore other than Indian and Paul Bunyan. We advise
that you interview prisoners in the penitentiary." Perhaps Ulrich
took this last resort; in any event she later thought the romanti-
cism of the Washington editorial mind had brought forth most of
the best writing in the series. To get the "color, vividness" that
Washington demanded, writers had to dig; what they found and
put into words were the "minor differences among towns superfi-
cially much alike." By recording these nuances, they revealed "an
America that neither the historians nor the imaginative writers of
the past had discovered." [24]

Strangely, this America—the America of the WPA guides—still
hasn't received much attention; though discovered, it has been
little explored. Thirty years ago Kellock could say that it was not
surprising the series hadn't been subjected to literary appraisal,
because "literary criticism is little practiced in the United
States." Things have changed since then, and yet the series—
which Mumford felt his generation's "finest contribution to
American patriotism"—remains still neglected, in part no doubt
because scholars quail at its size. Jerre Mangione's *The Dream
and the Deal* (1972) tells a good deal about the Federal Writers'
Project, but virtually nothing about the work it produced. Of the
handful of articles on the series, the best is Robert Cantwell's
"America and the Writers' Project" written in 1939. Cantwell
argues, with great flair, that the guides describe an America of
chance, free spirits, greed, and blunders:

a land in which prominent citizens built big houses (usually
called someone's folly) that promptly fell into ruins when the
owners backed inventions that didn't work. . . . How has it
happened that nobody ever thought before to trace the careers
of the vast majority who guessed wrong—the leading bankers
who put their money in canals in 1840 and in Maine shipyards
in 1856, who plunged on slaves in 1859, and bet that Florence,
in Baboon Gulch, Idaho, would be the leading city of the state?
What a fine group of far-sighted financiers have really turned
up in the Guides! . . . [The series] is a grand, melancholy,
formless democratic anthology of frustration and idiosyncrasy, a
majestic roll call of national failure, a terrible and yet engaging
corrective to the success stories that dominate our literature.

Fine; but is it really so "formless"? Cantwell would seem to have
given the series form in 130 words. The sketch may be refined or
supplemented, as we will do in a moment; nonetheless, its outline
is clear. Cantwell hasn't let size intimidate him; he has read per-
ceptively in a number of the guides. And he has found that this,
after all, was enough; for the series puts its rich and unexpected
image of America on every page.[25]

It is an idiosyncratic America, a country of anecdote or, as the
French would better call it, *petite histoire*. This does not mean
that "important" events—wars and such—don't happen in this
America; they do. But when they do, they aren't important; they
become, like everything else, incidental, curious, petty. Thus the
Civil War appears in the description of Fort Fisher, North Caro-
lina, where the sea, eroding away the Confederate breastworks,
occasionally unearths the skeleton of a soldier; or in the account
of the axe factory in Collinsville, Connecticut:

Right from Canton on Canton St. and left on Maple St. to COL-
LINSVILLE (alt. 400, town pop. 2397), 2 *m.*, where are produced
axes, machetes, and edged tools known wherever men struggle
with nature. Here in 1826 Samuel and David Collins and their
cousin, William Wells, established the first axe factory in the
world. Previously axes were made to order by blacksmiths, and
the purchaser ground his own blade. From this factory, John
Brown, a native of Torrington, obtained pikes for his insurrec-
tion at Harpers' Ferry.

The raid on Harpers Ferry gets a mention, but is treated no differently than the information, given in the next sentence, that "modern axes bear a strange assortment of names, usually descriptive of their use," or a sentence farther on, that "a red-headed axe is demanded in the north woods because it is easily found in snow." The raid and the red-headed axe are both facts, and in this America all facts are created equal.[26]

This democracy extends to men. The heroes of this America are seldom the great or the accomplished, for the gestures that bear most fruit "in terms of communities" (Cantwell's phrase) come usually from the little man. The Connecticut guide introduced New Haven of the 1930s as "an industrial city distinguished as the home of Yale University and celebrated for its elm-lined streets." It is plain which the writer felt more special: the university was very good, but the trees were glorious. Several pages later we learn to whom New Haven, the elm city, owed its chief asset: "The first of the city's elms were planted in 1686 when members of James Pierpont's congregation gathered to present gifts and to furnish the house of their pastor. One poor man, William Cooper, brought as his donation two elm saplings, which he planted before the minister's door." James Pierpont was a central figure in colonial America; a theologian of merit, he was also (to quote the *Dictionary of American Biography*) "the leading founder and an original trustee of Yale College." But in the American Guide's description of New Haven and Yale, Pierpont appears just this once. He is no more than the occasion for a poor man's deed richer, it would seem, than any of his own.[27]

The common-man hero could be of any color. In fact, if he was not white, and particularly if he was Indian, he had a better chance of inclusion. Whatever America's failure to practice democracy in life, the America of the Guide Series has a phenomenal democracy of retrospection. "Solomon, a Negro with an Indian wife," is remembered because, according to tradition, while driving his cattle to inland pasturage in the 1700s, he started a path, *Sol's Path*, across a hill called Totoket Mountain. Many

past events reveal a racial tolerance which, if usually imperfect, is always unsuspected:

> Left on this dirt road, along which laurel grows in profusion, through the *People's State Forest*, 1861 acres of woodland. At 2.3 *m.*, a bronze tablet (L) marks the site of an old dwelling known as the *Barkhamsted Lighthouse*. To the hillside, many years ago, trekked Molly Barber, of Wethersfield, and an Indian named Chaugham. Defying her family, they eloped, built a crude cabin here, and lived happily the rest of their lives.
>
> Unlike ordinary Indian cabins, Chaugham's house was always well lighted and served as a landmark for stage-drivers urging tired horses along the rough road. Sleepy passengers were aroused to attention by the booming voice of the driver as he shouted, "Thar's Barkhamsted Lighthouse, only five miles to port."
>
> Within the forest, near the site of the lighthouse, are the graves of Chaugham and about 40 other Indian men.

The Indian and the white woman lived happily between two cultures, respected of each, and live in memory.[28]

Necessarily this America is one of memory. "The Guides have no rigorous standards to determine inclusion," said Cantwell. People are mentioned who accomplished much and who never accomplished anything. "The only test seems to be that some living evidence of their presence . . . still persists in their town." The evidence need not be factual, often was legend; for in this America, myth counts as much as fact. The two interweave themselves through the series; without warning, like lightning in a summer sky, humdrum history erupts into legend:

> In 1641, Captain George Lamberton, New Haven skipper, in an effort to stimulate the fur trade, purchased Indian lands in Delaware. No sooner had he built his trading post than the Dutch and Swedes ordered him to leave and burned his establishment.
>
> Pinched by the failure of their efforts in Delaware, and hoping to recoup their fortunes, the New Haven traders in 1647 fitted out "The Great Shippe" for commercial voyage to England. The finest products of craftsmen and farms were loaded on board, but, by the time the ship was ready to sail, it was January, thick ice had formed on the river, and to the dismay

of the superstitious sailors, she was towed stern-first to open water. . . .

Day after day, through the hard winter and the spring, anxious eyes searched the seaward horizon. Other ships arrived, raising false hopes, but none brought news or had heard of "The Great Shippe." Then, on one bright June day, a joyous cry echoed along the waterfront. With every sail set, "The Great Shippe" was running into port. As hurrying feet echoed along every street, a hush of awe crept over the waiting throng. The squarerigger was sailing free, *into* the wind! Not a man appeared on deck save a solitary figure at the bow who, with sword upraised, pointed unwaveringly toward the sea. Suddenly the maintop snapped, hung an instant entangled in the shrouds, then masts and spars were blown away. The hull, still making straight for shore, shivered and plunged beneath the surface, enveloped in an enshrouding mist. When the cloud lifted, no sign of wreckage floated upon the quiet waters.

Without transition, the next paragraph returns to prosaic fact: commercial statistics, export of shoes, beef, and branded biscuits. In general, a guide gives authentic history first—"WINSTED (alt. 765, city pop. 7,883) . . . became a city in 1917 . . . lies in a well-watered valley . . . early forges . . . made clocks in 1807"— and then turns with relish to legend: "Winsted has always been a 'never-never-land' where the unusual is expected to happen and usually does. Tales of 5-legged cows, talking owls, tame trout and even a wild man are flashed over the wires from this area." [29]

Whether historical or legendary, every fact is precious in this America. Each deserves the chance to be appreciated. It seems that virtually anything, however inauspicious, may be scenic or significant, and thus reward attention. New Haven's "Points of Interest" include

1. *Trinity Episcopal Church*, . . . designed in 1814 by Ithiel Town, . . . gave great impetus to the Gothic Revival in America. . . .

5. The *City Hall* (1871) . . . was erected in an era when the Venetian-Gothic style was thought to lend dignity to any building. . . .

13. The *Bushnell House* (1800), . . . once the home of Eli Whit-

ney Blake, the inventor of the stone crusher, is an excellent ex-
ample of the Federal style that developed in the 19th
century. . . .

17. The *Southern New England Telephone Company* . . .

29. *Grove Street Cemetary* (1796) . . . containing the graves of
many illustrious dead. . . .

39. The *Yale Gallery of Fine Arts* . . . (open daily 2–5) . . .

56. *The University Heating Plant* . . .

89. *National Folding Box Company* (*adm. on application at of-
fice*) . . . engaged in the production of folding paper boxes.

All must be acknowledged.[30]

Are all equal? Surely not. Several pages back we noted that for
the American Guide Series "all facts are created equal," as they
are. The phrase belongs to Jacques Barzun and is catchier than it
should have been; it caught Barzun. He meant to say only that
some facts are more important than others to the enrichment of
cultural life, but he said it was a fallacy to think facts created
equal. He called this, sneeringly, "the documentary argument."
Not only is it the documentary argument, it is the assumption at
the root of all sensitive reporting and analysis. All facts *are* cre-
ated equal. Which means simply that all must be taken into ac-
count; all are potentially important, and any, however banal,
may prove crucial. This does not mean, however, that all are of
equal importance in every context, nor certainly that all should
be put before the audience. Reportage, analysis, or art that tries
to tell all is useless and an imposition. The American Guide Se-
ries doesn't try to tell all; indeed, Cantwell argued that it doesn't
tell nearly enough on certain critical issues, the ownership of
manufacturing wealth for one. Nevertheless, the series does pre-
sent a huge quantity of facts—so many that every reader finds in
every guide much that to him is useless.[31]

To *him*. To someone else, those useless facts will be the heart
of the work, will touch the soul of the country. And this is the ex-
cellence of the Guide Series: it presents an America that really is
quite like a nation. This is not one man's America; it is the Amer-

ica of many different kinds of men: tourist, antiquarian, ethnologist, sentimentalist, outdoorsman, architect, graveyard-enthusiast. The series responds to all these interests and many more by documenting "raw cultural material": some of the details of life in every American state, city, county, town, and many villages and hamlets.

In an article on the Index of American Design, *Fortune* suggested tantalizingly that a strict enough "respect for the object" makes artists of those who merely record. Not great artists, of course; "journeymen" artists whose talents are "useful" rather than outstanding, the kind of workers whom Holger Cahill, the director of the Federal Art Project, most encouraged, believing their best efforts formed a "great reservoir" from which "a genuine art movement" might flow.° In this sense the records the WPA workers made become themselves part of what the Index commemorates: one of "the popular arts, the practical arts, the arts which always must exist in a living society"—a thoroughly "American art" that exists "where it had always existed—at the so-called lower levels of anonymous and useful workmanship." At these levels the WPA arts projects did handsome and far-reaching service to the country.[32]

° No such movement emerged, but it is worth noting that when New York became the capital of the art world after World War II most of the leading painters—Pollock, de Kooning, Gorky, Davis, Knaths, Evergood, Baziotes, Pereira, Lawrence, Bloom, Tobey, Graves, Shahn, MacIver, Guston, Bohrod, Levine, Brooks, Gottlieb, Siporin, Rothko—were alumni of the WPA. WPA art had a vogue in the late sixties, and the WPA's perspective on American culture does not lack advocates. Hilton Kramer of the *New York Times* criticized the Metropolitan Museum's 1970 exhibition "19th-Century America" as "bourgeois" in its choice of popular arts: "The true genius of the American decorative arts and crafts in the 19th century is to be found in its folk expression—in the kitchen pottery, the wool coverlets, the patchwork quilts, and the humble, plain-style furniture that was created to meet the needs of workaday living. None of this folk art is represented."

CHAPTER 7

A
Documentary
Imagination

From the start of the Depression until Pearl Harbor, Theodore Dreiser wrote little fiction and published none. He felt that people everywhere were demanding another novel of him, but he couldn't bend his mind to the task. "How can one more novel mean anything in this catastrophic period through which the world is passing?" he said. "No, I must write on economics." His published work in these years consisted of what a sympathetic biographer calls "fighting factual books" of "propagandistic pamphleteering." The actual world, not any he could dream up, chiefly engaged Dreiser's imagination. And he was typical.°1

Daniel Aaron suggests that most writers in the thirties felt fiction too frivolous an activity for a time of social cataclysm. Rather than writing poems or novels or critical essays, they

° Even Wallace Stevens, that most aesthetic of writers, felt the tendency. In 1936 he said, "The social situation is the most absorbing thing in the world today." During the next decade much of his poetry struggled to come to grips with the realities of a time when, as he put it, "death and war prevented the jasmine scent." Stevens felt the Depression and the war had moved everyone's attention "in the direction of reality, that is to say, in the direction of fact," and he eloquently defended this documentary trend: "In the presence of extraordinary actuality, consciousness takes the place of the imagination."

"quite willingly sacrificed their artistic ambitions for the good of humanity" as they thought it and, like Dreiser, produced "journalistic ephemera." The writers who tried to create a socially relevant fiction, the Proletarian novelists, did their best to make their stories seem straight reporting. William Phillips, a founder of the *Partisan Review*, has argued that "a major shift in sensibility" occurred in the thirties and moved fiction toward greater realism, smaller subjects, and more recognizable worlds. He thinks that fiction then became, or tried to become, "continuous with . . . common experience." [2]

There can be no question that Proletarian fiction was part of the thirties' documentary movement. Josephine Herbst, one of the best known Proletarian novelists, always treated subjects she knew personally so that her fiction would have what she most valued: "first hand documentation." Jack Conroy, whose *The Disinherited* is often called the classic Proletarian novel, says of his Depression writing: "I, for one, consider myself a witness to the times rather than a novelist. Mine was an effort to obey Whitman's injunction to 'vivify the contemporary fact.'" This effort, characteristic in the thirties, was of course documentary. Indeed, Beaumont Newhall has suggested these words of Whitman's as the definition of documentary, "an approach which makes use of the artistic faculties to give 'vivification to fact.'" [3]

The social fiction of the thirties borrowed many of its techniques from documentary. John Dos Passos' *U.S.A.* used a pastiche of actual headlines, dispatches, song lyrics, leaflets, stump speeches, and slogans in its "Newsreel" chapters. Though these documents were authentic, to make them carry his meaning Dos Passos had to submerge their original values—a task at which he proved himself a master. His method was simple: abbreviate and juxtapose. Robbing things of meaning became both medium and message:

> Future generations will rise up and call those men blessed who have the courage of their convictions, a proper appreciation of the value of human life as contrasted with material gain, and

who, imbued with the spirit of brotherhood will lay hold of the
great opportunity

BONDS BUY BULLETS BUY BONDS.

Most Proletarian novels had extended imitations of public docu-
ments, usually newspaper articles. Clara Weatherwax's *March-
ing! Marching!*, a novel of such Proletarian zeal that it seems a
parody of the genre, filled an entire chapter with clippings about
putative public events. Because there were two versions of each
event—the establishment's and the radicals'—Weatherwax gave
both in contrasting clippings run side by side, illustrating the
U.S. as two nations:

STRIKE CLOSES BAYLISS MILL	STRIKE CALLED AT BAYLISS MILL
Efforts To Avert Walk-out Fail	*Demands Refused; Workers Walk Out Tomorrow*
Police Rally To Prevent Violence and Protect Property	BY A WORKER CORRESPONDENT
All negotiations for a peaceful settlement of labor disputes at the Bayliss Mill were today at a complete standstill. A company official who did not want to be quoted said that there was no doubt the breakdown was caused by the influence of alien agitators.	We workers of the Bayliss Mill have voted unanimously to walk out tomorrow because all worker demands have been turned down.[4]

No doubt the thirties' novel most closely related to documen-
tary is John Steinbeck's *Grapes of Wrath*. This, like the Prole-
tarian novels that influenced it, offered a large, if simplistic, pic-
ture of actual conditions in Depression America. One critic said
it "implemented its story with facts at every turn." Many of these
facts Steinbeck had learned at firsthand, while writing articles on
migrant workers in California. Stylistically, as Malcolm Cowley
remarked, the novel's panoramic interludes used to broaden the
story into an epic of a continent and a people owed much to the

techniques of documentary films like *The Plow That Broke the Plains* and *The River*. But *The Grapes of Wrath* had a tie to documentary stronger than these, though critics have overlooked it. Steinbeck actually started out to write not a novel but a "documentary book," text with pictures. The first documentary book of the thirties, Caldwell and Bourke-White's *You Have Seen Their Faces*, was published in the fall of 1937 to great acclaim. In March 1938 Steinbeck toured Okie camps in California with *Life* photographer Horace Bristol, planning to do a *Life* article and book with pictures. The story he found seemed to him too rich for photojournalism, however, and he wrote the novel. When *The Grapes of Wrath* appeared, *Life* boasted that "never before had the facts behind a great work of fiction been so carefully researched by the newscamera." [5]

Leslie Fiedler has argued that there are "two Thirties," two tendencies in the decade's thought which are not merely different from each other but totally in opposition. One tendency, visible in *The Grapes of Wrath* and, far more plainly, in the seventy-odd Proletarian novels that preceded it, was "radical" and advocated that the existing "socioeconomic system . . . be fundamentally changed." The second tendency, that of Franklin Roosevelt and the New Deal liberals, worked toward the reform, and thus the preservation, of the system. We can understand why, despite their "opposite" objectives,° the radicals and the New Deal each used the documentary approach. For both, documentary was the means of gathering the stubbornly particular facts most liable to be trusted then and of communicating these facts in the way then most likely to persuade.[6]

The New Deal and the radicals each sponsored documentary,

° Until 1936. Then the Communist line changed, the Popular Front period began, and most radicals turned "critical supporters" of the New Deal. Roosevelt, who had been pilloried as a stooge of the capitalists, now became, along with Jefferson and Lincoln, a communist hero; and American democracy, formerly a bar to progress, was hailed as the surest defense against Fascism (in 1938 *New Masses* recruited subscribers in an "I like America drive"). This confused realignment of the radicals late in the decade makes Fiedler's formula of two thirties only a handy half-truth.

but the documentary movement of the thirties was far larger than they. Much of it was affiliated with neither cause and appeared in art and expression then without the impetus of radical faith or New Deal money. The rest of this chapter looks at examples of such documentary to suggest that their impetus was the result of an imaginative tendency common at the time.

Let us first consider Martha Graham's work in the 1930s and, particularly, her most ambitious ballet of the decade, *American Document*. In the twenties and early thirties, Graham's dances had as little social or political relevance as her myth-haunted ballets of the 1950s. Her purpose then, as John Martin said, was "to pierce through all the strata of the trivial to the roots of human experience"; she ignored the accidents of historical time and place to dwell on the perennial. Her titles and program notes for the period include:

Desir (1926)
La Canción: "The Gypsy's Song—sometimes of life—sometimes of death—always of love" (1927)
Fragments: 1. Tragedy 2. Comedy (1928)
Four Insincerities: 1. Petulance 2. Remorse 3. Politeness 4. Vivacity (1929)
Adolescence (1929)
Lamentation: "A 'dance of sorrows.' It is not the sorrow of a specific person, time or place, but the personification of grief itself" (1930)
Bacchanale (1931)
Ekstasis: "Delight issuing from inevitabilities" (1933)
Celebration: "The spirit's triumph" (1934).

Of the eighty ballets Graham created before 1934, only two—*Immigrant* (1928) and *Poems of 1917* (1928)—alluded to the American experience or contemporary events. From 1935 to 1940, in contrast, three-fourths of her works either had American themes:

American Provincials: "The world of Hawthorne's Scarlet Letter" (1934)
Frontier: An American Perspective on the Plains: "A tribute to

. . . the pioneer woman . . . [and] her love for the land" (1935)
Horizons: 1. *Migration* (*New Trails*) 2. *Dominion* (*Sanctified Power*) 3. *Building Motif* (*Homesteading*) 4. *Dance of Rejoicing* (1936)
American Lyric (1937)
American Document (1938)
Columbiad (1939)
Letter to the World: "The legend of Emily Dickinson's life" (1940)

or referred to current disorders in Europe:

Marching Song (1935)
Chronicle: "The ugly logic of imperialism, the need for conquest, the inevitability of the conflict" (1936)
Deep Song: "Created at the beginning of the War in Spain . . . the anatomy of anguish from tragic events" (1937).[7]

George Beiswanger, dance editor of *Theatre Arts Monthly,* wrote in 1941 that Martha Graham's art of the late thirties had richly profited from her "digging of deeper roots into native soil." He found the most exciting and original of her "American theme" works to be *American Document,* a programmatic ballet reviewing the country's past, not in order to escape the present, but rather to "bring to bear upon today's perplexities all that was sturdy and upright and liberating in the American dream." Another critic, Owen Burke of *New Masses,* praised the ballet as a "dancer's moving testimony to the greatest of American traditions—democracy," a tradition then in danger from "the worldwide offensive of reaction."

Graham located America's traditions and dream in "documents . . . from our national background." "Our documents," she wrote in the ballet's program note, "are our legends—our poignantly near history, our folk tales." It was of such themes that she built her "essentially documentary, *American Document.*" The ballet had the form of a minstrel show, with an Interlocuter, or commentator, who explained the meaning of the dancers' gestures by

speaking words from American history. *American Document* was in five "episodes," each preceded by a "walk around" of all the company's members. The first walk around began with the Interlocuter's announcement that "the place is here in the United States of America" and "the time is now." The first episode, *The Declaration of Independence*, included a reading of the Preamble. The next, the *Indian Episode*, started in happy nostalgia for the time before the white man; the Interlocuter said: "I do not remember the flocks of pigeons in the virgin forest, before these states were. But my blood remembers, my heart remembers." He quoted a letter from Red Jacket of the Senecas while the dancers showed the coming of the white man and the Indian's loss of his land. Burke remarked that this "poignant *Lament for the Land* takes on a current significance, brings to mind migratory workers" and "refugees leaving their fascist-invaded lands and homes." The third or *Puritan Episode* juxtaposed readings from Jonathan Edwards and The Song of Songs. The fourth section was a dance to passages from the Emancipation Proclamation. The fifth, called simply *Now*, treated "the current economic situation," the *New York Times* said, and concluded with "a final tableau in celebration of democracy." *Now* pictured man in economic bondage; three female dancers, their hair disheveled and bodies bent, made begging gestures toward the audience while the Interlocuter intoned, "We are three women; we are three million women. We are the mothers of the hungry dead; we are the mothers of the hungry living." A male dancer appeared, man liberated, walking with relentless purpose; and the Interlocuter said, "This is one man; this is one million men. This man has power. It is himself, and you." *Now* concluded with triumphal leaps to Lincoln's resolve that "government of the people by the people and for the people shall not perish from the earth." Burke, writing for a communist magazine in a popular front period, didn't bother to mention *Now*'s social criticism, so moved was he by the final "stirring appeal for a militant democracy."

Martha Graham was moved, too. Her *American Document*

documents America in a simplistic way because she wanted to speak with "broad clarity of meaning" about her country's traditions. So keenly did she feel what she wanted to say, that to say it she subordinated her art. She found her thoughts best expressed in well-known words from the American past; Beiswanger explained that while "listening over the radio to evil words spoken by men across the seas, she recalled other words—the Declaration of Independence, the Emancipation Proclamation, the poems of Walt Whitman, the Bible—that had once held power for good." And to get these words spoken, she broke the traditional silence of the dance. Dance diminished into illustration, her art into what Burke called "an episodic theatre piece" not merely programmatic but frankly propagandistic. Like most artists in the thirties, Graham willingly sacrificed her art to put her message across.[8]

We see that her message relied on documentary of a cliché sort but wonder whether the dancing was documentary too. The ballet's form derived from the minstrel show and from the allegory of propaganda ("this is one million men"); its words and costumes derived from American history; its music, from folk tunes. But had Graham's finest imagination, her sense of dance, found a way to transcribe America in movement—and if so, how? The critics do not tell us, and the photographs of the production are inconclusive. It is clear that for many who saw them Graham's ballets of the thirties forcefully evoked America; a sensitive observer described *Frontier:*

> Two diverging ropes extend to the horizon. There stands a small, courageous figure of the pioneer woman. She dances her vision of a home on the land—rejoicing in a sense of space and freedom. Then comes a feeling of insecurity and a premonition of disaster; but her faith and self-reliance come flooding back. Finally she reaffirms her belief in the American continent, and in courage equal to survival.

But such descriptions are too impressionistic, do not give the detail we need. There is, however, a film of the ballet *Appalachian*

Spring which Graham created in 1944, the last work of her "American theme" period; and the film suggests that *American Document* documented America in dance, for the later ballet does.[9]

Appalachian Spring is programmatic also, though unlike *American Document* it is not a pageant and had no propaganda motive beyond the celebration of things American. Its subject is the marriage of a Pennsylvania farm couple in the nineteenth century. Its music, by Aaron Copland, quotes at length the great Shaker hymn "Simple Gifts" ("'Tis a gift to come down/Where you ought to be"). The ballet borrows steps and gestures from American folk dances (the Chorus, a church congregation of four women, does a Virginia reel), from children's games (the Preacher plays patty-cake with the Chorus), from the movements of a rider on a horse or in a buggy, and from the sudden toe-in, ankle-out pivots of the jitterbug. The Groom does leaps reminiscent of sailors' hornpipes and does them as the hornpipes were done—with an unbending boisterousness.

Equally significant are the non-dance gestures Graham incorporated into the ballet. There is a lot of plain walking, American walking with heavy feet, and shoulders loose and rolling; [*] there is a lot of standing around. The dancers clap and stamp as in a hoedown, and the noises are part of the ballet. Graham pays close attention to the texture of things, the detail of living. As the Groom saunters into the meeting house where the wedding takes place, he rubs his palm along the wall to feel the fiber of the wood. The Bride pantomimes holding a baby who squirms in her arms; she smiles and rocks it as vigorously as she would stir a kettle. Later she lovingly polishes a chair. The Bride and Groom's most touching moment together is from life, not dance; she is at a rail fence downstage, gazing out beyond the audience,

[*] Such was the walking in *American Document*'s "walk arounds"; the man who was one million men in that ballet had an American walk, too, though of another sort: brusque, determined, with legs striding, arms swinging, and hands tense.

and he walks up and puts his hands on the fence on either side of her, possessing, enclosing, protecting her. Over her shoulder she gives him a cozy look. The ballet's climax occurs during the Groom's solo dance after the marriage. When the Groom takes over the stage, Copland's music is at its most exuberant, and the audience expects leaps of passion and delight. There are leaps, but the Groom prefaces them with a stunning small gesture. He turns toward the audience, and instead of jumping for joy as the music is doing, he very slowly slides one foot forward across the floor and shifts his weight to it. For a long moment he does nothing else; his whole being is concentrated in that deliberate step. The most ecstatic thing he can do is really to feel where he is, the grain and character of the place.[10]

This would appear the consummate need of the thirties' imagination: to get the texture of reality, of America; to feel it and make it felt. We have seen this in the documentary photographs and radio of the period, in Franklin Roosevelt and the New Deal, and will find it in the nonfiction writing. But it was also present in such popular innovations as

¶ *The March of Time*, on radio (begun 1931) and film (1935). The early films, like the radio program, re-enacted public events; the later films tended to be straight documentary.

¶ The soap opera (*One Man's Family*, the granddaddy of them all, started in 1932). Social scientists sought the reason for the popularity of the daytime serial, and the reason they found was always the same: women listened because they felt the programs true to life.

¶ The newsreel houses, a phenomenon of the time: movie theaters showing only newsreels and short subjects, most of them documentaries. The writer Robert Bendiner remembers that in the late thirties newsreel houses were springing up all over Manhattan.

¶ The "inside" books. The paradigm, John Gunther's *Inside Europe*, appeared in 1936 and was revised and republished yearly

until 1943. Gunther's thesis was that the accidents of individual personality play a determinant role in history; therefore, he gave the reader the lowdown, the inside dope, "the intimate stories" about the leaders who threatened "the collapse of our civilization":

> Hitler, at forty-seven, is not in first-rate physical condition. He has gained about twelve pounds in the past year or so, and his neck and midriff show it. His physical presence has always been indifferent; the sloppiness with which he salutes is, for instance, notorious. The forearm barely moves from the elbow.

Gunther got his best stories from unattributed sources ("From one of the half dozen men in Germany indisputably most qualified to know, I have heard . . ."), and introduced in American journalism the extensive use of "blind" quotes from unnamed intimates to characterize the great.

¶ The Americana films, books (historical novels and romantic histories), and radio programs of the later thirties.

¶ The photo magazines—*Life* (1936), *Look* (1937), and their short-lived imitators *Click, Focus, Foto, Photo, Picture,* and *See.* When Henry Luce began *Life,* the idea of a photo magazine was by no means the novelty that a newsmagazine was when he began *Time* in 1923.° Indeed, Luce was fearful that someone would

° Photo magazines were already a proven success in Europe, having been developed in Germany during the 1920s by the editor Stefan Lorant and his photographers Erich Salomon and Felix Man. The foreign success was not copied sooner in the U.S. for two reasons. First, the Depression inhibited the necessary capital. Second, the European photo magazines were printed on newspaper stock, which was thought too low in quality for an American magazine of mass circulation. Until the mid-thirties, it wasn't possible to print photos on better quality "coated" paper at high speed because the ink smeared. *Life* was the result of a triple breakthrough in print technology, the simultaneous development of faster drying inks, a "machine coated" paper that was thin and cheap, and the "heatset printing" process which used extremely high temperatures to scorch ink dry as it was applied to the page. How best to "fire dry" ink was such an important secret that the press on which R. R. Donnelley, *Life*'s printer, perfected the technique was guarded by company police until the first issue of the magazine appeared.

beat him to the punch because, as he later recalled, "everyone seemed to be interested in publishing a picture magazine." Everyone judged right: *Life*'s immediate popularity was such that throughout its first two years not enough copies could be produced to meet the demand. In 1939 *Life* boasted it was "the greatest success in publishing history" and attributed its appeal to its "new *picture-and-word* editorial technique" which "makes the truth about the world we live in infinitely *more exciting, more easily absorbed, more alive* than it has ever been made before." Luce was especially pleased that *Life*'s photojournalism made "normal, decent, useful and pleasant behavior far more interesting than word journalism usually does." In its early years *Life* concentrated on just such behavior: family life, sports, courtship, farming, entertainment, work, hobbies; its most controversial photo essay of the thirties showed the birth of a baby. *Life* photographer Carl Mydans remembers that on a typical day in 1937, he took pictures of the processing of skunk fur in New York City's garment district, Representative Sol Bloom in his Boy Scout uniform, a steel strike in Johnstown, Pennsylvania, and beekeeping in Waycross, Georgia. The decent, everyday realities *Life* documented were of course thoroughly American. Luce ordered his editors to "get the photographers into the byways of America." Mydans says of himself and his co-workers on the magazine: "We had an insatiable drive to search out every fact of American life, photograph it and hold it up proudly, like a mirror, to a pleased and astonished readership. . . . America had an impact on us and each week we made an impact upon America." They did, because week after week *Life* offered its readers what they wanted: "an important American document," "a vital document of U.S. life," "here, set down for all time, you may look at the average 1937 American as he really is," and "take stock of some of the abiding things which are magnificently *right* about America." [11]

To feel the texture of reality, of America. Is not the same motive apparent in the education of the time? In, for example,

¶ The start of the American Studies movement, the object of which was, in F. O. Matthiessen's fine phrase, "a culture adequate to our needs."

¶ The new use of "primary sources" in college history courses. The sources were gathered in the thirties' many anthologies of "readings" and documentary histories, far the most popular and influential of which was Henry Steele Commager's *Documents in American History*, first published in 1934.

¶ Progressive education. "Picture two groups of schoolchildren," *Life* asked its readers in 1939.

> One is sitting stiffly in rows, memorizing Latin verbs. The second group, in another city, is standing with its teacher on the roof of a tall building. Below, the children see both sides of the railroad tracks. . . . They go down to the street and explore the city at close range. Then they go back to their classrooms, compare notes, discuss what's right and wrong with the city and what to do about it. The first group, meanwhile, is still memorizing verbs. This is the difference between the old and the new education.

The "new" or progressive education, though John Dewey had spelled out its theory a generation before, only entered America's classrooms in the thirties. Its principal ideas—that learning should be lived, that direct experience was the best teacher, that emotional growth counted at least as much as intellectual— dominated educational thinking then. Progressive colleges and schools like Bennington, Black Mountain, and Putney opened their doors, and interest in such experiments ran high: Louis Adamic's 1936 *Harper's* article on Black Mountain drew more letters than any article had in years. What these schools taught, according to John A. Rice, the founder of Black Mountain, was a method, a process, not mere facts. This method, which encouraged the individual student to examine and report his emotional responses to firsthand experiences of many kinds,° has analogies

° The painter Josef Albers, who came to America to teach at Black Mountain, had his students look at shards of colored glass for hours on end, be-

with documentary method. But the new education wasn't the toy of aberrant private schools. When *Life* showed how "Young Americans Study America" in 1939, the article had the significant subtitle, "Springfield, Mo. Has Progressive Education." The public schools of "a fairly typical American city" gave their children "first-hand, broad-gauge training in life."

¶ The Fugitive movement and the New Criticism, with their common insistence on what John Crowe Ransom called "local texture" as the source of meaning.

¶ The attempt at a "maximum of concreteness" (Paul Lazarsfeld's phrase) in much of the social science research of the period. Techniques used to gain this end included "participant-observer" studies like Allison Davis' *Deep South,* informant narratives like *The Professional Thief* ("by a Professional Thief"), and case histories of Balzacian detail:

> There were four rooms for Mr. and Mrs. Johnson and their three children—John 18, Helen 15, and Peter 11. The interviewer was ushered into the parlor, a chilly, unused room where he sat down upon a leatherette sofa with cracks in its back. Its companion piece, an overstuffed chair, stood over by the piano, and an oak table stood in the center of the room. On the table stood a vase of artificial flowers, a portrait of Mrs. Johnson's brother, Joe, in a sailor's uniform, and a green glass ashtray. Under the table was a well-worn rug.[12]

An imagination that seeks the texture of reality must fix upon particulars, and the imagination characteristic in the thirties did.° When Marquis Childs wrote "They Hate Roosevelt" about

cause, in a fine feat of discrimination, he judged that "a color correctly seen and understood is more important than a mediocre still-life."
° The radical intellectuals of the early thirties would seem the exception. If one takes them at their word, they went Marxist because it was the rational, even the historically necessary, thing to do. *New Masses'* 1932 symposium "How I Came to Communism" had testimony from six writers; only one of them, Michael Gold, the anti-intellectual of the group, mentioned a specific experience that led to his conversion. The others treated the step as though it were one of pure ratiocination. Edmund Wilson was typical: "It was only recently in trying to formulate a new policy for *The New Repub-*

the richest 2 per cent of the American people, he showed what "they" were like by reporting "certain recent examples" of the insensitive things "Joshua and Ellen Thornberry," "Jeremiah Skeane," and "James Hamilton II" said and did. Particularization of the same sort was the primary technique of Time Inc. journalism. *Fortune*'s 1933 series on Ivan Kreuger has been called "a classic example of how *Fortune* made business journalism come alive." The "how" was detail—detail to the point of irrelevance and light fabrication:

> Mr. Kreuger drew the bedroom blinds evenly and neatly to the sill. He smoothed the unmade bed-clothes and lay down. The street sounds had grown fainter through the darkened blinds. Looking up he saw the fat, gold stucco cherubs in the ceiling corners of the room. Odd witnesses! He turned his black coat back and laid aside the leather-covered large gold coin above his heart. For a long time he had worn it there as a guard against some shot, some madman. . . . He placed his feet together neatly side by side. He shot himself an inch below the heart.

Vincent Sheean invented the most popular way of putting the *isms* of the decade in human terms: he analyzed each as it had affected him, judged ideology through autobiography, turned the world's events into *Personal History* (1935).[13]

Reading the literature of the time, one finds this imaginative tendency, this turn to the particular, on every page. Frances Macgregor in her documentary book *This Is America* (1942) spoke of the extreme racial heterogeneity of the U.S.A. and said: "The skeptic may ask, 'How can there be harmony in such a country? How can Democracy work?'" And how was the skeptic answered? Did the author tell him of the political system, feder-

lic after [Herbert] Croly's death that I investigated Marxism and really understood the Marxist position." Clifton Fadiman claimed that "history" had been his teacher, but didn't gossip about the particular events history had instructed him with. He was similarly vague about the people who influenced him: "During the summer of 1931 I happened to spend time with people who knew more than I did. They too, perhaps, were just history disguised as individuals."

alism, interest groups? Not at all. Instead, she offered concrete proof: "We may answer by pointing to the hundreds of towns and villages that make America." Simply that. To the *fact* they exist, to the way of life that goes on in them, to its character and feel.[14]

The hitherto unimagined existence of workers, minorities, the rural, and the poor was, we have seen, what excited the imagination of most artists and reporters in the thirties. They tried to express the texture and particularity of the common man's life. Their aim, in Murray Kempton's words, was "a new kind of American realism that would open up subjects and explore a side of life neglected in the literature of their country." Alfred Kazin says that young writers in the thirties wanted "to prove the literary value of our experience, to recognize the possibility of art in our own lives." These lives and experience were lower middle class or lower (or so the writers claimed); what they wanted to move "into literature" were "the streets, the stockyards, the hiring halls." It wasn't only writers who wanted to put the common man in art. Aaron Copland praised the achievement of composer Marc Blitzstein: "the fact that for the first time in a serious stage work he gave the typical American tough guy musical characterization. Just imagine what it means to make a taxi driver sing so that the result sounds natural." Blitzstein did just what the age demanded: he found "a voice for all those American regular fellows" who hadn't been audible before.[15]

The art and reportage of the thirties made the nation vividly aware of these regular fellows and of almost unimaginable conditions of life. For this, John Grierson would give a large share of credit to documentary, which enabled "the nation . . . to be brought alive to itself" through its people's "*sharing of experience.*" Warren Susman would concur; he argues that the new media of the thirties—photo magazines, radio using direct remotes, documentary film—"helped reinforce a social order rapidly disintegrating . . . and helped to create an environment in which the sharing of common experience, be they of hunger, dust

bowls, or war made the uniform demand for action and reform more striking and urgent." Here, however, one may usefully disagree. For hunger and the Dust Bowl were not common experience. The people reading of them, or seeing photos or films of them, were not hungry, not Okies, not sharing the experience. And yet they cared. The thing that held American society together in the thirties was not documentary, though documentary gave it occasion to take hold. It was imagination with a strong fellow feeling; it was human sympathy.[16]

This is a delicate matter to talk about. One risks the glib sentimentality that pervades writing on the thirties. Here is an example of such writing, courtesy of Frank Brookhouser: "I think that in the thirties, despite their troubles and their tragedies, the men, women, and children in America loved more strongly, felt more deeply, generated more warmth, and held more compassion for their fellow men than ever in our history, before or since." That is too much, surely; it implies that Americans of the thirties belonged to a different, nobler species than the rest of humankind. They didn't. Yet the tone of the time, its spirit, *was* different. When Eleanor Roosevelt says that "fundamentally it was [a] spirit of cooperation that pulled us out of the depression," one does not laugh or squirm, for one recognizes there is a truth in what she says. People in the thirties do seem to have had—and certainly to have encouraged—a strong "concern *with others*," as the novelist Gerald Green argues. This was a time when a superabundance of such concern was admired. William Saroyan won fame with a short story which announced that it had been written "in tribute to Iowa, to Japan, to Assyria, to Armenia, to the race of man everywhere, to the dignity of that race, the brotherhood of things alive," and which ended with Saroyan, the story's narrator,

> thinking of seventy thousand Assyrians, one at a time, alive, a great race. I am thinking of Theodore Badal [the barber who is the subject of the story], himself seventy thousand Assyrians and seventy million Assyrians, himself Assyria, and man, stand-

ing in a barber shop in San Francisco, in 1933, and being, still, himself, the whole race.

It was a time, apparently, when certain kinds of human existence counted for more than today. Dawn McCulloch, a voice in *Hard Times,* compares then and now:

> How important a part radio played in all our lives, all during the Depression.
> Everything was important. If one man died, it was like a headline. Life was more important, it seemed to me. I remember a headline story of a young golfer—he had on metal shoes and was hit by lightning. Everybody in the neighborhood talked about it. It was very important that this *one* man died in such a freak accident. Now we hear traffic tolls, we hear Vietnam . . . life is just so, it's not precious now.[17]

Dawn McCulloch is speaking of a particular kind of life: the kind "we hear" about in the media, the life of people we have never met face to face. These people die—150 per day on the highway, so many per week in Vietnam, by the plane- and boat-load, in fire, flashflood, crime, and civil commotion—and only when the death is something close, bizarre, or ominous do we attend. Not the thirties. Then, for reasons having to do with ideology, war and peace, the new documentary media, and the imagination of the time, attention was paid. The radicals prided themselves on being "aware of every heartbeat of their time," Murray Kempton said; "they read and discussed every interior short paragraph of the New York *Times.*" Alger Hiss' wife Priscilla wouldn't let a casual acquaintance remark how fine the day was without cautioning her to remember the sharecroppers' plight. Moderates, too, spent their concern in the public arena. "The public world with us has *become* the private world," said Archibald MacLeish; "the single individual, whether he so wishes or not, has become part of a world which contains also Austria and Czechoslovakia and China and Spain. . . . What happens in his morning paper happens in his blood all day, and Madrid, Nanking, Prague, are names as close to him as the names by which he counts his dearest losses." [18]

Radio, as we have seen, brought them even closer. During the Munich crisis of 1938, Whittaker Chambers and his wife were among the millions who haunted their radios.

> We heard Jan Masaryk's voice break as he pled against the extinction of his country. Until the end, we heard, borne on the air waves across the ocean, the *Vltava*, Smetana's music, that describes the flowing of the Vltava River through Bohemia on its way to the sea. . . . As that childishly simple, descriptive music came over the air—a little peasant theme, repeated over and over like the hopeless crying of a child from whom everything has been taken—my wife wept. She wept for the Czech children and for all children.

Radio broke down what MacLeish called "the superstition of distance": "the superstition that what is done beyond three thousand miles of water is not really done at all; . . . that violence and lies and murder on another continent are not violence and lies and murder"; that Czech children were not all children.[19]

The medium sold itself precisely as a way of making unimagined distant people real and objects of human concern. C.B.S. boasted that "radio's response to human need" in the late thirties proved it "The Good Samaritan." When the Ohio and Mississippi rivers leapt their banks in January 1937, "day and night for two weeks the sound and the fury of the worst flood in American history spilled through the radio into the living room" of Mr. and Mrs. Joe Smith, Anytown, Indiana, C.B.S.'s mythic representatives of typical radio listeners. Though "the land had been dry where the Smiths live," they responded generously to the crisis. A G.E. advertisement of the period shows a mother dabbing her eyes with a handkerchief while her daughter comforts her. Near them stands the radio, a genial brown idol. The head-text reads: " 'Don't Cry Mother . . . It's *Only* a Program!' " The ad continues:

> Of course daughter is wrong. It's not just a program—it's real and the people in it live! Mother's tears and smiles are the natural reaction of one good neighbor to another neighbor's everyday problems.
> She shares the heartbreak of a girl who is hundreds of miles away—yes, farther than distance itself, for she lives in the land

of make-believe. But it isn't make-believe to this lady because, thanks to the golden tone of her General Electric Radio, every program is close, intimate and personal.

And persuasive, like anything we know, or feel we know, first-hand. Radio demonstrated its enormous power to arouse belief the night Orson Welles broadcast his "War of the Worlds." The nationwide panic that the show created suggests how much Americans then accepted the rhetoric of radio as a rhetoric of reality.[20]

Mr. and Mrs. Joe Smith, typical Americans of the time, believed the radio and the other new media, but these weren't what they cared about. They cared about the people the media presented. They believed in the reality of these people, though the people were but names or faces on a page, words from an amplifier, dark images on a bright screen, or a plaintive peasant melody cracked with distance. The Joe Smiths accepted the humanity of people they knew only secondhand, and paid these people the final compliment of feeling toward them as they felt toward those they knew personally. The Smiths were the Good Samaritans—not the radio.° They, not documentary media, held together a social order rapidly disintegrating. They held it together with imagination of a special kind and power. Imagination that worked, at a distance and vicariously, on evidence the media brought them. Documentary imagination.[21]

Which suggests a final idea. Because Americans in the thirties vividly felt the reality behind a document, they sometimes came to regard a document as surrogate for the reality, and hence precious—even valid—in itself. We see this in the fetish for "documents," and for the words "documentary" and "document." Jedediah Leland, Citizen Kane's sidekick, keeps the statement of principles Kane put on the front page of the *Inquirer* his first day

° In his 1941 essay "The American Century," Henry Luce declared that the United States "must undertake now to be the Good Samaritan of the entire world." Our sympathy had grown beyond all boundary.

as editor, because Leland has "a hunch it might turn out to be something pretty important: a document." The columnist Dorothy Thompson sought the highest tribute for Luce's "American Century" essay; she called it "an American document." Owen Burke described audience reaction at Martha Graham's ballet: "A people alive to the worldwide offensive of reaction against the simplest tenets of freedom, rose in ovation to a *Document* which opened with the reading of the Declaration of Independence." Such a "document" was a sort of counteroffensive. The economist E. Wight Bakke noted that a man without a job would, far more frequently than a man with,

> carry around documents such as certificates, letters of recommendation, . . . social-security cards, union cards, membership certificates in benefit clubs, anything which identifies him, that is, indicates he is a person with a certain standing. . . . One proudly showed a letter from the chief of police "To Whom It May Concern" that Mr. X had no record at the New Haven Police Station.

Those "documents," bits of printed paper, counted more than his own person in establishing his manhood. Archibald MacLeish argued in 1940 that if the United States was to persuade its Latin American neighbors "that a North American culture exists . . . worthy of admiration," the only way to do it was "by submission of the documents—the books, the poetry, the music, and the painting" the nation had produced. Theodore Dreiser wrote in 1941 that he would despair of America were it not for the Declaration of Independence and the Constitution. "These documents alone are Americanism—they alone distinguish our country and our problems from others." He held them up for his countrymen to venerate, the solution of all riddles. "It is the existence of these documents, as I have tried to show, that makes America still a country of hope." [22]

It remained for Thorton Wilder to suggest that a handful of documents—"the ideas and thoughts of the great men"— separated humanity from the ravening beasts and saved, if only

just, our civilization. In *The Skin of Our Teeth* (1942), George Antrobus, home from all the wars, remembers why he fought:

> ANTROBUS: "Maggie! I didn't dare ask you: my books! They haven't been lost, have they?"
>
> MRS. ANTROBUS: "No. There are some of them right here. Kind of tattered."
>
> ANTROBUS: "Yes—Remember, Maggie, we almost lost them once before? And when we finally did collect a few torn copies out of old cellars they ran in everyone's head like a fever. They as good as rebuilt the world." (*Pauses, book in hand, and looks up.*) "Oh, I've never forgotten for long at a time that living is a struggle. . . . All I ask is the chance to build new worlds and God has always given us that. And has given us" (*opening the book*) "voices to guide us; and the memory of our mistakes to warn us. Maggie, you and I will remember in peacetime all the resolves that were so clear to us in the days of war. We've come a long ways. We've learned. We're learning. And the steps of our journey are marked for us here." (*He stands by the table turning the leaves of a book.*) 23

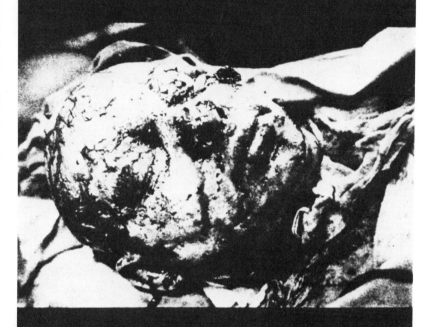

HE WAS AN ISRAELI BUS DRIVER

EVERY MORNING HE DROVE VILLAGE
CHILDREN TO SCHOOL ...
UNTIL MAY 22nd ...

Unattributed pro-Israeli leaflet, June 1970

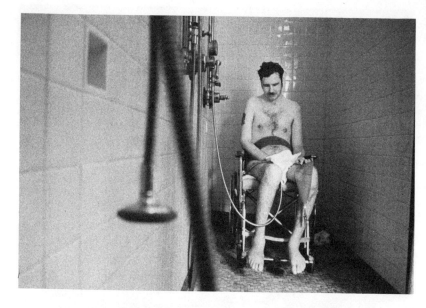

Co Rentmeester, Quadriplegic Vietnam veteran
"From Vietnam to a VA Hospital: Assignment to Neglect," *Life*, May 22, 1970
CAPTION: Quadriplegic Marke Dumpert, invalided out of the Marines as a
lance corporal, waits helplessly to be dried in a veterans' hospital.

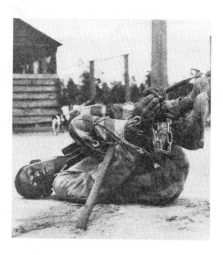

John L. Spivak, Prisoner in a Seminole County, Georgia, stockade
"On the Chain Gang," 1932

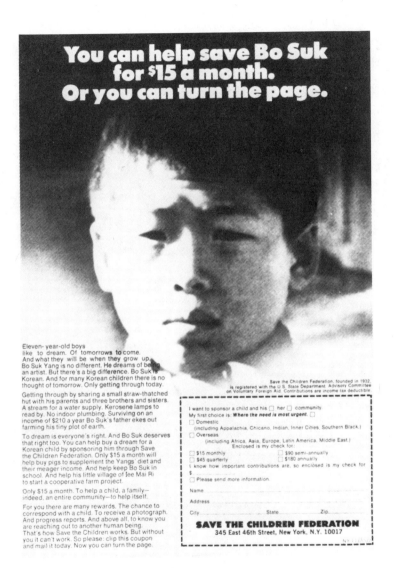

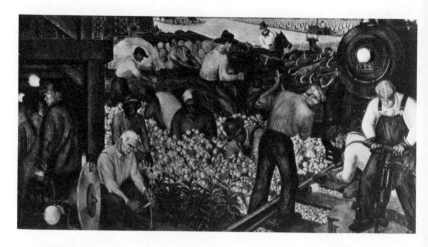

James Michael Newhall, *Evolution of Western Civilization,* one of a series of five panels; WPA Art Project, Evander Childs High School, the Bronx, New York, 1938

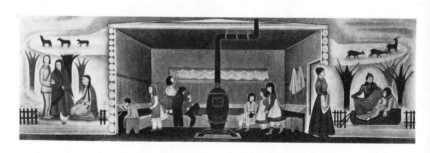

Emanuel Jacobson, *Early Schoolroom,* sketch for one of a series of panels; WPA Art Project, Illinois, ca. 1937

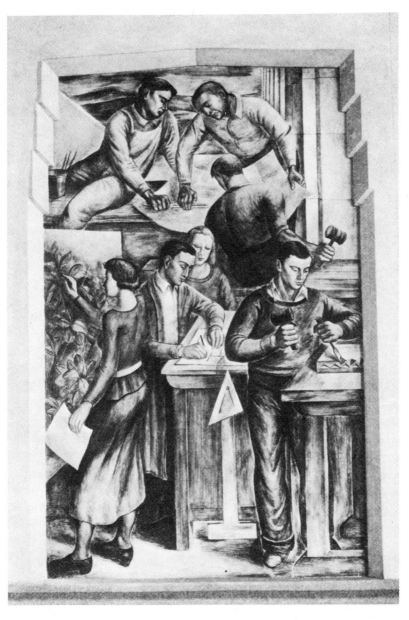

Edgar Britton, *Classroom Studies and Their Application*, one of a series of six panels; WPA Art Project, Illinois, ca. 1937

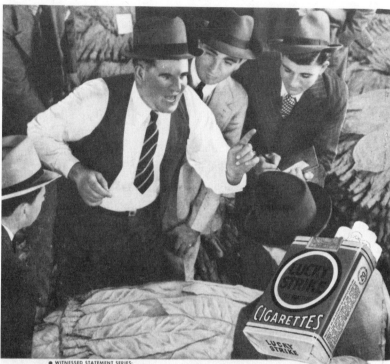

Advertisement for Lucky Strike cigarettes, *Life*, September 18, 1939

Lusha Nelson, *Friendless, U.S. Camera 1939*

Unemployment 1932, Roads and Bridges, Conservation, Recreation
from *Inventory: An Appraisal of the Results of the Works Progress Administration*, 1938

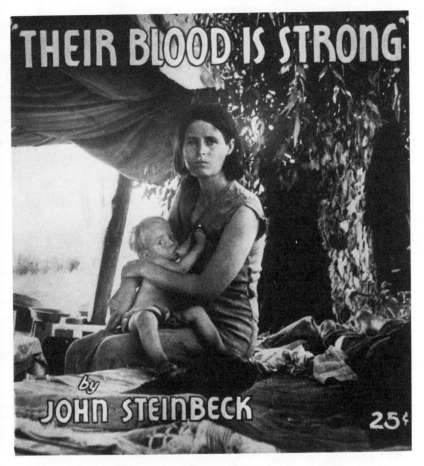

Dorothea Lange, Okie mother and child in California, 1936;
FSA photograph used as the cover to John Steinbeck's "Their Blood Is Strong," 1938

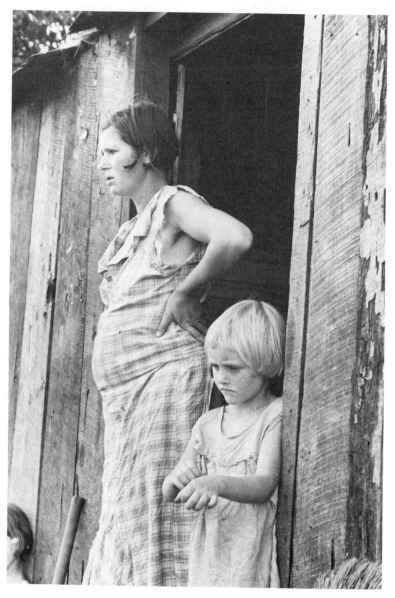

Arthur Rothstein, Sharecropper mother and child, Arkansas, 1935

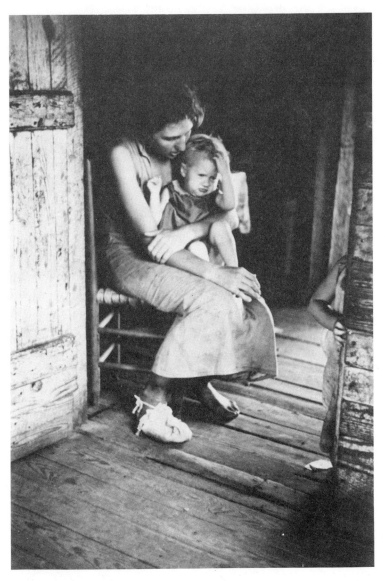

Walker Evans, Sharecropper mother and child (Ivy and Ellen Woods)
Let Us Now Praise Famous Men (1960 edition)

Arthur Rothstein, A cow's skull, South Dakota, May 1936

Walker Evans, *Butcher Sign, Mississippi, 1936*

Walker Evans, Sharecropper's washstand (the Gudger house)

Walker Evans, *Interior Detail, West Virginia Coal Miner's House, 1935*

Dorothea Lange, *Childress County, Texas, June 1938; An American Exodus*

Dorothea Lange, *Westward to the Pacific Coast on U.S. 80, New Mexico, 1938*
An American Exodus (1939 edition)

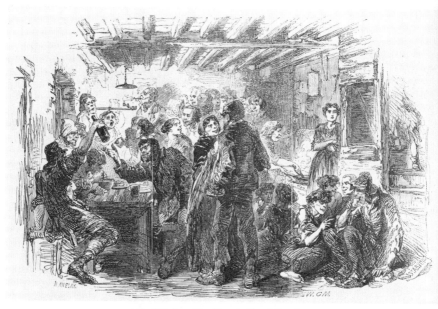

The Kitchen, Fox Court, Gray's Inn Lane
Henry Mayhew, *London Labour and the London Poor*, 1851-62

John Thompson, *The "Wall Worker"; Street Life in London*, 1877

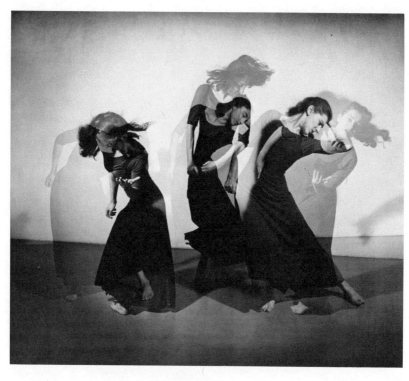

Barbara Morgan, *We Are Three Women . . . We Are Three Million Women*
dancers: Frieda Flier, Jane Dudley, Sophie Maslow
Martha Graham's ballet *American Document,* 1938

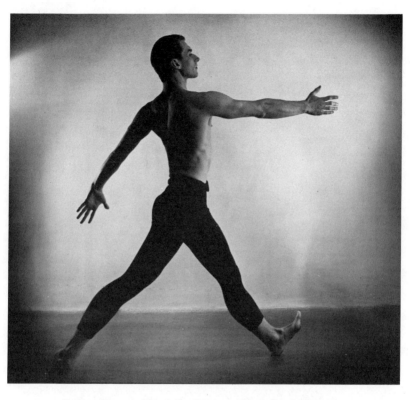

Barbara Morgan, *This Is One Man . . . This Is One Million Men*
dancer: Erick Hawkins
Martha Graham's ballet *American Document*, 1938

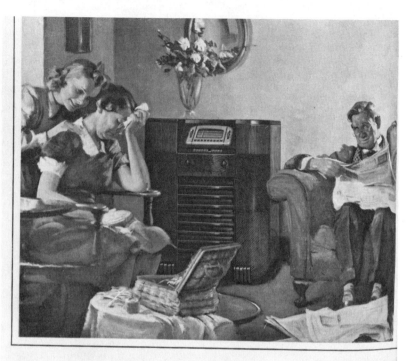

"Don't Cry Mother..It's _Only_ A Program!"

OF COURSE daughter is wrong. It's not just a program—it's real and the people in it live! Mother's tears and smiles are the natural reaction of one good neighbor to another neighbor's everyday problems.

She shares the heartbreak of a girl who is hundreds of miles away—yes, farther than distance itself, for she lives in the land of make-believe. But it isn't make-believe to this lady because, thanks to the golden tone of her General Electric Radio, every program is close, intimate and personal—an actual visit from the interesting neighbors on the other side of the dial.

What a wonderful thing this radio is! Its magic conjures people, nations, castles and kings right out of the air! It carries you on thrilling journeys to exciting places—brings colorful people to call who become closer

friends than the folks next door. Summons interesting guests whose songs and smiles crowd with pleasure hours that once were empty and lonely for so many of us—brings countless bits of radiant color to weave into the pattern of gray days.

The golden tone of the General Electric Radio affords such realistic reproduction that every word and sound sweeps in with full depth and color. It's almost like another dimension in radio. And, listening to G-E, all barriers of time and space seem to fall away. The unseen curtain of distance is lifted.

Great improvements are constantly being made in G-E Radios. G-E engineers have perfected a new Beam-

a-scope (eliminating aerial and ground wires, a new Dynapower speaker, a new super-powered chassis, a new tone monitor circuit, and other great contributions to finer radio reproduction. These developments mean reception of greater depth and brilliancy of tone—realism! All this adds up to greater radio enjoyment—a better seat at the greatest show in the world.

Radio plays such an important part in your daily life that you should enjoy it at its best. You can, for G-E golden-tone radios are priced to fit all purses.

And remember—it ceases to be "only a program" when it comes to you via the rich, golden tone of the new General Electric Radio.

GENERAL ⊕ ELECTRIC RADIO

LISTEN TO THE GOLDEN ♪ TONE OF GENERAL ELECTRIC

Advertisement for General Electric Radio, _Life_, February 19, 1940

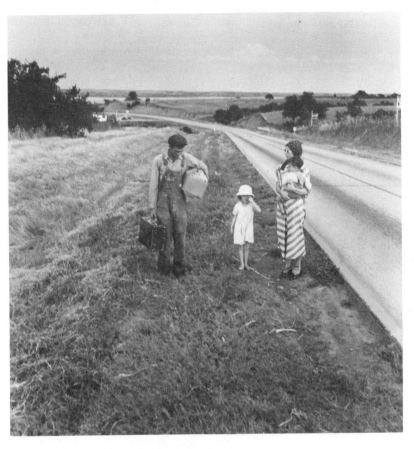

Dorothea Lange, *On U.S. 66 near Weatherford, western Oklahoma,* 1938
An American Exodus (1939 edition)

Rockwell Kent, Commemorative stamp
for the Workers Defense League and the
Southern Tenant Farmers' Union, 1936

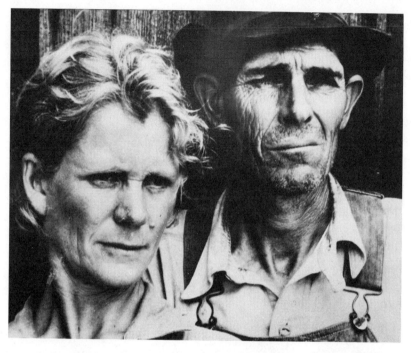

Margaret Bourke-White, *Maiden Lane, Georgia; You Have Seen Their Faces*
CAPTION: "A man learns not to expect much after he's farmed cotton most of his life."

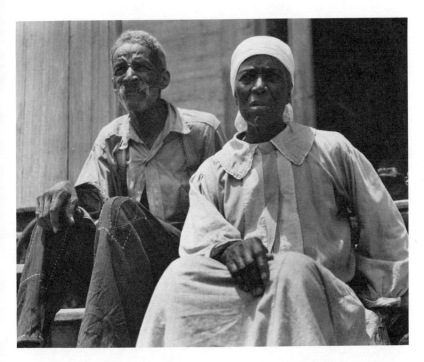

Dorothea Lange, *Couple, Born in Slavery, on an Abandoned Twenty-eight Family Plantation, Greene County, Georgia, July 1937; An American Exodus*

CAPTION: "I remember when the Yankees come through, a whole passel of 'em hollerin', and told the Negroes you're free. But they didn't get nothin' 'cause we had carried the best horses and mules over to the gulley."

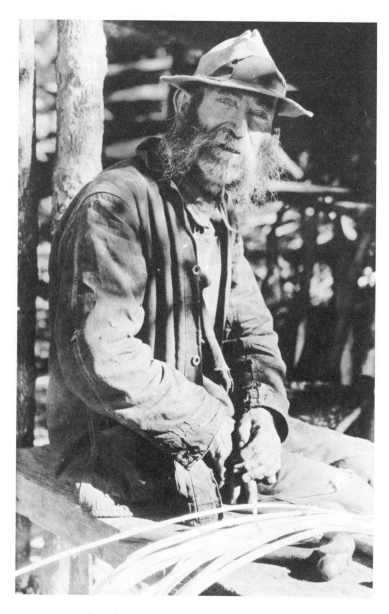

Bayard Wootten, *George Queen, Basketmaker*
in Muriel Earley Sheppard, *Cabins in the Laurel,* 1935

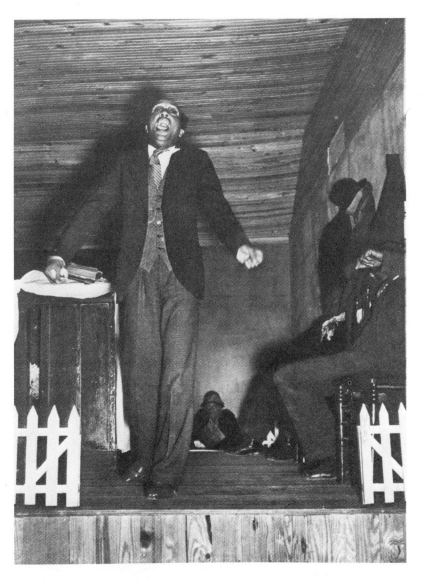

Margaret Bourke-White, *College Grove, Tennessee*
You Have Seen Their Faces
CAPTION: "We've got a first-class God."

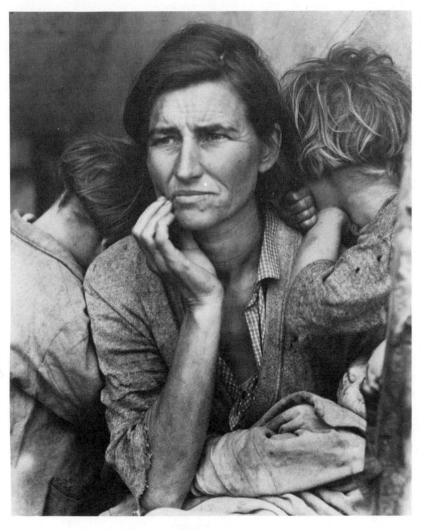

Dorothea Lange, *Migrant Mother,* Pea-picker's family, California, 1936

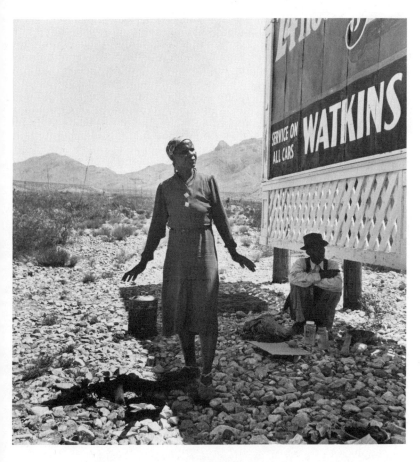

Dorothea Lange, *On U.S. 80 near El Paso, Texas, June 1938; An American Exodus*
CAPTION: "The country's in an uproar now—it's in bad shape. The people's all leaving the farm. You can't get anything for your work, and everything you buy costs high. Do you reckon I'd be out on the highway if I had it good at home?"

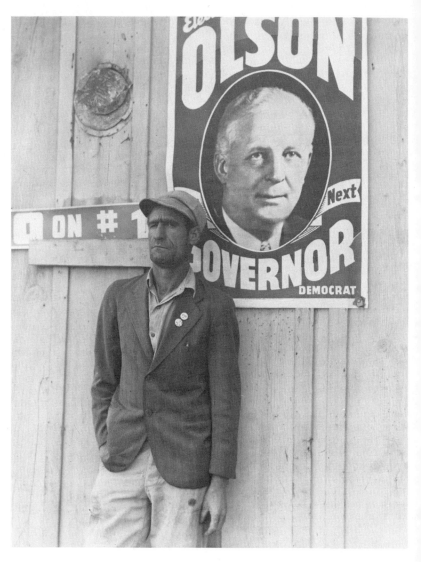

Dorothea Lange, Leader of cotton strike, Kern County, California, November 1938
An American Exodus

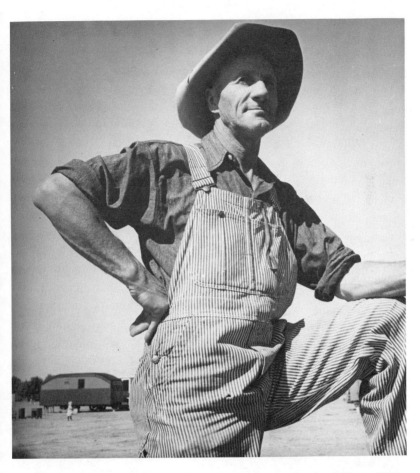

Dorothea Lange, *Farmer Who Left Nebraska, Calpatria, California, February 1939*
An American Exodus
CAPTION: "I put mine in what I thought was the best investment—the good
old earth—but we lost on that, too. The Finance Co. caught up
with us, the Mortgage Co. caught up with us. Managed to lose
$12,000 in three years. My boys have no more future than I have,
so far as I can see ahead."

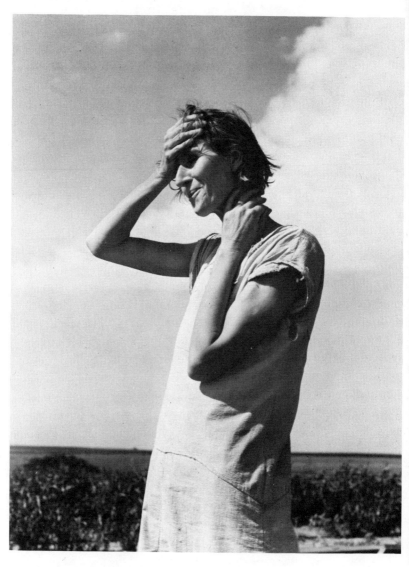

Dorothea Lange, *Woman of the High Plains, Texas Panhandle, 1938*
An American Exodus
CAPTION: "If you die, you're dead—that's all."

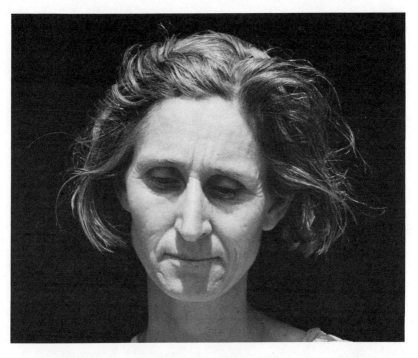

Dorothea Lange, *Woman of the High Plains, Texas Panhandle, 1938*

Edwin Rosskam, Restaurant mural; *San Francisco,* 1939

CAPTION: Above the stairway to the luncheon club, a gigantic female, husky enough to lift a truck, embraces a somewhat puny frightened world. Her blue and vapid eyes are undisturbed by the clatter of a mining drill around her hip. A two-ton redwood stump reposes snugly in the crook of her elbow. Out of her ample bosom, a young man in a sweater and slacks sails toy airplanes. Her left hand contains fruit salad.

Marion Post, Vermont winter (FSA photograph)
in Sherwood Anderson, *Home Town*, edited by Edwin Rosskam, 1940
CAPTION: America must keep rolling.

Margaret Bourke-White, The Statue of Liberty; *Say, Is This The USA*, 1941

CAPTION: New York, New York. Car hops and bobbin boys, auto courts and night shift hitchhikers and hotel greeters, beauty queens and bank nights, prayer service and union meetings, personal appearances and gossip columns, all-night movie and bunion derbies.

Frances Cooke Macgregor, *Plane Spotter*
This Is America, 1942

CAPTION: Ever watchful for those who would destroy democ-
racy, American soldiers, white and colored, are on
the alert. And at short distances along our shores,
for many miles inland, observation posts have been
erected where, twenty-four hours a day, seven days
a week, civilian air watches stand watch for hours
at a time, sweeping the horizon to be sure that no
plane may approach without being reported.

Russell Lee, *Sharecropper's child, southeast Missouri, 1938*

Walker Evans, Sharecropper child (Squinchy Gudger)
Let Us Now Praise Famous Men

Walker Evans, *Negro Church, South Carolina, 1936*

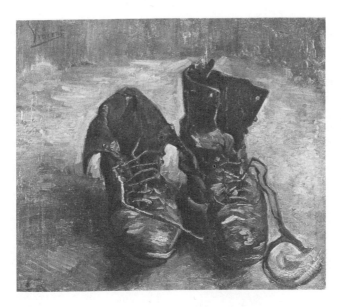

Vincent van Gogh, *Les Souliers* (Boots with laces), 1886

Walker Evans, Sharecropper's work shoes (George Gudger's)
Let Us Now Praise Famous Men (1960 edition)

Walker Evans, Sharecropper's fireplace (the Gudger front bedroom)
Let Us Now Praise Famous Men

Walker Evans, Sharecropper's fireplace (the Ricketts house)
Let Us Now Praise Famous Men (1960 edition)

Walker Evans, Sharecropper's kitchen wall (the Ricketts house)
Let Us Now Praise Famous Men

Walker Evans, *Joe's Auto Graveyard, Pennsylvania, 1936*

Walker Evans, *Trash Can, New York, ca. 1968*

Walker Evans, Snapshots on the wall of a sharecropper's house (the Ricketts house)
Let Us Now Praise Famous Men

Walker Evans, Sharecropper's landlord (Chester Boles)
Let Us Now Praise Famous Men

Walker Evans, Sharecropper family (Ivy, Ellen, and Bud Woods)
Let Us Now Praise Famous Men (1941 edition)

Walker Evans, Sharecropper family
(Ivy, Ellen, Pearl, Thomas, and Bud Woods, and Miss-Molly Gallatin)
Let Us Now Praise Famous Men

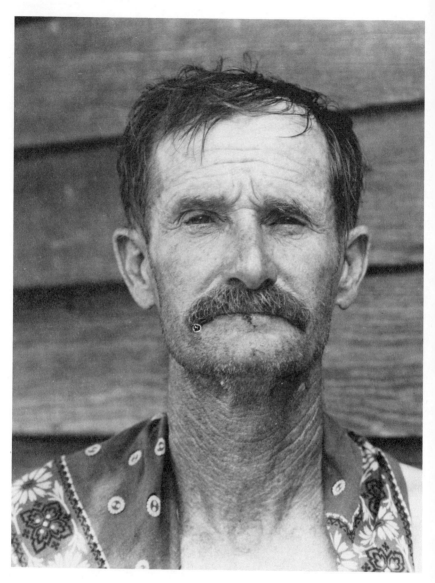

Walker Evans, Sharecropper (Bud Woods)
Let Us Now Praise Famous Men

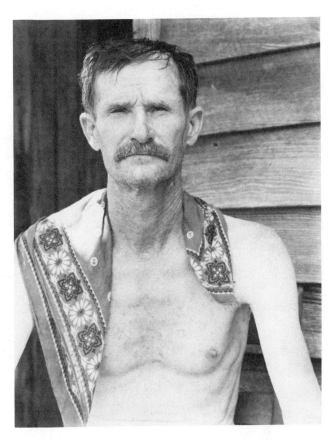

Walker Evans, Sharecropper (Bud Woods)

Walker Evans, Writer and sharecropper
(James Agee and Bud Woods)

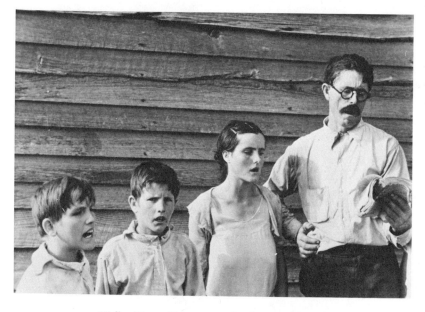

Walker Evans, Sharecropper family singing hymns
(Richard, John, Margaret, and Fred Ricketts)
Let Us Now Praise Famous Men (1941 edition)

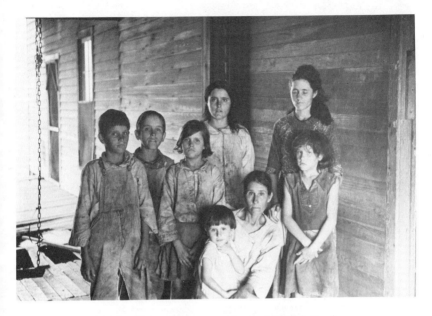

Walker Evans, Sharecropper family (the Rickettses)
Let Us Now Praise Famous Men (1960 edition)

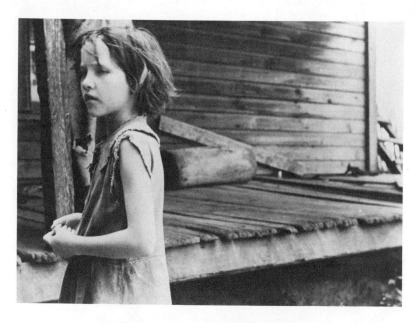

Walker Evans, Sharecropper child (Katy Ricketts)
Let Us Now Praise Famous Men (1941 edition)

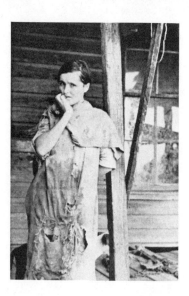

Walker Evans, Sharecropper girl (Margaret Ricketts)
Let Us Now Praise Famous Men (1941 edition)

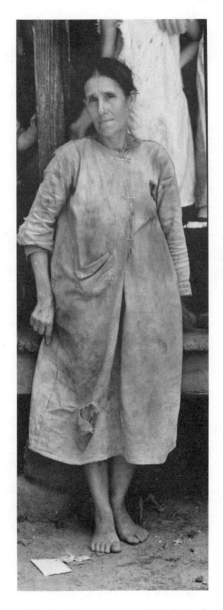

Walker Evans, Sharecropper wife (Sadie Ricketts)
Let Us Now Praise Famous Men

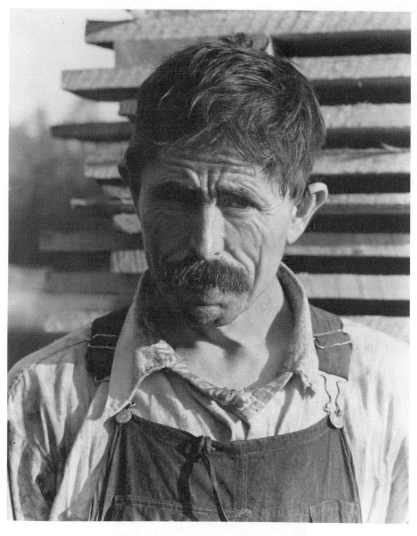

Walker Evans, Sharecropper (Fred Ricketts)
Let Us Now Praise Famous Men (1941 edition)

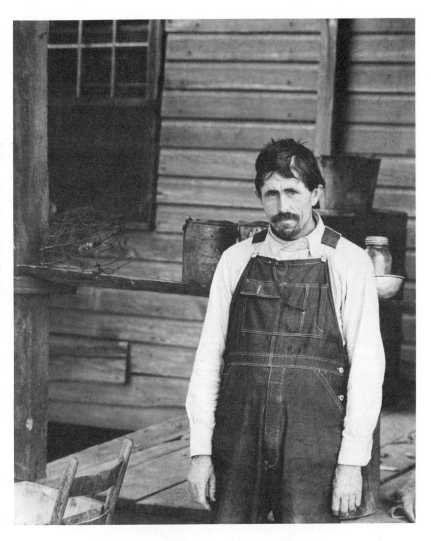

Walker Evans, Sharecropper (Fred Ricketts)
Let Us Now Praise Famous Men (1960 edition)

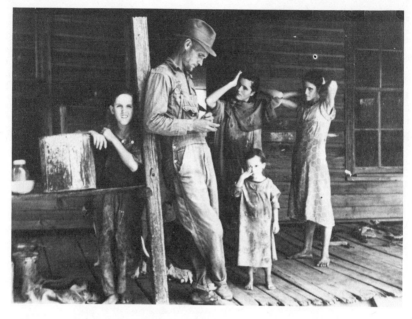

Walker Evans, Sharecroppers prepare to have their pictures taken
(the Rickettses and George Gudger at the Ricketts house)

Walker Evans, FSA houses for relocated sharecroppers
near Eatonton, Georgia, March 1936

William Christenberry, Farmhouse (formerly the Rickettses')
Hale County, Alabama, summer 1972

William Christenberry, Walker Evans in Hale County, Alabama,
October 1973

Walker Evans, Sharecropper wife (Annie Mae Gudger)
American Photographs, 1938

Walker Evans, Sharecropper wife (Annie Mae Gudger)
Let Us Now Praise Famous Men

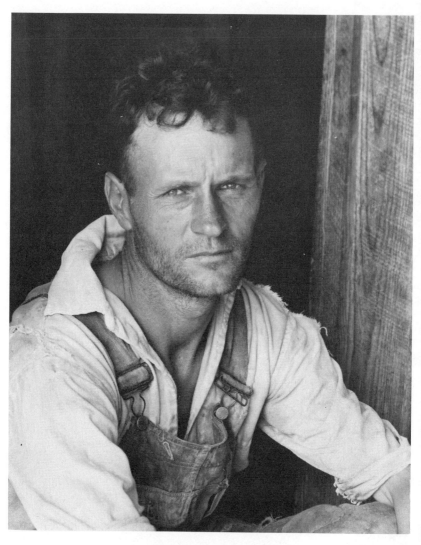

Walker Evans, Sharecropper (George Gudger)
Let Us Now Praise Famous Men

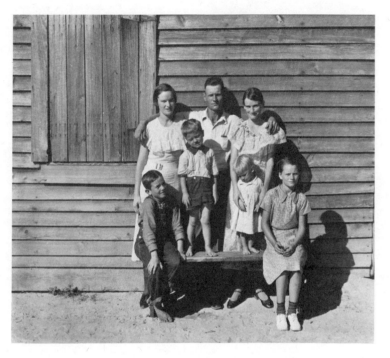

Walker Evans, Sharecropper family (the Gudgers and Emma)

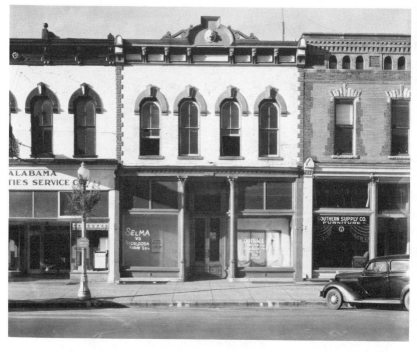

Walker Evans, *Main Street Block, Selma, Alabama, 1936*

The Documentary Nonfiction of the Thirties

John Grierson once remarked that the documentary film movement of the 1930s "might, in principle, have been a movement in documentary writing, or documentary radio, or documentary painting." In principle it might have been, and in fact it was. The documentary movement of the time included all these, plus theater, music, dance, and—as we have seen—much else. We turn now to the largest and least studied aspect of the movement, nonfiction documentary writing.[1]

When we speak of documentary writing, we mean three things: writing based upon or incorporating documents; writing that records the experience of common people, often in their own words; or firsthand reportage that tries to convey the texture of actuality as well as the facts.° These kinds of writing are not mutually exclusive: the reportage may quote the common man at length, and the documents give the feel of lived experience. In the thirties, documentary writing was chiefly used to make vivid the period's social conditions and thus influence public opinion. Among the forms of nonfiction using documentary techniques then, the most important were:

1. Social workers' case histories of the unemployed rewritten for the general public in what one reviewer called "a moving appeal to the conscience and good-will of middle-class people who know nothing about unemployment except as a mounting curve on a statistical graph."

2. Social science writing that tried, as John Dollard explained, "to grasp and describe . . . the emotional pattern of life" under examination in such a way as "to give the reader a more vivid sense" of it.

3. Reportage—radical and liberal—that used documentary techniques to expose America's shortcomings.

4. "Worker narratives," and the other attempts to get the common man to speak for himself (today we call this oral history).

5. "Documentary books," books with photographs and text.

6. The "I've seen America" books: firsthand reportage that tried to capture and preserve the feel of the country.[2]

The next six chapters analyze the literature in these categories. The categories are treated in the order just given, which makes sense as a chronology of thirties thought. Representative books and articles are

° Three basic techniques—direct quotation, case study, and firsthand (or participant) observation—describe the ways all written documentary works, the first two exemplifying the direct method of persuasion, and the last the vicarious.

discussed both as cultural history and as expression, for both content and form. Their form is significant for two reasons. First, though many of the books are more than a generation old, unread, and not in themselves worth reading, they provide the context in and against which was made a supremely fine book, *Let Us Now Praise Famous Men*. Second, the books illustrate various ways the literate have found to approach and describe actuality and their fellow men, in particular those—the socially disadvantaged—quite different from themselves. These ways of relation (in both senses of the word) are always attractive; they are in use today. Each has virtues and drawbacks, and these chapters suggest which ways of relation are better when, toward what end, and why. Whether certain ways aren't *ultimately* better, as James Agee fiercely believed, is a question that haunts these pages; but it is discussed later on, in the book's final chapters.

Popularized Case-Worker Studies

Clinch Calkins' *Some Folks Won't Work* was published in the fall of 1930 to wide praise. It begins, "This book is about unemployment," as though the subject were an odd one for a book. And oddly enough, it then was. *Some Folks Won't Work* was the first book on unemployment published in the Depression—which means, in a sense, the Depression's first book. Significantly, it was documentary: it attacked unemployment by describing the lives of particular unemployed people. It was documentary, too, in an even more literal and peculiar way, for it related the contents of certain documents: "three hundred family histories . . . gathered by the settlement workers of the United States." [1]

Calkins, a social worker and a poet of repute, wrote the book on behalf of the National Federation of Settlements as a "definition" of unemployment for "those who have not experienced it" to whom "unemployment means nothing at all." Her definition was not intellectual but emotional, and observers at the time found it of great power. Paul Blanshard said, "This is one book that deserves the description 'a human document.'" Marquis Childs and Paul Douglas declared that it would touch the heart of the most complacent Babbitt. Like hundreds of Depression

books that appeared later, *Some Folks Won't Work* addressed "the relatively fortunate middle class that reads books and experiences emotions," as Lionel Trilling, in 1942, bitterly defined his class. It tried to *move* the relatively fortunate to action on behalf of the disadvantaged.[2]

Like scores of subsequent articles and books, *Some Folks Won't Work* retold case studies done by social workers. The popularity of Calkins' book encouraged others in the profession to write for a general audience.° Trade books and articles by social workers including Frances Perkins, Harry Hopkins, Edith and Grace Abbott, Grace Adams, Beulah Amidon, Grace Anderson, Louise Armstrong, Lillian Brandt, Ewan Clague, Paul Douglas, John Fitch, Helen Hall, Paul Kellogg, Carey McWilliams, appeared throughout the thirties; and all of them used, in varying degrees, Calkins' technique of popularized case history.[3]

The tone of the social-worker books varied from cool to maudlin indignation. None advocated radical change in the economic system, though social workers writing for their colleagues, as in the social work magazines *Survey* and *Survey Graphic*, were not always so discreet. James Mickel Williams' book, *Human Aspects of Unemployment and Relief: With Special Reference to the Effects of the Depression on Children* (1933), published by the subscription of public welfare workers, left no doubt that it favored remaking America's economic order through a redistribution of private wealth. The assumption in these books, whatever their political bias, was that those who best knew unemployment and what to do about it were those who treated the condition at firsthand, "the social workers of public and private welfare offices, . . . the practicing physicians, public health nurses, clinical workers, visiting teachers, probation officers, and members of the staffs of psychopathic hospitals."[4]

° It was altogether typical of the time that a magazine contributor be "a social worker who resigned her position to test an experimental year of living by writing."

Calkins' technique, and that of social-worker documentary in general, was not to quote a case history, except for words the subject had said, but to retell the facts herself, letting her emotions play freely over them. This method, though it encouraged too much sentiment, got her main point across. The disastrous "labor statistics" about which the experts of the time differed so markedly had importance only insofar as they pointed to the "personal experiences" of the unemployed individual, "a very little figure." Calkins' attempt was to "isolate and visualize one single statistic" in such particularity that readers would know it to be a man like themselves.[5]

That the reader identify with the unemployed was her whole purpose. She concluded her introduction—as Agee later concluded the Preface to *Let Us Now Priase Famous Men*—with Lear's "Poor naked wretches" speech; and when she invited the reader, "Take a Grand Street car, or a bus across the lower East Side of New York," or "Say you are Arturo Giamo of Madison, Wisconsin," she was asking him to do as Lear commands: "Expose thyself to feel what wretches feel."

> What if your trade disappears with style changes, and you are one of the Hanlon sisters of Boston? All your working life you have depended upon making wire hat-frames for your support. They go out of style, and you are suddenly thrown back upon the savings which were to have seen you through old age.
>
> Or market changes may have been responsible for your unemployment. Or other business vicissitudes. You are Musset, the Chicago piano teacher, and the radio and victrola have undone you. Or you are Alberto Sapelli, a chef who has had the same job for eight years. The restaurant which employs you refuses to sell wine and goes out of business. You cannot even buy milk for your baby.

This is the most obvious, and not least effective, of Calkins' ploys: though never explicitly, she threatens "you," the reader, with the fate you read about. One reviewer called *Some Folks Won't Work* "a book to make the strong in you want to fight, unceas-

ingly, to put an end to unemployment; but the weakness that is
in you will shudder, and fear will whisper many times that per-
haps you and yours are not entirely immune." [6]

Readers at the time didn't feel immune; their fears made real
and immediate the hardship Calkins described. But it was the
suffering that was real rather than the sufferers, for the case his-
tories are meager and simplisitc. There is both too much
evidence—i.e., too many cases—and too little. One knows that
the author, "when I read of the Morrows of Boston," will tell all
she can of them, and that the Morrows will take, at most, 500
words. Then she will turn to another sad family. The Morrows
are not statistics, but neither are they quite human. They have
names (pseudonyms, of course); a few have dim faces; they some-
times speak a sentence or two. But they are wholly virtuous and
wronged: "not one drunkard, not one malingerer, not one incom-
petent was included," said Childs approvingly; "forces entirely
beyond their control put these men and women on the street."
There is no pettiness, no particularity of character, in these ideal
types. A reader finds it difficult to identify with them; the best he
feels—and the worst—is an emotion of dissociation: pity.[7]

Calkins evidently realized that the case materials she worked
with reduced the jobless and made it hard for the relatively for-
tunate reader to feel them as men like himself, for whenever she
could, she turned the tables. Rather than force the reader down
to their level, she showed the unemployed stubbornly clinging
to his. The people whose lives she described were once, in luck-
ier times, members of the reader's class, pillars of their churches,
generous to their inferiors. And Calkins found several telling in-
stances of their thwarted middle-classness. A Mrs. James of Salt
Lake City, whose unemployed husband refused to bootleg, had
always taken meticulous care of her home. Now she was too poor
to buy what she needed to clean it with. She explained:

> Some one comes in and asks, "When did you wash your curtains
> last?" and you've just got to smile and say you don't care for
> that sort of work any more, you just don't get a kick out of it,

that's all. And you know they're whispering behind their hands, "I believe she's lived so long with a lazy person she's grown lazy herself." It takes a strong character—you've just got not to care for anybody or anything to get along. It gets you a reputation for orneriness.

A reader feels for Mrs. James, if he does, not because she longs for his clean curtains, but because she is really so like him. She is too middle class to confess that she can't care for her life as she wants. She would rather make enemies of friends—and call that "character"! In her one sees pride as well as defeat, and may empathize as well as pity.

Such an instance was rare, however. The facts with which Calkins had to work were usually too thin and predictable. In consequence, the book hastens randomly from case to case; hustles the reader on to other suffering, almost as if to say, "That didn't move you? Wait. Wait: here's a story that may." And as with all case-study documentary, one finds oneself becoming a connoisseur of hardship, seeking new intensities.

Unlike a book of social science, *Some Folks Won't Work* had no theory to structure the cases; they and the feelings they tried to arouse were the entire purpose. Reading case after case was as useless a self-indulgence as listening to soap operas. Thus in order to give her book a center, Calkins put herself there. It was a logical move. She, like the reader, had not learned at firsthand the experiences she reported: she had them, as he must, from reading; she had them imaginatively. She could be guide and alter ego. In solving one problem, however, Calkins had created another: the narrative consciousness in the book.

The problem with the consciousness that relates the cases here, as often in thirties documentary writing, is that it sympathizes too readily and amplifies too much ("One's heart goes out to Doney, who has changed very much since he is not any more the regular support of his family"). The book's best moment occurs when Calkins admits the limits of her imagining and the final incomprehensibility of the facts with which she deals. She tells of

the Le Fevres, who "were reduced to starvation" and "simulta-
neously in every way destroyed as a family." The phrases are like
those applied to many cases; one expects the Le Fevres to be
only typical. Le Fevre was a carpenter, churchgoer, lodge mem-
ber ("a definite social goal-post," says Calkins; "participation . . .
indicates that a man is esteemed, is known by his first name," as
Le Fevre here is not). He lost job, lost home, borrowed, went
hungry, sickened—all standard hardship. "I can picture part of
the story," Calkins said, "but parts of it are beyond my power to
picture." For Le Fevre somehow got work. Calkins wondered at
it:

> Often I stand in my upper window at sunset and look over the
> woods toward Ardmore [Pennsylvania]. It was there in March
> [1929] the carpenter laid down his tools and died. . . . How
> did he get to the job in Ardmore from his home in Philadel-
> phia? It is over 30 cents away. Who lent him the carfare? Or
> did he walk? Or did he catch a ride? What conversation did he
> overhear, what printed words gave him the desperate hope that
> in Ardmore would lie his redemption? How did his words form
> themselves so persuasively in the mouth of one so restrained,
> with such a sense of form . . . ? "He begged awful," said the
> contractor. "I couldn't stand it. I didn't have the work, but I
> made him a job."

Le Fevre worked one day, began a second. Then

> at eleven in the morning the carpenter put away his job, took
> up his tools slowly, and laid them in their chest. "What's the
> matter? Ain't you satisfied?" inquired the contractor; "I'm satis-
> fied. Your work's going fine." To which *nunc dimittis* the good
> and faithful servant made no answer, but put his last saw in the
> kit, and lay down and died. At the hospital it was said that for
> five days his stomach had received no food.

"I stand in the window at sunset and ponder about the carpen-
ter," Calkins wrote. "I see the metal saw, I smell the sawed
wood. I can reconstruct his slowing movements, the classical ef-
fort towards completion, the laying away of the tools." But she

admitted she could not conceive the event. It happened to some-one else, to someone real; and however unfortunate the man was, however pitiful, his life was his—"inaccessible," as she said, to the prying, however sympathetic, of a social worker or a poet.[8]

CHAPTER 9

Social
Science
Writing

Research for the "Yankee City Series," a social anthropological study of Newburyport, Massachusetts, began in 1930, and the first of the series' five volumes appeared a decade later. In the introduction to this book, W. Lloyd Warner explained how the project had been written up. Most social science reports, he said, "emphasize what are called results which, on the whole, are made up of facts, ordered and classified with no mention of how they were gathered." He was contemptuous of such sham objectivity.

> These "facts" and their classifications are but the momentary end result of a long sequence of activity. That is to say, they are but expression of what the researcher was doing, thinking, and observing when he constructed his report. Thus had he presented it earlier, the "results" would have been what he was observing, thinking, and doing at that moment.

Warner considered research "fundamentally a learning process for the scientist who does it" and believed that in order to explain what he had learned a researcher should "communicate" the "process" that led him to his conclusions. Therefore, like most social scientists of the period, Warner took pains to give the

reader what John Dollard called "a vivid sense of the research experience" and the social phenomena studied.[1]

Very briefly Warner had outlined the two methods of social science writing in the thirties. One method, the more classical, presented its facts in general terms, abstractly quantified. The other presented specific facts whose importance was in part that they claimed to be representative, in part that they had a felt life of their own. In 1929 the influential sociologist Charles H. Cooley called the first the "method of statistics" and the second (which he advocated) the "life study method." The economist E. Wight Bakke in 1933 called the first method "statistical" and the second "descriptive." Thomas Minehan, a sociologist, in 1934 called the first "scientific" and the second "literary," and insisted that the latter was "the only acceptable method for ascertaining a complete and true picture in many fields." We will here call the first method statistical or quantitative, and call the second what it plainly is: documentary.[2]

The statistical approach to social reality, though much practiced in the thirties, was also much criticized. As we have seen, vital statistics were then hard to come by and often doubted. A writer would be congratulated if in place of "the dubious authority of statistics and concluding generalizations," he offered "the sound and the meaning of [a] miner's speech, his laughter, fears, and hopes, his silences and oaths, his humanity." A writer could be criticized, as Erskine Caldwell once was, for being "too statistical and superficial"—vices felt to be synonymous then. John Chamberlain liked Edmund Wilson's reportage because it was "impressionistic rather than statistical" and "figures are important only in so far as they affect human hearts." It is clear that the journalists most sensitive to the hardships of the time felt a quantitative description of society traduced the reality it tried to convey. Marquis Childs wrote in 1930: "Of the many refuges from unpleasant fact none is more convenient than the statistical method." James Rorty intended that his reportage describe "the people whose current dilemmas the statistics fail adequately to

express." Childs and Rorty's complaint was that to read, say, of a million people unemployed was not to come to grips with the fact of *one* flesh-and-blood human being out of work. This argument was put most baldly by David Cohn in his popular 1935 book on Southern Negro life, *God Shakes the Creation*. Cohn boasted that he had "deliberately avoided the use of statistics" because

> it is impossible, I think, to understand a complex society, or, for that matter, a simple society, save in the flesh-and-blood terms of the human beings who compose it.
> Does the great war stir your heart with agony because ten or fifteen millions of men lost their lives in it? Or does it sink more deeply into your innermost being because your neighbor's son, whom you knew as a child, went marching off to war in the glory of his youth and came back a broken body in a casket? That is why I deal so largely here with red blood and marrowy bone, and so little with pale percentages.[3]

The abstractness of quantitative social science writing cannot be denied. But many thirties research studies in this mode had palpable emotion behind them, were keenly interested in not only the representation of American society but also its reform. Such books include: the Chapel Hill series on the South and farm tenancy, the best known of which is Arthur Raper's *Preface to Peasantry* (1936); large-scale studies of unemployment like Ewan Clague and Webster Powell's *Ten Thousand Out of Work* (1933); and Robert and Helen Lynd's *Middletown in Transition* (1937).

There is no doubt, however, that the majority of social scientists in the thirties were drawn, like Lloyd Warner, to use the second kind of writing in place of, or in addition to, the statistical method. Certain of these scientists were troubled at using a strategy which reported particular experience rather than quantitative generalization. While preparing *Caste and Class in a Southern Town* (1937), John Dollard said he suffered "a bad conscience on the score of method. Should the researcher expect to be believed if he cannot hook his findings into the number system and present them in the manner conventional in the physical

sciences?" And yet he found the statistical approach "inapplicable" to his needs. Other social scientists, like the journalists of the time, felt statistics falsified the facts they purported to describe. As early as 1924 Edward Lindeman, the sociologist who coined the term "participant observer," protested that to assume that life could be interpreted by "arithmetical answers" was wholly false. In 1929, in his last article, Charles Cooley spoke of the ultimate purpose of the social sciences and of the one way this purpose could be realized: "We are seeking, I presume, to get at the human meaning of our institutions processes as they work out in the lives of men, women and children. How can we expect to succeed without perceiving in human terms what is going on?"

Most social scientists of the Depression decade felt as he did. In 1933 Thomas Minehan, having collected over five hundred case histories of runaway youngsters, began to write *Boy and Girl Tramps of America.* He "analyzed the data statistically, worked a few correlations in conventional sociological form." But as he did so, "scenes of boys on the road, pictures of girls in box cars kept pushing into my mind to cry against facts I had tabulated so carefully and arranged on such neat graphs. . . . To describe their life in statistical terms was not only inadequate, it was untrue." Despite his profession of scientist, Minehan refused to accept people he had known as "so many cases to be analyzed, so many sticks to be counted and arranged in sequential order. They were boys and girls, flesh-and-blood youngsters," and it was in this form—as humans, not as numbers—that he had to try to communicate them.[4]

The techniques used in thirties social science writing to convey flesh-and-blood reality were those we noted before: the case-study method, the participant-observer report, and the informant narrative. These techniques were not mutually exclusive: all could be used in any study to give what the Chicago sociologist Clifford Shaw called "a more concrete and vivid picture" of human experience. Indeed, much of the excellent social science at the time used both the case-study and participant-observer

methods (informant narrative presented some difficulties, as we will see in Chapter 11) and framed or reinforced these with such statistics as were obtainable. Nevertheless, the methods are distinct strategies and will thus be considered.[5]

Case Study

Throughout the thirties, social scientists published reports on unemployment similar to those of social workers. The research for these studies and the case histories they analyzed were usually collected, even as late as Eli Ginzberg's *The Unemployed* (1943), by social workers, not sociologists or psychologists. And many of the studies had the same weaknesses as the social-worker books.[6]

Their chief weakness was not, as Ginzberg thought, the "wealth of unorganized data" that case studies offer a reader; the weakness was redundancy. The studies were not rich, merely repetitious. And the social scientists arranged them that way. "There is an ever-present tendency in [case] studies," Wight Bakke warned, "to describe what is exceptional and striking instead of what is typical." The scientists countered the tendency by using case histories of "representative" people, "common" men, "the normal, happy American family." Of the twelve case studies printed in full in *The Unemployed*, Ginzberg said: "Every effort was made to select representative cases. This explains the absence of extremes"—and also the absence of intellectual interest. To read one case is to have read them all.[7]

When every case history is chosen as typical, the generalizations drawn from them are vapid and obvious. Robert C. Angell's *The Family Encounters the Depression* (1936) was a book of 307 pages, 250 of which were taken up in case studies of 50 families arranged according to their members' mutual "integration" and "adaptability." From this mass of overly coherent evidence, Angell made such summations as the following: "As I think back over the documents dealing with Type I families ["highly integrated, highly adaptable"], a general picture is sketched in my

mind. It is a picture of kindly devoted parents and loving, if sometimes thoughtless, children." Some people, Angell declared, could cope with hardship; some people could not. A 1938 book on the same theme, *The Family and the Depression: A Study of One Hundred Chicago Families,* came to similar "definite conclusions":

> (1) well-organized families met the depression with less catastrophic consequences than families that were already disorganized; (2) families and their members tended to react to the depression in much the same way as they had previously encountered crises; and (3) the period of unadjustment and disorganization characterized by emotional strain which typically was manifest in the early stages of the depression generally was succeeded by a period of adjustment or maladjustment.[8]

A more sophisticated study, Mirra Komarovsky's *The Unemployed Man and His Family* (1940), was based upon case materials of novelistic thoroughness and "symbolic" readings of actuality: to find who wore the pants in a family on relief, an investigator was to note whether the man still had his armchair near the radio or the best lamp. Yet the theory informing this book, too, is intellectually thin. The "first pattern" Komarovsky discerned in 59 case histories was that for some families the man's lack of a job was the *"crystallization of an inferior status";* "in other cases," however, "unemployment has *weakened the authority of a husband over a loving wife."* [9]

In each book using extended case histories, the histories all sounded the same. And that, perhaps, was the point. Redundancy and obviousness were virtues. In a time of trouble, the confirmation of what the audience already knew could be exactly what a social scientist (or any other good citizen) *wanted* to achieve, and the case-study method the perfect means. Ginzberg's *The Unemployed,* a report on "What Unemployment Does to People," interpreted 180 case histories of Irish Catholic, Jewish, and white Protestant families living in New York City, and showed that the unemployed were like everybody else. There

were "no striking differences" between those who found work
and those who failed. "Our families were conspicuous because of
their normal sexual and social behavior." They were not politi-
cally alienated:

> Marx, Freud, and even conservative theorists would have us be-
> lieve that people who suffer serious social and economic re-
> verses will react by political extremism. The facts tell us
> differently. Neither the Communists nor Father Coughlin gained
> a single supporter!

Nor ignorant of current affairs:

> Although many families had no firsthand knowledge of Europe
> and others had only dim recollections of "the other side," their
> appraisal of international developments was no better and no
> worse than most people's.

And as for differences among the religions,

> No important differences could be found in the reactions of
> the Catholic, Jewish, and Protestant groups. . . . Birth control
> alone offered some clear-cut distinctions . . . [and] soon this
> last significant difference will have disappeared.

This is consensus social science. It uses the case-study method
to efface individuality. It selects only "representative cases" so as
to picture a united community—60 Catholic families, 60 Jewish,
60 Protestant. In short, this is both a book of the Depression and
a war book. It begins: "In the fourth year of World War II, dem-
ocratic and fascist countries are both preoccupied with labor
shortages," and goes on to prove, while never announcing its the-
sis, that those who had been without work, being just like other
Americans, could be relied upon to be loyal. "They could accept
defeat for themselves but they could never countenance it for the
United States."

For Ginzberg, as for most social scientists in the thirties, the
plight of the unemployed was what it was for the social workers:
an occasion for sentiment. Those without work had not been per-

manently scarred by their hardships, he argued. But they remained sound thanks to their inner qualities, not because their trial was easy. And "we," the relatively fortunate readers of the book, we failed them: "we lacked knowledge and we lacked courage." Ginzberg predicted that the country, having won victory on the battlefield, would only "win the peace" if we recalled that, as "war involves the entire community," so the fight against unemployment. " 'It is for us the living, rather,' " he said, concluding his interpretation with words heroic and somewhat pertinent, " 'to be dedicated here to the unfinished work which they who fought here have thus far so nobly advanced.' " And he then introduced the case histories of twelve families who had undergone the ordeal by unemployment. These cases he commended to the attention of legislators and administrators, economists, sociologists, psychiatrists, social workers, "even the theologian." But, he continued, "these cases are meat not only for the specialist. After all, they tell the story of a group of urban families well adjusted in years of prosperity, and charges on the state in years of adversity." Ginzberg felt them to be "meat" for anyone of sympathetic heart. And with their tales of sad reversals in fortune, they were indeed like *One Man's Family*.[10]

Those working with case histories face a dilemma. If they gather or simplify cases to prove a point, as the social-worker books did, the cases lose their essence, their individual texture.° If, on the other hand, they collect cases without a definite end in mind and publish them at length, only the most banal theme will unite all the evidence. The best social science writing in the thirties used the case-study method quite differently from the books mentioned so far. Dollard wanted "to view the caste and class structure of Southerntown from the angle of a human being born

° The same thing happens if the cases are *created* to prove a point. Lloyd Warner tried this in "Profiles from Yankee City," a long chapter of fourteen vignettes showing the lives of "typical Yankee City people." These profiles are ludicrously didactic; the characters—none an actual individual, some entirely imaginary—are too convenient for belief. The sketches have thus neither the "reality" of fiction nor, by a long shot, that of life.

in the town," a perspective "possible only in the life history." But his book printed no life histories as such. Instead, having collected a number of histories, he picked from them vivid details that corroborated the pattern of life he found in Southerntown: "Take the cases of two Southerntown Negroes who own land to illustrate," he would say, and then describe a relevant portion of their experience.[11]

Such precision of reference was something new; case-study social science, largely an American invention, had never before been succinct. The first classic of modern American sociology, W. I. Thomas and Florian Znaniecki's *The Polish Peasant in Europe and America* (1918–20), took four volumes, and its length was part of its argument. Thomas and Znaniecki were consciously flouting the European sociological tradition exemplified in the work of Emile Durkheim. Rather than concise generalizations derived from statistical analysis of official records, they sought to understand social experience through the intricacies of particular lives. Whereas Durkheim had counted death certificates, marriage licenses, and the like, they worked with private letters, reminiscences, case histories. Defiantly they insisted these "personal life-records, as complete as possible, constitute the *perfect* type of sociological material," and they published such material far more complete than was needed to support their general remarks. The important school of sociology that evolved from their work at the University of Chicago, the "Chicago school" led by Robert Park, inherited this tendency. The case histories in books like Louis Wirth's *The Ghetto* (1926), John Landesco's *Organized Crime in Chicago* (1929), and Harvey Zorbaugh's *The Gold Coast and the Slum* (1929) run so long they obscure the reason they were introduced. At times they take on such a life of their own that the social scientist resuming his analysis seems an interruption.[12]

The most skillful social science writers of the thirties learned to select from case-study material only instances essential to their

immediate argument. These significant details they often related in the subject's own words. Wight Bakke's *Citizens without Work* (1940) discussed the negative influence of unemployment on personal relations:

> The way in which friendships tend to break up is vividly portrayed by the wife of a rubber worker: "This friend stood up with me when I was married. She was in the habit of bringing palms to me on Palm Sunday. Two years ago she came. At that time she saw that I needed new teeth. We were beginning to feel the depression and I had not gone to the dentist to get my teeth fixed. A year ago she came with her husband, and again she found me without my bridgework. She married a man who is fairly well-to-do, and I felt very much ashamed that I was still without my front teeth. My friend, I think she was ashamed too because this year she did not come to bring me the palm. I waited for her all afternoon. I thought of going to see her, but she lives out in Fair Haven and for such a long trip I would have to stay for a little while, and that would mean taking off my coat and I did not have a suitable dress to put on."

The instance is as important as the theory it supports. But they balance: the one says no more than the other, though their modes of discourse are very different. The truth behind the theory gets presented as it actually was "experienced by an individual . . . in concrete describable situations." The particular event seems not only the warrant but also the source of the generalization.

In this respect Bakke went further than other social scientists of the time. Eli Ginzberg selected "typical" cases to portray normal reactions to unemployment; John Dollard chose symbolic instances to show how social prejudice shaped human behavior. But Bakke actually based his theories on what he learned from individual informants. A tire worker said,

> I'll tell you my reason for steering clear of any radical party. And it's as selfish as hell. But here it is: There's one place where I can belong to a goin' concern. I fought enough losin' battles in my life, and, by God, in politics I'm goin' to play a winner if I

can. A man can be a Democrat or a Republican and be able to get drunk once in a while on election night because he won. But the Socialists—when do you think they're going to have the chance to get drunk?

And though the tire worker was the only subject who expressed the idea, Bakke suspected that the desire to belong to a going concern was "an unspoken but nevertheless important motivation" of the unemployed's political behavior.

Bakke's method and goal were thus the same: "Let the men speak for themselves." When the men speak in his *Citizens without Work* or *The Unemployed Worker* (also 1940), they are not the sentimental and craven types that customarily appear in thirties writing about the jobless. Their general tone is frank and resilient. A woman admits her looks have been damaged by starchy relief food and defies the interviewer not to agree: "Now, you tell me how any man that has red blood in him can think that I'm as attractive as I used to be." Despite a decade of proof to the contrary, each man blames himself for his economic failure, and Bakke hypothesizes that this feeling of responsibility was perhaps "the minimum demanded by self-respect." When a subject starts to get high-minded and piteous, he corrects himself, or his world (or Bakke) does. Bakke quoted from his casebook a scene in which a woman on relief said:

> If you give to the poor you will get reward in heaven, but you must always do it in a spirit of love. One day a poor man came to my door when I had only a dime with which I expected to buy fish for the children's dinner. Believe me dimes these days don't come any too easy, so I was torn between two desires. One was to help the poor man, and I know the teaching of the church is that we should always give alms to the poor. The other was to buy fish for my children because I had been taught that charity always begins at home, and besides it looked to me like it was sensible that charity should begin at home. I finally asked my mother, who advised me to buy fish for the children. . . . So I bought the fish, and never in my life have I eaten such awful fish. If I had given the dime to the poor man it would have been better, and it was a definite warning to me.

But the exchange was not over, and Bakke continued: "Immediately, however, her mother spoke up and said in words, I think, which would be repeated by the majority of individuals in contemporary New Haven: 'The trouble was, Maria, that you didn't pick out good fish.' " [13]

The excellence of thirties social science writing was that it often captured what Bakke did here: the particularity and richness of an ordinary life—the gnawing ideal and the fish gone rotten. In 1940 Paul Lazarsfeld suggested that the wisest use of the case-study method "may lie in the analysis of exceptions to general trends, which should be ascertained by crude statistical procedures." There is a sense, however, in which the case-study method used seriously will always report experience contrary to general trends; experience too real for abstraction; particular experience, whose depths can only be hinted at. [14]

Participant Observation

In 1931 Wight Bakke, then a graduate student in economics, traveled to England to study the effect of unemployment insurance on workers' willingness to work. He immediately found the research he planned could not be done. There were no "objective data," no "statistics," for him to analyze. He was forced to use documentary devices. He interviewed the jobless, spoke with social workers, collected case histories, paid several unemployed men to keep "a diary-time-study" of their activities. Primarily, though, he learned how the British unemployment insurance operated "from the point of view of the ones most concerned with its operation, the workers," by all but becoming one. Abandoning the traditional research methods of economics, he turned anthropologist and dwelled among the subjects of his study. His resolution "to take lodging with a working-class family, to share their life insofar as it was possible to do so, to join in their activities or loaf on the streets or at factory gates as the occasion might require" had a timid tone (the idea wasn't his; the British Minister

of Labour had suggested it). But Bakke carried it out, and his study, like most social science research at the time, grew from "observation of . . . life circumstances . . . made while living among them." [15]

During the twenties the sociology department at the University of Chicago had pioneered the use of the participant-observer method. Robert Park advised students to live among the people they were studying and record "only what you see, hear, and know" at firsthand, as he had while a newspaper reporter, his original career. When Nels Anderson enrolled for an M.A. in the early twenties, the Chicago faculty deemed it a distinct asset that he had been a migratory worker and a tramp; he was sent out to analyze the milieu he came from, which he did in *The Hobo: The Sociology of the Homeless Man* (1923). It was standard procedure at Chicago for Paul Cressey, a social worker turned sociologist, to plan to study the taxi-dance hall in 1925 by collecting case histories of typical taxi-dancers, patrons, and proprietors. When these subjects refused to be interviewed, it was equally standard for him to send his fellow students into the dance halls "to become as much a part of this social world as ethically possible" and report back what they found. The Chicago sociologists saw two advantages in the participant approach. First, it enabled the researcher to get at information he might otherwise have missed. Second, it gave the reader a sharper taste of the phenomena studied. Ernest Burgess commended Cressey's *Taxi-Dance Hall* (1932) because it put the reader "vicariously . . . in the place of the taxi-dancer or her patron, participating, as it were, in their experiences, and getting some appreciation of their outlook and philosophy of life." By the late twenties, participant observation had such cachet that the Lynds claimed their research for *Middletown* (1929), a book quantitative and historical in its methods, had resulted primarily from "participation in the local life" of the city.[16]

The participant method dominated social science research in the thirties. It was during this decade that America's anthropolo-

gists first turned the method upon the natives at home. Lloyd Warner undertook the Yankee City project specifically to study a modern community with techniques he had employed among the stone-age aborigines of Australia. He believed that "information is always gathered in the context of reciprocal interaction"; thus he and his co-workers learned by taking part in the society. In Newburyport they did not have to go hunting or build their own huts. Rather, "fieldmen were put into factories to observe the behavior and relationships there," and were lodged in workers' houses to the same end. The researchers themselves disarmed suspicion by appearing to be what the locals thought they were. Thus to the older inhabitants, they were historians or genealogists; to the industrialists, they were social economists; "to the members of the various ethnic groups we were fair-minded gentlemen"; and "to those who saw us at entertainments and parties, . . . we were young men having a good time, not too intent on our work." In such gatherings, Warner added, "we were able to obtain some of our most valuable information"—being unattached Harvard men and very willing to mix.[17]

The most important studies of the Negro in Southern life, Dollard's *Caste and Class in a Southern Town* and Allison Davis' *Deep South* (1941), grew from similar involvement in a locality. To research the latter book, "a white fieldworker and his wife, and a Negro fieldworker and his wife lived in the society for a little over one and one-half years." So thoroughly did they conform to the society's behavior codes that after six months "they appeared to be accepted as full-fledged members of their caste and class groups, and dropped their initial roles of researchers." Hence their observation was done "in the actual societal context, in situations where they participated as members of the community." Davis and his colleagues were anthropologists and consequently trained in the participant method. Dollard, a psychologist, came by it of necessity. He had originally planned to gather life histories for a book on the personality of Southern Negroes. He soon realized, however, that to understand the Negro he

needed a larger context, one that included the white. "I was compelled to study the community," he said, "for the individual life is rooted in it." His "basic method" of research became "participation in the social life of Southerntown." He didn't question, much less interview his neighbors; rather, he "settled into the life of the community and was variously defined as a boarder, a friend, a buyer of gasoline, a person with hay fever." [18]

Dollard and Davis found it useful to play down their research role and blend into the community. They did not, however, actually mislead people about themselves or their objectives. Some researchers did. Wight Bakke, for example, often assumed roles to draw out his informants; he got the unemployed to air their feelings about radicals by pretending to be a militant Communist, a fellow traveler, an angry jobless man, and a naïf looking for the party office. [19]

The social scientist most extreme in his role-playing and participation was no doubt Thomas Minehan, who spent two years in boxcars and hobo jungles collecting information for *Boy and Girl Tramps of America* (1934). A Ph.D. candidate in sociology at the University of Minnesota, Minehan wanted to learn "what the man who is down and out thinks of us and our civilization." But he found that when he questioned such men on the street or at a relief station, they tried to anticipate his ideas and please him into giving a handout. Deferential, they pleaded and wheedled in "the whine of the panhandler." He soon decided that he could not learn "the inner mind of the man on the bread line" as a middle-class investigator in a good suit talking to "social cases." So he disguised himself in old clothes, pinned money in his underwear, and went on the bum.

Living as a vagrant among vagrants, Minehan said he "ascertained opinions and attitudes not to be ascertained by other methods." The runaways, work-seekers, tramps, and beggars leveled with him as they had not when he was their social superior. He found their talk was different—quieter, more sullen, without a whine. He found, too, what their deference had been: a ruse.

"If [a woman] asks you in the house to eat," counseled Fred, who had been asked in often, "always wipe your feet on the stoop; don't say much at first. Take off your hat and act scared, kind of. Wait until you've finished eating and she is sitting down and looking at you. Then she asks you something and you answer polite-like. If she is a fat woman and sitting down you can tell her anything. Pretty soon she will be bawling and you can have the house."

The best pages in the book concern the training of a panhandler —the contrivances for arousing pity, the precepts of an unimagined profession:

Ask for just a little.
Scare them a little.
If the line is full of woman's clothes she is a poor cook and you better ask for a dime.
Bulldogs can't run. They have no wind.

It may be true, as Minehan said, that he could gain this knowledge no other way. A comprehensive study of the derelict, *Twenty Thousand Homeless Men* (1936), was prepared from life histories gathered in Chicago's relief shelters by sociologists using direct interviews. The study gives "verbatim reports" from the histories, and each has a plaintive tone. According to what they told the sociologists, the sheltermen were totally helpless and pitiable. They weren't brassy craftsmen like Minehan's beggars; none boasted how well he got by at the bottom of the world. The social workers heard what the down and out tell their betters; Minehan heard what they tell one of their own, a new tramp whom they want to both help along and put in his place. Minehan could give another perspective on hobo life because he was a man who had been there: "I saw and experienced it." [20]

He had been there, but despite his training he understood the experience little better than "the child tramps" themselves. Like many participant-observers of the time, he empathized so thoroughly with the group he reported on that he shared even their illusions. They thought themselves romantic outcasts; to join

their number he put on the "disguise" of "another homeless wanderer." They pitied themselves: on a wet winter night a group was jailed for vagrancy and ate a cold wretched meal.

> "And now," remarks Texas, hardened young road kid of fifteen, "after our nice warm supper we'll crawl into a nice warm bed."
> "Why," asks Bill, "do they always have to have sour bread in jails?"
> "Why do they have to have jails?"
> "Or sheriffs."
> "Or hard times."
> "Or bums."
> "God! I don't believe that anybody knows what it is all about."
> "We come and we go," says an old man. "Where the hell we come from or why and where the hell we are going nobody cares and nobody knows."
> The discussion becomes philosophically pessimistic. We sit upon the floor and tell sad stories of the death of dreams.

As they pitied themselves, so Minehan pitied and sentimentalized them:

> I know Fred's story. So do all of us. Home might have been happy for Fred, playing with a younger sister, eating Mother's cookies, attending the circus with Father. But Father died and Mother followed six months later, and this morning as spring creeps over the frost-ribbed hills, Fred is a bum, welcome nowhere, pushed out of one city and into another. . . . Still in his tired eyes shines something of the eternally unconquered Teuton, and the habits of cleanliness his mother taught him keep him neat and tidy on the road, the qualities of courage and honor his father inculcated keep him straight in the midst of a life of shame and dishonor.

The strength of Minehan's work was also its weakness: he participated too much; he saw the young tramps merely as they wanted to be seen. He romanticized them, glamorized their camaraderie, hardship, and free living, certified their doom. In picturing them thus, he wasn't only guided by firsthand experience. The shrewdest review of *Boy and Girl Tramps of America* suggested that Minehan had written the book "with one eye on the

boy and girl tramps and the other on Hollywood." Warner Brothers' sentimental protest film *Wild Boys of the Road*, starring Frankie Darro, had been a surprise hit of 1933 and plainly influenced Minehan's revision of his dissertation for a general audience (it influenced also, needless to say, the fact the book got published).° Hollywood's stereotype of the young tramp as victim, pariah, and value-bearer of a negligent society was of course just what the youngsters wished to believe, and the convention Minehan exploited. In *Boy and Girl Tramps of America*, as in Eli Ginzberg's *The Unemployed*, it is hard to distinguish social science that panders to the sentimentality of its subjects from the fictions of mass culture—movies and soap operas.[21]

Even so excellent a study as William F. Whyte's *Street Corner Society* (1943) was marked by an excess of participation. In 1936 Whyte, an upper-middle-class nondegree student at Harvard, decided to analyze the social structure of an Italian slum in Boston. An economics major, he discovered gradually, and much to his dismay, that statistics were no help at all; the only way to gain the "intimate knowledge of local life" he needed was "to live in Cornerville and participate in the activities of its people." He took a room with an Italian family and began to hang around with "corner boys" at the settlement house and pool hall.

Whyte had to achieve very close relationship with a few people in Cornerville and be tolerated by the rest; accordingly, he did two somewhat contradictory things. First, he always told the truth about why he was there—indeed, explained in detail to community leaders who would listen. Second, he never seemed to care about his project, never worked or worried about it in public. He carefully asked no questions. Weeks at a time he spent with Doc's gang, the Nortons, apparently doing nothing but what they did, playing cards, bowling, swapping jokes and insults. He made himself, as Doc remarked, "just as much of a

° *Wild Boys of the Road* had been prompted in turn by the success of *Road to Life*, a 1931 Soviet film about the *bezprizorni* or "wild children" who roamed Russia after the 1917 revolution.

fixture around this street corner as that lamppost"—and just as inoffensive.

As an acknowledged outsider, Whyte could take part in the Nortons' activities without prejudicing them: when he won a bowling match, all the gang members warmly kidded him because no member's status was jeopardized. As an outsider, he could be disciplined and educated like a child and yet, simultaneously, be appealed to as a fortunate spectator who might enjoy a situation by reason of his distance from it. Once Doc announced to him wearily: "I'm batted out. I'm so batted out that I didn't have a nickle to put on the number today. When a Cornerville fellow doesn't have the money to put on a number, then you know he's really batted out. Put that in your book."

But while Whyte's closeness to the corner boys enabled him to picture their lives with a novelistic thoroughness, it also biased his views toward their society. He strongly endorsed the Nortons' contempt for the "college boys" of Cornerville, for non-Italian teachers and social workers, for the settlement house and police and politicians. When an especially prissy social worker disparaged the Nortons, Whyte, in an aside to the reader, quickly took their part: "The 'roughnecks' to whom Mr. Ramsay referred were the corner boys. Whatever one might say about them, they were the people." And Whyte's loyalty was less to his study than to them.[22]

The participant-observer approach brought thirties social scientists into close relation with what they studied, and enabled them to convey its felt life. Less positively, the method lent itself to the engagé emotionalism characteristic of writing at the time. Social scientists now consider most research of the period sensational and lacking objectivity; these faults were in large measure the result of the participant method—of too much involvement with the subject.

Documentary
Reportage:
Radical

In early 1932 Mauritz Hallgren, correspondent for *The Nation,*
traveled from city to city, writing a series of seven articles under
the title "Unemployment in the United States: How Many Hun-
gry." He began the Pittsburgh report:

> Arturo Avanti, which is not his real name, lives in a shack on a
> dreary, dirty, all-but-forgotten alley in Hays Station, Pennsyl-
> vania. We went to see Avanti, among others, to learn what the
> steel companies are doing for their employees in these difficult
> times. It is the proud boast of the companies that none of their
> workers are suffering; all the men still on the pay roll, though
> there is no work for them to do, are being helped.

How much helped, Hallgren wanted to know. He found, how-
ever, that

> the companies will not discuss their welfare work for publica-
> tion; they will not say how much they are spending, or give out
> details of any kind. Hence, it was necessary to go to the workers
> themselves to find out just what this company relief amounts to.

The case of Arturo Avanti told him. Avanti had worked for the
Carnegie Steel Company for twelve years; he had five small chil-

dren and his wife was pregnant. He went to the mill each morning, and many afternoons and evenings, but worked only one day in seven, for which he earned $3.60. On such a wage his family would starve. "But," said Hallgren coolly, "the company has been helping." In the three months since Christmas it had provided the Avantis with $7.00 worth of groceries. The week before Hallgren's visit, the company sent Avanti a letter warning that his membership in the company union would lapse unless he immediately paid up his dues, which had been raised from $1.00 to $1.25 a month. Avanti couldn't pay—he hadn't money enough to give his children milk—and so "his name was struck from the rolls. Thus does one steel company help its employees." To live up to its boast that none of its workers were suffering, it kicked the sufferers off the payroll.

Hallgren's example didn't strain for pathos or indignation: its few details were vague. He said the condition of the Avantis and their house "testified most convincingly to the inadequacy" of the company's help, but didn't detail the conditions. Nonetheless, this is documentary reportage. Like all documentary, it describes the lives of specific individuals who represent a group of common people generally overlooked in the society. Like all documentary of the early thirties, it used a specific case to sabotage the general claims, the proud boasts, of those in power. For like most practitioners of documentary reportage at the time, Hallgren believed that the American socioeconomic system demanded fundamental revision; he was a Marxist, "a spokesman for the advanced radicals," as *The Saturday Review of Literature* called him.[1]

Hallgren's two paragraphs on the Avantis use every technique of documentary reportage. There is direct quotation—and from a document: the union's letter warning Avanti that he would be dropped from the rolls. There is a case history of an actual person. And the entire report derives from firsthand observation by the author, who went to see Avanti, and whose impressions and feelings, though expressed with restraint, are to guide the reader's own.

Exposé Quotation

When the Homestead Steel Works Employees Insurance and Safety Association wrote Avanti, the letter told him to pay his dues and made clear the consequence of not paying. But when Hallgren quoted the letter in his article, its meaning wholly changed. Now it demonstrated the cynical way one steel company "helped" its workers. This is exposé quotation, the documentary technique of quoting verbatim a public figure or authority to suggest something other than what the authority intended.

Such a strategy is as old as reporting. Among its masters in America was Lincoln Steffens; its most frequent practitioner today is I. F. Stone, who uses "the overlooked or understressed statements of public figures" to reveal their unacknowledged ends. The technique appears often in thirties reportage, and notably in John Spivak's exposés. The most influential of these turned on the presentation of documents in new and damning contexts. Spivak's book on the Southern chain gangs juxtaposed photostats of Georgia convict punishment records, kept to prevent unauthorized punishment, with convict death certificates, and pointed out the remarkable correlation between prisoners who talked back and prisoners who a short while later succumbed to "heart failure," "sunstroke," and the like. He proved that the evidence on which Grover Whalen, New York's Police Commissioner, accused a Soviet trade agency of subversion had been forged. He showed that a congressional committee had expunged from its record testimony implicating prominent financiers and politicians in a conspiracy to overthrow the government of the United States. And he brought to light documentary evidence, all in the public domain, of Father Coughlin's illegal money manipulations.[2]

Spivak's use of exposé quotation is elegantly shown in "Shady Business in the Red Cross," a 1934 *American Mercury* article. He begins in lawyerly fashion by drawing up "twenty charges against the Red Cross" based on "evidence" he has found. One of

the charges accuses the Red Cross of being "neither neutral nor non-combatant, as the Treaty of Geneva, signed by the United States, requires." He then submits evidence: passages from the congressional charter incorporating the American Red Cross; from the government regulations which made "the Red Cross Nursing Service the reserve of the Army Nurse Corps"; from Red Cross reports, financial statements, fund-raising propaganda. Already the reader sees inconsistencies in the Red Cross' purpose and methods. Spivak raises them in an interview with Judge John Barton Payne, head of the American Red Cross, and gives Payne's answers.

> "Does the Red Cross consider itself an organization of non-combatants?"
> "Oh yes!" he exclaimed. "Exclusively so." . . .
> "But doesn't the oath that a nurse has to sign place him or her in the combatant class and thus establish them definitely as military combatants?"
> "Oath!" he exclaimed. "I know of no such oath. Where did you see such an oath?"

In the Red Cross' "Official Instructions to Nurses," which Spivak had quoted. "Nurses are expected to respond in the event of war," the instructions said. Pursuant to an agreement between the Red Cross and the Secretary of War, "when called upon for military service, they will be required to take the Oath of Allegiance specified in military regulations." Spivak had even quoted the oath. "Well, that's a government oath," said Payne; "Under the Treaty of Geneva they are definitely non-combatants." Spivak pointed out that their military service was contrary to a treaty which the American Red Cross was required by Congress to uphold. Payne replied,

> "If there's a difference between our national requirements and the Treaty of Geneva, why, we'd have to be governed by circumstances."
> "Which means that humanity would become a scrap of paper?"
> Judge Payne did not answer.[3]

Exposé quotation turns a subject's most calculated utterance, his public statements, against him. It shows his ideals so compromised in practice as to be but scraps of paper. It is a highly persuasive technique because it is based upon the logical contradictions in evidence made available to all inquirers: Father Coughlin denounced those who played the stock market, yet brokers' records showed several of his corporations doing just that— and with money contributed him for the needy. Because its appeal is intellectual, a reporter using the technique can afford to be dispassionate, even nonchalant, in exposing corruption and folly. In the thirties, however, exposé quotation was usually accompanied by other more fiery documentary devices.

Case Study

Erskine Caldwell, writing for the New York *Post* in 1935, said: "It is not difficult to cite cases that are representative of conditions in tenant-farmer communities from Georgia to Arkansas." He then recounted one such case. Near Keysville, Georgia, six adults and nine children lived in a two-room cabin. There had been no food in the house for three days when one of the men appeared with a pound of salted hogside and two pounds of corn meal.

> A six-year-old boy licked the paper bag the meat had been brought in. His legs were scarcely any larger than a medium sized dog's leg and his belly was as large as that of a 130-pound woman's. Suffering from rickets and anemia, his legs were unable to carry him for more than a dozen steps at a time; suffering from malnutrition, his belly was swollen several times its normal size. His face was bony and white. He was starving to death.
>
> In the other room of the house, without chairs, beds, or tables, a woman lay rolled up in some quilts trying to sleep. On the floor before an open fire lay two babies, neither a year old, sucking the dry teats of a mongrel bitch. A young girl, somewhere between fifteen and twenty, squatted on the corner of the hearth trying to keep warm.

> The dog got up and crawled to the hearth. She sat on her
> haunches before the blazing pine-knots, shivering and whining.
> After a while the girl spoke to the dog and the animal slunk
> away from the warmth of the fire and lay again beside the two
> babies. The infants cuddled against the warmth of the dog's
> flanks, searching tearfully for the dry teats.

The case continued in this vein for 1800 words.[4]

We have already noted that the case-study method, in docu-
menting individual hardship, encouraged emotionalism. The rad-
ical reporters who used the technique in the early thirties took
full advantage of this fact. Their reporting went into piteous and
lurid detail about the lives of the poor, trying to influence the
reader's politics through his feelings. John Spivak's highly praised
"Letter to the President" (1934) told of a pregnant fifteen-year-
old Mexican girl working in a California cotton field for thirty-
five cents a day and sleeping in an outhouse; it dwelt upon the
poignancy of her fondest wish: that President Roosevelt turn on
the outhouse light because she feared giving birth in the dark. Meri-
del LeSueur reported in *New Masses* how one jobless woman
waiting month after month in a Minneapolis employment bureau
went mad with fear, hunger, and boredom, and how another, her
savings gone, sold her body for fifty cents.[5]

Even the most restrained case-study reporting of the early thir-
ties, Edmund Wilson's in *The New Republic,* was sentimental.
The case that excited his keenest powers of description was one
"John Dravic," a Yugoslav immigrant and unemployed machinist
who lived with his wife and three young sons just across the river
from Manhattan. Wilson caught brilliantly the industrial rawness
of the Dravics' community—the little houses wedged among the
factories, "the finest country weather . . . made gassy and tar-
nished with smoke"—and yet also its tangible small life:

> gardens with some white flowers as well as green vegetables; a
> corner saloon with billiard tables and Polish newspapers; stores
> with Italian names and cheerful objects in the windows: vases
> of pink and yellow flowers and a stuffed eagle spreading its

wings; a little backyard apple orchard with whitewashed trunks and branches all in white bloom; and a small slimy and greenish but perceptibly alive stream, the rusty grate of an iron bedstead sticking out of it and a baby-carriage tire on the bottom.

With great care Wilson portrayed John Dravic's character. Though he spent every day walking about Manhattan looking for work, Dravic didn't neglect his duties at home. In the spring of 1931, when he had been without a job for five months, he planted a vegetable garden and tended his flowers. He was cordial to the boarder in his house, an Italian woman on relief. He continued to teach his two older boys music. "He loved music and had two violins, a 'cello and a guitar. One of the boys learned the violin and the other the 'cello, and they would play trios almost every evening. Sometimes they would get other people in and have an amateur orchestra." But Dravic was a desperate man, too, and Wilson made credible his sudden borrowing of $300 and buying a cigar and candy store with "slovenly looking signs which said 'Soft Drinks' and 'Cigars' scrawled up in watery white paint on the insides of the windows." The store was a failure from the start, but Dravic went to it diligently for weeks and waited all day for customers.

There was a social message in Dravic's case, Wilson believed, yet even this propaganda ("the contemporary line of Marxism," as Wilson later called it) was unobtrusively handled. The Dravics

> didn't know anybody well, because they had only been in Buchanan six years, and in a community of mixed Germans, Poles, Hungarians, Italians and Jews it takes longer than that to make friends—that's one reason they don't get together to organize.

The Dravics'

> oldest boy went to high school and was bright. He made a dollar by writing for the interscholastic *World News* a digest of an article in *Popular Science* called "Is New Russia, Built by Americans, a World Menace?" which told about the American engineers in Russia and what the Russian government was doing for the workers.

Wilson didn't bother to point out, as a *New Masses* writer would, that there was no unemployment in the Soviet Union. He didn't need to: his readers knew the argument as well as he.

Early in the morning of May first, John Dravic killed his sons and himself with a pistol. And Wilson's effort to dignify the Dravics' lives was undone in their dying. He reported one fitting gesture: when Mrs. Dravic and the Italian boarder "found John Dravic on the floor of the boys' bedroom, he was reaching with his hands and straining with the upper part of his body as if he were trying to grab something to get up by"—just as he had been doing throughout his unemployment. But Wilson wrung the boys' deaths for all the emotion he could. He said that Dravic had, as every night, taken the youngest from his crib to the bathroom and then "put him into bed with the other two boys. He had evidently pulled the covers over them before he killed them." He was such a kind and dutiful man, Wilson implied, that he tucked them in before he shot them. Wilson ended the report thus:

> They were all dead by six o'clock in the morning, and poor Mrs. Dravic, who the day before had had a family that played trios in the evenings, had nothing left but four corpses for whom the cheap undertaker had done his best to patch up heads blown out with point-blank pistol shots. The only comfort was that the baby looked pretty good.

Wilson cared deeply about the Dravics, but he cared more about moving his audience. Thus he would pretend to agree with "poor Mrs. Dravic" that there was some comfort in the baby's looking pretty good. He would exploit the Dravics, make piteous dumb things of them, to stir the reader's feelings. If it would help his cause, Wilson could be as cynical as the agitprop sloganeers. It is testimony to the desperation of the time.[6]

Participant Observer

Far the most common sort of documentary reportage in the thirties used vicarious persuasion: the writer partook of the events he

reported and bared his feelings and attitudes to influence the reader's own. As we have seen, this reporting technique responded to the appetite of the people of the time for lived, firsthand experience, and to their particular trust in the truth—the nonfalsifiability—of such experience. When *America Faces the Barricades,* John Spivak's radical "report on the state of the Union," appeared in 1935, R. L. Duffus, a *New York Times* editor, reviewed it on the front page of the Sunday book section. Though their politics differed, Duffus thought Spivak convincing in his descriptions and "natively fair-minded and realistic." There was "no easy way of testing the accuracy of his reporting," Duffus conceded, because Spivak had all his information firsthand, as the reader could not; Duffus felt, however, that this only strengthened Spivak's case: "Maybe the picture is overdrawn, but those who have not been where Mr. Spivak went have no right to be too positive." Had they been there, they might draw the picture the same way.[7]

The way Spivak drew pictures, the technique of participant reporting, was the vehicle of the thirties' most dramatic, most remembered journalism. John Dos Passos at Anacostia Flats with—literally and emotionally—the Bonus Marchers:

> "Home, boys, it's home we want to be," we sang in all the demobilization camps. This was God's country. And we ran for the train with the flags waving and a new army outfit on and our discharge papers and the crisp bills of our last pay in our pockets. . . . And now look at us. A bunch of outofwork ex-service men . . . getting on into middle life, sunken eyes, hollow cheeks off breadlines, palelooking knotted hands of men who've worked hard with them, and then for a long time have not worked. . . . The [debt] moratorium was a bonus to European nations, the R.F.C. was handing out bonuses to railroads and banks, how about the men who'd made the world safe for democracy getting their bonus, too? God knows we're the guys who need it most.

Malcolm Cowley with the Marchers on the Johnstown, Pennsylvania, road after the U.S. Army routed them from Washington:

The road curled downward into the valley where Johnstown
sweltered between steep hills. On either side of us were fields of
golden grain, cut and stacked for threshers. . . . It was a land-
scape not unlike the high hills north of the River Aisne. In that
other country, fifteen years before, I had seen gaunt men com-
ing out of the trenches half-dead with fatigue, bending under
the weight of their equipment. The men on the Johnstown road
that day were older, shabbier, but somehow more impressive:
they were volunteers, fighting a war of their own. "And don't
forget it, Buddy," one of them shouted, "we've enlisted for the
duration."

Josephine Herbst, Mary Heaton Vorse, Meridel LeSueur describ-
ing the agonies of strikers, radicals, the unemployed, the Mid-
west farmer in drought years in a land "stripped with exploita-
tion and terror":

Decoration day . . . was so hot you couldn't sit around looking
at the panting cattle and counting their ribs and listening to
that low cry that is an awful asking. We got in the car and
drove through the sizzling countryside. . . .
 We stop and talk to a farmer. His eyes are bloodshot. I can
hardly see from the heat and the terrible emotion. . . . We both
know that the farmer across the river shot twenty-two of his cat-
tle yesterday, and then shot himself. I look at him and I can see
his clavicle and I know that his ribs are rising out of his skin.
. . . When I shut my eyes the flesh burns the balls, and all I can
see is ribs—the bones showing through.

The reporters of Loyalist sympathy in the Spanish Civil War: Er-
nest Hemingway, Robert Capa, Joseph North, H. V. Kaltenborn,
Martha Gellhorn, Josephine Herbst, Lillian Hellman, Dorothy
Parker, Vincent Sheean—and the *New York Times* correspondent
Herbert Matthews:

AIR RAIDERS KILL
1,000 IN BARCELONA,
TERRORIZING CITY

Barcelona, March 17 [1938]—Barcelona has lived through
twelve air raids in less than twenty-four hours, and the city is
shaken and terror-struck. Human beings have seldom had to suf-

fer as these people are suffering under General Francisco Franco's determined effort to break their spirit and induce their government to yield.

I have just come back from the principal morgue, which is at the Clinical Hospital, and there I counted 328 dead lying side by side. Those were more or less whole bodies. Then there are the others in hospitals and, above all, those who lie in the ruins of dozens of buildings and whose bodies never will be recovered.

So no one will ever be able to say how many died in these bombings, certainly no fewer than 1,000, perhaps many more. . . .

One feels helpless trying to convey the horror of all this in cold print, which people read and throw away. One comes back from the scenes dazed: men, women, and children buried alive, screaming in the wreckage of their houses like trapped animals. I have never seen so many weeping women. . . .

There is terror in the air—terror that freezes the blood and makes one either hysterical or on the verge of hysteria, for everyone knows the planes are coming back.[8]

Matthews himself was not unmoved. The vicarious method tends, as we have remarked, to exaggerate the narrator's emotions, sometimes to the point of hysteria. Matthews kept his feelings within bounds, was careful to take "what humor one can out of this tragedy; otherwise it would be hard to remain sane." But thirties documentary journalism is full of reporters who surrendered completely to emotion, or who pretended to. Barrie Stavis reported the bombing of Barcelona for *New Masses*:

At twelve noon—you could set your watch by it—the first bomb hit. . . . I race to the spot—already police lines are established—I show my card—I'm passed through the lines. . . . I'm in the way—I stand to one side—I step on something slippery—it gives way, soft and spongy—I look down at the thigh of a man—just the thigh—nothing else—and my weight has made it ooze—my knee caps dance up and down doing a mad jig—I look around to lean against something—I pass a tree blown away at its root and lean against another—something on my sleeve dropping soft, like rain—I look up—caught in a branch a woman's arm dangling, her fingers still clutching her purse—another man sees it—together we shake the tree and the arm comes slithering down, landing at my feet —the purse caught in a branch swings back and forth in a slow

arc—and blanket spread on the ground—in it a piece of a woman, a breast and a leg—the man shovels the woman's arm into the blanket and drags the whole business to the lorry for pieces.

In this rhetoric the narrator as person disappears: there is no thinking; there are sense impressions and gestures—showing the press card, shaking the tree—without acknowledged motive. The "I" is a camera that mindlessly records the event, an animal that mindlessly—"my knee caps dance up and down"—feels it.[9]

The narrator here is subject to his emotion in a way that seems contrived, self-indulgent. Oddly, were the report not *written*, were it spoken "direct" via radio remote, the emotions might not be so excessive. Herbert Morrison's description of the Hindenburg disaster in May 1937, usually called the greatest eyewitness report in broadcasting, was much like Stavis' article, a string of sentence fragments in a tone of horror and distress. But Morrison, though he made claims more extreme than Stavis ("Oh my, this is the worst catastrophe in the world!"), was thoroughly convincing. He went to pieces right before the listener, sobbing, sputtering ("the people! All the humanity!"), fighting to control himself; and the listener could not fail to recognize the honesty of his feelings.[°][10]

In print reportage, an indirect medium, such extreme emotion is less plausible. A writer, by the fact of writing, has moved from the immediacy of his experience; his rhetoric should acknowledge as much. To be trustworthy a print reporter needs to have more control of himself and the topic; be able, however obliquely, to see the experience as the reader must—from the outside. The absence of such control suggests to a reader that the

° Morrison's normal broadcast delivery contributed to his breakdown. He imitated the style of near hysteria popularized by Gabriel Heatter in his remotes from the Lindbergh baby kidnapping trial. When confronted with something that actually moved him, something that demanded cool and unprecedented description, Morrison tried to stick to his usual delivery, failed for lack of breath, and began sobbing.

writer either has been demented by his experience or is indulging his emotions to try to move the audience. The lead article in *Partisan Review* for September-October 1934 was Tillie Lerner's "The Strike," about the bloody general strike in San Francisco that July. The article began:

> Do not ask me to write of the strike and the terror. I am on a battlefield, and the increasing stench and smoke sting the eyes so it is impossible to turn them back into the past. You leave me only this night to drop the bloody garment of Todays, to cleave through the gigantic events that have crashed one upon the other, to the first beginning. If I could go away for a while, if there were time and quiet, perhaps I could do it. All that has happened might resolve into order and sequence, fall into neat patterns of words. I could stumble back into the past and slowly, painfully rear the structure in all its towering magnificence, so that the beauty and heroism, the terror and significance of those days, would enter your heart and sear it forever with the vision.

Rather than undertake her topic, Lerner tried to show how deeply it affected her; rather than describe the experience of the strike, she spent 3000 words savoring it. Her object, plainly, wasn't to inform others' opinions but to move those of her opinion. Like most radical reportage in the thirties, "The Strike" didn't try to stir the belief of the uncommitted so much as stir the true believer.[11]

John Spivak's participant reporting had quite the opposite goal. He used firsthand documentation to try to make the radical arguments of the time credible to nonradicals. And he frequently succeeded; moderates like R. L. Duffus and the social worker John Fitch thought him "a reporter who does not let his prejudices blur his insight." Spivak's method of persuasion had two parts, either of which would have been ineffective alone.[12]

First, he let other people voice his "prejudices" while he played the aggressive but unbiased truth-seeker. In 1934 he interviewed a young woman tending a battery of spindles in a North Carolina cotton mill. She confirmed what radicals then believed: the New Deal was beneficial only to big business.

"How're things?" I asked. She was too busy to stop and I walked alongside.

"All right," she said, swiftly. Her eyes followed the turning spindles.

"Better since the NRA?"

"Yeah."

"How much do you make?"

"Twelve-fifty."

"How many hours?"

"Eight. We used to work twelve."

"Less hours and more pay, eh? NRA do that?"

"Yeah. But we got doubled-up."

"What's that?"

"Doubled-up. Stretched-out. We got to do twice as much work as we used to. Got to work faster, too. So it's all the same as before. We get exactly what we got before."

"How much was that?"

"Six dollars a week. Now we work twice as much so we get twelve dollars. No difference."

"But you have four hours extra a day, haven't you?"

"Yeah. But what good's that? I'm too tired to go out when I get through."

Everywhere, throughout the country, I heard the same cry from the workers: the speed-up, the killing speed-up which is exhausting their bodies, sending them home sodden and spent, with just energy to eat and rest for the next day's grind.

One can try to refute Spivak's generalization, but there is no refuting the girl at the spindles. Like all documentary evidence, her testimony is unarguable: that is how she feels, too tired to do anything. In reply, the best one can do is to say, as Frances Perkins did in a 1934 book defending New Deal labor policy, that other mill girls felt differently:

A cotton mill worker, a "winder," in North Carolina says: "I think the NRA is a great thing. It has put more money in my pay and the short hours has made a new person out of me, as when I used to work 11 hours I could not feel like going anywhere to have a good time. Now I have plenty of time for rest before play. I hope there will always be an NRA." [13]

Spivak let other people voice his prejudices—and then did one thing more. If the speakers had radical sympathies, as they

usually did, he hastened to add that such opinions were not in the majority—not yet. After quoting the mill girl and generalizing about the workers' opposition to the NRA-promoted speedup, he continued:

> Despite what the "New Deal" has really done to the workers, so great is the popularity of President Roosevelt, so great is the faith of the worker in his promises, that in the face of wage cuts and the government's successful efforts to settle strikes in favor of the employer while telling the workers what marvelous gains they have made, most of our people still believe that these conditions are only temporary and that before long things will get better for them.

Spivak said most workers still believed in the New Deal, yet every worker he quoted was a revolutionary or on the brink of becoming one; some "had already picked up rifles to get what they thought was rightfully theirs when no one seemed inclined to give it to them." In the last chapter of *America Faces the Barricades,* Spivak summarized his findings:

> By the time this survey was finished I was convinced that if the average American worker were given a fairly decent living wage, the chances are that he would go through life working contentedly, rearing his children, going to the movies, and watching the baseball scores without much caring as to who runs the country or how.

But this America—a land of nonpolitical people living tolerable small lives—he had never mentioned before and did not make a vivid possibility now.[14]

In short, Spivak's method was to document only his prejudices, giving them the power of dramatization at firsthand, and then to generalize from a less biased sample. He brought his points alive but made them more credible to a moderate audience because he had, Duffus said, the "fine intellectual honesty" to admit that the American worker didn't want a revolution. What counted was, of course, that the points were brought alive. If the audience felt them to be real, it would understand why, though Spivak said

"the American worker does not want to overthrow the government," he would say two pages later, "we are in for a period of great unrest . . . which will continue until the present economic system has been completely changed." [15]

Spivak tried to make the views of people he agreed with plausible to those who didn't hold the views. A radical reporter of the time treating people whose views he disagreed with was normally more blunt in his use of the participant method. Most often he simply exposed his opponents' inhumanity, selfishness, and folly at firsthand. A striking instance of this technique is *Where Life Is Better,* James Rorty's record of his seven-month "unsentimental journey" through the U.S. in 1935.° Nearly everything Rorty saw he loathed. A self-proclaimed radical, he especially despised the "cheerio radio optimism" he found everywhere and the "American addiction to make-believe. Not even empty bellies can cure it." He wondered what had happened to his countrymen: "Have we lost all instinct for reality, all aptitude for simple human relationships?"

While driving through Ohio, Rorty picked up a dapper hitchhiker. This young man, whom Rorty calls "Yowzir" after his hearty way of saying "yes, sir," was the son of lower-middle-class parents who at great sacrifice had put him through high school and college. Rather than the doctor or lawyer his family hoped he would become, Yowzir was a salesman and traveled from city to city selling block subscriptions to Macfadden publications. On learning this, Rorty tried to be magnanimous:

> I did not wish to think badly of Yowzir. After all, he had been to college. Maybe this profession of his was just a survival expedient, like stealing fruit or picking up coal along the tracks. Did he like the McGladden publications, I asked? Did he read them?

° The phrase "where life is better" was sarcastic. Rorty had coined it in earnest as the title of a "boost" pamphlet he wrote in the mid-twenties while an advertising man. Nearly a million copies of the pamphlet, "California, Where Life Is Better," were distributed, and during the Depression the slogan "Come to California where life is better" brought hordes of the unemployed.

"Yowzir, I'll tell the world I read them. They're some swell books. Wait a moment!"

Helpless to prevent him, I watched while he opened his suitcase, extracted samples of all the McGladden publications, and presented them to me.

My gorge was steadily rising, but there was still something to be learned from Yowzir, and I hung grimly to my task.

Rorty now inquired what the salesman did for women while on the road. Yowzir's "extraordinarily trivial face assumed an expression of wise and sophisticated virtue." He didn't go to prostitutes, he said. He had found that "if you use your head, you didn't have to pay for it." Rorty was enraged. "The little pimp! . . . He didn't even have the grace to pay for his sexual pleasures. I studied his face, and if there was an atom of decent humanity in it, I was unable to see it." Nevertheless, Rorty asked the man a last question: what did he think of the prospects for business recovery? Yowzir said he had been at ROTC camp and "all the boys" judged that what the country needed was "another first class war"; war would give everybody jobs and take care of labor troubles and the Communists who started them. Hardly had he ceased speaking when Rorty

stopped the car in the middle of a deserted stretch of scrubby pine land.

"Get out!" I said.

He hesitated, and I extracted a monkey wrench from the side pocket of the car.

I left Yowzir standing by the side of the road, his face contorted with bewilderment and indignation. His mouth was open, but he hadn't dared to curse after me.

According to Rorty, not only was Yowzir stupid, indecent, and a warmonger, he was yellow.[16]

In this extraordinary interview Rorty judges himself no less than Yowzir. He too is pompous, adolescent, violent. It is he that has little aptitude for "simple human relationships": he won't accept opinions he has solicited nor honest gifts. His portrait of the salesman is ungenerous, even snide. More important, its tone is

not justified by the facts he reports. His point of view, his partici-
pation, has distorted his understanding of what actually hap-
pened.

A participant observer must intrude upon the reality he de-
scribes, and it may be unavoidable that his participation somewhat
distort the things and people observed. What is remarkable in
the radical reportage of the thirties, however, is the *size* of the
distortion, the discrepancy between the facts and the lessons that
purport to be implicit in them. The largest distortions were of
course practiced against those hostile to the radical cause. When
Edmund Wilson, probably the decade's finest reporter, described
the 1931 confrontation between William Z. Foster, the leader of
the American Communist Party, and Hamilton Fish, chairman of
a House committee investigating Communism, Foster became, as
Benjamin Stolberg noted, a "Communist St. George slaying the
dragon of Hamilton Fish." People not communist, or not prole-
tarian, were, as Wilson pictured them, diminished people. They
were genteel ninnies, like the British tourists whom he accom-
panied to Russia in his *Travels in Two Democracies* (1936); they
were "Mr. and Mrs. X," "The Best People," upper-middle-class
ciphers whose economic role entirely defined them: "insipid, fat-
uously cheerful, two-dimensional, spic and span" people, who
had "Louis Quatorze radio sets" and "green and purple toilet
paper"—but no children, no useful goals or untainted pleasures.
Stolberg said that Wilson conveyed "a perfect feeling of the utter
futility of such 'liberal' goo-goo societies" as the People's Lobby
led by John Dewey, and showed "how empty and unhappy right
under the skin is the life of our more unctuous and better edu-
cated Babbittry." But Wilson did this by discounting the virtues
of liberalism and the reality of the Xs. He wasn't so gross as
Rorty: he called into question the "decent humanity" of those
whom he opposed delicately and while feigning not to. "In a re-
cent book about politics it was asserted," he wrote in 1931, "that
the President [Herbert Hoover] 'can hardly be classified as a
member of the human family.' This is an exaggeration."

A generation later, in 1957, while discussing the "pretenses" that induce nations to make war, Wilson condemned, by implication, propaganda of the sort he and other radical reporters had used in the thirties. "The desire to believe . . . in a wicked wicked man who has put himself outside humanity," he wrote, "stimulates our sense of virtue and enables us to be perfectly sure we are fighting on the side of the right." But it is a "primitive" appeal, "distorting in its view of the world, degrading in its effect on ourselves." [17]

The radical reportage of the thirties was characteristically "primitive" in its emotionalism, and distorting and reductive in its vision of the world. That it was bespeaks the fanaticism of the time and, even more, its reckless despair: in making a new order, *nothing* of the old was worth saving.

Informant
Narrative

In "Detroit Motors," a 1931 article for *The New Republic*, Edmund Wilson experimented with various ways of communicating the life of the proletariat. His case study of two electrical workers was sentimental; his participant report on the Ford factory overdid its rhetoric—derived from Hart Crane—of industrial brutalism. The strongest vignettes were not in Wilson's words but in the workers' own. A telegraph company typist remembered the punch-press work she did until she married:

> The presses are awfully close together and there are no stools, you have to stand. There's an awful ringing in your ears from the noise of the presses, but I used to hum tunes to the rhythm —I used to hum the "Miserere." . . . If you made a misstep on the pedal, you were liable to lose a finger—I always had some kind of a cut. When an accident happens nobody ever tells about it and sometimes you don't know definitely till a week later—but I could always tell if something had happened as soon as I came into the room: the place always seems very clean and everybody's very quiet. Once when I was there a girl lost her finger and gave a terrible shriek—and another time when the same thing happened to another girl, she just put a rag around her hand and quietly walked out. . . .
> People often don't use the safety devices because they can

work faster without them. Then your chest would get cut up from the trimmings—mine was all red. And the oil gives you an itch—your arms get itchy and you just about go crazy—they gave you some white stuff to put on it, but it didn't do any good.

But I got so I had a certain amount of skill—I used to take satisfaction in turning out so many pieces a day and I got to be known as a fast worker. . . . There was a freedom at L——; you could go in a gingham dress. And I could bully the foreman and everybody. At the telegraph company, the supervisors aren't supposed to fraternize with the girls.—And I enjoyed wearing a clean cap on Fridays—on Fridays we all wore a clean cap and I used to get a kick out of it.

The woman worked in cruel circumstances. Yet hearing her speak, one realizes that to say *only* that would be to distort her experience. For she turned the cruelty of her work into something of human value, a challenge to be overcome. Her experience as she related it mocks the sentimental simplicities of propaganda—or of simple propaganda at least.[1]

Since the aim of documentary is to make real to us another person's experience, make us see what he sees and feel what he feels, it is only sensible that the person speak directly to us. All documentary tends to direct quotation, but documentary can be *all* quotation and nothing else: it need not include the commentary of a social scientist, historian, or reporter. What results then is a kind of documentary writing we will call informant narrative. In the 1930s such writing was frequent and went by a variety of names: "worker narrative," "folk writing," "folk-say," "folk history," "vernacular literature," "notes from a diary," "Letter from America," "a personal experience," or, simply, "a document."

Informant documentary is of course a type of confession literature; it makes the same experiential claim. Unlike pulp confessions, though, it is neither romantic nor salacious, deals seldom with love, sex, crime, or natural calamity, and often with social problems. Indeed, that is the reason most informant narrative of the thirties came to be written and published. Consider the following articles:

"My Brother Commits Suicide," by Anonymous, published in *The New Republic*, May 1931. A teacher too poor to attend his brother's funeral in Texas reproaches a system that, providing no work for honest men, drives some to kill themselves.

"Boys Going Nowhere: Notes from the Diary of an American 'Wild Boy,'" by Robert Carter, *The New Republic*, March 1933. Unable to find a job, young Carter bummed around the country and here offers a sinister and pathetic glimpse of life on the road.

"In the Nazis' Torture House: A Document from Germany," by Karl Billinger, *New Masses*, January 1935. The author, writing under a pseudonym, describes the hideous tortures the Gestapo practiced on him.

"School Children See Massacre," *The Nation*, July 1937. Eighth-grade pupils in Chicago who were eyewitness to the "Memorial Day Massacre" at Republic Steel wrote compositions about it for their teacher; she submitted the compositions to the magazine.

"'Examination by the G.P.U.': A Personal Experience," *New Masses*, March 1938. Peter Kleist, a German engineer in Russia guilty of an impropriety, relates how correct was his three months questioning by the Soviet secret police: "There was never any suggestion of mental 'third degree' and certainly no physical coercion."

All the articles were written by people having personal experience of an event or social condition not common knowledge; none of the writers had public importance apart from his experience.[2]

The sources of thirties informant documentary are many and antedate the decade. Pulp confession literature, an important influence, was enormously popular in the twenties (*True Story*, the first of the genre, appeared in 1919). At that time, too, avant-garde magazines like *The Transatlantic Review* and *transition* published a great deal of colloquial writing on American themes, most of it in the first person. H. L. Mencken, the decade's literary czar, encouraged the autobiographical writing of workers like Jack Conroy and bohemians like Jim Tully. The largest impulse toward writing by and about the worker came, however, from Michael Gold, who, on taking over the editorship of *New Masses*

in 1928, challenged "the working men, women, and children of America to do most of the writing." "EVERYONE has a significant life story to tell," he assured his readers; "write for us as you would write a letter to your best friend." Gold aspired to make of *New Masses* a magazine of "workers' correspondence" such as he had seen in the Soviet Union where the press was full of "simple direct accounts of the daily life of the workers." "WE WANT TO PRINT," he trumpeted,

> Confessions—diaries—documents—
> The concrete—
> Letters from hoboes, peddlers, small town atheists, unfrocked clergymen and schoolteachers—
> Revelations by rebel chambermaids and night club waiters—
> The sobs of driven stenographers—
> The poetry of steel workers—
> The wrath of miners—the laughter of sailors—
> Strike stories, prison stories, work stories—
> Stories by Communist, I.W.W. and other revolutionary workers.[3]

Worker narratives were a mainstay of radical journalism in the thirties; as Daniel Aaron has suggested, they were the ground from which the Proletarian novel grew. It is little realized, though, that such narratives appeared in *all* general magazines of the time. A narrative's tone conformed to that of its journal: a narrative in *New Masses* in 1932—dogmatic, vituperative, impassioned—was very different from one in *Harper's* or *The Atlantic Monthly*. Yet these magazines had narratives too—from "workers" as genteel as their readers. The January 1936 *Harper's* published "I'm on Relief," an article by "a College Graduate." The writer explicitly identified himself with his comfortable audience: "Now I had had, a year before, no more expectation of going on relief than you, sitting there now reading this, have that you will go 'on.'" His goal was to convince "you" that he was like you, that there were "friends of yours, and others like you, on the

[relief] rolls," and that "even you would have been if God hadn't preserved, without apparent rhyme or reason, your job or your income." His persuasiveness began with his command of the tone proper to *Harper's* of the time: earnest, tolerant, calm.

A more unusual worker narrative appeared in the March 1936 *Atlantic Monthly*, Caroline Henderson's "Letters from the Dust Bowl." An Oklahoma farm wife for twenty-seven years, Henderson was also a highly cultured woman. She wrote with the impersonal grace one finds throughout the genteel magazines of the time and enriched her prose with allusions to Shakespeare, Tennyson, William Vaughan Moody, Alexander Selkirk. She described drought, crop failure, human folly with notable lack of bitterness. When the Supreme Court killed the AAA, she said mildly: "People here, business men as well as the farmers themselves, realize that the benefit payments under the AAA and the wage payments from Federal work projects are all that have saved a large territory here from abandonment." She remained calm even while telling of the greatest horror, the stifling dust storms: "Nothing that you see or hear or read will be likely to exaggerate the physical discomfort or material losses due to these storms." Her letters are not "vivid and pathetic" as the *Atlantic* editors said; or rather, they *are* vivid—moving—exactly because they are not pathetic. They have the strength of the magazine's tone at its best: a cool rectitude.[4]

There were worker narratives for all classes but the wealthy and all degrees of sophistication. The worker himself was frequently not blue collar but a "brain worker," as the fifty-three intellectuals styled themselves who signed the 1932 "Culture and Crisis" declaration in support of William Foster for President. In fact—and this is odd for documentary—the worker's stock-in-trade might be communication. Thus *The New Republic* ran a 1933 article "On Being Fired" by an advertising copywriter who boasted that his job had been "conditioning the reflexes of ten million shopgirls," and *New Masses* published in 1936 a "Letter from a Hearst Striker," a disgruntled reporter whose usual work

was "pounding out copy a mile a minute" in the service of the American whom *New Masses* most loathed. By the mid-thirties the worker in a worker narrative was bourgeois as often as not.[5]

The aim of informant documentary—to let the unimagined members of society "speak for themselves in their essential character," as W. T. Couch put it—was seldom realized. And this for two reasons: first, the people who spoke up, the literate ones, wrote about themselves according to formulas they knew from their reading; second, the people who did not speak up, the illiterate or inarticulate ones, were hard—though not impossible—to capture in print.[6]

It is plain that Caroline Henderson and the college graduate on relief wrote about themselves according to the genteel formulas of the *Atlantic* and *Harper's;* their point was in large measure that they *could:* though of the socially disadvantaged, they were quite like their relatively fortunate readers. The Proletarian formula was more rigid than the genteel. As Aaron suggests, it required a mixture of prophetic rant, "self-conscious toughness," cheeky anti-intellectualism, slang, "metaphors of death and putrescence in describing the 'sick' and 'rotten' bourgeoisie," and unabashed "sentimentalism and self-pity." In short, it was the way Mike Gold wrote, and during the late twenties and early thirties, the worker narratives in *New Masses* zealously followed it. As the thirties progressed, though stalwarts like Gold and H. H. Lewis kept up this rhetoric, most radical writers abandoned it. They sought richer and more various models.° They became more

° *New Masses* changed. Worker narratives appeared less often, and Proletarian bombast was increasingly confined to the cartoons and poems. The magazine came to rely on a staff of regulars, all professional writers. In 1935 these included John Spivak, Joseph North, the critic Isidor Schneider, the aesthetician Stanley Burnshaw, and the light satirist Robert Forsythe: Forsythe, who earned his living as drama critic for *Collier's* under his given name (Kyle Crichton), had a weekly column in *New Masses* where he propagandized for Communism in a prose nearly as urbane and inoffensive as *The New Yorker's.* His tone suggests how confident some intellectuals then were of the revolution: they didn't feel they needed to shout, nor even raise their voices much.

writers than proletarians. Jack Conroy didn't work in a mill any longer; he edited *Anvil* and wrote for the WPA. In 1965 Nelson Algren, who had been on the fringe of the Proletarian movement, damned it in a sentence: "The great fallacy of the era of Proletarian literature was that, with the single exception of Richard Wright, it was conducted by intellectuals." Algren exaggerated, but only a little.[7]

Intellectuals turned up in the strangest places. Consider Tom Kromer, the twenty-eight-year-old drifter who wrote *Waiting for Nothing*. This is one of the most remarkable informant narratives of the thirties—"a document more candid and less squeamish than any of the recent novels dealing with the depression," said Robert Cantwell when the book appeared in 1935. It seemed to another reviewer that "there is no glamour in this autobiographical record, no sentiment, no laughs, no color, no pathos, no humor, no nobility." Kromer himself declared his book free of all literary pretension:

> I had no idea of getting *Waiting for Nothing* published; therefore, I wrote it just as I felt it, and used the language that stiffs [bums, vagrants] use even when it wasn't always the nicest language in the world. . . . The "Stiff" idiom is, of course, authentic.

The book itself is authentic—and yet it shows the chilling influence of literature. A prison librarian reported that inmates at the Welfare Island Penitentiary snorted when the first pages of the book were read to them, because "drifters, bums, and mission stiffs simply do not talk in the manner assumed by Tom Kromer." The "stiff idiom" he was so pleased with is a pastiche of tough-guy jargon, pseudo-biblical lack of contractions ("A four-bit flop is what I want. I do not wish to play nursemaid to your virgins. I am broke, and besides, I am sleepy"), Elizabethan turns ("Say, I'd like to meet that guy, and I had a million dollars"), and the inevitable Ernest Hemingway:

> It is night. I am walking along this dark street, when my foot hits a stick. I reach down and pick it up. I finger it. It is a good

stick, a heavy stick. One sock from it would lay a man out. It
wouldn't kill him, but it would lay him out. I plan. Hit him
where the crease is in his hat, hard, I tell myself, but not too
hard. I do not want his head to hit the concrete. It might kill
him. I do not want to kill him. I will catch him as he falls. I can
frisk him in a minute. I will pull him over in the shadows and
walk off. I will not run. I will walk.
 I turn down a side street. This is a better street.

Not only is the idiom derived from literature, the content is
too. The whores have hearts of gold; the bums are noble. Tom is
solicited by a young woman on the street:

"You—you want to go with me?" she says. . . .
"Where are you going?" I say. I am only joking.
"I—you—you don't understand," she says. She looks down at
her feet. . . .
 "You are not used to this," I say. "You are not so good at it.
Why don't you go to the mission?"
 "I am not used to it at all," she says. "You are the first one. I
guess I am sort of clumsy, but I'll learn."
 "Not if I can help it," I say. "You hungry?"
 "That's why I am on the street," she says. "I'm damn near
starved."
 "I am holding four bits," I say. "Let's eat."

Together Tom and the girl have a "shamefaced idyll of the un-
employed," as Cantwell thought it. The idyll comes from a
grade-B Hollywood tear-jerker:

She peels the spuds. I clean the coffee-pot.
"James, the salt," she says.
"Yes, m'lord, and the pepper besides," I say.
 We are having a good time. It does not take much for a cou-
ple of hungry stiffs to have a good time. The spuds that began
to sizzle on the hot plate are enough. The pot of coffee that fills
the room with its smell is enough.
 "People meet in funny ways, don't they?" she says.

Society may abuse them, they remain always good. The girl says,

 "When I stepped out of the doorway to you, I wanted some-
thing to eat. Nothing was wrong that would give me something
to eat."

"That is the way I felt when I started to knock a guy in the head once," I say. "That is the way I felt when I started to hold up a bank once."

"But you didn't knock a man in the head or hold up a bank?" she says. "You only started to. You didn't really do it?"

"No, I didn't do it," I say.

Kromer pretended to be telling about himself, but he wasn't. The "Tom Kromer" of the book is a craftily simple version of the Tom Kromer who wrote it: the former doesn't know where his next meal is coming from, but the latter knew to tell it like *A Farewell to Arms*. And though the latter never appears in the book, it is he the reader cares about and wonders at. Why did he write *Waiting for Nothing*? He claimed to have no idea of publishing, but this can't be true. The book describes life on the road for those not on it—that is all it does; surely Kromer wouldn't describe begging techniques, a main theme in the book, for his own amusement. And why was it written as it was, in a manner one reviewer called "slightly self-conscious literarily"? The only possible answer is that the real Kromer, Kromer the author, had artistic longings. Though a vagrant, he was already a member of the intelligentsia (he had gone three years to college and taught high school for two), and he wrote his narrative in the style he knew was then recognized as the truest; he wrote, said Cantwell, "with something of the sharpness and unblinking acceptance of the horrible that characterized Ernest Hemingway's very early stories of the War." His book, because its content is derivative, is finally less interesting as a social document than as literature. *Waiting for Nothing* has the appeal of a strong, flawed first novel in which the center of energy is the novice author finding his voice. Recognized as a young writer of promise, Kromer left the Proletarian world, married, moved to New Mexico, and edited a little magazine.[8]

It is no doubt inevitable that those who write informant narrative be literate and that, being literate, they tend to write like recognized writers. Those not literate, those without the education or inclination to write, present a much more serious prob-

lem: how can they be captured in print at all? The oral historians of our day—Oscar Lewis, Jan Myrdal, Studs Terkel, to name three—have solved this problem with the tape recorder. But those who went out to document America in the thirties did not have tape recorders, and the other recording methods were too expensive and bulky. Narratives had to be gathered in the same ways social scientists and reporters gathered testimony. And the drawbacks were the same.[9]

During the early thirties social scientists confidently minimized the drawbacks. The Chicago sociologist Ernest Burgess suggested that informant narrative, which he called "life-history," would be as valuable a "new instrument for the study of human behavior" as the microscope had been in biological research. He especially liked the fact that "life-history as a human document . . . admits the reader into the inner experience of other men" and thus helps him "realize the basic likeness of all human beings." Burgess saw little problem in maintaining the scientific usefulness of a first-person narrative so long as it was a "verbatim document." He told his students to solicit such documents by encouraging people who usually would not write about themselves to do so in any way they pleased. The life histories of two such people—a mugger and a rapist—appear in the best known studies Burgess supervised, *The Jack-Roller: A Delinquent Boy's Own Story* (1930) and *The Natural History of a Delinquent Career* (1931). Both histories are interesting, and very like pulp confessions of the time: the central character tells of his sins (gloatingly), his capture and punishment, and his true repentance. Like Macfadden products, these narratives seem less self-explorations than performances. It is evident they were written, and written as they were, not to please their writers so much as to please others (the jack-roller's reformation was so convincing he won parole). Their motives apart, the narratives are of dubious scientific value. The sociological generalizations the editor draws from them in his footnotes are thin and superfluous. The rapist said his crimes began when, as a boy, after much hesitation he stole an apple from a fruit stand; the editor commented: "This is a vivid

description of Sidney's first experience in stealing. Many careers in juvenile delinquency and adult crime originate in precisely this manner." [10]

Yet so popular was confession literature that throughout the later thirties and early forties one prominent social scientist after another—John Dollard, Gordon Allport, Clyde Kluckhohn, Robert Angell—wrote monographs attempting to legitimate "the human or personal document" as source material. These books criticized the undirected life history and suggested that informant narrative explore precise and "scientific" questions. But when this was tried, the opposite problem appeared: the testimony became cut-and-dried, overdirected; social scientists used first-person narrative merely to confirm their theories, not to let informants voice their essential characters. Thus the study *The Professional Thief* (1937) is neither the autobiography nor the confession it purported; indeed, it is not "by a Professional Thief" so much as by Edwin H. Sutherland, a sociologist. A former thief, Chic Conwell, wrote a portion of the text—but in response to questions Sutherland put him. The two then discussed what Conwell had written, and after each meeting Sutherland "wrote in verbatim form, as nearly as I could remember, all that he had said." Finally Sutherland organized this manuscript, writing "short connecting passages" as though he were the informant. Somewhere in the process Conwell the man was entirely lost. Ninety-nine per cent of the text is straight sociology:

> The cost of fixing cases, whether federal, state or municipal, is not standardized. Some cases are more serious than others. In some cases many angles have to be taken care of, such as reinstating an old case, a period of newspaper hysteria, the effrontery to the crime commission, and the addition of related charges, such as vagrancy or habitual criminal. The cost of fixing cases varies, also, in different parts of the country.

For pages at a time the word "I" does not appear, though it certainly would were an individual telling of his life. Consider this sentence: "The following are some cases of such emotional shocks which were known personally." Known to whom? To Conwell?

But surely he would say, ". . . which I knew personally." *The Professional Thief*, though it had the form of documentary, was too rigid a piece of social science to let an individual come alive.[11]

If Conwell's actual words were not so compromised by Sutherland's intervention, doubtless he would appear a more credible person. Still, he would be used to prove another man's theories. One sees how stultifying this can be in the verbatim testimony of striking miners recorded in *Harlan Miners Speak*. This book of reportage grew from the 1931 visit to Harlan and Bell counties, Kentucky, of a group of writers, headed by Theodore Dreiser, under the auspice of the Communist-sponsored National Committee for the Defense of Political Prisoners. Kentucky's coal fields were the scene of a confused and bloody war, with two unions fighting for the little work available and mine owners trying to crush the radical union, which had Communist support. Neither the owners nor their henchmen would submit to Dreiser's interview; indeed, they finally had Dreiser, John Dos Passos, and several of the writers with them indicted for criminal syndicalism. The only people Dreiser's committee could question were members of the striking radical union. Though a stenographer took down these interviews word for word, they make tedious reading. To a man, the union members said what was expected of them: that they were poor and put-upon, pitiable and helpless; that their lives were simply rotten. These interviews suggest that Nathan Asch may have been right when he argued, in 1937, that a documentary reporter should converse with informants but never "question" them, because "they always tell you the things they think you want to hear." Significantly, the interviews come to life on the few occasions where the miners' pat testimony breaks down:

Q Is there any particular reason why you are out of work?
A I guess the reason now is they have me victimized.
Q What do you mean by that?
A I don't know. They call you that when you join the Union.

A woman testified that her family lived on a meal a day of "water and grease and a little flour in it," and that her children were naked. A committee member prompted helpfully, "They probably don't go to school?"; she agreed they didn't. The member asked what her family did for entertainment. They had none. "Do you ever go to a motion picture?" No. "You have never had a Victrola, I suppose?" Suddenly the woman turned defensive:

> A You see, I have a grown son in Detroit and he had a bicycle and he traded for this Victrola when he was at home but it is old and the records are old and broke and the children plays with it sometimes.
> Q You haven't got such a thing as a radio?
> A Oh, no, don't know nothing about such a thing.

And the interview was back in the groove, the poor again dumb and righteous.

The liveliest testimony came from an informant who disputed the committee's prejudices and turned the tables on its members. Herndon Evans, a local newspaper man, printer, and AP stringer, headed the Harlan County Red Cross and supported the mineowners. Yet he believed, or claimed to, that he was serving the cause of humanity and social justice as much as the committee believed it was, and he ably defended his views. He had answered questions from several committee members when Dreiser genially broke in:

> Q Mr. Evans, I do hope you do not mind answering these questions.
> A Not at all. In fact I really enjoy it, but I would like to ask you a few questions, if you do not object?
> A Not at all.

Two answerers: the conversation was for once a real one.

> Q You are a very famous novelist and have written several books. Would you kindly tell what your royalties amount to?
> A I do not mind. $200,000.00, approximately. Probably more.

Q What do you get a year, if you do not mind telling?
A Last year, I think I made $35,000.00.
Q Do you contribute anything to charity?
A No, I do not.
Q That is all.
A No, do not stop there, go right ahead and ask me something else.

Dreiser gave some family history, explaining that he subsidized several relatives. Evans was remorseless: "May I ask you what percentage of your income you give that way?" Dreiser launched a tangled explanation of how, though he believed in economic "equity,"

> any one that has property must pay to keep it up. . . . I employ four secretaries and I do not pay them any small matter for salary. . . . I am not dancing around at the Waldorf, but work most of the time. I am conducting this investigation at my own expense. . . . When it comes to the spending of money I think I will average among the rest of them.
>
> Q What I was trying to say was that me, with my $60.00 per week, give more to charity, and believe more in the standard of equity than you do with your $35,000.00 per year.
> A I do not think so.

The interview continued, Dreiser slipping further into the past ("as a matter of fact, for the first twenty years of my life I never made more than $14.00") to argue his case. But this was the conclusion. Evans thought one thing—"I have contributed more to charity than you and . . . my life is more equitable than yours" —and Dreiser disagreed. Each man maintained his point of view. Neither humbled himself to achieve a resolution, or to persuade or curry favor.[12]

Informant narrative that gave such liberty to its subjects was rare in the thirties—but there are examples. The three best, surely classics of the documentary genre, are the WPA's *These Are Our Lives* and *Lay My Burden Down,* and an obscure pamphlet "The Disinherited Speak: Letters from Sharecroppers."

These Are Our Lives, subtitled *As Told by the People and Written by Members of the Federal Writers' Project of the Works Progress Administration in North Carolina, Tennessee, and Georgia,* was published in 1939. It consists of 35 life histories chosen from more than 400 that project workers gathered in three Southern states. W. T. Couch, the book's editor, announced that the histories were collected in the belief that "the people, all the people, must be known, they must be heard"; but "the people, all the people" meant some of the people: the populist sample noted in Chapter 7. In fact, so biased was the sample that Couch, who had before him all the WPA life histories taken in the South, remarked that there were none of factory owners or managers, and few of middle-class people. This didn't trouble him: "I doubt whether any owners have ever spoken better for themselves than Kate Brumby and Smith Coon [two poor people in the book] speak for them." In addition to being populist, the people in *These Are Our Lives* are bowdlerized. Couch did not include any of a number of "extremely sordid stories," though he thought them of considerable interest. Why didn't he? He explained in a dependent clause: "because space is limited and the stories here presented seem to me to deserve attention first." The histories he chose all showed resourceful, unembittered men and women coping with social disaster. Rather than emphasize the wrongs done worthy folk, the stories emphasized the folk and ennobled the American people in a time of foreign menace.

The chief weakness of the histories is that they were told to people who were trying to prove themselves as writers. Though the histories were, as Couch insisted, "written *from the standpoint of the individual himself,*" most were distorted by another standpoint, that of the young writer looking to be noticed. The story "A Little Amusemint" starts with James, a poor factory worker, gazing at two Duroc hogs he is fattening, when

> a woman turned into the lane and stopped at the big Spanish oak whose branches shaded the hogpen in which James' hogs grunted contentedly. The woman might have been a book-

keeper, a teacher, a stenographer, a clerk, or perhaps a social worker. James looked up at her and made no speculation as to why she was standing there. He observed only that she was dressed in Sunday clothes and that she seemed friendly.

Already the history is disjointed. Who is this mysterious woman on whom so much speculation is lavished? Surprisingly, she is not the subject but the author (how she knew James' thoughts one is never told). She chats with James and Lizzie, his wife, getting intimate details of their poverty, childlessness, his reformation from drink and a daily four-ounce bottle of paregoric—but she never exposes so much as her name. The situation is incredible and quite repellant. And it never should have been a situation. If the narrative was James and Lizzie's, Ida Moore, its writer, had no place in it.

Many writers intruded. Few got as much of the limelight as Ida Moore, but they could get a lot less and still distort the way an informant presented himself. Old Clyde Fisher, as he called himself, a Negro workman of about sixty, lived alone—"I'm a bachelor man now"—in a one-room house in Knoxville. He kept his Franklin stove going full blast, though the room was already hot. He was telling gayly his life and opinions

> People go to Egypt now lookin' fo' knowledge. The reason they don't want to give the 'Gyptians credit is 'cause they's niggers. Shucks, undertakers ain't learnt yet how to fix the body like the 'Gyptians done. Wish I knowed how. Make me a barn full of money, mummyin' up the folks. Make 'em so hard and lastin' you could stand 'em up on the graves. They'd be the corpse and the headstone all at once

when he changed tone

> My, you're jest sweatin'. Let me open this door. Why, I'm 'bout to burn you up. Chile, I believes in my fire. Yes'm, I must have plenty of fire and a good bed to sleep in.

And the reader suddenly knows why Fisher was so jolly and carefree. He was talking to a woman, Lillian C. Love by name,

and spoke as he did because he was performing. His saying that
he had "plenty of fire and a good bed to sleep in"—which
(feather) bed he went on to describe—suggests that old Clyde
Fisher may have been courting the writer.[13]

Lay My Burden Down: A Folk History of Slavery, though its
narratives were also taken down by members of the Federal
Writers' Project, has none of the flaws of *These Are Our Lives*.
Despite the recording medium, the ex-slaves speak for them-
selves so purely that today's oral historians recognize the book as
an important forerunner of their technique. The book's excel-
lence is due in large measure to B. A. Botkin, who edited it in
1944 from narratives collected in the mid-thirties. Like Couch,
Botkin had an immense body of material—over 10,000 manu-
script pages—from which to select; unlike Couch, he had a phi-
losophy. A pioneer folklorist, he knew the pitfalls for interviewer
and informant. He rejected out of hand as "lacking not only in
flavor but also in reliability" all narratives written in the third
person, as "A Little Amusemint" had been. Any narrative that
showed signs of having been retouched or of the writer's preju-
dices and sympathies he did not use. When an informant was
"guilty of flattery and exaggeration, of telling . . . what he thinks
the interviewer wants to hear," such excrescences were cut. As a
result, in *Lay My Burden Down*, as in all fine oral history, "the
interviewer succeeds in eliminating himself entirely and the
reader is brought face to face with an informant."

The heart of informant narrative is particular experience, but
Lay My Burden Down has a deep and moving general meaning
as well. This meaning is not the propagandistic one Botkin saw
in 1944 "in the light of the present, with its new freedoms and
new forms of slavery." The ex-slaves' experiences were more
complex, more human, than mere "autobiographical propaganda"
against tyranny. As Botkin said, the narratives answer the ques-
tion "how does it *feel*" to be slave and to be free, but most of
these old people's feelings were mixed. All but a very few of
them had hated being slaves. Yet they could not simply reject

that period of their existence, since it was their childhood and youth when life lay before them, when they had parents, when their experience was keenest ("I tells my childrens, ain't no days like the old days when I was a shaver"). Whether the experiences were bad or good (and they were not always bad), memory of them was irresistible. A man says of a whipping he received three-quarters of a century before, "I has that in the heart till this day"; but he speaks only in sadness, the bitterness all used up. And this is what the narratives most remarkably make one feel: deliverance from the pain of living, and the sadness of that deliverance. The ex-slaves, most of them in their eighties, had come to terms with their lives, analyzed and understood them, and forgiven them: "I was born in slavery, and I belonged to a Baptist preacher. Until I was fifteen years old I was taught that I was his own chattel-property and he could do with me like he wanted to, but he had been taught that way, too, and we both believed it." To hear them speak is to have a sense of what it must feel like to have lived enough to be at peace with the world, oneself, and God:

> White folks come to me sometimes . . . You just ought to hear me answer them. I tells them . . . just like I would colored folks.
> "Them your teeth in your mouth?"
> "Whose you think they is? Certainly they're my teeth."
> "Ain't you sorry you free?"
> "What I'm going to be sorry for? I ain't no fool."
> I tell them. Some of 'em want to argue with me and say I ain't that old. Some of 'em say, "Well, the Lord sure has blessed you." Sure He's blessed me. Don't I know that? [14]

"The Disinherited Speak" was published in 1937 by the Workers Defense League on behalf of the Southern Tenant Farmers' Union. A twenty-nine-page pamphlet, it reprints letters, unedited "except for occasional punctuation," from union members to the union's officers. At the time it was intended as propaganda: the sharecroppers' distress, the cruelties practiced on them, their pleas for help and guidance, and their awkward prose were to

stimulate pity and donations; a league appeal on the back cover concluded: "The Southern Tenant Farmers' Union needs financial aid immediately. . . . If you understand the plight of the disinherited and know of the necessity of sharecroppers organization, you will send your contribution."

"The Disinherited Speak" was apparently not commented on when it appeared and is today forgotten. But it is a classic of informant narrative, poignant and terrifying and unsentimental, deserving of republication, and a useful complement to *Let Us Now Praise Famous Men*. Indeed, it offers a perspective on the tenant farmers that Agee could not. He said that the hardship of their lives had stunted their consciousnesses, but he didn't pretend to transcribe examples of their thinking. The letters in "The Disinherited Speak" give access to their minds. And because the writers intended to communicate with the world, a reader doesn't feel he is prying; the way they wrote was the way they wanted to present themselves to sympathetic people (the union leaders) whom they didn't know personally.

The letters of the tenants tell a great deal about them. We see in their iteration of ideas a radical distrust of language itself. Does this yet mean what it says, they keep asking:

> mr. h l mithcell dear sur, I am wright you a few lions to fine out when is the contractor coming out, and I want to know how to go about with my business, an what to do, and I want to no about mr. a. g. sweet forced us to move out in cold snow, bad Weather. so after all of that we ant give the union up yet, in after all of the hard time We had this winter we ant give up. we show have had a hod time this winter. some time we had wood and some time we did not, but by the help of the lord we have made it this fore.
>
> but lisen Mr. mitchell, ant we suppose to get some money for sickeness in case by your land low forced you out in the bad Weather in it make you sick? so mr. a. g. sweet forced us out an it maid my wife sick, an I ant non the best of my seft, an we had a hod time tring to fine a place to move but we got one at last. so this is all from your truly, JESSIE TOWNSEND

We see in the trouble they have explaining themselves their inability to get outside their experience and reflect upon it.° Many of them were so innocent, so inexperienced, that they did not really conceive the otherness of others: they couldn't quite imagine anyone not knowing them and their lives. In the following letter an Arkansas tenant farmer explains his problem to the union's executive in Memphis.

Mr. H. L. Mitchell.
Dear Sir, please send me my mail hear at Armorel. I was put out and told that I would be charged for staying in the house until move. he heared that I was a union member, and he dont want any on his place. also he askd my boy James why I had said he did not Settle with me right. That he would make me pay for every thing that had been misplaced on his place, for an ax that Charlie Parker left at my house. he was a day hand, and after Golighthy would not pay him for his work, and when he left I did not have an ax. he said I could use his. now I have to pay for it again. so please write me at Armorel Ark. I will be here with My Brother Sam.

And yet, withal, we see their strength, their tenacious purpose to enter the world by gaining command of the rhetoric and policy of those who sought to help them. One letter included these paragraphs:

now Mr. Mitchell my whole heart and mind is on this union studding some way and some plan that i can do to be a help to the union because i wont to see it over the top. now Mr. Mitchell i hasen forgot those stamps and books you sent me i hasen sold all of them but i has sold some of them but if i dont sell them soon i am going to make you my report any way.

now mr. Mitchell in our meating we discusted the lesson you sent us tell me how many time are we supposed to discust one lesson we had discusted the defience comittie and their work in our past meating now; tomorrow we will hafter to discust the

° Not true of all the tenants. One likened his condition to the fate that awaited the convicted kidnapper of the Lindbergh baby: "Kind Sir I am on the Twist farm, the Place I Suppose Huptmann will Be Sint Provided they don't Kill him in the Electric Chair."

same lesson because i didnt know how many times we had to discust one lesson and i hadent ordored another lesson now the women disided in our past meatting to put on a big progrom at the church in the behafs of the union.

Another letter said:

Dear Sir I take great plasure in Writeing you a few Linds to let you no that thro a Long Strougle We was Bless With 21 Men in our organizing Monday night, May the 4th, 1936, by MC. Bass. We Pray Gods Blessings for Success.

Please Sen Me a full Line of instructions, the obglation Sheat.

hopeing to obtain Early Reply. We no in union there is Strainth first & last.

<div align="right">Oblige,
C. C. Latcher.[15]</div>

"The Disinherited Speak," the WPA narratives, and similar informant writing of the mid- and late thirties suggest how much people of the time were interested in other people—not only in people simplified and sentimentalized, but in people as they were: moody, hectoring, hard to understand.

CHAPTER 12

The
Documentary
Book

When *You Have Seen Their Faces*—Erskine Caldwell and Margaret Bourke-White's documentary book using text, photograph, and caption to report the plight of Southern tenant farmers—appeared in 1937, it was considered something unique: "the first volume to be presented in a new genre," "a new art." [1]

In fact, it was not new. If a documentary book is one that uses words and photographs to describe a social condition, the first of the kind in America would seem Jacob Riis' *How the Other Half Lives,* published in 1890. For Caldwell and Bourke-White, though, there were many recent and more obvious precedents. Perhaps the most important of these was the "photo essay" in the Luce magazines, for which Bourke-White had worked since 1929, and, specifically, such features as *Fortune's* "Life and Circumstances" series of the mid-thirties, which included articles like "Success Story: The Life and Circumstances of Mr. Gerald Corkum, Paint Sprayman at the Plymouth Motor Plant," "A Farm in Illinois: The Life and Circumstances of Mr. George Wissmiller," and "Family on Relief: The Life and Circumstances of Steve Hatalla, Who Lost His Job Four Years Ago." These articles balanced text and photos as the documentary books later

did, and to the same end: to make vivid the lives of people on society's lower rungs.[2]

The documentary book had, however, many other precedents. Alfred Kazin thought Pare Lorentz had developed this "new genre" in *The River* (1936), the words and images of which "were not only mutually indispensable, a kind of commentary upon each other, but curiously interchangeable." There is no question that the documentary film influenced the documentary book: Archibald MacLeish called his prose-poem accompanying FSA photographs in *Land of the Free* (1938) a "Sound Track." But the usefulness of photographs in studies treating social conditions was evident long before Lorentz. The six-volume *Pittsburgh Survey* (1909–14) of labor and living conditions among the working class was illustrated with photos by Lewis Hine. Rexford Tugwell and Thomas Munro's influential *American Economic Life and the Means of Its Improvement* (1925) was the first book about American society with pictures on virtually every page.[°] The success of Yale University's fifteen-volume *Pageant of America* (1925–29) demonstrated the popularity of such a "pictorial" approach. Indeed Lorentz himself had come to prominence with a kind of documentary book, *The Roosevelt Year: A Photographic Record* of Franklin Roosevelt's first year in the White House. Lorentz's book competed with another 1934 book of writing, photos, and documents about the President, Don Wharton's *Roosevelt Omnibus.* Both of these were pro-New Deal, but more concerned with human than with social questions: an advertisement for the *Omnibus* called it "one of the grandest human interest books every published," included a snapshot of the President eating, and promised "Roosevelt the *man* will fascinate you."[3]

"Human interest" pictures were abundant in the books of the

[°] The pictures were selected by Roy Stryker, then a graduate student of Tugwell's at Columbia University. Tugwell shared Stryker's interest in photo documentation and, in 1935, as head of the Resettlement Administration, invited him to establish the Photography Unit. The idea of the unit, Tugwell says, "was mine and Stryker's, and we wanted to make as complete a record as we could of an agonizing interlude in American life."

thirties. Arthur Raper's *Preface to Peasantry* (1936), a sociological study of farm tenancy in Georgia, began with two touching, irrelevant snapshots of handsome former slaves standing in grassland; a caption said, "An ex-slave—he washed his hands and face for his first picture." The University of North Carolina Press published a series of books on rural life—Charles M. Wilson's *Backwoods America* (1934), and Muriel Sheppard's *Cabins in the Laurel* (1935), for example—with superb, and unaccountably forgotten, photographs by Bayard Wootten. Agnes Rogers and Frederick Lewis Allen's *American Procession,* a best seller in 1933, used photos and pithy captions to describe American life since 1860 and to mock such follies as the bustle and the Boom.[4]

But most books that combined words and pictures had a definite social purpose. Lewis Hine's *Men at Work* (1932) portrayed construction workers and engine-builders as the selfless priests— "some of them are heroes; all of them persons it is a privilege to know"—of the modern cult of the machine. Walker Evans' portfolio of photographs in Carleton Beals' *The Crime of Cuba* (1933) showed the island's misery and violence, and implied that revolution was at hand and a good thing. The most startling picture books of the early thirties were unabashed propaganda: Frederick Barber's *The Horror of It: Camera Records of War's Gruesome Glories* (1932), and Laurence Stallings' *The First World War: A Photographic History* (1933). Stallings' photo compilation, cheaply reproduced by offset lithography, inspired similar books on current problems. Most of these books copied his tricky montage and ironic juxtaposition of image and text. On a typical page, the most egregious of these compilations, M. Lincoln Schuster's *Eyes on the World: A Photographic Record of History-in-the-Making* (1935), ran a photo of a Dust Bowl family on its knees in prayer outside an unpainted cabin, and captioned it with the words of the song "It Ain't Gonna Rain No More."[5]

Though *You Have Seen Their Faces* was not the first documentary book, it began what one critic has called "a five-year spurt of talent in this genre." This spurt of talent (and commerce)

produced more than a dozen books, including ones on Spain, Czechoslovakia, and Russia, and many on the United States and its oppressed minorities: tenant farmers, migrants, Indians, Negroes, Nisei. The point of all these books was the same: to make the reader feel he was firsthand witness to a social condition. In an early winter of the war, Ansel Adams, while photographing landscape in the California Sierra Nevada, happened on the Japanese-American relocation center at Manzanar. So moved was he by "the human story unfolding in the encirclement of desert and mountains" that he changed his plans; he photographed people. "The wish to identify my photography in some creative way with the tragic momentum of the times" led him, like most artists of the thirties, into propaganda on behalf of the victims of social injustice. He made a documentary book, *Born Free and Equal: Photographs of the Loyal Japanese-Americans at Manzanar Relocation Center;* and the Nisei as he portrayed them were not only loyal, they were comely, gentle, educated, bright-eyed, valiant, and unembittered—all smiles, in fact. Adams said he conceived his book "on a human, emotional basis," and addressed it to "the average American citizen." Adams wanted the citizen to see for himself the wrong done in his name: "throughout this book I want the reader to feel that he has been with me in Manzanar, has met some of the people, and has known the mood of the Center." Documentary photography, as Dorothea Lange and Paul Taylor explained in 1939, rested "upon a tripod of photographs, captions, and text," the single intention of which was to let the subjects, the "living participants" of a social reality, "speak to you face to face." Having looked at a documentary book, "you" could no longer be ignorant of them. You had seen their faces.[6]

It became a commonplace to say, as Malcolm Cowley did, that in a documentary book the pictures, not the text, conveyed the "important qualities"—

> drama, for example, and class conflicts and stories to the extent that they are written in the gullied soil, the sagging rooftree of a house or the wrinkles of a tired face. The roles of text and illus-

tration are completely reversed. . . . The pictures state the
theme of the book, whereas the prose serves as illustrative mat-
ter.

MacLeish, characteristically, turned this idea into high-powered
rhetoric: "*Land of the Free,*" he wrote,

> is the opposite of a book of poems illustrated by photographs. It
> is a book of photographs illustrated by a poem. . . . The origi-
> nal purpose had been to write some sort of text to which these
> photographs might serve as commentary. But so great was the
> power and the stubborn inward livingness of these vivid Ameri-
> can documents that the result was a reversal of that plan.

It was true that photographs carried most emotional punch:
while a text would often generalize, they were invariably particu-
lar. Caldwell said, "Ten million persons are living on Southern
tenant farms in degradation and defeat"; Bourke-White showed
the worn, soiled faces of a dozen such people. Taylor wrote,
"through Oklahoma stream emigrants from Kansas, Missouri,
Arkansas—westbound"; Lange photographed a family of four
walking alongside U.S. 66 near Weatherford, Oklahoma: a down-
cast man in cap and overalls carried a metal suitcase and a car-
ton of food; a woman wore a surprising candy-striped dress of
waffled cotton, open-ankle pumps, a worker's bandanna, and sun-
glasses with white frames; she carried an infant in her arms; be-
tween the man and the woman walked their frowning five-year-
old daughter in a faded dress.[7]
 If the pictures in a documentary book stimulated most
emotion, though, the emotion was guided by the text. Beaumont
Newhall has observed that "before a photograph can be accepted
as a document, it must itself be documented—placed in time and
space." This the text did: it told who was suffering where, and
why, and what could be done to help. The essayist George P. El-
liott points out that documentary photographs, with the excep-
tion of those by Walker Evans, are not presented in "the severe,
classical method used by 'pure' photographers": each print inde-

pendent of the others, all in uniform format and identified only by title. Instead, such photos accompany a "verbal commentary," are arranged in narratives, and "demonstrate a thesis." [8]

No documentary book of the thirties argued a thesis harder than *You Have Seen Their Faces,* the decade's most influential protest against farm tenancy. Erskine Caldwell got the idea for the book early in 1936. He had written a great deal of fiction—*Tobacco Road, God's Little Acre, Kneel to the Rising Sun*—and a good deal of reportage about the sharecropper. He wanted to "show that the fiction I was writing was authentically based on contemporary life in the South" and felt that to do this his book "should be thoroughly documented with photographs taken on the scene." [9]

Caldwell's agent put him in touch with Margaret Bourke-White, who, at twenty-nine, was the most successful photographer and one of the highest-paid women in America. Bourke-White, "the poetess of the camera," worked half-time for advertisers, half-time for the Luce magazines, the only staff member at *Fortune*—and later at *Life*—whose work got a byline. She was famous for her industrial photographs and had done a widely praised text and photo book about the Soviet economy, *Eyes on Russia* (1931). While photographing "Drought," a 1934 *Fortune* article on the stricken Great Plains, she was deeply affected by the human misery she saw, and learned, as she later said, that "a man is more than a figure to put into the background of a photograph for scale." While she had no specific interest in sharecroppers, she was eager to photograph the poor and accepted Caldwell's offer to join him. In the summer of 1936, the summer Agee and Evans spent in Hale County, Alabama, on the article that grew into *Let Us Now Praise Famous Men,* Caldwell and Bourke-White traveled through nine Southern states. [10]

Caldwell's text to *You Have Seen Their Faces* is a sober report on the economic weakness of Southern agriculture and the inhumanity of the tenant system. These related problems were already well known. They had been treated in a score of books and

hundreds of articles. Indeed, since early 1935, as a sardonic Southerner observed in 1941, "the word 'sharecropper' was appearing regularly in lurid newspaper headlines in cities where neither the editors nor the readers had a very clear understanding of what a sharecropper really was."° Behind the headlines was a series of violent events that brought national publicity to the sharecropper's plight. These events included: the jailing of a young Methodist minister who addressed the Southern Tenant Farmers' Union meeting at Marked Tree, Arkansas, in January 1935, and told the people in the audience that if they were not fed, he would lead them in lynching every plantation owner in the county; the plantation owners' subsequent reign of terror against STFU members; and an attack on Norman Thomas and STFU leaders at Birdsong, Arkansas, in March. These events were reported by the press services, by the Scripps-Howard chain, by the *New York Times,* and by magazines, including *Time, The New Republic, The Nation, Survey Graphic,* and *New Masses.* They were also reported in the newsreels, by cameramen who had difficulty filming the bloodshed without falling victim to it.[11]

The violence, though recognized as a national disgrace, greatly stimulated interest in the tenant problem. By February 1935, Scripps-Howard and the N.E.A. syndicate had feature writers touring the South, filing stories on the "peonage of 8,000,000 share croppers"; the New York *Post* had Erskine Caldwell. In March the *New York Times Magazine* carried an article by Henry Wallace on "The Dangers of Tenancy": "We have been talking about the evils of farm tenancy in this country for a great many years. It is high time that America faced her tenant situation openly, and pursued a vigorous policy of improvement." In April the reporter Cecil Holland noted that the tenant farmer, "a

° The terms "sharecropper" and "tenant farmer" originally had distinct meanings: a sharecropper was a tenant, but a tenant—who might rent his land for cash rather than a percentage of the crop—wasn't always a sharecropper. Thirties media, much to James Agee's disgust, used the two terms interchangeably, and they are so used here.

'forgotten man' of the Roosevelt Administration, and of several previous ones, is now in the national spotlight." [12]

The sharecropper remained in the spotlight throughout 1935, 1936, and beyond, the subject of, among other things: a *March of Time* film (*Trouble in the Cotton Country*), a Warner Brothers' social-protest melodrama (*White Bondage*), a National Sharecroppers Fund documentary (*America's Disinherited*, music by Paul Bowles), an annual "National Sharecroppers Week," a Rockwell Kent commemorative stamp, and—Mary McCarthy remembers—innumerable New York parties to raise money for the sharecroppers at which "the liquor was dreadful, the glasses were small, and there was never enough ice." In November 1936 a *New York Times* editorial on Southern tenant farming said, "The problem itself is a familiar one." [13]

Thus in November 1937, when *You Have Seen Their Faces* appeared, the problem it treated was known to virtually everyone who read the book. Public opinion was formed, and the book catered to it. Caldwell said what the sociologists, government officials, and journalists had been saying, and said it in their tone: "There is no evidence to show that any plan thus far advocated will in itself be sufficient to change the economic condition of the Southern tenant farmer. There is no reason to believe that any plan would succeed unless it were accompanied by re-education and supervision." Like other observers, he criticized one-crop agriculture, "feudal plantations," and the Christian church in the South. His only specific recommendation was a call for "a government commission . . . to make a study of tenant farming"—but here too he was repeating a common idea. In late 1936 Franklin Roosevelt appointed a special Committee on Farm Tenancy, which made its report eight months before Caldwell's book came out. [14]

Caldwell's descriptions of tenant life were generalized and discreet, in marked contrast to his New York *Post* articles. He portrayed the sharecropper in a "representative," and sentimental, type:

> As a young man he began life with hope and confidence and the will to work and succeed. . . . After five years of sharecropping, he was beginning to see that he was not making much progress. . . . Things were no better after ten years. He moved to another farm, a larger one, because by that time four of the children would soon be big enough to help plow and cultivate . . . He worked as hard as he could for five or six years on the new farm. But sharecropping on farmed-out land was making him worse off every year. Their clothes became a little more ragged, their faces became a little more haggard.

As Caldwell described him, the tenant farmer was an entirely piteous creature who, by himself, could never "remove the association of animalism from his mind." [15]

Caldwell diminished—brutalized—the sharecropper because his audience expected such a picture, not because he fully believed it. While discussing the economics of tenancy, he cited the typical case of "John Sanford" of Emanuel County, Georgia, who had once "made enough to buy two beds, half a dozen chairs, a dresser, a washstand, and the kitchen stove. . . . He does not own anything else, except for a change of clothes and a few odds and ends." In *Let Us Now Praise Famous Men* Agee spent 150 pages describing similar "odds and ends" and demonstrating that none of it was junk or unworthy of attention; that, on the contrary, it all had "beauty" and "wonder" and "sorrowful holiness." Caldwell shared Agee's feeling for the sacredness of a tenant's possessions. Bourke-White, whose remarks about Caldwell are not always generous (they were married in 1939, divorced in 1942), made a point of praising his humility before the people of their inquiry. Once, she remembered,

> we went into a cabin to photograph a Negro woman. . . . She had a bureau made of a wooden box with a curtain tacked to it and lots of little homemade things. I rearranged everything. After we left, Erskine spoke to me about it. How neat her bureau had been. How she must have valued all her little possessions and how she had them tidily arranged *her way*, which was not my way. This was a new point of view to me. I felt I had done violence.[16]

Caldwell himself did the tenants violence in his text, disparaged their lives and possessions—but he did so because he knew his readers would and knew that to convince them otherwise would take enormous imaginative labor on his part and theirs and undermine his polemical purpose. About farm tenancy his text made the "usual liberal complaint," as George Elliott thinks it: "How awful this is. Aren't you ashamed that you let fellow Americans live like this?" That was the message his audience expected; indeed, the popularity of *You Have Seen Their Faces* lends weight to Robert Warshow's belief that the tendency of mass culture is to eliminate the "moral content of experience, putting in its place a system of conventionalized 'responses.' "[17]

But so conventional a text as Caldwell's would never have sold had his book not offered something new on the sharecropper: photographs. *You Have Seen Their Faces* was called the *Uncle Tom's Cabin* of tenant farming, and Norman Cousins said it would deserve the credit "if all the talk about the share-cropper's plight is ever translated into action," thanks to Bourke-White.[18]

We have seen how Bourke-White made her subjects' faces and gestures say what she wanted them to. And what she wanted to say is blatant on every page. Faces of defeat, their eyes wizened with pain—or large, puzzled, dazzled, plaintive; people at their most abject: a ragged woman photographed on her rotted mattress, a palsied child, a woman with a goiter the size of a grapefruit; twisted mouths (ten of them), eyes full of tears. These people are bare, defenseless before the camera and its stunning flash. No dignity seems left them: we see their meager fly-infested meals, their soiled linen; we see them spotlit in the raptures of a revival meeting, a woman's arms frozen absurdly in the air; we see a preacher taken in peroration, his mouth and nostrils open like a hyena's.[19]

The meaning of these pictures is underscored in the captions Caldwell and Bourke-White gave them. "The legends under the pictures," they explained in an introductory note, "are intended to express the authors' own conceptions of the sentiments of the

individuals portrayed; they do not pretend to reproduce the actual sentiments of these people." The captions quote people saying things they never said. The words Caldwell and Bourke-White put in the tenants' mouths made them as abject as possible. A sharecropper with a furrowed face and watering eyes was made to say: "A man learns not to expect much after he's farmed cotton all his life." The woman on the mattress: "Sometimes I tell my husband we couldn't be worse off if we tried." The last woman in the book: "I've done the best I knew how all my life, but it didn't amount to much in the end." The last man: "It ain't hardly worth the trouble to go on living."

Caldwell and Bourke-White used ironic captions to sour the book's few "happy" pictures. A handsome smiling twelve-year-old boy was made to say: "My father doesn't hire any field hands, or sharecroppers. He makes a lot of cotton, about sixty bales a year. Me and my brother stay home from school to work for him." (And the reader was meant to think: the poor boy doesn't understand that he is being cheated of an education.) A bewhiskered man with an amiable bright eye, large grin, and no front teeth: "I get paid very well. A dollar a day when I'm working." (How low their expectations.) Negroes picking cotton: "Bringing the white-boss's fine cotton along." (They don't even realize they are exploited.) The captions, like the rest of the book, reduce the lives and consciousness of the tenant farmers to force the audience to pity them. The subjects say either "Look at me, how wretched my life is," or "Look at me, my life is so wretched I don't even know it." [20]

In the Notes and Appendices to *Let Us Now Praise Famous Men*, Agee reprinted a New York *Post* article on Bourke-White written shortly after *You Have Seen Their Faces* appeared. The article is a gushy woman's-page feature, and Bourke-White fell in with its rhetoric: she let it be known, for example, that the coat she had on was designed for her by Hollywood's top designer and called it "a superior red coat, and such fun." By putting the article in his book, Agee changed its meaning (a good example of

exposé quotation). In the context of *Let Us Now Praise Famous Men* the article makes Bourke-White appear a spoiled insensitive ninny who stooped at nothing to get a sensationalistic picture that humiliated its subject: "The striking photograph of a Negro preacher caught in the very height of his emotion and oratory Miss Bourke-White took on her knees right in front of the pulpit, the preacher's own emotion making him entirely oblivious to exploding flashlights." Agee's reprinting the article strikes one who reads the book today as a mean and gratuitous taunt. Mean it was —"vicious," Walker Evans says—but it wasn't gratuitous. One must remember the huge critical acclaim that greeted *You Have Seen Their Faces*, particularly its most sentimental features: Malcolm Cowley, perhaps the period's leading arbiter of taste, announced that the "quotations printed beneath the photographs are exactly right; the photographs themselves are almost beyond praise." The book sold excellently and went into a paperback reprint. So popular was Bourke-White's emotionalistic photography that even when she spent months of her own time, unpaid by Luce or advertisers, trying, as she said, "to do something really worth while, something lasting," she still made money. Evans' work, in contrast, was generally thought idiosyncratic, old-fashioned, cold, insufficiently reformist. While Bourke-White moved from triumph to triumph, Evans was fired by the FSA Photography Unit (in March 1937) and for years thereafter did not have a steady job.[21]

Let Us Now Praise Famous Men has many offensive things in it, nearly all of them intentional, but there is nothing stronger than the attack on Bourke-White. Evans says that Agee and he were "furious" at *You Have Seen Their Faces*, feeling themselves "outsmarted by an inferior motive." They felt Caldwell and Bourke-White's book guilty of

> a double outrage: propaganda for one thing, and profit-making out of both propaganda and the plight of the tenant farmers. It was morally shocking to Agee and me. Particularly so since it was publically received as *the* nice thing to do, the *right* thing to do. Whereas we thought it was an evil and immoral thing to

do. Not only to cheapen them, but to profit by them, to exploit them—who had already been so exploited. Not only that but to exploit them without even *knowing* that that was what you were doing.

Evans suggests that the most useful contrast between *Let Us Now Praise Famous Men* and *You Have Seen Their Faces* is of the authors' consciousnesses as they appear in the books.

You notice that Agee is saying ad nauseum almost throughout the book: "For God's sake, we must *not* exploit these people, and how awful it is if we are. And we *are* working for this goddam profit-making corporation that's paying us, and we feel terrible about it." You didn't find that in Bourke-White anywhere. Nor even awareness of the fact that she should have felt this.

Instead, what a reader feels behind the photographs and captions in *You Have Seen Their Faces* is an imagination twisting the facts to squeeze the easiest and most maudlin emotions from them; a spirit that regards its craft, its effect, rather than its subject. Caldwell and Bourke-White's book ends with a photo of a man dead in the eyes, saying, "It ain't hardly worth the trouble to go on living." One turns the last page and finds an afterword by Bourke-White: "Notes on Photographs." Her first sentence reads: "When we first discussed plans for *You Have Seen Their Faces*, the first thought was of lighting." No doubt it was.[22]

There was another documentary book on Southern agriculture, H. C. Nixon's *Forty Acres and Steel Mules* (1938), and it deserves mention for two reasons. First, it treated the matters Caldwell and Bourke-White did without emotionalism or oversimplification. Nixon, a university professor, an "Agrarian," and a sometime farmer, acknowledged the South's poverty and documented it with many photographs of "rural slums" and their inhabitants. He argued, however, that "it is not safe to generalize too freely about farm tenancy" and certainly false to say, as Caldwell had, that "share croppers and share tenants are humanly hopeless." He printed seven pictures of husky, well-clothed, unintimidated sharecroppers, most of them smiling; his caption was a question:

"Have You Really Seen Their Faces?" Nixon insisted "there are health-giving elements in Southern rural life which even ignorance and poverty cannot nullify"—a sentence that usefully contradicted Caldwell, but one that suggests the weakness in Nixon's writing. For though he claimed to base his argument on firsthand experience "among human beings on an Alabama upland plantation over a period of two decades," his prose was invariably abstract, a mixture of social science and Southern orotundity. It *said* that the tenant farmer had an interior life, but it never gave a telling example, never made the reader feel the fact.

The photographs did better, and they are the reason to consult the book today. *Forty Acres and Steel Mules* reprints nearly 150 FSA pictures, far more than any other book. A number of these are human documents and show the compensations of rural life: the closeness of families whose members work the land together, the seasonal tempo of farm labor, the home-made diversion—pick-up baseball, a dip in the swimming hole. An equal number are social documents exposing the sordid circumstances in which the poorest farmers lived. A greater number, though, are noncommittal records—"tweedle dum documents," as Edward Steichen called them. They show, for instance, how cotton was raised, hoed, picked, weighed, ginned, shipped. FSA photographs of this kind haven't been much reprinted, but as Nixon's book suggests, they are the backbone of the collection.[23]

It was not photographs like these that Archibald MacLeish selected from the FSA file to accompany his poem *Land of the Free*. He chose instead, as he said recently, "the remarkable Depression photographs": pictures of deep social relevance. Indeed, it was these that prompted him to write the poem. The eighty-eight photographs excellently reproduced in *Land of the Free* include many FSA classics: Lange's "Migrant Mother," Russell Lee's "Hands," Evans' "Graveyard and Steel Mill in Bethlehem, Penn." These, like nearly all the images in the book, are highly emotional. The narrative strategy MacLeish used to unite the photographs was that of Proletarian literature: social injustice finally overcome by men acting together. The poem begins, "We

don't know / We aren't certain," and ends, "We wonder / We don't know / We're asking." But while the people in the early photographs are confused, beaten, passive, the·people at the end, after several images of strikes and mass rallies, are belligerent, even menacing. Their questions are challenges: they may not "know" the answer to their problems, but they have a darned good idea.

Land of the Free was praised when it appeared for the way it caught the sentiment of the time. What is most remarkable in the book, its militant tone, felt appropriate then, MacLeish says, because "We were all angry." Written in the summer of 1937 and published before the 1937–38 "Roosevelt recession" came to an end, the book has the flavor of a radical piece of the early thirties because it seemed at the time that Roosevelt's flexibility might prove no more availing with the inscrutable economic gods than Hoover's rigidity and that the only recourse would be greater solidarity among the members of the New Deal coalition and greater defiance by Roosevelt of the capitalist system and its rulers.[24]

Dorothea Lange and Paul Taylor's *An American Exodus* (1939) was not made to threaten the system, merely reform a part of it. In fact the book in a sense began as field reports to the federal government. In 1935, Taylor, a professor of labor economics, was Field Director of the California ERA's Rural Rehabilitation Division and wanted to impress the FERA and the Resettlement Administration with the necessity of helping Dust Bowl migrants in the state. The migrants were traveling about the agricultural counties, working when they could, squatting in makeshift camps by the roadside without adequate shelter, sanitation, or drinking water. Taylor envisioned a series of "public camps" that would provide the migrants these "minimum decencies" and access to public services. He presented his suggestion in a novel way. He used a good deal of direct quotation—let the migrants "tell in their own words what they left behind and what they seek"—and he included photographs.[25]

Taylor said he chose a documentary method to "convey under-

standing easily, clearly, and vividly"; but he was criticized for it. His ERA boss at first refused him permission to hire a photographer, saying, "Why do you need a photographer? Would social scientists generally ask for a photographer?" Taylor agreed they wouldn't, but explained that he wanted to "bring from the field itself visual evidence of the nature of the problem" to help "those unable to go to the field but responsible for decision." His boss finally let him hire Lange on a month's trial and with the title of "typist." Before the month was over, Taylor submitted to the ERA commission a report recommending the construction of migrant labor camps. The photographs accompanying the report passed once around the table, and the commission voted $200,-000 to start the program. Taylor's boss never again asked why he wanted a photographer.[26]

His fellow social scientists were not all so understanding. Taylor's method—"to observe, then to select"—depended on his "personal observation of people in the situation to be studied." But when he brought back descriptions of individuals' lives, including their words and images, his statistician friends demanded numbers. Taylor would admit he didn't have the numbers, but add prophetically, "By the time you statisticians know the numbers, what I'm trying to tell you in advance about will be history, and you'll be too late." Taylor collected what he called "nonstatistical notes from the field" in part because he couldn't get figures about the "trends . . . where I think I see the 'future' " until the future was history. And he wanted to be "in advance" of history, influence it—not be too late, like the statisticians. That was of course the other reason he collected nonstatistical, or documentary, evidence: his method of communicating "the essentials of a social situation" brought results. Migrant camps—though not enough of them—*were* built, first in California,° then from the Pacific Northwest to Florida.[27]

Lange and Taylor tried to describe social conditions so as to

° One of the California camps was the "government camp" John Steinbeck extolled in Chapter 22 of *The Grapes of Wrath*.

change them, tried to modify the future; and more than the other documentary teams, they succeeded. When they began their collaboration, Taylor was the senior partner. Lange had been a romantic portrait photographer in San Francisco until 1933, when, haunted by the distress she saw in an alley outside her studio's corner window, she "resolved to photograph the *now*, rather than the timeless; to capture somehow the effect of the calamity which overwhelmed America." Taylor happened on a 1934 exhibit of her work and used a picture in an article on the San Francisco general strike of that summer. In early 1935 he hired her for the California ERA. In their reports and a 1935 *Survey Graphic* article on the migrants, "Again the Covered Wagon," Lange's pictures did no more than haphazardly illustrate Taylor's text, which did not refer to them. Later, when her work—done for the RA and the FSA—was nationally known, his writing did little more than provide background. It is unfortunate that their collaboration wasn't better balanced, for *American Exodus*, done in the latter period, would have gained by it. In "San Francisco and the General Strike" or "Again the Covered Wagon," Taylor's writing had an easy interplay of general and concrete:

> The struggle against unsanitary conditions, flies, and bad water is too much for many [migrants] and they give up. "I hate to boil the water, because then it has so much scum on it," said the pea-picker who drew his water from the irrigation ditch.

In *American Exodus*, however, he let the camera and the words of those photographed take care of the concrete while he generalized, often in ways tangential to the theme:

> Since Emancipation large plantations have survived more vigorously in the [Mississippi] delta than anywhere in the Cotton Belt, with sharecropping and tenancy substituted for slavery as their foundation. Today about 85 percent of the farm land is operated in plantations; the largest in the world is in Bolivar County. In county after county in the delta in Mississippi and Louisiana the colored farm population still outnumbers the white by four and five to one.

The problem with Taylor's writing in *American Exodus*, contrary to what his statistician friends thought, is that it wasn't documentary enough; it had too many numbers. As Carey McWilliams said in 1940, Taylor's text was "quiet, scholarly, dispassionate, unassailably accurate," and "not really essential." [28]

What was essential in *American Exodus*, McWilliams felt, were the photographs of the migrants and the quotes of what they said. Lange and Taylor had collected the quotes in the field and used them as photo captions. They were careful to distinguish this technique, however, from that of Caldwell and Bourke-White: "We adhere to the standards of documentary photography as we have conceived them. Quotations which accompany photographs report what the persons photographed said, not what we think might be their unspoken thoughts." The quotations have an exaggerated folk pungency:

> Hit's a hard get-by. The land's just fit fer to hold the world together.
>
> Lot's of 'em toughed it through until this year.
>
> No, I didn't *sell* out back there. I *give* out.
>
> Yessir, we're starved, stalled, and stranded.

But this dry, almost truculent, tone is both more credible and more seemly than the abject despair Caldwell and Bourke-White forced on their subjects. It is a shield against despair; it shows a people still in command, prideful, unvanquished: "I won't have relief no way it was fixed." The most desperate quote is spoken by the subject of the most desperate portrait: a tall tenant farmwife in a frayed dress made of sacking, with one hand on her forehead, the other on her neck, and her face tensed as though about to weep with rage. She says, "If you die, you're dead—that's all": a desperate statement, but a conscious denial of despair. Nonetheless, it is true that the quotations all show one kind of people, the wronged and strong—indomitable casualties of natural and economic systems beyond their control. The effect of

so many quotes saying the same thing is sentimental; surely the migrants were not *all* so tough and competent.

Lange's finest photographs are of people, and these, like the quotations, show a tendency toward the sentimental. Everyone in her portraits has character; nearly all are handsome. Yet— such is her greatness—few are simple. Again and again her people have an emotional complexity, an ambiguity, that breaks their stereotype and makes us look again. Her best portraits—the "second lookers," she called them—forbid simple response. George Elliott has pointed out how the "Migrant Mother," the subject of Lange's most famous portrait, almost *smiles* with anxiety. He notes also that her sharecroppers, rather than being "hopeless and pitiable," are shrewd or belligerent or humorous—or all of these. In short, Lange's people, like the real people they are, often surprise the viewer: a woman camping in the shade of a U.S. 80 billboard stands like a queen, her hands held six inches from her body and delicately bent back; a CIO organizer has the eye of a hired killer; a farmer who lost and left everything in Nebraska is good-humored and paternal.[29]

Lange's portraits are remarkable by any standard, and especially when one considers how they were made: in the field, on brief acquaintance (she spent less than ten minutes with the "Migrant Mother" and didn't get her name), and of subjects aware what she was doing. Her years as studio photographer stood her in good stead: she knew how to win people's confidence rapidly and free them to be themselves. But to say that she captured some of the ambiguous reality of her subjects is not to say that her photographs were not also calculated to make her point.

Consider the "If You Die, You're Dead" picture of the tenant farmwife. It is certainly a portrait less ambiguous than many of Lange's, though the woman's desperation is somewhat balanced by the force and eloquence of her gesture, the lean power of her long naked arms, and the puzzling tension in her mouth (is she going to weep or spit?). In the original edition of *American Exodus*, the woman's image is enormous, overwhelming. It covers

nearly the whole page, leaving an inch or less of margin on all sides. Moreover, her image is cropped at the waist so that she looms hugely before the viewer, presses herself and her anguish closely upon him. In the 1969 edition of *American Exodus,* this photograph, like most of the portraits, is recropped. We now see the woman to her knees, but more important, we see her surroundings: bushes, brown flat land. There is a great deal more air around her; she is a smaller and more distant figure, with large margins of blank paper on all sides. She seems solidly planted on the page, not—as in the first edition—about to fall in the spectator's lap. She is no longer so overpowering. It is appropriate that she not be. The recropping of Lange's portraits, which is similar to the revision Evans did on ten photographs in the second edition of *Let Us Now Praise Famous Men,* changes their meaning and makes it plausible to a new generation of viewers. The woman no longer is an oppressive current problem weighing on the audience. She is rather a person who behaved a certain way at a certain time, a figure in history whose hardship the viewer is incapable of easing—or a symbol of timeless sorrow. The photograph insists we sympathize far less than the earlier version does. It has acquired, or is acquiring, the coolness of art.[30]

While the woman could serve as an object of useful pity, Lange heightened the emotion of her image. When she no longer could, Lange reduced it as much as the image allowed. Not only this, she acknowledged a side of the woman that she, Lange, had kept hidden. In her 1966 Museum of Modern Art retrospective, she included with the recropped version of "If You Die, You're Dead" a second portrait never shown before. Here, in close-up, the farmwife's strong, exquisitely thin face is reposed; it glows softly white in a full warm sun. Her chin and mouth are without hardness; her thoughtful eyes, though downcast, are at peace. Pare Lorentz said in 1940 that "if Lange has any point of view, it is that she likes people. And her one desire seems to be to photograph, and record them as they are." Lange liked people, but she had enough of a "point of view" not to let this beautiful resigned

woman be seen by an audience of the thirties. In a 1971 letter
Taylor says that neither Lange nor he

> gave thought to including the second photograph in *An Ameri-*
> *can Exodus.* The [first] photograph was made at the moment
> the woman spoke the words quoted, and neither of us doubted
> that this was the one that belonged in *An American Exodus.*
> The second photograph was made *after* she had uttered the
> quoted words, and was reflective rather than tortured.

Just so. Lange's way of propaganda—a fastidious way—was
through presentation and choice of images, rather than, like
Bourke-White, through manipulation of the subjects.[31]

Lange and Taylor were justified in feeling theirs "a pioneering
effort to combine words and photographs." But with *American*
Exodus, the pioneering days of the documentary book were al-
most over. From 1939 through 1942 eight others appeared, all
negligible save *Let Us Now Praise Famous Men.* Five of these
books were authored, edited, or had their pictures chosen by
Edwin Rosskam, a photographer and entrepreneur of photos.
Four of Rosskam's books appeared in the short-lived Face of
America series (1939–40). In *Washington: Nerve Center* (1939),
Rosskam explained that the series was built on a "clean cut defi-
nition of the role of two media—the word and the image." He be-
lieved that "neither the writer's paragraph nor the pictorialist's
composed rectangle" sufficed any longer and the "new unit" of
composition was the "double-page spread" in which word and
image collaborated but did not duplicate. "These are books," he
said, "without word pictures and—to the extent I have been able
to make them so—without literary photographs." Such was his
pledge, yet the series' most perceptive combination of word and
image disobeyed it. Rosskam's *San Francisco* (1939) had a photo
of two businessmen before a thirties mural in a fashionable res-
taurant, and beside the photo a caption describing the mural:

> A gigantic female, husky enough to lift a truck, embraces a
> somewhat puny and frightened world. Her blue and vapid eyes
> are undisturbed by the clatter of a mining drill around her hip.

A two-ton redwood stump reposes snugly in the crook of her
elbow. Out of her ample bosom, a young man in a sweater and
slacks sails toy airplanes. Her left hand contains fruit salad.

The caption, which expresses the same facts and the photo but in
a different medium, forces a reader to really *look* at the mural for
the first time and to perceive how absurd the WPA style could
be. Despite what Rosskam said, the "word picture" still had its
uses.[32]

Rosskam's "double-page spread" with photo and text intermin-
gling was patterned after *Life*. But the photographs he used, un-
like the magazine's, had not been made to tell the story he had
them tell, and they seldom told it well. The photos came from
the FSA file, and Rosskam chose them because he knew the file
(he had been in charge of exhibits), and because the photos were
good and, more important, being public property, were free. His
double-page mania led him to shuffle word and photo together
indiscriminately, with little regard for their tone or content—
"lay-out becomes master," he proudly confessed. One can see this
in Sherwood Anderson's *Home Town* (1940) and, even more,
Richard Wright's *12 Million Black Voices: A Folk History of the
Negro in the United States* (1941), for both of which Rosskam
chose the photographs and did the make-up. The texts, which
were written without their authors knowing what images they
would accompany, are perforated at odd moments with pictures
meant to mean what the context would have them mean. "Our
Strange Birth," the first chapter in Wright's book, begins with a
full-page reprint of Lange's "Hoe Culture," a close-up of a ragged
farmer's arms and hands holding a handle. "Strange Birth" in-
deed: the man is plainly a white. Readers were supposed to ac-
cept him as black, though, because he was poor and agricultural
and the book discussed the hardship of "the black sharecropper."
In *Home Town* Rosskam printed a Marion Post photo of cars on
a snow-covered Vermont street and appended this caption:
"America must keep rolling." That was a message many people
wanted to put across in the late thirties and early forties. But it
had no relation to what the photo shows, and none with Ander-

son's text. As Walker Evans says, the caption is "meaningless," a "typically stupid and cheap use of the work" the FSA photographers did; it "degrades the picture." So in general did Rosskam's books. He used many photographs, some of them first-rate, but he stripped them of their integrity by insisting on just what they should mean.[33]

Badly presented though they are, the photographs still are more interesting than Anderson's text to *Home Town*. He wrote this description of small-town life at a moment of sudden and profound reverence for things felt to be quintessentially American and jeopardized by the war in Europe. Nevertheless, one might suppose that the author of *Winesburg, Ohio* would judge the small town with a certain shrewd coolness. Anderson begins by saying he has just answered a letter from a young man who wanted to go to New York because he "feels cramped" at home and "feels that he must get among other intellectuals, bigger people than he finds in his home town, people with bigger thoughts, vaster dreams." And Anderson, the creator of George Willard, an avatar of the young man, says he told him not to budge: "I said to him, 'Why not Oak Hill? What's the matter with Oak Hill?'" In *Home Town* the writer who preached freedom to a generation of American intellectuals speaks warmly of "staying put," "staying closer home," "thinking small." "Lincoln would still have been Lincoln had he never left Springfield," he says, adding that Springfield was then a small town. Anderson viewed "the Oak Hills, the smaller scenes" through a miasma of sentimental nostalgia.

> It may be that, after the beginning of . . . a friendship between two small town young men, one of them later goes away to some city, but he will never forget his small town friend. . . . As a city man, he will never again form another friendship that will mean to him quite what his remembered small town friendship meant.

As Anderson pictured it, the American small town was an Eden without conflict:

> The town boy grows up, suddenly becomes a young man, begins going about with a small town girl, takes her to church and to dances and to the moving pictures. He takes her for a ride in the evening in his father's car and presently they are married. They have children. The small town man reads a city newspaper, listens to the radio. He is a Democrat or a Republican.

And without the source of conflict, individuality. People in the town either are simply virtuous, like the washerwoman who "will work her arms off, she says, rather than go on relief," or they are innocent, like the lawyer who, for reasons unknown, is a helpless slave to the bottle. All are fundamentally decent. The "awkward country boy" who gets a girl in trouble says, "Oh well, I guess I better marry her, but gee, I made no promises at all." The two young men who formed the undying friendship once "went together to a nearby larger town. There was something they both wanted intensely or thought they wanted. They went together to a certain notorious house, stood trembling and ashamed before the house and then came away." Not only were the boys too good to have prostitutes, so was the town.[34]

Wright's text to *12 Million Black Voices* was as sentimental as Anderson's, though in an opposite way. Where Anderson described the American small town as Eden, Wright described the Negro's life in the United States as unmitigated hell. The one exaggerated and emotionalized as much as the other. Consider Wright's paragraphs on the middle passage of a slave ship. He has said that in the seventeenth century men-of-war hunted slavers to stop their trade.

> We captives did not know whether to feel dread or joy when a man-of-war was sighted, for the captain [of the slave ship] would command that a few of us be pitched alive into the sea as moral bait to compel the captain of the pursuing ship to desist from his duty. Every mile or so one of us would be bound to a cask or spar and tossed overboard with the hope that the sight of our forlorn struggle against the sea would stir such compassion in the captain of the man-of-war that he would abandon pursuit, thereby enabling the slave ship to escape.

At other times, when we were sick, we were thrown alive into the sea. . . . At still other times we went on hunger strikes; but the time allotted us to starve to death was often too short, and the ship would arrive in port before we had outwitted the slave traders. The more ambitious slavers possessed instruments with which to pry our teeth apart and feed us forcibly. Whenever we ᴄould we leaped into the sea.

Wright's Negroes are both piteously weak and improbably heroic. They are thrown, bound, into the sea (Wright repeats the incident to be sure the reader catches its full pathos), and "whenever" they can, they throw themselves in the sea. Wright's use of the first person plural conflates the present with the past so that all American Negroes of all time are made to share his opinions (Saunders Redding said he agreed with practically nothing in the book). Wright's history, in deliberately ignoring the reality of the past, promulgates such dubious analogies as that between "the slave traders" and "our contemporary 'captains of industry' and 'tycoons of finance.'" His whole effort is to shock, touch, enrage his audience, as he was enraged, and he used any means to this end.[35]

The other documentary books of the time celebrated America and its people's great diversity and greater unity. These books included Oliver La Farge and Helen Post's *As Long as the Grass Shall Grow* (1940), Caldwell and Bourke-White's *Say, Is This the U.S.A.* (1941), and Eleanor Roosevelt and Frances Macgregor's *This Is America* (1942). The first of these books was on the American Indian and his acculturation; the other two treated many minority groups and subcultures. All three, like *Home Town*, were sentimental; the latter two were explicitly patriotic. The strategy behind these books was simple. Caldwell and Bourke-White showed ROTC enlistees, Kansas silos, Negro schoolchildren in Mississippi, B-girls, Future Homemakers of America, a small-town editor, Chicago steelworkers, the Statue of Liberty, and much else; Roosevelt and Macgregor showed a Vermont farm, a Pacific beach, a Negro, an Indian, a German-American, a synogogue, a refugee, the main street of Hingham, Massachu-

setts, a plane spotter, and much else. Everything shown was a handsome specimen of its kind, and all were—the books insisted —fully and faithfully American.

> America is composed of all the races, and Herr Goebbels has told the Germans that there our weakness lies. With so many racial types existing in the United States, the social tension, he prophesies, will tear us apart. And Hitler is sure that he can foist revolution on us because of our wide variety of religious beliefs and racial origins.
>
> Herr Goebbels, Herr Hitler: you have pointed out not our weakness but our strength.[36]

This unity-in-diversity-as-strength theme would become the central strategy of America's entertainment, propaganda, and reportage of World War II. "Dolan and Spaulding, MacCaffray and Coccimiglio, Vafides and Cohen, Antoine and Bjorklund"— such lists occur throughout the period's fact and fiction. These might be the names from an Army platoon in a movie, or the bomber squad in John Steinbeck and John Swope's documentary book, *Bombs Away: The Story of a Bomber Team* (1942). They might appear in a piece by Ernie Pyle or John Hersey that mused about the heroic boys who carried the American cause up the spine of Italy or into the valley of a Pacific island. They might be the names of a group of soldiers and sailors whose stateside furloughs were documented in *Life*.[37]

In fact, however, these were the names of high school boys playing "on the same football team, all on one side," in *This Is America*. The caption to their game photo was headed: "All Nationalities Play Together." And their play gave a picture of how the American people imagined they went to war: all their "nationalities" blended like that improbable amalgam of Welsh, Scot, Irish, and English in *Henry V*. This early list has the germ of most important stereotypes in our World War II literature: Dolan and MacCaffray, fun-loving faithful Catholics, one of whom dies, with last rites, in the fourth reel; Spaulding, the spoiled college draftee who learns to suffer and serve others;

Coccimiglio, a timid city youth who hates Fascism and who has an uncle in Italy who hates Fascism, too; Bjorklum, the tall fair-haired slow-thinking farm boy who can't get comfortable in G.I. boots; Valides, the dark dapper womanizer who, when not in the stockade, wins a dozen medals for bravery; Cohen, the Brooklyn Jew who is radioman or navigator, wears glasses, and has the funny lines.[38]

Like a great deal of thirties literature, the documentary book began as a way of calling attention to America's failures and ended by celebrating its successes.

CHAPTER 13

Documentary
Reportage:
"Conservative"

The same transition from criticizing America to celebrating it may be seen in thirties documentary reportage. Nathan Asch reviewed John Spivak's *America Faces the Barricades* in September 1935 and said:

> It is a relief to get some news about America. New Yorkers are kept much better informed about the state of mind this week in Abyssinia, about what is happening today in Moscow, in Madrid, than they ever get to be about the great Pacific Northwest or the Ozarks or the Cotton Belt. . . . So that when a purge occurs in Germany everyone understands it and has almost predicted it, but when a general strike is called in Terre Haute, people are astounded. And when an Erskine Caldwell or a John L. Spivak actually does go out and look for his America, the act itself is so unusual that it's a sensation.

Two months later Ferner Nuhn, a writer doing field reporting for the AAA, reviewed *Some American People,* Caldwell's account of what he found traveling the U.S. from coast to coast, and seconded Asch. "There should be more books like this," he said. There were to be scores of them.[1]

Asch and Nuhn were responding to a new tone, a new style,

they sensed in the documentary writing of the mid-thirties. There had been documentary journalism in the preceding years, including reports from the hinterland: "Letters from America," "Farm Sketches—from Kansas to Oregon," "Tragic Towns of New England," "Drought: Field Reports from Five of the States Most Seriously Affected." But these articles, as we saw in Chapter 10, concentrated on economic conditions; when they tried to capture what Asch called the people's state of mind, they simplified it into pathetic helplessness or incipient rebellion. The writers of this reportage were radical in outlook: they respected the Soviet example, not the American. Indeed, to judge from what they said, they had no special affection for the United States nor, often, democracy. In 1932 Edmund Wilson declared with a grim kind of pleasure: "Karl Marx's predictions are in the process of coming true. . . . The money-making period of American history has definitely come to an end. Capitalism has run its course, and we shall have to look for other ideals than the ones that capitalism has encouraged." Capitalism's ideals, the values of the "old-American-stock," Wilson discarded in a sentence: "Any validity they may have had is gone and they never were very profound in the first place." He put his faith in "cool-headed revolutionaries" who "are not democratic in the old American sense." James Rorty called for a government of the Left to stop the drift he saw toward Fascism; such a government should begin, he thought, by doing away with "the democratic dogma expressed in the phrase 'We, the people.' We have never had in this country any such identity of interest as is implied in that first person plural." The radical reporters of the early thirties looked at America, Donald Davidson believed, to find "details to fit the Marxist notion of what America should look like." Certainly the country they found, as they described it, was a harrowing one of despair and suffering, apathy and rage—one that still looked, Alfred Kazin said, as it had in March 1933, with all the banks shut and men milling on street corners. These reporters studied America, in brief, because they wanted to change it, and change it drastically.[2]

In reviewing Spivak's book and, five months later, Rorty's *Where Life Is Better,* Asch tried to define another kind of "news about America" that reporters might give. This news would not be harrowing, like news of Europe or of misery at home; it would be "a relief." It would inform its readers about larger and more durable facts than a given family's hardship—inform them, for instance, "about the great Pacific Northwest or the Ozarks or the Cotton Belt." It would describe not the astounding events that happened to the people of a region (a general strike, say), but rather the people's state of mind, their character, "that thing in them which is so typical of them that it's not news to them." This reportage, unlike Rorty's, would strain to be "humble enough to get to see America." That would be its aim: to document America and not just economic conditions. The reporter would "look *for*" America, not merely look at it to find facts that supported his theories. The America he sought would be personal, "*his* America," and perhaps eccentric.° He would not cut or contrive it to fit anyone else's notion of how the country should look, but neither would he insist on promulgating his idea. Rather he would leave it "up to the reader to draw his own conclusions." [3]

It was plain, though Asch didn't make the point, that the chief end of such reportage would be descriptive, not instrumental. A reporter would go "in search of America" (the subtitle of Asch's 1937 book documenting America) to locate and define it, not to change it. Necessarily his writing would express different values from the earlier, radical reportage. It would tend to perpetuate the status quo, a fact radicals of the time were quick to notice and deplore. Indeed, there is a sense in which the status quo *was* its goal. For the documentary reportage Asch tried to define was

° Americans internationalized the idea of the personal nation. *Death in the Making,* Robert Capa's 1938 documentary book on the Spanish Civil War, said .that each man fighting for the Loyalist cause "had to discover *his* Spain." Kurt Schuschnigg, Chancellor of Austria until the Anschluss, wrote a memoir in 1937 under the title *Dreimal Österreich.* In 1938 this was translated into English and published in Great Britain as *Farewell Austria* and in the United States as *My Austria.*

fundamentally conservative in the same way the New Deal was. The New Deal's central motive, historians agree, was to preserve the American socioeconomic system by reforming it. The documentary reporters of the latter thirties were interested in reform and propagandized for it. But their primary emphasis was on what they felt to be constant and valid in American experience. All would have said, as Louis Adamic did say in *My America* (1938): "I want America to remain America." [4]

The idea of looking for America was an old one. Walt Whitman had suggested that America was not a place but a condition to be sought, a relationship endlessly lost and found. In *Our America* (1919) Waldo Frank wrote sentences that could stand as epigraph to the entire documentary movement of the later thirties: "We go forth all to seek America. And in the seeking we create her. In the quality of our search shall be the nature of the America that we create." The idea was old, but always before it had been a metaphor. During the thirties it became literal: hordes of writers and intellectuals actually traveled around the United States. One of them, Anita Brenner, remembered that as early as the summer of 1935

> there were quite a lot of us riding around the country at about the same time, in search of the same information. We pulled in and out of industrial centers, spent many days in small towns, hung around CCC camps and other federal projects, stared appalled at the shanty settlements and cabin villages of our pariahs—Negroes, Mexicans, poor whites . . . picked up all sorts of people constantly, and listened and listened and listened.

As we have noted, it was thus, at firsthand, as lived experience, that meaningful information and "real" education were then thought to be acquired. Chatting with a friend in 1939, Franklin Roosevelt mentioned the advice he had given a young New York college grad who thought he knew it all.

> I said, "Take a second-hand car, put on a flannel shirt, drive out to the Coast by the northern route and come back by the south-

ern route. Don't stop anywhere where you have to pay more
than two dollars for your room and bath. Don't talk to your
banking friends or your chamber of commerce friends, but spe-
cialize on the gasoline station men, the small restaurant keeper,
and farmers you meet by the wayside and your fellow automo-
bile travelers."

Roosevelt didn't spell out what the trip would teach the young
man, but the listener knew: the rich heterogeneity of his nation;
the wisdom of the people; and, not least, some humility—though
the shirt was of flannel not of hair.[5]

In the thirties countless reporters and social analysts went on
the road in search of America, and they began a genre—the "I've
seen America" book—that continued a generation later in, for ex-
ample, John Steinbeck's *Travels with Charley: In Search of
America* (1962), Erskine Caldwell's *Around about America*
(1964), Bill Moyers' *Listening to America* (1971), Calvin Trillin's
U.S. Journal (1971)—and, on TV, Charles Kuralt's spot documen-
tary series *On the Road* (1967–). The genre's ground rules are
nowhere more clearly set forth than in Caldwell's introduction to
his *Some American People* (1935). Caldwell here accuses Ameri-
cans of not knowing how to travel, of "confusing travel with sheer
motion" and "Grand Views." These errors he debunks:

> There are no memorials, vistas, or landmarks anywhere between
> the Atlantic and Pacific worthy of going fifty miles to see. . . .
> What is worth traveling thousands of miles to see and know are
> people and their activity. . . . By visiting sections of the coun-
> try, such as the cotton states, the Northwest, and tight, indus-
> trialized New England, the stories of its people will be found in
> ever changing versions.

Caldwell argues that since the purpose of travel is to gain "a
sympathetic understanding" with other people, it doesn't allow
for "exhaustive study" of social conditions nor provide "a surprise
package of plumed panaceas." [6]

Some American People did in fact offer plumed panaceas; it is
a hybrid of thirties documentary reportage, part radical, part

conservative. Long chapters detail the lives of Southern tenant farmers and industrial workers in Detroit, and the author suggests that their hardship demands the replacement of "a profit system that should have no foothold in modern civilization." But in "Cross-Country," the book's first section, there is much less propaganda. "Cross-Country" is a series of twenty-four vignettes Caldwell collected while traveling from Oregon to Maine. His bias against his "selfish civilization" and the profit motive appears in many sketches: the one time anger overcomes the fine mildness of his prose is when a restaurant serves him bad meat because it "can't afford to throw a spoiled T-bone into the garbage." Caldwell disapproved of the capitalistic system and loathed its anonymous masters—"Henry I . . . the father of Modern Detroit," for instance. But when he met a live capitalist face to face, his sympathies were such that he would not only acknowledge the man's humanity but usually take a liking to him. This is the best thing in Caldwell's reportage: the struggle of his fellow feeling against his ideology.[7]

In the vignette "Our Garden of Eden" he portrays a wealthy Iowa farmer who winters in Long Beach and whose frivolous children are in Europe. It would be easy to make such a man a caricature of capitalistic waste and insensitivity. Caldwell did not. Though he disliked the man's values, he didn't pervert his character. The farmer comes across a credible and sympathetic human. He didn't think his children frivolous; on the contrary, he was proud of them and encouraged them.

> I wrote a letter to my boy in France just two nights ago, telling him not to worry about having enough money to keep him in good style. He's been living over there in Paris for two years now, and he's getting along fine..He's taking up writing for a career. . . .
> I've got a girl traveling in that part of the world, too. . . . The last letter I had from her said she was interested in a foreign fellow she met in Italy. I couldn't figure out from the letter if it was anything serious or not, but you never can tell what will come of it.

One hears the man's affection for his children, but also his willingness to let them do what they please. The farmer was similarly sensitive to his own good fortune and the hard luck of others, though he treated both in a joking tone: "I've been reading accounts of the drouth in all the states surrounding us, and I'm pretty well up on the subject. The whole trouble is that people made the mistake of settling down in the Dakotas, Nebraska, and elsewhere, instead of settling down in Iowa." Actually, the southern third of Iowa had also suffered a drought year, and the farmer said, "It's pretty near a disgrace to have a dozen or so counties down there living on Federal emergency relief." But he meant it was a disgrace to his Iowa pride, not to his economic morality. He was in favor of the government's helping those who needed it, and he wished all might share his luck. Several days before he had given a thousand dollars to his church's foreign mission fund because "every time I start thinking about the heathen Chinese over there in China I feel it my duty to give what I can in the way of money." The charity was an unimaginative one perhaps, but this man, within his limits, was not: he actually thought about others and tried to help them. He was well meaning and generous, and Caldwell, though he didn't care for the system that made the farmer rich, nonetheless allowed *him* his virtues. In Caldwell's best reportage—unlike, say, Rorty's—propaganda was moderated by a fairly complex humanity.[8]

Caldwell was not, however, the first reporter of the thirties to travel America and document what he found without trying to change it radically. The first was Sherwood Anderson. In November 1933 Anderson wrote an extraordinary letter to Raymond Moley, adviser to President Roosevelt and editor of the new weekly magazine *Today*. Anderson wrote Moley because he had a suggestion and "some timidity about making it directly to President Roosevelt." His suggestion was that Roosevelt speak to the people, via radio, at least once a week. He thought there was an "inevitable isolation of any man in high position" and that Hoover's failure had been his not having overcome it and talked to

the American people "man to man." He, Anderson, used to wish "that President Hoover could come away from the Presidency for a few months and ride about America with me in my little car, talking man to man with workers, men out of work, country merchants, country lawyers, farmers, bums, small capitalists—well you know—with Americans just as they are." Thanks to the radio, Roosevelt "more than any man who has been President within the memory of any of us now living . . . has made us feel close to him," Anderson said. But he felt the President would "gain something very real by making talks to the rest of us over the radio a regular part of our lives." The President would gain "a sense of intimacy with many people—the listeners," and so be cured of his loneliness. The listeners, in turn, would know him and his job better. The interchange would "help to give us what just now we are all crying out for. That is understanding."

Today published Anderson's letter, and Moley replied to it in a note printed alongside. He didn't speak to the question of weekly Fireside Chats; instead, he agreed that the President had to explain himself to the people. "But the people," Moley continued, "must explain too, and be heard. The President and those in high office hear flattery and special pleading. They read what Washington newspaper men write. But they know nothing of what the farmer says to his neighbor when he meets him in the morning on his way to the corn field, or in the afternoon when he meets him in the village. . . . I wish you would help us make these people's ideas heard," Moley told Anderson, extolling him as a great reporter with "no axe to grind, no cause to promote." And Moley picked up the idea of the trip Anderson had wanted to take Hoover on, adapted it, and expressed it in a reverential tone similar to Anderson's: "Go out through the states as Walt Whitman used to and talk to people and write what they say and what you think of what they say, in the form of letters to *Today*. We will print them. That is our way to promote 'man-to-man' understanding." [9]

Anderson's letters to *Today* started to appear the next month

and were republished, slightly altered, in *Puzzled America* (1935). His articles reported firsthand on the lives of "mill workers, tenant farmers, the unemployed, the plain, simple people of the United States," as the radical journalists had been doing. But his tone was different. Where the radicals were outraged, bitter, dogmatic, he was calm, bittersweet, confused. " 'Puzzled' America is right," the reviewers said; "and Anderson seems as much puzzled as any of his subjects." He conceded as much on every page, once saying, "You, the reader, must imagine the writer as going about constantly puzzled as you are." One reviewer, Hamilton Basso, argued that such a tone was appropriate: "Any person who goes out into America in this year of disgrace, seeing the country as it is and not as he wishes it to be, can hardly return without some mild puzzlement at least. The only persons immune to it are those who go equipped with a political philosophy that makes the future foreordained." Anderson was no political prophet, Basso said, "but he can see what lies under his nose (which is a kind of far-sightedness not to be discounted too lightly)." Donald Davidson felt that Anderson's "realistic" eye and lack of "doctrine" proved his natural affinity with the Roosevelt administration and suggested he was "the unofficial Poet Laureate of the New Deal." [10]

Like the New Dealers, Anderson expressed his belief in America and democracy. Most of the people he encountered did too —or they voiced "a willingness to believe, a hunger for belief, a determination to believe." They said, "Let's give this democracy thing another whirl." Or they said, "If some one man can go through with it—a Roosevelt or some other—if he can lead us into something new—the workers have a real chance—if he can do this without terror of revolutions—it's worth a shot, isn't it?" Or they said, "I want belief, some ground to stand on." This faith or wish for faith in America was Anderson's only firm conclusion, "the absolute net of what I have been able to find out about Americans in these last few years of travelling about."

All other generalizations—and they were many—got contra-

dicted. For example, Anderson noticed that Americans out of work, if kindly spoken to, would begin apologizing for their failure and blaming themselves. One such man thought the well-to-do

> would presently pass a law. He said he expected it would be done, that he looked forward to seeing it done. He said he thought that the poor and the unemployed in America would have to be killed. It was, he thought, the only way out. . . .
> "But you would be one of the first to be killed," I said.
> "I know, but," he said, "you see I haven't succeeded. I don't believe I ever will succeed," he said. "I might as well be put out of the way."
> It is, as yet, I suspect, about the average American point of view.

That was the average view at one moment, yet not many weeks later Anderson remarked that rich and poor Americans alike shrank from the idea of revolution.

> Anything like revolution means to the American mind just one thing. There is the picture of men standing, with their backs to a wall, in the act of being shot. Your average American doesn't think of himself as being one of those who are doing the shooting. "It would be just my luck to be one of those standing there, with my back to the wall."

Anderson knew he contradicted himself—even joked about it. On the book's first page he said he was trying to be as "impersonal" as he could; on the second he said, "I cannot take the impersonal tone. It will not do any more." [11]

The strength of Anderson's reportage lay precisely in his readiness to be inconsistent, disconnected. Beyond an amorphous faith in America, he had no political convictions, and his writing suggests that Robert Cantwell was right in feeling that "a loss for politics is journalism's gain. A line, a theory, a conviction may give direction to a work; lacking one, or holding one unclearly, a writer tends to turn over his material more closely, finding journalistic liveliness in it." The liveliness Anderson sought was not

journalistic but real: little, particular truths. Harvey Swados has remarked that Anderson's writing has virtues that baffle the critics and endear him to countless readers. The prime virtue is evident on each page of *Puzzled America*. Consider the beginning of the chapter "A Union Meeting":

> I went to a union meeting in a mill town. Most of those in attendance were out of work. Every one wanted to talk, and many did. . . . The real leaders are seldom speech-makers. In an amazing number of cases just now, they are rather small, sincere, determined women. Going about among union men and women in America gives you a curious respect for women. They have nerve.

One notices first the writing's most salient quality: its clearness. One understands each sentence instantly, without reference to the others. The sentences seem deliberately simple and short, as though an effort to complicate or subordinate clauses would falsify experience. One notices also that the sentences, for all their clearness, do not quite hang together. "*The real leaders are seldom speech makers.*" No one said they were. On the contrary, Anderson said, "Every one wanted to talk, and many did." "*Going about among the union men and women of America gives you a curious respect for women.*" Why "curious"? If they are the leaders, they deserve unabashed respect. "*They have nerve.*" The point had been made, but iteration encourages the reader who had started to worry that he didn't understand what Anderson was driving at.[12]

The chief quality in Anderson that attracts readers is, in short, his solicitude; he takes care to be easy reading. We feel behind his sentences a mind working to put the facts simply for us—the "you" he addresses so often. If it is true, as E. B. White estimates, that most readers are lost half of the time, Anderson's readers are lost much less. He is always throwing them a rope: "I am in the country to try to find out something. I am asking questions. For the moment I am a reporter. Here is what I have found out." His technique was well adapted to his Depression theme. For in

order to make each fact clear, he separated it slightly from the others—and the resulting style embodied his meaning. Content and form both describe a world in which things don't quite hang together, in which there are odd discrepancies between the good will and humanity of each individual and the unfathomable harshness of the system in which all live. Anderson's prose shows a world unglued, an America that puzzles because it is itself a kind of puzzle.[13]

His America, like the America of the Guide Series, was many lands. It didn't prove anything simple, didn't cohere in one myth. Basso remarked that what Anderson did was to say, "Here is our contemporary America. Make of it what you can." This was the excellence of his reportage, but also its weakness. For he shrugged his shoulders and gave up too easily and too soon. He insisted, as James Agee did, that reality was untellable—"I am writing from the coal-mining country. There is too much to tell. On every side of me there are stories. . . . I should not be writing . . . America is too vast"—but unlike Agee, he did not then work supremely hard to tell it. He did not turn over his material closely enough. He claimed that it was not simple, and yet he always simplified it by refusing to elaborate its complexities. He simplified most obviously when, like all "I've seen America" writers of the time, he sentimentalized his subject, the American people.[14]

Not all documentary writers of this school refrained from trying to make a single myth about America. Nathan Asch did not, and his *The Road: In Search of America* (1937) is an instructive failure. Asch, the son of the Yiddish writer Sholem Asch, had published four novels when, in 1935, he bought a bus ticket several yards long and set out to "see all of America." He believed that if only he saw enough a pattern for the book would take form because "one part of the country would explain another part; cities would explain farming communities; individuals would become symbols for many people," and all of it "would fuse, synthesize into a clarifying whole." Malcolm Cowley has

pointed out that such an Emersonian belief in "an all-pervasive design" which unifies disparate experience was characteristic of thirties writers under Marxist influence, for whom the design was the class struggle. And it is significant that Asch, whose reportage dealt with "the private histories" of anonymous apolitical people, had to bring in a political—and Marxist—cliché on the next-to-last page of his book to give it a pattern: he said he wanted a million hands to grasp the "death" inside America's workers

> and tear it out and show it was not death, it was not defeat; it was want that was fought and struggled against daily; and since it was not some exceptional, unique, exotic want, but usual and everyday and common in its suffering, it united them all and some day it would by all of them be fought together, vanquished.

The desultory prose suggests how little Asch believed his own conclusion.[15]

One reviewer was persuaded by Asch's "failure to 'find' America" that any such report would be inconclusive: "A thing like a country may be lived in or theorized about but . . . in the end it must remain . . . inscrutable." What was truest in *The Road*, as in all "I've seen America" books, was the life experienced, not the lesson drawn from it.[16]

The center of life in the book is Asch himself, his consciousness. The book's severest critic, Christopher Lazare, thought Asch "distraught, inaccurate, and often offensive: facts are distorted, obfuscated, and lost in the author's sobs and sighs, and a widespread social condition is reduced to the terms of his personal hysteria. The reader becomes more and more aware of the author's emotional state." Identical charges were later directed at James Agee (whom one reviewer thought "in a much more tragic condition than any exploited sharecropper") and for similar reasons. Lazare criticized Asch because Asch expressed emotions Lazare preferred to hide or deny. Asch clutched impulsively the hand of a Negro sharecropper; he kissed the hands of a poor Chi-

cago girl whose highest dream was of becoming a taxi dancer, and said to her, "Forgive me, my sister" (Agee would contemplate such gestures, but refrain). The social condition that Lazare felt Asch reduced to personal hysteria was tenant farming. Here is the "hysteria": Asch, unable to sleep, thinks about the sharecropper life he has seen.

> If I could understand cotton, and hate; if I could only place inside of me the want I had seen and make it my want, live day after day and month after month and year after year in constant privation and know that there was no relief, no balm anywhere, nothing about me but loathing and nothing before me but death.
>
> Or if I could only not care and sleep quietly.

Lazare disapproved of both alternatives, the second because it was socially irresponsible, and the first because Asch tried "to take upon himself the guilt of an entire social system."

Asch and Agee both had feelings of intense guilt before the socially underprivileged. Both acknowledged the feelings, and each strove—Agee more in imagination than act—to abase himself and "feel what wretches feel." An optimistic liberal of the time, Lazare deplored such feelings and behavior. He wanted a social analyst in the tone of the magazine for which he was writing, *The Nation:* a hard-headed reformer who fought the good fight without losing a good night's sleep; a social worker who never condescended to become, even imaginatively, his cases; a practical New Dealer who believed wrongs can be righted, not that privation had "no relief, no balm," even as human experience had none. It is true that Asch didn't make a forceful, nor even a frank, argument for the tragic vision of life. But despite the temper of the time, such an argument could have been made, as Agee proved.[17]

From 1938 until the war began, "conservative" documentary reportage was at zenith. The "I've seen America" book, a novelty in 1935, became the dominant nonfiction mode. Writer after writer told how, when, and where he "discovered" America, how

"knowing" the country (that is, traveling it) provided his most vital education, and what America meant to him. The reportorial method was Sherwood Anderson's: a compilation of extraneous firsthand impressions, with repeated disclaimers to any general truth. Each writer insisted he spoke only for himself and from his particular experience; each admitted cheerfully that other people not only might but inevitably would disagree. Jonathan Daniels in *A Southerner Discovers the South* (1938) speculated that "there are as many Souths, perhaps, as there are people living in it"; and Louis Adamic asserted confidently, "Each of us living in the United States has his own America." °18

This America could be any event, artifact, or condition that was decent and commonplace: during the war, correspondents reported that G.I.'s, asked what the America meant that they were fighting for, said it meant baseball on Sundays, dry socks, a kid brother riding a bike with no hands, a piece of apple pie "with a few raisins and lots of cinnamon: you know, Southern style." This America was inexpressibly rich and diverse, as hard to pin down as Proteus; it could not be known better, only *more*. Far the best-selling "I've seen America" book of the thirties was, significantly, far the longest, Adamic's *My America*, which Malcolm Cowley thought "as loose and patched and formless as a tenant farmer's overall. . . . A hodge-podge, a chowchow, a mishmash." Cowley felt there was "more real order in American society than there is in Adamic's book about it," and accused him of refusing to put his experience in "any intelligible pattern." But a lack of pattern was the pattern of choice: it emphasized the values felt to be most American, precious, and threatened—freedom and democracy. A man could pick any America he pleased, and

° Writers told about "their" Americas, sometimes in ways of general interest. Duell, Sloan and Pearce began the excellent *American Folkways* series under the editorship of Erskine Caldwell. This series had writers document the region of America they knew best, and included books by Meridel Le-Sueur (*North Star Country*), H. C. Nixon (*Lower Piedmont Country*), Oscar Lewis (*High Sierra*), and Carey McWilliams (*Southern California Country*).

one man's America was as valid as another's. Cowley himself, disillusioned with the Marxists' all-pervasive design, took up the pattern of patternlessness soon after he panned Adamic's book. By 1941 he was comparing America to the "lost world" of Atlantis, an especially favored location where "very ancient animals continue to flourish":

> Henry Ford and Norman Thomas, Oswald Garrison Villard, Senator Taft, General Wood and Comrade Michael Gold. These prehistoric monsters are not friendly to one another. . . . But all of them were produced by the same conditions and depend for their survival on the same biological environment. . . . All of them, however much they differ on other subjects, are determined to believe that their lost world will continue to exist.[19]

Each "conservative" documentary writer said he spoke only for himself, yet all said the same thing: America must be saved. In a time of foreign peril, the country's virtues, its basic rightness, were recognized on every hand. "Democracy is something we don't talk about much except when we are in trouble," said Theodore Dreiser in *America Is Worth Saving* (1941); in the years before the war, our writers talked of little else. Dreiser felt democracy was "the American plan" to lead the nation from error. "There is so much wrong with America at the present moment," he wrote, "that it is a source of constant amazement to me that room remains for so much that is right." The reportage of the time documented what was right, and in a tone of "constant amazement." Formerly this tone of wonder had been used to describe the U.S.S.R.:

> The thing to remember about the Soviet Union . . . is that it exists. The thing to remember is that for the first time in human history a socialist society has been brought into existence.
>
> That is a fact that you cannot easily get over. You can argue for ever as to the merits of this socialist society, but you cannot argue away the fact that it exists.

Now it was applied to America:

> Have you ever tried to see the entire United States of America at one look? It is an unforgettable experience. For there is no denying it: the United States is something amazing.
> It is difficult enough, first of all, to accept the simple fact that the United States continues to exist.

The miracle of existence had been brought home.[20]

The tone of awe and amazement often took on a religious color. The reportage was then a form of benediction. Writers sought out anyone who might plausibly embody America's past and without presumption bless its future. Necessarily the people they chose were the very old. The last person described in Benjamin Appel's *The People Talk* (1940) is a Virginian born during the Civil War whose grandfather talked with a man who fought in the Revolutionary War. The Virginian himself reminded Appel of "George Washington come to life again, a plainer George, an older George, but of the same stock. 'That was fightin',' he says as if the Revolutionary War were only yesterday." And he expresses confidence in future American triumphs over tyranny. George Leighton's *Five Cities* (1939) began with a short prologue which Clifton Fadiman thought the finest thing in the book. Fadiman confessed that "these few pages, in which a dying ninety-four-year-old frontier woman has her last say about her country and yours, quite literally made me catch my breath." He was so moved because the woman chose to spend her last minutes on earth slowly whispering the political banalities everyone wanted to believe:

> "The world," she said, "is in dreadful torment now." The clock on her dresser could be heard ticking. "I hear a great deal of criticism of the President. Do you?"
> Her grandson nodded.
> "Do you know anyone," she said, "who could do any better?"
> "No."
> "Neither do I," she said. . . . "Do you believe—you know, Hitler, Russia, people here without food or hope—do you believe that the world is coming to an end?" . . . A look of confidence, born out of some knowledge that the man could not

fathom, spread over the old woman's face. Her body was almost done, but thought and spirit remained. "It isn't coming to an end." [21]

To the problem of who might plausibly bless America, Irving Berlin offered the final solution in 1938 when he called on God to do it.° Such a device was more viable in song than in prose and wasn't much borrowed by documentary reporters. But Berlin's ecstatic tone and, especially, his "From the mountains,/To the Prairies,/To the oceans, white with foam" had great influence.°° As the war drew nearer, it was rare that a book documenting America did not have a passage, usually in the final pages, where the enumerated glories of the land aroused the author's confidence in the nation and its destiny. The following, a double benediction—land blesses man, man blesses land—concludes Marquis Childs' *I Write from Washington* (1942):

Realizing the danger to America, to the free America I have known, I acknowledge . . . a hundred times over [that] I owe so much to my country. I can say that, yes, say it with pride. I have known so much of the strength and the breadth and the beauty of it.

I remember riding out of Taos toward the purple mountains, riding down a canyon golden with the late October sun. I remember the hot, sweet breath of the Iowa summer, blown across the long green pasture. I remember the smell of the grapes on the shore of Lake Erie. . . . I remember the Florida marshes. . . . I remember the Golden Gate and the long rollers pounding up the shore. . . . And New York in the electric air of early spring, and Boston Common, and the dark, uncertain shape of Pittsburgh from a plane.

Yes, and I remember Washington, early December, and the Monument in the beginning dusk, pure and beautiful, the branches of the big elms naked and clear. It is wonderful be-

° Actually, Berlin had written "God Bless America" in 1918, but thinking it "sticky," had filed it away. Twenty years later it no longer seemed unduly sentimental, and he gave it to Kate Smith to use on the air. By 1941, the song was epidemic.

°° Woody Guthrie's most famous song, "This Land Is Your Land" (1940), praised America "From the redwood forest, to the Gulf Stream waters." As originally written, the song's refrain was "God blessed America to me."

yond anything, the people and the country. . . . Knowing America, knowing Washington, I can believe in [a] future.[22]

By December 7, 1941, the rhetoric America would use during World War II was largely invented. A major portion of it derived from the "conservative" documentary reportage of the thirties: its emphasis was on particular experience and the little man, its tone was sentimental (though it pretended to toughness), its principal theme was diversity as strength.

The "I've seen America" book itself went into eclipse when America's reporters—not to mention America's sons—began to see the world. In fact, its vogue was waning even before Pearl Harbor. By then everyone knew what America was—it was everything American. It couldn't be further analyzed or defined; one could only point to instances of it. Such instances were becoming a cliché, though they would entirely revive when men laying their lives on the line called attention to them. Documentary writers like Erskine Caldwell who felt that people, not exalted landscape, were America began to find the people changed. The gas-station man, whom the President had recommended as an inside source on America, was now too busy to be introspective. He was tired of being, and, besides, he was too confident. It was clear to him, as to most of his countrymen, that the Depression was at long last over and that God had indeed blessed the land (only look at the rest of the world). Tough days were ahead maybe, but the gas-station man didn't worry. He knew his job, knew he was needed, and, affable but unyielding, was ready to take on whatever had to be done. In *Say, Is This the U.S.A.* (1941), Caldwell wrote an epitaph for the "I've seen America" book of the thirties:

> There was a time not so long past when it was the practice of many well-intentioned writers to make periodic tours of the country's gas stations for the purpose of feeling the American pulse. They tore over the mountains and prairies, day and night, stopping spasmodically to inquire of filling-station attendants the current state of the nation. . . . Probably I would

have continued touring the filling-station circuit if it had not been for an incident that occurred in Missouri.

We stopped at a filling station and I asked the attendant if he believed that the patriotism, granting its existence, of the American people would arise to the occasion if a foreign aggressor should threaten the peace of the U.S.A. . . .

With a business-like gesture the attendant handed me a neatly printed card. It read as follows:

"I am 36 years old. I smoke about a pack of cigarettes a day, sometimes more and sometimes less, but it evens up. I take an occasional drink of beer. I am a Baptist, an Elk, and a Rotarian. I live with my own wife, send my children to school, and visit my in-laws once a year on Christmas Day. I wear No. 9½ shoes, No. 15½ collar, and No. 7¼ hat. I shoot a 12-gauge shotgun and have a 27-inch crotch. I like rice, sweet potatoes, and pork sausage. I vote for F. D. R., pull for Joe Louis, and boo Diz Dean. I wouldn't have anything against Hitler if he stayed in his own backyard. I don't know any Japs, but I've made up my mind to argue with the next one I see about leaving the Chinese alone. I'm in favor of the AAA, the CCC, the IOU, and the USA. If I have left anything out, it's an oversight. My business is selling gasoline and oil. If you want your tank filled, just nod your head. If you don't want anything, please move along and give the next fellow a chance. I thank you." [23]

Let Us Now Praise Famous Men

*L*et Us Now Praise Famous Men has suffered the worst fate James Agee could imagine: it has achieved "the emasculation of acceptance"; it now is recognized as a classic of the 1930s. Indeed, there are critics—Robert Fitzgerald and Warren Susman, for example—who think it *the* thirties' classic. Susman values the book so highly because he finds it "represents much of what was characteristic of the thirties' finest contributions." But surely this reason is too simple. For *Let Us Now Praise Famous Men*, though in many ways characteristic of the period, was in more ways not.[1]

It is ironic that this book should now be acknowledged a great and representative work of the thirties, because it was then dispraised, misunderstood, and, above all, ignored. *Fortune*, one of the most liberal magazines of the decade, assigned Agee to write the article which, much expanded, became *Let Us Now Praise Famous Men*—but *Fortune* didn't publish the article. Harper and Brothers, one of America's most prestigious publishing houses, contracted for the book —and then turned it down. Both *Fortune* and Harper judged Agee's writing on the lives of three Alabama tenant families unfit to print. That *Let Us Now Praise Famous Men* got published at all was, Walker Evans says, "a strange thing—a fluke." And once published, it wasn't read.[2]

In April 1936, Eric Hodgins, *Fortune*'s managing editor, assigned Agee, a staff writer, to do an article on cotton tenancy. *Fortune* was running a documentary series on the "Life and Circumstances" of poor and lower-middle-class Americans, and Agee's piece was to follow the pattern of the series and be "a photographic and verbal record of the daily living of an 'average,' or 'representative,' family of white tenant farmers." Agee, a young Harvard-educated Southerner whose writing Henry Luce admired, had done two articles on the TVA and was the logical choice for the tenant assignment. He requested that his photographer be Evans, a member of the FSA Photography Unit, and Hodgins complied, perhaps because Time Inc. needed its staff photographers to backlog pictures for *Life*, which would begin later that year.° In the summer of 1936, Agee and Evans went South and, from Hodgins' point of view, literally disappeared for two months, more than twice as long as their field work was supposed to last.[3]

The documentary article Agee finally handed in did not obey the

° The FSA loaned Evans to Time Inc. on condition that the work he did became government property.

pattern of the "Life and Circumstances" series, nor *Fortune's* stan-
dards of decorum. The article, subsequently lost, was at least ten
times longer than asked for and, Evans recalls, "pretty thunderous."
According to Dwight Macdonald, it fitted neither the "liberal" nor
the "conservative" category of *Fortune* articles of the time, being
"pessimistic, unconstructive, impractical, indignant, lyrical, and al-
ways personal." In brief, it was, Fitzgerald says, too long, too per-
sonal, and too violent.[4]

It had another shortcoming. The "Life and Circumstances" series
treated its subjects in a tone of breezy condescension, probably be-
cause the magazine's editors feared their readers—well-off, hard-
headed businessmen—would be bored by the lives of average folk
were they not made quaint and amusing. In a typical article, "Success
Story: The Life and Circumstances of Mr. Gerald Corkum—Paint
Sprayman at the Plymouth Motor Plant," *Fortune* ran a close-up
photo of a newspaper, a *Saturday Evening Post,* and a *Webster's
Daily Use Dictionary* on a living room table with a cotton doily; the
photo was captioned: "The Corkum Library." Agee, however, treated
his subjects without condescension and without trying to amuse. He
took their lives, customs, aspirations, woes no less seriously than they
did. He did not sensationalize their distress by "parading [their] na-
kedness, disadvantage and humiliation" as *Fortune* intended him to do.
Instead, he went to great length to dignify the tenant farmers and to
insist that they were, in all important respects, as worthy and pre-
cious as any *Fortune* reader.[5]

One would assume that such "errors" of tone could have been cor-
rected and Agee's report made to fit *Fortune's* formulas.° If necessary,
it could have been rewritten by someone else, as a few of his pieces
were. This was not done. According to T. S. Matthews, *Fortune's* edi-
tors tried cutting Agee's report, "chopping it in bits," and when radi-
cal surgery failed, they gave up on it. They held the manuscript for a
year—"a year of vacillation," Agee felt—and then released it to him
to do with as he pleased. Fitzgerald believes the article wasn't used
because of a change in *Fortune* management and an increased con-
servatism in editorial policy. It is improbable that *Fortune's* policy
ever had been liberal enough to run the piece as Agee wrote it, but
there *was* an important staff change several months after he turned it

° Perhaps not, though. Evans is sure that Agee "half consciously made the
article so it would be unacceptable. He saw to it that it would *not* get into
Fortune." Agee himself while writing the piece assured Father Flye it
would be "impossible in any form and length *Fortune* can use."

in. Hodgins was succeeded as managing editor by Russell Davenport, who discontinued the "Life and Circumstances" series. Why he dropped the series is not known; Robert Elson, Time Inc.'s historian, says that during this period the managing editor could do very much as he pleased and simply may have been tired of the series. Did Davenport also kill Agee's article? Had Hodgins already? Did they both? It is now impossible to say. Louis Kronenberger remembers Davenport as hard to write for because he always wanted copy done as he would have done it. A writer as individual as Agee would seem likely to give such a man fits. But Ralph Ingersoll, the managing editor before Hodgins, suspects that Davenport would have been sympathetic to Agee's report, and Hodgins not. One thing is certain. Being new to the editorship, Davenport would have had less incentive to salvage the article and thus justify its expense; he could claim its being unpublishable was his predecessor's fault.[6]

Fortune didn't try to rework Agee's manuscript, but Harper and Brothers did. In 1937 Agee's friend Edward Aswell, a Harper editor, persuaded the company to contract for the book, which was tentatively titled *Cotton Tenants: Three Families,* and to pay Agee a small advance. When *Let Us Now Praise Famous Men* was completed in 1939, Aswell fought to have it published as submitted, but Harpers' senior editors demanded extensive revision. What they wanted, needless to say, was a book they could instantly recognize as "characteristic of the thirties' finest contributions"; a book that catered to the values of the time by portraying the sharecropper as the helpless and brutalized victim of a social condition; a book, in short, like *You Have Seen Their Faces,* only with some thin differences that would pass for originality. What they got instead was a book original to its bones; a book that undermined the period's values, cast doubt on its ideals, insulted its proprieties.[7]

Agee at first agreed to make the revisions Harpers wanted, and the book's photographs were printed under Evans' supervision. Then Agee changed his mind. He refused to touch the text. Harpers considered it the publisher's right to do some editing in spite of the author's wishes, but decided not to exercise the prerogative. In the fall of 1939, after further haggling with Agee and dispute among their editors, Harper and Brothers rejected *Let Us Now Praise Famous Men;* "or, speaking as truly," wrote Agee in an early draft of the 1941 Preface, "the authors withdrew it, rather than make certain required changes through which it might be less unpalatable to the general reader." Though weary of the book and the pains it had cost him,

Agee was too proud of it to let "the publishers, or others, . . . disguise or . . . ingratiate" it by toning down its eccentricity. No publisher seemed likely to accept the book on his terms; three quickly refused. Agee tried to persuade Evans to edit it for him, or at least to suggest changes. Evans refused. "I said, 'Absolutely not. I won't touch it,'" he remembers. "I saw things that needed to be done. But I thought that it was too great and that its faults had better be left in it. Even though it *needed* it, it wasn't I who was going to touch it." [8]

Agee was ready to abandon *Let Us Now Praise Famous Men* rather than have a distorted version of it published, when, in the spring of 1940, Houghton Mifflin agreed to publish the book with only minor changes (the deletion of words that were, as Agee put it, "illegal in Massachusetts").° This generous offer came about because of what Evans calls a personal accident. One of Agee's friends on *Fortune* was John K. Jessup. Jessup's wife, Eunice, was a literary scout for Paul Brooks, an editor at Houghton Mifflin and a good friend; she strongly recommended the book to him. Evans says that Eunice Jessup's fight for the book

> caused considerable loss to herself. Because it was *such* a flop. Paul Brooks lost confidence in her and said, "If you're going to give me something like *that,* I'm not going to take your advice anymore." They sold 300 copies, I think, and took a loss on it, remaindered it. [9]

When Houghton Mifflin accepted the manuscript, Agee insisted on revising it, adding a new preface and a score of footnotes.°° *Let Us Now Praise Famous Men* finally appeared at a time that could not have been less opportune. It was published in September 1941, after the fall of Europe and as the Battle of Britain entered the terrible months of the Blitz. Five years earlier, when Agee began the article, tenancy was "stylish" and a "focus of 'reform'"; by 1941 the American people had heard all they wanted to about the problem.°°° As Agee

° An example: the "Note" at the back of the book listing "anglo-saxon monosyllables" debased by the "marxian, journalistic, jewish, and liberal logomachia" of New York's intellectuals originally began: "fuck, shit, fart, piss, cunt, cock, ass," and continued with the words it has in the final text: "god, love, loyalty, honor," and so on.

°° He insisted, too, that the book be published as modestly as possible—without any "selling job." He asked Brooks if it could be printed on newspaper stock, and Brooks said no because the pages would crumble to dust in a few years. Agee said he thought that might not be a bad idea.

°°° An essay written that year on Southern agriculture referred to the sharecropper's plight in one sentence: "The low income, low standard of

himself admitted, "Now that we are busy buttering ourselves as the last stronghold of democracy, interest in such embarrassments has tactfully slackened off." But it was not only tenancy and the war that kept readers from the book: the book itself did too.[10]

By the standards of the time, *Let Us Now Praise Famous Men* was an outrage. It was *more* outrageous even than the *Fortune* article, because Agee didn't accept the advice of *Fortune*'s editors. The "errors" they criticized he willfully compounded. They thought the piece too long, with too much detail—for example—on the tenant houses; Agee vastly enlarged the section on the houses. They thought the report too subjective; Agee made his "individual, anti-authoritative human consciousness" more firmly "the governing instrument" and "one of the centers of the subject." They thought his writing too personal, too self-revealing; Agee told how he used to masturbate in his grandfather's house, complained of his need for a whore, and imagined one of the tenant families having group sex with Evans and him.[11]

"Agee was a very embarrassing man," Evans says; "I love the prose, but sometimes I blush reading it." Even by today's standards, when intimate confessional reportage appears in every general magazine, Agee's self-exposure is often startling, an affront—just as he intended it to be. For he *wanted* to shock, wanted to do violence. In the blurb to the first edition, he wrote:

> Thoreau said: "I desire to speak somewhere without bounds . . . for I am convinced that I cannot exaggerate enough even to lay the foundation of a true expression." The mode of life that the authors of this book are attempting to portray is typical of millions of Americans yet so remote from normal life that only the most extreme violence can shock the reader into awareness.

Agee felt the way to shake the reader into awareness was to cheat his expectations by violating as many canons of documentary reportage as possible. The *Fortune* editors had told him his report was not journalistic enough—too rhetorical and philosophical and arty. And it almost seems that Agee said to himself that if people thought the *article* had those faults, he would show them something that *really* did.° He

living, poor living conditions, bad nutrition, lack of educational facilities, ill-health, and other evil conditions of tenant life are too well known to need amplification."

° This is speculation. Archibald MacLeish believes that such a " 'suspicion' is suspect and not up to Agee. He was the last man in the world who would magnify the things that displeased *Fortune*. Jim was a writer—better,

would write a book that "would be 'literature' or 'religion' or 'mysticism' or 'art.'" He would write a "classic" (another degraded anglosaxon monosyllable).[12]

And he did. There can be no doubt that *Let Us Now Praise Famous Men* is a classic of the thirties' documentary genre. Like many another classic, it epitomizes the rhetoric in which it was made, and explodes it, surpasses it, shows it up. Henry James once observed that a book is excellent "in proportion as it strains, or tends to burst, with a latent extravagance, its mould," the literary form in which it was cast. *Let Us Now Praise Famous Men* culminates the documentary genre and breaks its mold. It reveals the limitations, the tragic superficiality, of a way of seeing and speaking, of a perspective on life, and —in some measure, perhaps—of a time.[13]

To its excellence and uniqueness as documentary, text and photograph each contribute. Agee insisted that both means of expression were "coequal, mutually independent, and fully collaborative" in the book; he listed Evans as co-author and tried to give him half the royalties (Evans would accept only one-quarter). Though their work was collaborative, their styles were quite different, even opposite. Agee was a putter-in, and Evans a taker-out. As one critic has said,

> Agee was essentially a modeler, in the sculptural sense of that term, building up each image by adding detail upon detail, until he had achieved an almost baroque, many-faceted surface of multiple nuances. Evans, on the other hand, is essentially a carver, clearing away all excess, clarifying, penetrating, revealing some fundamental precision of focus.

But though their styles were different, Agee's and Evans' deepest meanings were the same; theirs was, as Evans says, "psychologically and emotionally a collaboration." Both used the form of social documentary to say that social problems, whatever their magnitude or poignancy, were of subordinate concern, and that the true center of man's existence, where he affronted the "normal predicaments of human divinity," lay elsewhere.[14]

a poet, not a feudist." MacLeish, a good friend of Agee's, adds that he never saw or heard of the article until the book appeared. When the "suspicion" was put to Evans, he said: "I wouldn't be at all surprised, but that was a facet of Agee's character. Agee was such a rich man that there are a hundred facets to be examined. And that's one of them; I think it's valid. He did have—mind you, he was only twenty-seven years old—he did have an *outsized* combativeness and an immoderate supply of moral indignation, not stopping short of violence."

CHAPTER 14

The
Photographs

When Walker Evans' retrospective opened at the Museum of Modern Art in January 1971, Hilton Kramer of the *New York Times* wrote:

> For how many of us, I wonder, has our imagination of what the United States looked like and felt like in the nineteen-thirties been determined not by a novel or a play or a poem or a painting or even by our own memories, but by a work of a single photographer, Walker Evans?

Kramer was, as he knew, not alone: the foremost art reviewers of the day agreed with the Museum's John Szarkowski, who introduced the exhibit by declaring that Evans more than any other man had created "the accepted myth of our recent past." One reviewer said: "We have not seen our land and its people in the same way since Evans turned his camera on it." And another: "His photographs [have] become part of our past, whether or not we were ever there." [1]

Evans' version of the thirties, his cool yet disquieting vision of America, has prevailed. It has prevailed against the sentimental simplifying of the propagandists and the anecdotists, against the gigantism and bathos of Margaret Bourke-White, against the

lurid excitements of *Life*. His work has at last begun to gain due
recognition: it has lately been the subject of journalistic com-
ment, a documentary film, a five-minute report on the *C.B.S.
Evening News;* in 1970 and again in 1971, it was extolled in *Life*.
Now that his reputation is high, it may be hard to remember how
recently it was low. Evans has always had eloquent admirers—
James Agee, Lincoln Kirstein, William Carlos Williams, Glenway
Westcott, Lionel Trilling—and they have finely analyzed his art.
But until 1960, his reputation was limited, esoteric. In that year
U.S. Camera observed that some of the best photographers
America ever had worked for Roy Stryker on the FSA, named
seven of them, and omitted Evans. That same year, however, the
second edition of *Let Us Now Praise Famous Men* was published
by Houghton Mifflin to take advantage of the cult forming
around Agee because of his *Death in the Family,* film scripts and
film criticism, and early death. The book sold well and since 1966
has had four paperback printings. It has introduced Evans' pho-
tographs to a new generation and trained them to see the thir-
ties, and America, through his eyes.[2]

What is Evans' vision? First, as a reviewer wrote in 1941, it is
emphatically not "in the you-have-seen-their-face manner." It is
not a stolen shocking glimpse, a candid exposé. There is nothing
candid in Evans' best photographs, and little of the exposé; he does
not glimpse but frankly, interminably, stare. His subjects are con-
scious of the camera, of its manipulator, and of the unknowable
audience behind it. They are not taken off guard; on the con-
trary, they have been given time to arrange and compose them-
selves for the picture. In some of the portraits one can feel the
subject gently holding his breath until the shutter snaps and the
ordeal of being seen is over. In Evans' world, Lincoln Kirstein
once remarked, "even the inanimate things, bureau drawers,
pots, tires, bricks, signs, seem waiting in their own patient dig-
nity, posing for their picture."[3]

Evans does not "expose" the reality he treats, he reveals it—or

better, he lets it reveal itself. He does not seek out, he in fact avoids, the spectacular, the odd, the piteous, the unseemly. Bud Woods' skin cancer, the Rickettses' "stinking beds," the horde of flies on the tenants' food and on their children's faces—these he does not show, though Bourke-White and Russell Lee showed them. He shows instead Bud Woods with a bandanna on his shoulder covering his sores, as one naturally would cover them from a stranger's eyes; he shows the Gudgers' neatly made bed; he shows an infant asleep beneath a flour sack to keep the flies off him. In short, he records people when they are most themselves, most in command, as they impose their will on their environment. He seeks normal human realities, but ones that have taken a form of such elegance that they speak beyond their immediate existence. These realities are the material of his art, which he calls "transcendent documentary photography": the making of images whose meanings surpass the local circumstances that provided their occasion.[4]

To Evans, the word "documentary" has a definite and crucial significance. It means that the reality treated is in no way tampered with. Nothing is imposed on experience. Documentary, he says, is "stark record." Any alteration or manipulation of the facts, for propaganda or other reasons, he considers "a direct violation of our tenets." He was shocked when his FSA colleague Arthur Rothstein was found to have moved the cow's skull, because "that's where the word 'documentary' holds: you don't touch a *thing*. You 'manipulate,' if you like, when you frame a picture—one foot one way or one foot another. But you're not sticking anything in." For Evans, documentary is actuality untouched; the recorder not only does not put anything in, he does his best not to disrupt or revise what is already there. Evans took the superb group portraits of the Ricketts and Woods families without telling the subjects how or where to stand or sit or look. He set up his camera on a tripod where he found a number of the subjects gathered; let them get other people if they cared to and

arrange themselves as they liked; asked whether they were comfortable and let them stir again if they were not; took the photograph. "I knew I couldn't miss," he says.[5]

In a brilliant 1942 review of *Let Us Now Praise Famous Men*, Lionel Trilling commended Evans' "perfect *taste*, taking that word in its largest possible sense to mean tact, delicacy, justness of feeling, complete awareness and perfect respect." This taste, this respect, Evans exercises on behalf of his viewers as well as his subjects. The latter are not degraded by being made objects of pity or revulsion or fun, and the former are not degraded by being thus solicited. Both are encouraged to be composed. Evans' technique is never loud or tricky; it does not try to disconcert the viewer into paying attention. He photographs straightforwardly, as people take (or used to take) snapshots: from the front and center, from eye level, from the middle distance, and in full flat light. Contrast his work again with Bourke-White's. Her technique overdramatizes virtually everything she treats. She shoots from bizarre angles and in operatic lights. She photographed a girder, for example, not from the side so that one might see how it joined two parts of a building, but from directly *on* it, looking down its length, so that the girder appeared a metal highway running spectacularly nowhere. She photographed the Statute of Liberty from underneath its skirts; a billboard from beneath it and to the side; a plane's cockpit *through* its whirling propeller; people from too close or from a ladder or, in the case of the Negro preacher, from on her knees right in front of the pulpit. She portrayed industrial machines not as everyday things men work with but as bright-tongued beasts in black caverns of smoke. She would freeze a facial expression (and the viewer's blood) with a livid flash three feet from her subject. And the purpose of these unusual techniques was just to be unusual: to pep up the content, to wheedle the viewer into emotion by making it seem that what he looked at was fresh, subtle, and passionate, and not what it was: a sentimental cliché. Bourke-White wanted—too obviously—to move her audience;

Evans characteristically seemed not to care. In his book, the viewer can turn the page if he likes, Evans' technique will not grab at his sleeve.[6]

His technique is simple (though deceptively so, as anyone finds who tries to imitate it), and his subject matter—lower-class life— is the staple of documentary. Yet Evans' photographs avoid cliché. This is not because of anything he *does* to the subject (he puts nothing in; he intrudes as little as possible), but rather be- cause of what he discovers in it, the unlooked-for riches he unearths. His work proves what he means when he says, "Pho- tography isn't a matter of taking pictures. It's a matter of having an eye."[7]

The riches Evans sees are many and complex, but Agee summed them up in one word, "beauty." Agee wrote of the tenant houses and, by implication, of the lives lived in them: "It seems to me necessary to insist that [their] beauty . . . inextricably shaped as it is in an economic and human abomination, is at least as important a part of the fact as the abomination itself." Here is the crucial difference between Bourke-White and Evans: Bourke-White exposed sharecropper life as an unrelieved abomi- nation; Evans showed its abomination and its beauty, discount- ing neither. This beauty is not a gentle one; "it's not beauty in the conventional sense," Evans says. In fact, it is a tragic beauty, and tragic twice over: because of the abominable conditions in which it grows, and because it cannot be recognized or appre- ciated by those who create it.

A. D. Coleman has written that most FSA "pictures of the un- inhabited interiors of rural shacks make one aware of the squalor and poverty of the inhabitants—while I have occasionally felt the urge to pull up stakes and move into those recorded by Evans, for he makes me aware of how imbued with an instinctive artful- ness they were." Coleman, an art critic, is aware, but the tenants of the shacks were not. Their artfulness was instinctive, uncon- scious; "to those who own and create it," Agee said, "this 'beauty' is . . . irrelevant and undiscernible." However, the beauty is not

fictitious, as George Elliott has claimed. Elliott argued that a good documentary picture deals "an esthetic twist of the knife" because "the elegance of the visual structure . . . exists only in the picture and not in the scene referred to." Such an argument, certainly untrue,° would imply that only photos revealing the hideousness of the life of the poor, photos like those in *You Have Seen Their Faces*, were authentic. In documentary photography, as Agee wrote of Helen Levitt's work, "the actual is not at all transformed; . . . the artist's task is . . . to perceive the aesthetic reality within the actual world." In documentary, the beauty, if any, is *in* the scene, though it takes an outsider's eye to behold it.[8]

For a sensitive viewer, that is enough of a knife twist. Thanks to his economic standing, he has an aesthetic background which permits the appreciation of a beauty not his that feeds upon a misfortune not his but to some extent his responsibility; a beauty that cannot be perceived by those who made it in the hardship of their body and spirit; yet a beauty that he realizes would be, could they but understand it, a high consolation for their suffering. No wonder Agee and Evans were troubled at "spying" on the tenants, and felt their mission "obscene" and a "betrayal." Throughout *Let Us Now Praise Famous Men*, Agee agonizes over what they had done, and "by what right, and for what purpose, and to what good end, or none," they were witnesses and communicators of the lives of "an undefended and appallingly damaged group of human beings." He worried particularly at his recognition of the beauty in their lives, to which he had "only a shameful and thief's right"; he felt himself guilty of what we might call bad faith (he called it a sin). He worried not least about his audience—"you who will read these words and study these photographs . . . by what right do you qualify to"—and

° Agee specifically answered it when writing of the Gudger house: "This square home, as it stands in unshadowed earth between the winding years of heaven, is, *not to me but of itself,* one among the serene and final, uncapturable beauties of existence" (italics added).

how they would react to the beauty. As regards Evans' photographs, he need not have been concerned. Most viewers of the time saw that Evans' work was *like* other documentary pictures they had seen, and so thought it the same thing; they noticed in it only the abominable and accepted it as propaganda of a staid and listless kind. More sensitive viewers detected the beauty Evans recorded, but found it reinforced the abomination and hence the social-reformist message. Glenway Westcott wrote of Evans' photographs in 1937: "For me this is better propaganda than it would be if it were not aesthetically enjoyable. It is because I enjoy looking that I go on looking until the pity and the shame are impressed upon me, unforgettably." [9]

The beauty Evans documents he did not invent. Much of it he was not the first to notice: the photograph he made of George Gudger's work shoes, for example, borrowed the subject of Van Gogh's famous painting *Les Souliers.* (The photograph is better because merely factual; Van Gogh sentimentalized his boots, made them as wistfully ragged and gay as Norman Rockwell would.) But it cannot be doubted that Evans, more than any visual artist of our time, has called attention to this beauty.[10]

It is a beauty of the literal, of the world as it is. In *Let Us Now Praise Famous Men,* as in virtually all his finest work, it is a beauty of the lower classes and the poor. Evans says he is frequently asked why he always photographs such people—why not members of his own (upper-middle) class or the rich or, at any rate, the educated? Once when asked this question, he replied with mordant gentility that he would be happy to photograph other sorts of people, "the Duke and Duchess of Windsor, for example. I believe I could find something interesting . . . even in them." What Evans finds of interest in the poor, in "simple people" (as Agee called them), is first of all the *visibility* of their lives. Look at his photographs of the Gudgers, George and Annie Mae, or of their kitchen or bedroom or whitewashed fireplace or George's shoes; look at the Bud Woods family gathered in Bud and Ivy's bedroom for their picture; look at the Rickettses, their

kitchen wall, their table with food on it in tins and jars and cook-
ing pots, or their snapshots, nailed to the wall, of the children
when young and of the children's grandmother. These are not
simple people if we mean by "simple" having just one signifi-
cance and that readily apparent. On the contrary, the best of
these portraits are stubbornly enigmatic.[11]

Yet in another sense, these people *are* simple: they are *there*,
unhidden; complexities and all, they are visible. What one sees,
looking at them and the things they touch, is an incapacity to
dissemble. They and their lives are wholly exposed. George's
shoes are shoes for work—they have no other pretension. The im-
plements on the Rickettses' wall are there for use: to eat with,
carry kerosene, mold tallow; the pots that cooked their food are
put on the table to be eaten from. Agee wrote that the beauty of
the tenant houses started from their having "not any one inch of
lumber being wasted on embellishment, or on trim," "not one
trace of relief or of disguise." There are disguises in the tenants'
lives—all is not unrelieved utility; but their disguises, like the tis-
sue paper Annie Mae cut in eaves and hung from the mantle of
the whitewashed fireplace, are slight, transparent. While around
Emma, his pretty sister-in-law, George Gudger behaved with
"clumsy and shame-faced would-be-subtle demeanors of flirta-
tion," which everyone but he saw through. Louise Gudger wore a
party dress that any middle-class mother would instantly recog-
nize for the counterfeit—"precious imposture," said Agee—it was.
These people are simple, then, because their means and purposes
of deception are so obvious and rudimentary. Their lives, though
not bare, are uncovered to view and, in them, the essentials of
the human condition.[12]

The documenting of such lives is a central theme in photogra-
phy, not just in Evans' work. There is a reason why slum-dwell-
ers, children, manual laborers, fishermen, athletes, farmers, sol-
diers, and tribe members are the main characters in Edward
Steichen's photographic collection *The Family of Man:* the best
photographs have been taken of these people. Jacques Barzun
deplored Steichen's choice of images because it slighted "whole

ranges of man's life," specifically "Intellect," "Mind," and "The Law." But these things are enormously difficult to portray. One cannot photograph an idea, and a photograph of a man thinking may show, as the collection's picture of Albert Einstein did, a bumbling old fellow, fingers on lips, who looks as though he is trying to recall where he put his lunch bag. The poor, the primitive, and the young are the natural heroes of photography; all others have learned too much disguise. Among the people Evans recorded in *Let Us Now Praise Famous Men,* there was one whose face wore a determined mask—the first man in the book. This person was capable of successful deception; he had the power to mislead. Significantly, he was of the middle class, the owner of the land George Gudger farmed.

Most photographers have used the visibility of "simple people" either to expose social problems or to make sentimental observations on "the good and the great things, the stupid and the destructive things" in life—as Steichen boasted the pictures did in *The Family of Man,* a sentimental collection. Evans, however, does something else. Rather than show how simple the poor are, how feeble, how limited, he shows them to be complex, strong, and pervasive. He uses their poverty to demonstrate how much they possess. Evans suggests that all they touch, and all that touches them, is permeated with their being. Whereas the prosperous attenuate their selfhood through many possessions and roles, the poor condense theirs in a few. Their world and everything in it bespeaks them, symbolizes them. It is entirely a work of art.[13]

The boldest spokesman for this idea was Agee himself, who proclaimed throughout his writings that "the unimagined world is in its own terms an artist":

> There can be more beauty and more deep wonder in the standings and spacings of mute furnishings on a bare floor between the squaring bourns of walls than in any music ever made.

> The partition wall of the Gudgers' front bedroom is importantly, among other things, a great tragic poem.

To Agee's theory that all simple people are artists, Evans offered concrete proof. His photographs document these people's sense of form, balance, symmetry,° and their fierce—almost appalling —hunger for order. His work has come to characterize the thirties for us because it expresses the culture that we imagine to have dominated American life then, the culture of poverty (or as Agee called it, "the whole world-system of which tenantry is one modification"). We accept Evans' vision of America as the essential image of the Depression years because we believe ourselves, our people, our land, then to have been poor. A. D. Coleman has pointed out how the time's desperate economic and social conditions helped Evans "make the country his":

> There is, even today, no telling whether Evans found the real America. Perhaps the concept itself is meaningless, since his search began at a time when the country did not, in a certain sense, even exist. The Depression terminated all American dreams, all futures, save a few apocalyptic ones; the country became a vacuum, waiting to be filled. . . . For all the flux of the era, the nation was paradoxically in stasis, fixed in time like a museum exhibit. In the clarity of this full stop Evans recognized—and was one of the first major artists to do so, certainly the first photographer—that man had made the country into a work (or a series of works) of art.

The art of commonplace reality.[14]

William Carlos Williams wrote in 1938 that Evans' pictures present "what we have not hitherto realized, ourselves made worthy in our anonymity," our dailiness and poverty. Evans' work continues to do this, and his eye for beauty redeems stuff more intractable than ever. His images of recent years include: "Trash Can, New York, ca. 1969," which wire vessel is shown meticulously crammed to the brim—but not over—with papers, a plastic overnight bag, and, on top, like the most fragile treasure

° On the mantle of the Rickettses' wildly cluttered fireplace, even *there*, a patent-medicine bottle, a shaving-cream box, eyeglasses, and a large whetstone on the right are offset by a can of oil, match and aspirin boxes, a tin plate, and a puzzling stick of wood on the left.

in a Christmas stocking, a shiny uncrushed empty gallon can of pine-scented room deodorant; a gruesomely charred plywood sign announcing fresh water in "Anna Maria Island, Florida, 1968"; and a still-untitled 1962 photo of a crumpled Wrigley's gum wrapper, a cigarette butt, and spatterings of white paint grouped, with chance artistry, beside a sewer grill. Such photographs have yet to be accepted as representations of beauty—they may never be. But Evans' work of the thirties *has* been. It is not too much to say that for many educated viewers of his time, Evans has made the lives of the lower classes aesthetically respectable (which is *full* respectability these days, so highly do we value "art"). Moreover, these lives being as they are, he has inevitably made hardship and poverty respectable. He has shown that the "underprivileged" have a beauty in their lives and, on this count at least, may be spared anyone's tears. Evans has returned them a dignity that welfare workers, radicals, social scientists, propagandists, the media, and liberals of all stripes have too often taken away in hope of promoting their social betterment. He makes his audience respect, not pity, them.[15]

While praising the "moral quality" of Evans' work, Trilling superbly analyzed his portrait of Annie Mae Gudger,° whose face

is a single concentrated phrase of suffering; you are bound to have an immediate outgoing impulse toward it, but this is at once hemmed in, at once made careful and respectful, by what the camera does. It is significant that, like all the pictures in the book, this is a portrait; it was "sat for" and "posed" and not only does the pose tell more than could be told by unconsciousness of the camera but the sitter gains in dignity when allowed to defend herself against the lens. The gaze of the woman returning our gaze checks our pity. . . . In this picture, Mrs. Gudger, with all her misery and perhaps with her touch of pity for herself, simply refuses to be an object of your "social consciousness"; she refuses to be an object at all—everything in the pic-

° No one has noticed that there are *two* Annie Mae Gudgers: she of *Let Us Now Praise Famous Men* and she of Evans' *American Photographs* (1938). The differences between the two women are real and complex, but it is no doubt significant that the Annie Mae of the documentary book is more acute, puzzled, and bitter.

ture proclaims her to be all subject. And this is true of all of Evans' pictures of the Gudger, Woods and Ricketts families.

It is true of all the photos in the *second* (1960) edition of *Let Us Now Praise Famous Men*, and of most in the first. The people in these pictures stand before us vivid with ambiguity and secret meaning; coolly eye us, as people do at first acquaintance; and are plainly difficult to get to know. As with real people, we have to *work* at knowing them, commit ourselves to a kind of relationship over time. Because the photos have no captions, we must read more than 250 pages, with care, before we learn, in the section on "Clothing," who most of the people are. (And when we know, how much more each picture means!) Warren Susman applauds *Let Us Now Praise Famous Men* for "brilliantly combining photographs and text," but in a sense it doesn't combine them at all. The two parts of the book are, as Agee insisted, "mutually independent." As Evans suggests, his photographs "subsume a collaboration with the words, instead of literally having one." The pictures and the text, each going separate ways, at moments clarify what the other records. The text illuminates a few of the secrets we see in the tenants' faces—a very few. Their mystery remains, and would, we realize, in some final and important form no matter how much we were told.[16]

But we must notice that the tenants of the second edition are not exactly those of the first. The original (1941) edition had thirty-one photographs, half the number of the second. Nevertheless, the first edition had six photos that do not appear in the second. One of these, a picture of Fred Ricketts, his eldest daughter, Margaret, and his sons, John and Richard, singing hymns outside their cabin, was dropped "regretfully," Evans says, because the original negative had disappeared. This picture is a serious loss: it revealed an unexpected Ricketts (virile, competent, wearing heavy hornrimmed glasses) and offered the most positive glimpse of tenant life in the 1941 edition. Two more photos were dropped —of the Gudgers' rear fireplace, and of Bud and Ivy Woods

seated in their bedroom °—because they too closely duplicated other pictures. The three remaining photographs, however, were plainly cut for reasons of taste. They no longer met Evans' standards. They were indiscreet, sentimental, tendentious—in short, the kind of thing Bourke-White did.[17]

Technically and aesthetically, these photographs seem crude beside Evans' characteristic work. They were made with a Leica, and its 35mm negatives yield prints that are gray and blurred in contrast to his usual pictures, which come from 8″ by 10″ negatives. Two of the three photographs are, untypically, candids. One of these is a glimpse of nine-year-old Katy Ricketts, her face half turned away, her mouth and eyes half-opened. The girl looks stupid, as anyone would with his mouth and eyes that way. But one cannot be sure what the photographer meant us to see: was the child a moron? had she an eye defect? The picture is oddly composed, with the girl at one side; but its only other subject, the Rickettses' front porch, is too ill lit and out of focus to draw our attention. All in all, the photo seems an "accidental revelation which does far more to hide the real fact of what is going on than to explore it"—Kirstein's definition of the kind of prying sensationalism Evans loathed. The second candid, a better picture though even less clear, is of Margaret Ricketts on the front porch, girlishly surprised by the camera. She holds one hand to her cheek and nips at its pinky in a gesture of timidity and wonder, while her eyes begin to be delighted. Despite those eyes, which have a trace of mischief, it is a cloying image. Margaret's dress is a patchwork of rags, damp down the front from her having washed the dishes; it has none of the character Mrs. Ricketts lent a similar garment in her stunningly delicate portrait. Margaret's dress, like the rotten mattress Bourke-White photographed, is pathetic to the point of bathos. The final picture

° The chief beauty of this portrait is Bud Woods' debonair pose. One knee crossed on the other, arms folded loosely in his lap, he holds himself like a Calvert Man of Distinction. He is wearing rumpled denim pants with long johns under them; his feet and, except for a bandanna, his torso are bare; his eyes burn dully, like lamps left on in daylight.

dropped from the 1960 edition is a close-up of Fred Ricketts' sorrowful face, his head bowed (was Evans on steps above him?) with adversity and myopia. His shirt collar is filthy, his brow is twisted, his eyes are watering.[18]

It is obvious that these pictures caught their subjects unguarded, and emotionalized and humbled them, trying to rouse the viewer's pity. Compare the photo of Ricketts just described with the one that replaced it in the 1960 edition. Here Ricketts is seen from the middle distance, from head to knees. He wears new overalls and a fresh white shirt. He looks the viewer in the eye with mild sad baffled hostility. When a second edition was planned, Evans intended to repeat all the photos in the 1941 edition and add again as many. He did not see his job as a "revision" of the experience he had recorded in 1936 and composed for the book in 1939; he wanted the 1960 photograph section "to be identical in intent and style and meaning—just stronger. An amplification." Yet he admits that what he actually made is different enough to seem "another composition." He apparently decided that what he had to say could be better put with less insistence and with an even greater tact.[19]

To this end he made many changes. He reduced the size of most images. Though the 1960 edition has pages one-half inch longer than the 1941, he cut the standard picture length by an inch, from 7½″ to 6½″. In the original edition, four close-up portraits (Louise Gudger's was one) were set on end to increase the size of the image; in the second edition these portraits, reduced in size, are set straight. Evans widened the margins so that pictures would no longer seem to bleed out into the world, as the full-page ones did in the first edition. He recropped ten of the twenty-five photos he used from the earlier edition to give *more* of the images and have more air around their (consequently smaller) subjects. For example, the portrait of Annie Mae Gudger in the 1941 edition is 7½″ long, fills the page, and is cropped just above the V of her dress; thus her head, from top to chin, measures 4½″, her face takes half the page, and her pressure on

the viewer is enormous. By contrast, in the 1960 edition, her por-
trait is 6½″ long, has ⅝″ margin at the top and 1¼″ at bottom,
and is cropped well below the V of her dress; her head, 3½″
long, is frail on the page, as befits her fine-boned beauty; she is
far less an assault. In place of the three piteous Rickettses, Evans
chose a series of portraits showing their close and varied family,
the members of which smile and scowl and get the dinner ready
and pose nicely for the camera with indescipherable stares. His
social message, insofar as he still had one, comes across more
strongly for not being overemotionalized. It is made in the chil-
dren's freshly washed faces (some things a mother needs only
pride to do),° in their dirty but ample clothing (some things take
just a little more than pride), and in their terrible opaque eyes,
glowing with malnutrition (some things she can do nothing
about).[20]

The surprise is not that Evans was moved toward propaganda,
but that he was moved so far. He got into trouble with Roy Stry-
ker because his photographs were insufficiently "political," too
"aesthetic" and "ivory tower." Stryker thought he was profiting
from his FSA assignment to do his own work—and that's what
Evans tried to do. He says, "I was just in a sense taking advan-
tage of the FSA and using the government job as a chance for a
wonderful individual job. I didn't give a damn about the office in
Washington—or about the New Deal, really." But in fact Evans'
relation to the FSA assignment, and to the social concerns of the
thirties, seems to have been more complex than he indicates.
There is no question that he disliked working for Stryker, whose
intelligence and taste he did not respect.°° There is no question
that he thought Stryker and the FSA photographers who toed his

° Note that in the picture of Mrs. Ricketts and her seven children the girls
on either side of her cross their hands in front of their genitalia. Katy, at
her mother's left, holds her hands rigid, having, one suspects, just been told
to put them there.
°° Evans: "I've been particularly infuriated by reading here and there
that he was 'directing' his photographers. He wasn't directing *me*; I wouldn't
let him."

line "a little hypocritical or self-deluded" in their use of social
documentary to advance their careers (after all, they weren't
going to be punished for praising the New Deal's good works
and encouraging more of the same). Nor is there any question
that he distrusted the idealism of the New Deal with its emphasis
on "doing some sort of 'uplifting' work." Evans hugely valued his
uncompromised independence, refused to walk under anyone
else's banner; he put a warning at the front of his *American Pho-
tographs:*

> The responsibility for the selection of the pictures used in this
> book has rested with the author, and the choice has been deter-
> mined by his opinion: therefore they are presented without spon-
> sorship or connection with the policies, aesthetic or political, of
> any of the institutions, publications or government agencies for
> which some of the work has been done.

But all this is not to say that Evans' individual opinion did not
often correspond to the policies of those for whom he worked; he
may have marched alone and still been part of the parade. Fur-
thermore, just because he didn't *want* to compromise doesn't
mean he didn't. Though he refused Stryker's direction, he some-
times did what he knew the office in Washington wanted. He
says Stryker expected him to "record government housing and
toot it up," and he concedes, "Once in a while I would." He re-
members that for much of his time at the FSA, "We were work-
ing at a pretty white heat." *We:* the other photographers and he,
all of them documenting, in various ways, the lives of the rural
and small-town poor.[21]

For Evans was not immune to the forces, aesthetic or political,
working at the time. He was no more cold-hearted than the next
man; he would do what he could to help the sharecroppers, even
publish a few pictures poorer than the rest to make their suffer-
ing plainer. Indeed, Evans' opinions about how photographs
should be used are more complex than critics have supposed. His
attitudes are greatly, though not always predictably, influenced
by the way photographs in fact *are* used. He is every bit the

"purist" critics claim him to be, but he believes the medium has many sorts of purity. In short, he respects quality, but finds it different in an impressionistic or anecdotal or family or journalistic or erotic or sports photo. He has a particular appreciation of the range of uses to which the documentary photograph can be put. And how could it be otherwise? Though his central concern has been to discover images that transcend the condition they document, he earned his living from 1945 to 1965 as a *Fortune* reporter-photographer, recording conditions in their literal and most immediate aspect. He says of the pictures he made for the magazine: "They were only meant to be effective reporting journalism insofar as they were to be published in *Fortune*. When they transcend that, that's just gravy for me, but that's what I'm most interested in." Though an artist, Evans was also a master of what he once called "the plain, non-artistic photograph" and valued its efficacities.[22]

Chief among these efficacities is persuasion. Evans would not want to be associated with the word "propaganda"—its taint has gone too far. But he would acknowledge that the craft (as opposed to the art) of documentary photography is concerned with influencing people's responses to contemporary social facts, and that a good deal of his own work has been. Propaganda or not, he sees nothing vicious in this use of photographs when done with restraint:

> Some people think that all photography is inherently importunate, particularly that of people where they're invaded by the camera. I get over that by feeling that it's in the great tradition [of documentary photography] and that it isn't really harmful. To importune is not to hurt very deeply; and to importune for a good reason is justified. Actually, I'm shy enough not to want to photograph anybody; I make myself do it because there's a larger value at stake. And the shyness disappears when I get absorbed in the work; if I get excited and know I have something good, I'll do *anything* . . . almost.[23]

Evans chose the pictures in *Let Us Now Praise Famous Men* somewhat for propaganda value, to benefit what he felt a good

and generous cause. His bias was far less than that of other docu-
mentary photographers of the time: he did not tamper with the
reality he recorded; he shunned the maudlin and the cliché. Yet
bias there was—a bias, like Dorothea Lange's, of selection. In the
first edition he used the Leica photos of Fred Ricketts and his
daughters, and kept out other, better pictures. In both editions
he ran a noble portrait of Bud Woods' face, suffering but indomi-
table, one eye firm and the other uncertain, chin up, mouth set.
He did not use a portrait of Woods taken at the same time and
more characteristic of the man, who seemed to Evans "hardbit-
ten, sore, and shrewd." This second portrait shows Woods' head,
the bandanna on his bare shoulders, and his naked torso almost
to his navel.° His face is cunning, disgusted, and mean. His body,
disturbingly close to the viewer, is, as Agee observed, "still vital
and sexually engaging"; but at the same time it is shrunken and
vague compared with the face—an old man's body yet somehow
menacing. This Woods is he whom the book describes as "dimly
criminal." It is an extraordinary portrait, though perhaps no
more so than the one Evans used.[24]

The photograph that most reveals Evans' bias in *Let Us Now
Praise Famous Men* also did not appear in either the 1941 or the
1960 edition; furthermore, unlike the second picture of Woods, it
resembles nothing else in the book. It is a posed family portrait
of the Gudgers in their Sunday best, standing beside their cabin.
Evans made the picture early in his and Agee's stay at the Gudg-
ers' because George Gudger wanted it. George had Evans take a
number of pictures of the family at various times, and Evans
obliged, since this was a way of gaining their favor and of put-
ting them more at ease with the camera. In *Let Us Now Praise
Famous Men* Agee recounts the first picture-taking session at the
Rickettses' when George coolly insisted that his children and he
(Annie Mae was absent) would be photographed alone; the pose
he arranged then was "perfectly in one of the classical traditions:

° Evans: "Incidentally, look at the style. That's hippie style. The moustache
and the bandanna. *And* the nakedness."

that of the family snapshots made on summer sunday afternoons thirty to forty years ago, when the simple eyes of the family-amateurs still echoed the daguerreotype studios." Everybody looked at the camera, George placed his hand on his eldest son's shoulder, Louise stood directly in front of her father, Burt sat at her feet, and so on. The portrait of the Gudgers outside their home was arranged in the same style. George put the children—George Jr., Burt, Squinchy, Louise—on a bench behind which stood the adults—George himself in the middle, Annie Mae to his left, her sister Emma to his right. They all faced forward, squinting in the huge light of an Alabama summer morning, and smiled at posterity in separate ways.[25]

George Jr., sitting on the bench down right, grins wryly, his head cocked to the side. His hair is parted in the middle and slicked down; this, his grin, and his tough-guy nose give him the incongruous look of a subteen Mencken. He wears a pair of overalls (his newer pair: they have cuffs with room for him to grow), and his feet are bare. Burt and Squinchy stand on the bench at center, Squinchy propped with his mother's hands. The picture has taken too long getting made, and their smiles have soured. Squinchy frowns down at the bench top. Burt grimaces furiously with his eyes shut against the sun. Louise sits very straight on the left edge of the bench. Her hands are folded, fingertips just touching, in the lap of her cheap starchy dress. She wears new sneakers. Her smile is keen, inquisitive, and faint. Standing behind her and to the center, Annie Mae positively beams—a wide shy grin with her mouth closed. She wears a cotton print dress in a floral pattern with scoop neck and large ruffled collar (a dress Agee curiously did not describe). Her shoes, adult versions of a girl's maryjanes, are brightly polished. Emma smiles with tense good humor. Her mouth is open and somewhat uneasy. We see why when we look at George, the picture's central figure. He is combed and freshly shaven, wears a clean white shirt open at the throat, and has a plug of tobacco in his breast pocket. He is not smiling; that would be effusive and weak, and

he is here, above all, powerful. He eyes us frankly, in an attitude
of nonchalant—though by no means indifferent—command. He
rests his arms, with a proprietary heaviness, on the shoulders of
the women beside him. (Emma doesn't know what to make of
this: above the waist her body leans toward him; below, it stays
discreetly straight.) This George Gudger needs no one's pity: he
is the master of the brood and relishes his fortune.[26]

This family portrait may come to be acknowledged the classic
photograph of *Let Us Now Praise Famous Men*. For just as Agee
and Evans' book exposes the limitations of thirties documentary,
it reveals the limitation in their book. They commended the full
humanity of their subjects, but they did not fully disclose it.
Evans showed George Gudger's unshaven hangdog face after a
day in the field, but not his Sunday face which told the world he
was cock of the walk. Agee described George as "clumsy and shame-
faced" around Emma—a bungler who hadn't the nerve to kiss
her goodbye. He certainly never led us to expect that George
could so casually embrace his pretty sister-in-law. The portrait
suggests that Agee gently accentuated his subjects' poignancy: he
would let George have his picture taken with his hand on his
son's shoulder, but not about two pleased and handsome women.

The portrait is too much for the book as the book stands: it
explodes it. Evans no doubt realized how subversive of his and
Agee's social purpose such a picture would be; when he devel-
oped the negative in 1936, he glanced at it and put it aside with-
out bothering to strike a print. He forgot about it until he came
across the negative in the late sixties while preparing his Mu-
seum of Modern Art retrospective. "I was quite amazed when
I saw it," he says. He now could judge it without concern for its
polemical value. If the photo was good, the Gudgers could be as
proud and happy as they liked, even misleadingly so. The photo
was good.[27]

A casual viewer may misunderstand it, but not someone who
has read the book. The reader can see behind the banal beauty
of this family's Sunday portrait the appalling beauty from which

it grew. He perceives the miracle of aspiration and energy the Gudgers here represent: being this clean without running water or sanitary facilities, this decently dressed on little money, this self-respecting in economic servitude, this gentle despite their hardships—just smiling as they smile. Whereas Arthur Rothstein felt he had to trick his subjects into giving him "true" expressions rather than "Sunday-snapshot smiles," Evans suggests that the truth will include the smiles. A great deal is hidden in those smiles, and for once what is hidden is almost hard to see. Annie Mae's closed-mouth grin is a mark of a reserved, self-delighting character, an enhancement of her beauty; one does not notice that it is a curtain for her missing teeth.[28]

The Gudger family portrait is the final and most daring testament to the tenants' humanity. It attempts something one would have thought impossible: to see the Gudgers honestly yet as they really *want* to be seen. And it succeeds. Evans says that were there to be another revision of the pictures in *Let Us Now Praise Famous Men* he would put it in.[29]

The portrait, like most of Evans' best work, has a meaning more ultimate than has been hinted at. One feels it immediately on seeing the picture. It is the "nostalgia," the "terror," the "infinite sadness," the "silence," much remarked upon in his art. This feeling is created by the composition of the Gudger portrait. A family is gathered in several square yards before the blank wood wall of an unpainted cabin. Its members are a copious source of energy, each radiating a self, and all together radiating a harmony of kinship. But they cover less than a quarter of the area of the image; there is a wide stretch of sandy dirt at their feet, of dark boards above and to the right of them, and of boards and a black corridor to the left. Though they shimmer with consciousness and life, their bereft environment has the upper hand. The people actually seem to huddle together for companionship in an alien world. They are beautiful, as is virtually everything Evans records. But the cause of their beauty is in large measure its transience, which he makes almost visible.[30]

Evans' work has frequently been called "timeless," and in a sense it is. His *vision* is timeless, a cool and unqualified staring. His is a contemporary art, an "art of silence" as Susan Sontag defines it: "Traditional art invites a look. Art that is silent engenders a stare. Silent art allows—at least in principle—no release from attention, because there has never, in principle, been any soliciting of it. A stare is perhaps as far from history, as close to eternity, as contemporary art can get." But if his vision is timeless, what it sees is not. Indeed, its stability and imitation of eternity only further emphasize how instable, how rotted with time, its subjects are. These torn posters, hand-printed signs, swept kitchens, Model A Fords; these eloquent buildings and enigmatic people will not endure. Their *image* may be rescued from oblivion, but what a small part of them this is.[31]

Evans' art has such power because it accentuates the root discontinuity of the photographic medium. It makes permanent what our eyes tell us cannot be. No other art does this so vividly, because none other has to collaborate so much with the actual world. A number of Evans' finest pictures—for example, "Main Street Block, Selma, Alabama, 1936"—recall Edward Hopper's paintings of city buildings and streets. But there is a difference. Hopper's buildings are *his,* translated into a medium where they lose the identity, if indeed they ever had it, of actual buildings on specific streets. They are fictions in a realm untouched by change; nostalgia is one emotion they definitely do not evoke. In contrast, the things of Evans' world are only lent him for a moment. He may manage to prolong the moment indefinitely, make it transcendent; but the things are not changed thereby. They shall pass, his pictures tell us, having made them stay.[32]

Evans' apparent subject is the vanishing America in which we live. A. D. Coleman says he shows us that "this nation is not imperishable and will not last forever—that time, if nothing else, will see us disappear." Evans' *actual* subject is time, seen in the beauties of the fallen world. His vision is daunting, and not only because it makes us look at our mortality. It insists on doing

what we ourselves rarely dare: it takes us, our lives, the things we use and are used by, our civilization, our humanity, with ultimate seriousness. It stares at our customary locales—advertisements, slums, street corners, relatives and passersby, cemeteries —as though they were of eternal significance. And how terrible it is to realize that though they are not, they are we.[33]

CHAPTER 15

The Text

In his Preface to *Let Us Now Praise Famous Men,* James Agee warned that he intended the book "as a swindle, an insult, and a corrective." Though his tone was somewhat righteous and self-congratulatory, his words were well chosen. For the book, as Alfred Kazin noted when it appeared, was "an attack on the facile mechanism . . . of most documentary" at the time. Agee subverted the genre in which he wrote: showed how its usual rhetoric diminished "human actuality." So doing, he posited and in part achieved the ideal, impossible book that would fulfill the documentary promise and speak "the language of 'reality,'" which never can be spoken.[1]

Let Us Now Praise Famous Men was published in 1941, and the reviews make plain how odd and troubling it then appeared. Though most of them had warm praise for the book,° all

° The idea that the first edition was "abused by all but the most perceptive critics" has been promulgated by the publishers of subsequent editions to explain the wretched sales. It is a convenient myth since it dovetails with the broader Agee myth of unrecognized genius and "wasted talent." In fact, however, nearly all the reviews were positive. Most criticized parts of Agee's text but insisted that others had "the proportions of a major novel" (George Barker, *The Nation*), contained "some of the most exciting U.S prose since Melville" (*Time*), and were "as fine a piece of prose and honesty as one can find in American literature" (Harvey Breit, *New Republic*).

were puzzled by it. *The New Yorker*, for example, while commending it to their readers ("superior, highly original, accurately poetic writing"), described it as follows: "A comprehensive study of three Alabama tenant families, though not quite what you'd expect." And this tone of slight wonder—of dealing with something too new and original to be easily defined—occurs throughout the reviews. Having studied the literary and social context in which the book was made, we can see why. *Let Us Now Praise Famous Men* was importantly different from what "you," a reader of the time, were prepared for.[2]

Agee's text deliberately violated expectations—swindled, insulted, corrected them on every page. Consider:

¶ It used the case-study method, but not to simplify the tenant families. It insisted that its subjects, rather than being average or representative types, were each unique: "a creature which has never in all time existed before and which shall never in all time exist again." It tried to examine social problems from this perspective, "however seriously that may impair the work as a sociological study."

¶ It did not dramatize its subjects in their social role and show them as "sharecroppers" per se: disputing with their landlord, paying exorbitant prices at the plantation store, being ridiculed and ignored by town officials, nor even (very much) working. Instead, it recorded their personal lives: their meals, their traveling to work, their Saturday in town, their worrying about their kin, their posing for pictures, their going to bed and getting up.

¶ It did not report its subjects' lives in a tone that affected to be their own. Interestingly, Agee experimented with this technique, "writing the book in such language that anyone who can read and is seriously interested can understand," because he felt "the lives of these families belong first (if to any one) to people like them and only secondarily to the 'educated' such as myself." He gave up the effort, finding that he couldn't contrive a "credible language" and that the naïve tone made "perfectly defenseless children" of the tenants.

¶ It did not portray the tenants as brutes or puling babes. It found no taint of "animalism" in their minds, as Erskine Caldwell had. Rather, it showed the delicacy of their internal and interpersonal lives. While trying to persuade Emma not to follow her hated husband to Mississippi, Annie Mae and George Gudger are as subtle in their gestures and awarenesses as Jamesian heroes:

> Annie Mae is strong against her going, all that distance, to a man who leaves her behind and then just sends for her, saying Come on along, now; and George too is as committal over it as he feels will appear any right or business of his to be, he a man, and married, to the wife of another man, who is no kin to him, but only the sister of his wife, and to whom he is himself unconcealably attracted: but she is going all the same, without at all understanding why. Annie Mae is sure she won't stay out there long, not all alone in the country away from her kinfolks with that man; that is what she keeps saying, to Emma, and to George, and even to me; but actually she is surer than not that she may never see her young sister again, and she grieves for her, and for the loss of her to her own loneliness, for she loves her, both for herself and her dependence and for that softness of youth which already is drawn so deep into the trap, and in which Annie Mae can perceive herself as she was ten years past.

¶ It did not curry favor with the reader, as documentary writing usually does. Its first thirty pages—from the annoying note that begins the Preface ("serious readers are advised to proceed to the book-proper"), through a Book One that ends before one is told it has begun, through spasms of pretension ("sonata form," "*Essai de Critique Indirecte*") and sophomoric humor ("Ring Lardner / Jesus Christ / Sigmund Freud . . . unpaid agitators"), to a slough of prose-poetry that means nothing on first reading and too little on subsequent ("In their prodigious realm, their field, bashfully at first, less timorous, later, rashly, all calmly boldly now, like the tingling and standing up of plants, leaves, planted crops out of the earth into the yearly approach of the sun, the noises and natures of the dark had with the ceremonial gestures of music and of erosion lifted forth the thousand several forms of their entrancement")—its first thirty pages are "devoted largely to

alienating the reader," as *Time* observed. And, Selden Rodman added, this is by no means the last time that the reader is "unmercifully slugged, drugged, browbeaten, and outraged."

¶ Unlike most documentary reportage, it did not try to demand that its audience be moved on behalf of its subjects. Agee of course *wanted* his readers to be, and hectored them throughout his early drafts:

> I wish I could write of a tenant's work: in such a way as to break your back with it and your heart if I could: but still more: in such a way that "innocent" of them though you are, you might go insane with shame and guilt that you are who you are and that you are not what some one of these persons is, who is living, while you are living. Good God if I could only make even this *guilt* what it is.

But he cut or toned down such fulminations in the final text (compare: "And how is this to be made so real to you who read of it, that it will stand and stay in you as the deepest and most iron anguish and guilt of your existence, that you are what you are, and that she is what she is"), except for a short passage where his bitterest loathing was pointed, characteristically, at himself:

> My self-disgust is less in my ignorance, and far less in my "failure" to "defend" or "support" the statement [just made], than in my inability to state it even so far as I see it, and in my inability to blow out the brains with it of you who take what it is talking of lightly, or not seriously enough.

¶ It was not pragmatic and present-oriented, but tragic and elegiac.

¶ Though Agee called himself "a Communist by sympathy and conviction," his text was not radical, nor even reformist, nor even socially constructive. Only once, for part of a sentence, was it direct propaganda—and then with tongue-in-cheek (Agee hoped the book might make the reader "feel kindly disposed toward any well-thought-out liberal efforts to rectify the unpleasant situation

down South"). Warren Susman thinks the book without any particular social or political lesson or doctrine, and this certainly was Agee's intention. He started a notebook of *pensées* about his reporting, and later quoted many of them in the "Preamble" to Book Two; one note he chose not to include was this: "Tenantry as such . . . does not particularly interest us, and the isolation of tenantry as a problem to be attacked and solved as if its own terms were the only ones, seems to us false and dangerous, productive, if of anything, chiefly of delusion, and further harm, and subtler captivity."

¶ It did not claim that the depredations of the tenant system were rectifiable; in fact, it thought it "at least unlikely that enough of the causes can ever be altered, or pressures withdrawn, to make much difference." True, Agee spoke several times of a cure for the tenants' suffering and once announced: "I know there is cure, even now available, if only it were available, in science and in the fear and joy of God." But by Part Three, the book's last and finest section, "science" has fallen away, and it is clear that Agee felt the cure would have to come from "our father, who art in heaven," when "there is to be an end to it," the "waiting and listening since the human world began," and, the Messiah returning, the meek would inherit the earth.[3]

In short, not only did Agee's text not *cater* to the accepted beliefs of the thirties, it obstructed and even denied them. It used the documentary genre to qualify or disprove the genre's usual values. And it accomplished this, surprisingly, through an intensification of documentary method. For if the two modes of documentary are direct and confessional (as we found), Agee, in *Let Us Now Praise Famous Men*, practiced both to the uttermost.

His 50,000-word "inventory" of the tenant houses is direct reporting of a scale and intensity without parallel in English letters. He describes the physical contents of his subjects' lives right down to their cups and footwear, the grain of the wood in their bedroom wall, the unidentifiable brown dust in the corner of a drawer. Documentary writers of the thirties used concrete facts

and instances to lend validity to the reformist theories they re-
tailed; Agee threw out theory and retailed fact—by the yard.
There was a logic to his cataloguing: if a single concrete instance
gave some validity, many instances must give more. And this is
what his extraordinary "Shelter" chapter is saying at every point:
look, it is *all* valid.

> Upon this towel [on the bureau in the Gudgers' front bedroom]
> rest these objects: An old black comb, smelling of fungus and
> dead rubber, nearly all the teeth gone. A white clamshell with
> brown dust in the bottom and a small white button on it. A
> small pincushion made of pink imitation silk with the bodiced
> torso of a henna-wigged china doll sprouting from it, her face
> and one hand broken off. A cream-colored brown-shaded china
> rabbit three or four inches tall, with bluish lights in the china,
> one ear laid awry: he is broken through the back and the pieces
> have been fitted together to hang, not glued, in delicate bal-
> ance. A small seated china bull bitch and her litter of three
> smaller china pups, seated round her in an equilateral triangle,
> their eyes intersected on her: they were given to Louise last
> Christmas and are with one exception her most cherished piece
> of property. A heavy moist brown Bible, its leaves almost weak
> as snow,° whose cold, obscene, and inexplicable fragrance I
> found in °° my first night in this house.[4]

Had the inventory been done in the usual documentary tone
and for the usual reason—to shame the reader with the woeful-
ness of the underprivileged—it would be intolerable. As things
are, because words, unlike photographs, cannot "communicate si-
multaneity," the inventory is slow going, as Agee warned it
might be. And yet it works; his phenomenal energy and serious-

° The image was taken from Hart Crane's poem "My Grandmother's Love
Letters," which letters had been "pressed so long / Into a corner of the roof /
That they are brown and soft, / And liable to melt as snow." In fabricating
his linguistic approximation of reality, Agee stole from many great writers.
°° To give his writing freshness, Agee made unexpected and often subtly
exact use of prepositions. Dust would normally be "on" the bottom of a
clamshell; Agee said it was "in." He found the Bible's odor "in" his first
night, not merely his first night. He spoke of the beauty of the Gudger
house being "inextricably shaped in an economic and human abomination,"
where one would usually say it had been shaped "by" these abominations.

ness carry it off. He is like Adam creating an entire, unimagined world by scrupulously naming it (the comparison becomes almost explicit when he hastily designates—"the snakes are blacksnakes, garter snakes, milk snakes, hoop snakes"—the beasts of the field, the birds of the air, and the plants). He persuades the reader that the poor and ordinary things the tenants possess can bear such attention, are worthy it. They are worthy because they are used: even the scrap pile of lard tins, mule shoes, broken pieces of machinery and tools on the Rickettses' kitchen porch "cannot properly be called junk because they are here in the idea that a use will be found for them." And they are worthy because, as Evans showed, they are beautiful.[5]

In "On the Porch: 2," the book's intellectual center, Agee wrote: "Calling for the moment everything except art Nature, I would insist that everything in Nature, every most casual thing, has an inevitability and perfection which art as such can only approach." Clearly the perfection Agee meant, Nature's inevitable beauty, wasn't always pretty or agreeable; the word he most often chose to describe it was "cruel," and one memorable phrase, "the cruel radiance of what is." Kenneth Seib, a literary critic, believes that Agee's "theory, that art is a kind of second-class Nature and that every part of Nature contains absolute beauty, is unconvincing. If it is true, why bother to create art at all? . . . [The theory] betrays him into a shameless lack of responsibility in his use of language." Seib evidently thinks that Agee was tricked by a belief in the spontaneous perfection of Nature into writing spontaneously—that is, any way he felt like at the moment. Agee may have sometimes written thus, but not because of his theory. He denied (though less clearly than he might have) that art and Nature were identical. "Human beings and their creations [other than art] and the entire state of nature," he wrote, "merely are the truth." This truth, he said, "words cannot embody; they can only describe." Consequently, it was the business of the serious writer—the poet, as Agee called him—to "continually bring . . . words as near as he can to the illusion of

embodiment." Agee bothered to create art, then, for the reason all Romantics do: to bring words more closely into correspondence with the truth, Nature, the world.[6]

He realized that a final correspondence was impossible: the dissociation of word and object meant that reality, the truth, couldn't be told. "Failure, indeed, is almost as strongly an obligation as an inevitability," he acknowledged; "and therein sits the deadliest trap of the exhausted conscience." His inventory of the tenants' lives challenged the exhausted conscience of the documentary writing in his day, and, more widely, the "primal cliché and complacency of journalism" in general. He asserted that more direct, true, and unbiased reporting would be done by a poet, and he showed how.

> The one static fixture in the hallway [of the Gudger house] is at the rear, just beyond the kitchen door. It is a wooden shelf, waist-high, and on this shelf, a bucket, a dipper, a basin, and usually a bar of soap, and hanging from a nail just above, a towel. The basin is granite-wear, small for a man's hands, with rustmarks in the bottom. The bucket is a regular galvanized two-gallon bucket, a little dented, and smelling and touching a little of a fishy-metallic kind of shine and grease beyond any power of cleaning. . . . The dipper again is granite-wear, and again blistered with rust at the bottom. Sometimes it bobs in the bucket; sometimes it lies next the bucket on the shelf. The towel is half a floursack, with the blue and red and black printing still faint on it. Taken clean and dry, it is the pleasantest cloth I know for a towel. Beyond that, it is particularly clammy, clinging, and dirty-feeling.

The things of the world are reported with such patient literalness and precision that their qualities, on briefly heightened description, start to life before us—and we see the dipper bobbing in the bucket, taste the slimy water, feel the thin saturated gritty towel.[7]

The world is finally incommunicable, just like the weird fox whistles—"if they were foxes"—that Agee and Evans hear at book's end. But though the language of reality cannot be mastered, Agee (unlike Sherwood Anderson, for example) found this

no reason not to struggle toward its "inachievable words." His direct reportage suggests what documentary writers might do if they really took the life of their subjects without preconception, on its own terms, with the eye of a stranger who is yet, as Agee found himself to be, a close relation.[8]

More than Agee's direct reporting of reality, it was his extraordinary participation in the narrative of *Let Us Now Praise Famous Men* that set the book apart from other documentary writing of the thirties. This aspect of the book drew far the most criticism. Agee was called to task for his "bad manners and exhibitionism," for "too many awarenesses on the subjective side," for a sincerity that was "too much, too prostrate." Even Lionel Trilling, who best perceived the book's excellence, thought Agee's autobiography and self-examination didn't succeed because too much of the reader's attention was taken up with subtracting Agee from his report. Quite simply, *Let Us Now Praise Famous Men* was confessional in a way no documentary had been. In prior documentary writing—and in subsequent, down to the "new" or "personal" journalism of the sixties—confession was a strategy for telegraphing to the audience the feelings it should feel. The writer was an experiencer of a certain social condition, and his firsthand reactions were to guide the reader's own. The writer's personality figured in the report, if at all, in abbreviated form, as a type: usually the cool-headed fact-gatherer or the weeping Jeremiah. His complexities and passions, and the full story of how he got the story were left out of account.[9]

Not with Agee. He exposed himself infinitely more than he did the tenants. He made public his tangled and often disreputable desires, his moral outrage at the "obscene and thoroughly terrifying" assignment he had taken on, and his (paradoxical) "self-nausea" at how poorly he was doing it. Like other documentary writers, he participated in the life he studied, tried to get "inside the subject." Yet simultaneously he confessed his distance from the tenants: showed how his participation came about and how thin it was. He participated, but he showed so *much* of the participa-

tion that he was seen to stand apart. He presented himself as he was: an actual man of complex personality in real relation with other actual inaccessible people—like George Gudger, whom he knew "only so far as I know him, and only in those terms in which I know him; and . . . that depends as fully on who I am as on who he is." [10]

Agee used the reality of his relation with the tenants to prove *their* reality—not "as 'tenant' 'farmers,' as 'representatives' of [a] 'class,' as social integers in a criminal economy," but as humans. And he proved the relation's reality by laying bare his side of it.[11]

He showed how hard he worked to make relation possible, to set people at their ease and encourage them to trust him. With a landowner, he was "even more easygoing, casual, and friendly than he was." With a Negro couple he had accidently terrified, he stood "shaking my head, and raising my hand palm outward," and smiling, so that "they should be restored, and should know that I was their friend." During the picture-taking at the Rickettses' house the first afternoon, he

> was spreading so much quiet and casualness as I could. . . . It was you I was particularly watching, Mrs. Ricketts; ° you can have no idea with what care for you, what need to let you know, oh, not to fear us, not to fear, not to hate us, that we are your friends, that however it must seem it is all right, it is truly and all the way all right: so, continually, I was watching for your eyes, and whenever they turned upon me, trying through my own and through a friendly and tender smiling (which sickens me to disgust to think of) to store into your eyes some knowledge of this, some warmth, some reassurance, that might at least a little relax you.

Agee made the face, though it disgusted him, because he thought it would help Mrs. Ricketts understand his genuine good will. He

° Agee's direct address of the tenants is an example of how he sought relation with them even in remembering and writing of it. His narrative becomes a kind of letter. This effect is intensified in his manuscripts where he used the tenants' actual names.

did the right thing consciously, trying to achieve relation. His first night in the Gudger house he forced himself to eat a good deal more than he could hold so that he wouldn't seem to be eating to be polite. He found that George and Annie Mae were "quietly surprised and gratified in my appetite" and that the meal was the beginning of his "intimacy" with them.[12]

He made it clear that he identified with these people in a deep, even reverent way very different both from the facile pity of most documentary and from the blunt opportunism of Franklin Roosevelt's remark quoted at the start of the inventory of the tenants' lives: "You are all farmers; I am a farmer myself." The Gudgers, though his exact contemporaries, seemed to Agee "not other than my own parents"; their house, "my right home, right earth, right blood, to which I would never have true right." At times he felt so close to the tenants he could "know almost their dreams" and, like Walt Whitman, "lie down inside each one." He judged that Fred Ricketts' ruined feet were in part the consequence of a habit he, Agee, shared: "half-consciously to alter my walk or even to limp under certain conditions of mental insecurity." In a heroic metaphor a page in length, he equated Annie Mae's preparation of breakfast with the "earliest lonely Mass" at which he served as altar boy while "a child in the innocence of faith." [13]

Agee makes plain to the reader why he worked at achieving intimacy with the tenants and why he so identified with them. He liked them. He took pleasure in the give-and-take, the easy tension, of being with them. He and Evans looked forward to their subtle negotiations with Bud Woods, who became "a sort of father to us" and who himself enjoyed the sessions and liked the young men long before he ceased mistrusting them. Agee valued the tenants' trust and affection. It was Mrs. Ricketts' "unforgiving face," her resentment of Evans and him the first afternoon, that more than anything made him choose this group of people to live with. "We shall have to return," he thought, "even in the face of causing further pain, until that mutual wounding shall have been

won and healed, until she shall fear us no further, yet not in forgetfulness but through ultimate trust, through love." Evans has said that Agee made the tenants fall in love with him and that their love was reciprocated.° Both facts are apparent in the book, nowhere more so than in the luminous passage in which Agee confesses that "something very important is happening . . . between me and Louise."

> She has not once taken her eyes off me since we entered the room: so that my own are drawn back more and more uncontrollably toward them and into them. From the first they have run chills through me, a sort of beating and ticklish vacuum at the solar plexus. . . . Inevitably I smile a little, quietly, whenever I meet her eyes, but that is all. I meditate, but cannot dare a full and open smile, in any degree which presupposes or hopes for an answer, not only because I realize how likely she would be not to "return" it, which, needing her liking so much, I could not bear, but because too I feel she is a long way above any such disrespect, and I want her respect also for myself.

It is impossible to imagine such a moment in any other documentary work of the thirties.[14]

Agee divulged not only his love for the tenants but his carnal thoughts about their women. His extreme candor about sex and his sexual needs and fantasies troubled the original reviewers more than anything else. The "New Book Survey" in the *Library Journal* reported that *Let Us Now Praise Famous Men* had "beautiful, lyric prose of high merit," and, in the next sentence, "many objectionable passages and references"—shorthand for smut. Thirties documentary (and radical fiction, too) piously ignored human sexuality,°° except when it was degraded by eco-

° Agee kept up his friendship with the tenant families. At least once he visited them again, bringing his wife Alma to meet them. He corresponded and exchanged presents with them until his death.
°° Henry Roth, the author of *Call It Sleep* (1934), was asked in 1971 why he hadn't written other books. He said he had tried to in the thirties but that the "dichotomy" between the "proletarian virtue" he wrote about and his own sexual desires produced a guilt that immobilized him. Speaking of himself in the third person, Roth wrote: "He desired what his [hero]

nomic need and, typically, a girl or woman sold her body to get food. Agee, quite against the temper of the time, insisted on bringing into the open the sexual motive in normal behavior. He drove the car, and Emma sat beside him,

> her round sleeveless arms cramped a little in front of her. My own sleeves were rolled high, so that in the crowding our flesh touched. Each of us at the first few of these contacts drew quietly away, then later she relaxed her arms, and her body and thighs as well, and so did I, and for perhaps fifteen minutes we lay quietly and closely side to side, and intimately communicated also in our thoughts.

In such passages as this, Agee brilliantly disclosed the unacknowledged sexuality of everyday experience: the random small liaisons that happen all the time but that one doesn't talk about nor even, sometimes, realize. But he did something more: he verified the tenant woman's reality as a human, a woman, and not merely an integer in a criminal economy. To admit that such encounters can take place between a social "victim" and the reporter documenting his or her life is to bridge the social and economic gulf between them and severely weaken the idea that hardship is the *basic* fact of the victim's life. Cultivating real relation with the tenants meant that Agee had to go so far as to agree with Bud Woods, in the book's funniest moment, that there was a danger he, Agee, might be overcome with passion for Woods' slatternly wife, Ivy, and hence had better sleep under another roof.[15]

Agee's recording the delicate dance of attraction between the tenant women and him is one of the book's triumphs. The same is not true, however, of his implicating them in sexual fantasies which seem to have been his alone. His suggestion that before re-

eschewed. . . . This was the dichotomy. More and more drawn to things sensual, more and more imaginatively kindled by vileness, at the same time as he strained to project a party hero. . . . What guilt that dichotomy could engender! A party stalwart in letter, a satyr in proclivity. The proclivity condemned as degenerate."

turning to her husband Emma "could spend her last few days alive, having a gigantic good time in bed, with George, . . . and with Walker and me" is a huge presumption because Agee claims the others had the idea in mind ("this has a good many times in the past couple of days come very clearly through between all of us except the children") but gives no evidence to justify the claim. In the car Emma frankly relaxed her body against his; there is no comparable gesture of intimacy in the earlier scene. One appreciates why Evans would find the scene an embarrassment, since he is said to have been harboring a disreputable idea that in fact did not cross his mind.[16]

This may be the chief problem in Agee's text: his confessions, sexual and otherwise, are occasionally forced on others. The problem is not his confessions about himself, his sexual exploits, his hunger for "a girl nearly new to me"; these are boastful and boyish, and entirely his business. (As a matter of fact, they are justified in the scheme of the work, a point argued later.) Neither is the problem the claims he makes about other people when these are confirmed by gestures of theirs which he reports. The problem is the humiliating things he imputes to others while giving the reader no reason to believe them true. For instance, did Annie Mae actually say, as Agee seems to imply, "Oh, thank God not one of you knows how everyone snickers at your father"? Or was it Sadie Ricketts? Or neither of them? Did Annie Mae really say, "I tell you *I* won't be sorry when I die. I wouldn't be sorry this minute if it wasn't for Louise and Squinchy-here"? Which of the tenants said, "I reckon we're just about the *meanest* people in this whole country"? Did any? Who said, "How did we get caught?" Wasn't it just Agee putting words in the tenants' mouths? "In what way were we trapped? where, our mistake? what, where, how, when, what way, might all these things have been different, if only we had done otherwise? if only we might have known." [17]

Paul Goodman, reviewing *Let Us Now Praise Famous Men* in 1942, accused Agee of constantly reading himself into the ten-

ants' lives, sometimes with "insufferable arrogance." In fact,
though, Agee can do it without any arrogance whatever, provided
the reader knows he is doing it. He can guess at the tenants'
dreams or imagine—touchingly, plausibly—Louise's thoughts
("But I am young; and I am young, and strong, and in good
health; and I am young") and the reader accepts his inventions
as such, as the best hunches of a sensitive onlooker. Arrogance
starts, however, when he fabricates and doesn't tell the reader—
which he did, at least in part, in the "how were we caught" sec-
tion. Agee elsewhere took such care to dignify the tenants that
his handling of them here is incomprehensible. One doesn't doubt
that the tenants felt such raw despair; indeed, Agee often alludes
to it. What one *does* doubt is that they *told* him these things.
Surely Annie Mae Gudger never spoke thus of her husband to
James Agee: "He no longer cares for me, he just takes me when
he wants me." That Agee would half pretend she had said it,
rather than frankly acknowledge it a guess on his part, violates
the fundamental insight of *Let Us Now Praise Famous Men;* it
strips the tenants barer than they actually were. The sentence
imposed on Annie Mae treats her as the captions treat the people
in *You Have Seen Their Faces.*[18]

Evans acknowledges that the "how were we caught" section
makes him "squirm a little; I think it is a wrong note. Still, that's
part of Agee's general psychological belief: give them every-
thing; let's have the truth. He may have squirmed, too, and said,
'Well, squirm or no squirm this has got to go in.'" Certainly this
impulse motivated Agee's confessions about himself. He went out
of his way to expose what he called his "present immaturity": his
erotic fixations, his guilt and death-longings, his hunger for "first"
intimacies and apathy at subsequent. His telling these embarrass-
ing facts is an important part of the book's strategy. He tells the
truth about himself, humbles and even humiliates himself, so that
he can uncondescendingly tell of the tenants' humiliation. He
strips himself to have the right to report their nakedness. And
there is a way in which the reader, who intrudes upon Agee as

Agee intrudes upon the tenants, must also strip himself to look upon them. If he gets by the book's efforts to alienate and bore him, he must still pass the test of Agee's confessions. If these seem to him depraved and lunatic, as they did to several reviewers, and if he cannot recognize how similar compromising truths might be told about him, he will not see the tenants as Agee thought they truly were, as people like himself.[19]

Through all his writing Agee was concerned to inculcate "a way of seeing" which might help in "restoring us toward sanity, good will, calm, acceptance, and joy." He was, as Evans insists, primarily a moralist. In *Let Us Now Praise Famous Men*, he sought to teach the educated thirties' reader how to feel and respond toward the underprivileged. This is the question with which the book permanently confronts its audience: how should we, relatively fortunate people, behave toward the unfortunate, the crippled, the deceived? And Agee's answer, which he puts into practice throughout the narrative, is as outrageous as it is Christian and simple: we should establish real relation; we should fall in love with them.[20]

Lionel Trilling, while he thought Agee's argument "the most important moral effort" of his generation, believed there was a fault in its presentation. He felt Agee was suggesting that the poor and the damaged be loved *because of* their afflictions. He said Agee wrote of the tenants "as if there were no human unregenerateness in them, no flicker of malice or meanness, no darkness or wildness of feeling, only a sure and simple virtue, the growth, we must suppose, of their hard, unlovely poverty." Trilling's criticism, which has been echoed by several recent scholars, is in part true. Agee believed that in poverty and suffering (and in failure, too) there was virtue.° For him, the poor *were*

° One comes to the conclusion that Agee wanted his writing on the tenants to fail in society's eyes as thoroughly as it could—even perhaps to the point of not getting published. He felt that his book's being a "success" would be an "unmistakable symptom that salvation is beaten again," because it would mean he had catered to the values of his audience. To succeed in his own terms, then, Agee had to be a failure. He believed that the will to worldly

blessed; they were the "famous men" whose children are within the covenant and whose seed shall remain forever. Writing in 1947 of Helen Levitt's photographs of slum-dwellers, he said: "This is the record of an ancient, primitive, transient, and immortal civilization, incomparably superior to our own." The idea wasn't put so baldly in *Let Us Now Praise Famous Men*, but no doubt Agee held it then. Nevertheless, he certainly did not claim the tenants free of human unregenerateness:

> In the people of [the rural South] you care most for, pretty nearly without exception you must reckon in traits, needs, diseases, and above all mere natural habits, differing from our own, of a casualness, apathy, self-interest, unconscious, offhand, and deliberated cruelty, in relation toward extra-human life and toward negroes, terrible enough to freeze your blood or to propel you toward murder; and . . . you must reckon them as "innocent" even of the worst of this.

To Agee, then, the tenants were "innocent" but not good.[21]

Agee wanted to believe that a love relation between "the extremes of the race"—the educated and well-off, and the poor and ill-used—was possible and would redeem the world. He put this idea in a fervent and obscure paragraph comparing the tenants to the Union soldiers "constantly waiting" for deliverance from the Confederate prison camp at Andersonville. He said that because a "regard of love" had been achieved between the tenants and him, there would come at length "rescuing feet" that would "deliver you [the tenants] freedom, joy, health, knowledge like an enduring sunlight." But as though embarrassed at the sentimentality of the idea, he hid it in grandiloquence and clouded allusion,° and finally undercut it by implying that these boons would fall not to the tenants alone "but to us all," with the coming of the Messiah.[22]

success was "a mortal and inevitably recurrent danger" but thǎt, even for an American, it was "avoidable." Throughout his life he managed to avoid it, though at great cost.

° He said he didn't think the Soviet example would be followed in America, but here is how he said it: "Whether [the deliverance] shall descend upon us over the steep north crown I shall not know, but doubt."

It was characteristic that Agee couldn't decide whether human or God's love would save the world. His text to *Let Us Now Praise Famous Men* is radically tentative, unfinished. The parts of it earliest composed were used unrevised, sometimes in quotation marks, with footnotes contradicting what the author formerly thought. In "On the Porch," written in 1937, Agee said journalism was not to be blamed for its broad and successful lying; "Why not?" he asked in a 1940 footnote. In his 1939 responses to a *Partisan Review* questionnaire, which he included in *Let Us Now Praise Famous Men* to make explicit his contempt for "socially conscious" literature, Agee said he had often considered but not yet resolved what he would do in the next world war, perhaps join the infantry or run away and hide. A footnote written in the fall of 1940 observed that nonresistance to evil was the only way to conquer it and that any military draft should be resisted. A second footnote, written on the galley sheet in April 1941, apologized for treating the "whole question so tamely and inadequately," but said there wasn't time for the lengthy discussion needed. The author still had not made up his mind.[23]

Throughout the text Agee begins topics, breaks them off, reverts to earlier ones or shifts ahead (telling the reader not to be "puzzled by this, I'm writing in a continuum"), stops, often in self-disgust, and takes up the first topic once more. Over and over he redefines his theme, purpose, method, and starts again "a new and more succinct beginning." "I will be trying here to write nothing whatever which did not in physical actuality or in the mind happen or appear," he promises when the text is already half over. "These matters had in that time the extreme clearness, and edge, and honor, which I shall now try to give you," he says in the book's last sentence. These constant starts and abrupt revisions do two things: make the text disorderly and provide its fundamental order.[24]

Agee was the first of many people who have tried to explain the ordering principle in *Let Us Now Praise Famous Men*. "The book as a whole," he said in the middle of the book, "will have a

form and set of tones rather less like those of narrative than like those of music. That suits me, and I hope it turns out to be so." Evidently it didn't quite, for he appended a footnote comparing the forms of the text to those of movies and "improvisations and recordings of states of emotion" as well as music. When he finished the book, he tried writing a preface to explain its structure and found he couldn't: "For three or four months it has seemed to me that in twenty-five hundred words or so I could unify and make clear everything about this book that I wanted to or needed to. I have pretty well given that up now." [25]

Critics have sought to clarify the work by comparing it to *Moby Dick,* a Shakespearean five-act drama, and a Beethoven symphony—analogies which prove as unrevealing as they sound. Four scholars have found the key to the text, as they think it, in a distinction Agee tried to make among "four planes" of narration in the book. At least two of the planes are redundant, and all, as Agee conceded, are "in strong conflict" in many passages; but even *were* they always distinct, that would not explain why any one appeared at a certain moment and, hence, why the narrative has the curious shape it has. No one yet has pointed out the several minor skeins of imagery Agee ran through the text: for example, his descriptions of the land as sea and as night, with the tenant house "a little boat in the darkness," a "pitiably decorated little unowned ship of home," a "home . . . lifted before the approach of darkness as a boat and as a sacrament"; however, these certainly do not give the narrative a form.

One critic, Eric Wensberg, has claimed as much for the largest group of metaphors in the book, those taken from religion. It is clear that *Let Us Now Praise Famous Men* borrows a great deal from religion. The title itself comes from the forty-fourth chapter of Ecclesiasticus, of which Agee quotes the first fourteen verses. He quotes also the Lord's Prayer, the Beatitudes, two lines of Psalm 42, and all of Psalm 43. He makes secular metaphors of Christian terms: altar, sacrament, crucifixion, recessional, induction, introit, gradual, to name but a few. Furthermore, it is likely that he chose to end the narrative with his first supper at the

Gudgers' in part because it seemed to him a sacramental meal, a first communion (as it were) with his new parents. Finally, the book's main purpose is religious: to praise the "human divinity" of the humblest men and to proclaim, like an Old Testament prophet, that the covenant is broken. Nevertheless, when Wensberg maintains that "the book's design . . . is that of a religious service," he exaggerates. One may agree with him that the "Title Statement"—"Let us now praise famous men"—set alone on a page at the end of the book is like the text to a sermon, and that, indeed, Agee called the poem at the beginning of the book "Verses." But what part of the services is "A Country Letter"? "At the Forks"? "Work"? Presumably, "Inductions" would be the communion ceremony, but why does it *precede* the sermon text? Every page in the book is the most telling refutation of Wensberg's theory: they do not read like parts of a church service.[26]

A better suggestion of the book's design has been made by Dwight Macdonald, who compared it to an anti-*Works and Days*, "a chronicle of decay instead of growth, where the land does not nourish those who labor on it but destroys them." There is much of the black pastoral in *Let Us Now Praise Famous Men*, and surely Macdonald is right to define its form in terms of an anti-genre or (what is the same thing) a mixed genre. But when he says that "Hesiod chronicled a way of life; Agee and Evans, a way of death," he overstates the morbidity of farm labor in the book. After all, Agee's final proof of the common humanity of tenant, journalist, and reader is that "quite soon now . . . we shall all be drawn into the planet beside one another." To call the book an antipastoral ignores its religious dimension, and also —and much more serious—its fierce skepticism about its ability to communicate the reality it treats.[27]

This urgent, at times tormented, straining to perceive and describe truly is the narrative's fundamental tone. On page after page Agee bemoans his incapacity:

> What's the use trying to say what I feel.
> The most I can do—the most I can hope to do—is to make a number of physical entities as plain and vivid as possible.

Two essentials, I cannot hope to embody even mildly but must say only, what they are, and what they should be if they could be written.

Let this all stand however it may: since I cannot make it the image it should be, let it stand as the image it is: I am speaking of my verbal part of this book as a whole.

He realized of course that to understand and convey "the whole problem and nature of existence" was "beyond what I, or anyone else, is capable of." His attempt kept the text in continual revision, as he weighed each word to choose the one that least diminished the truth and struggled vainly toward a narrative structure that would make the ineffable clear. His manuscripts are full of paragraphs dropped and revived, uncertain commands to himself ("Better omit or put in as a postscript"),° sections interpolated "from a former preface" or "from an earlier draft towards a more whole attempt." The book's most important scene, the first meal with the Gudgers, is clumsily given as a flashback, a "reversion," in a narrative that isn't taken up again. So miscellaneous is the text that Agee could find no better way to include large portions of it than to call them "Notes," "A Few Notes," "Notes and Appendices." The whole odd arrangement of the chapters seems to have been decided on the spur of the moment, in pencil, on a scrap of paper, with casual arrows shifting tens of thousands of words about.[28]

And this lack of order *is* the order in the text: Agee's straining to communicate reality, and failing, and straining again give the narrative its form. It is a form we might call antidocumentary or metaphysical documentary or neo-Christian documentary, a form of repeated prefaces and incidental notes to a book that cannot be written, a form that must "fail" because, as Trilling said, "failure alone can express the inexpressible." The form imitates the process of consciousness, wherein perception is sudden, inexplicable, quickly lost, and always beginning again. What one feels constantly behind the words on the page is a consciousness labor-

° The passage referred to wound up in the Preface.

ing toward the world, Nature, the truth. *Let Us Now Praise Famous Men* is a prologue, a "preface or opening," to reality. The book's symbol might be the parenthesis Agee often left unclosed — (—open to the world. Or, even better, the punctuation mark he used to such fascinating excess and named a chapter for: the colon. Once, having summarized the tenant environment in a paragraph, he said, "This is all one colon:" and ended the sentence and paragraph thus, leaving two lines blank below. He may have been referring to his narrative,° for in a sense *it* is all one colon that prefaces and points the reader to reality: a colon to a text that cannot be given.[29]

The book's hero is, as Agee said, human consciousness, the instrument that tries the many soundings of reality and the source "we have to thank for joy." Because Agee's consciousness is so forceful and rich, his most persuasive propaganda against the tenant system was exactly that it diminished consciousness, atrophied "the use of the intelligence, of the intellect, and of the emotions." In tenant life "a consciousness beyond that of the simplest child" would result "in a great deal of pain, not to say danger"; hence, the faculty had to be reduced or killed. This was the obscenity of tenant life.[30]

Since Agee's consciousness is so crucial to the book, one must ask finally whether its tone of tragic resignation was appropriate. Was the best answer to pray "in most reverent fierceness" and "hope better of our children, and of our children's children"? The people of the thirties, most of them, did not think so; they believed in the promise of the New Deal. The reviewers of the 1941 edition had the same liberal optimism, and nearly all the 1960 reviewers pointed out how wrong Agee had proved as social prophet. Priscilla Robertson, who reviewed the second edition in *The Progressive* of January 1961, said: "The truth is, James Agee couldn't imagine anyone's being either happy or self-propelled.

° In a draft Agee explained his odd punctuation: "These parentheses, colons and question marks are intended to indicate what it seemed that words could not as well."

He was a tragic poet who had to see and magnify and beautify into art the suffering in any life." She thought *Let Us Now Praise Famous Men* "not much more to be trusted as a source book for life in the Thirties than *King Lear* for early Britain." Robertson's opinion has particular interest because in the summer of 1937 she and Louise Boyle, a photographer, spent some weeks living with an Arkansas sharecropper family. Though quite as poor as Agee's tenants, these people were

> full of hope and busy working for a better life. Many things favored them in those New Deal days. Since the W.P.A. had given the husband the first steady cash he had ever earned ($21 a week), he was free to buy at chain stores instead of the landlord's "robbersary." Our friends called on local politicians who wanted votes and on government labor schools; the Southern Tenant Farmers Union gave them a way of raising wages and a sense of excitement and sociability.

And, Robertson concluded, her tenants were right to be hopeful:

> The system which seemed to Agee eternal . . . did actually break down. This happened partly because some Americans were unwilling to have the system continue after they saw how bad it was; partly, because of machinery and industrial change; and largely because the Americans whose lives were at stake stood up to help themselves.[31]

So it seemed in 1960. Today, in 1973, we know that the system and its victims are still with us. Though most have been displaced from tenant farming, they still are poor; some of them, as the McGovern committee found, still are hungry. The Census Bureau stopped counting "sharecroppers" in 1964 because of their declining number, but whatever one calls them there are still hundreds of thousands of sharecroppers in the South, most of them casual farm laborers for a few months of each year and on relief the rest of the time. The shacks in the Mississippi delta are still lived in and look little different now than they did thirty-five years ago. Robert Coles and Paul Good, in recent documentary books that acknowledge Agee's inspiration, have pointed out that

these "American serfs," as Good calls them, are in some ways worse off than the tenant farmers of the 1930s.[32]

And what of the tenant families in *Let Us Now Praise Famous Men?* William Christenberry, a sculptor and a teacher at the Corcoran Gallery School of Art, comes from the small city Agee called "Centerboro" and has traced the fortunes of some of the book's people. They have been little affected by the social advances Patricia Robertson noted—nor even by the cataclysm she conveniently ignored: World War II. "George Gudger" died in the early 1940s, overwork a contributing factor. "Annie Mae" made a fortunate remarriage to a man of somewhat easier circumstance; she is still alive. But the children of the other families have been as damaged in their lives as their parents were. "Margaret Ricketts," for example, whose dreams were "of a husband, and strong land, and ladies nodding in the walks," in fact never married, as Agee guessed she wouldn't; bore a mentally defective child of an incestuous union; is today impoverished and despised by the polite members of her community. The doom Agee foresaw has been largely realized.[33]

Let Us Now Praise Famous Men is a book of doom and desperate resignation. Comparing Evans' pictures with Dorothea Lange's, A. D. Coleman found the former to have "a subtler terror,"

> for although the conditions Lange documented were brutalizing, they were implicitly temporary and rectifiable, so that one's sorrow could be tempered with anger—at those standing in the way of change—and hope. The grief Evans evokes may be quieter, but there is no tempering it ever; for Lange dealt with chance, while Evans deals with fate.

Because we are Americans and optimistic and vain of our good intentions, we most of us prefer to believe in change and chance, and not in fate. We would like to think that Agee and Evans' tragic vision was mere aberrance and defeatism; that "progressive" social improvement is attainable; and that, as John Kennedy said in January 1961, "here on earth God's work must truly

be our own"—and *can* be. But at the moment this is written, after a decade which began with Kennedy setting the American people about God's work and which then saw the destruction of the ideal of a Christian anti-Communism, the collapse of the War on Poverty, the decay of the belief in nonviolent change, it is at least possible to detect a value in what Agee and Evans, with such bitter reluctance, did. They transformed the hardship of three tenant families into a symbol of the life of all men; the suffering of others they "beautified into art," made an indelible music of. And they maintained—though they too preferred not to believe it and even argued against themselves—that life was like that: suffering, whatever its cause, could not be prevented and could be redeemed, if at all, only by redeeming consciousness. When liberals protested that life need not be like that because the suffering caused by social evils, at least, wasn't necessary, Agee and Evans replied with Beethoven: "He who truly hears my music can never know sorrow again." [34]

That the world can be improved and yet must be celebrated as it is are contradictions. The beginning of maturity may be the recognition that both are true.

Afterword, 1986

There is only one question I've been asked more than once about this book: "How did you come to write it?"

The answer begins "Necessity." I was an American Studies graduate student at Yale in 1970 and had to write a dissertation. If possible, I wanted it to be a useful piece of work. I remember asking A. N. Kaul, one of my favorite teachers, what he would write on, were he in my shoes. He laughed and said I reminded him of Raymond Weaver, who, in about 1920, asked a colleague at Columbia University what to write a book on and was told to look into a forgotten nineteenth century sea writer named Melville. Kaul chuckled, "I haven't a Melville up my sleeve."

At first I thought I was going to write on the shift in American reading habits from fiction to nonfiction. The New Journalism was then at zenith, and though I was a literature student, I was more interested in it than in the academic and postmodern fictions of the time. I found that, according to publishers' statistics, Americans started buying more nonfiction than fiction suddenly, in the 1930s.

That decade interested me because I was brought up on its myths. My parents had been leftists then; my father, who became a Wall Street banker, said hearing John Strachey speak would have made

him a Communist if he hadn't already been a Socialist. Many of the kids in my high school were also children of the Left, and in the halls between classes we sometimes threw around the old phrases: "petty bourgeois revisionist," "capitalist lackey," "dialectical obscurantism." I was born in 1940 and knew I had grown up in a peculiar world; I suspected a good part of the reason lay in the 1930s.

The art of the thirties appealed to me. From 1964 to 1968 I had been a cultural officer in Africa for the U.S. government and had worked with journalists, photographers, painters, broadcasters, and with documentary film. Doing propaganda I became interested in how it worked. Thirties art and expression offered a wide field for propaganda research.

As I got into the Depression decade I found I had connections with it I hadn't known about. One of my aunts was Clinch Calkins, whom I made the central figure of chapter 8. She had died several years before I cared to know the fascinating stuff she could have told me: how Harry Hopkins worked (she was his ghostwriter: parts of his 1936 *Spending to Save: The Complete Story of Relief* echo her *Some Folks Won't Work*), and what the Federal Writers' Project headquarters was like (she was close to Henry Alsberg, the FWP director; he went to a party at her house the night he was fired). I discovered that two of my parents' closest friends, John Fischer and Robert Thorpe, had worked for the PR division of the Farm Security Administration, collaborating and feuding with Roy Stryker.

New friends came forward to help. While I was trying to read James Agee and Walker Evans's *Let Us Now Praise Famous Men*, Richard Warch, our upstairs neighbor (and now President of Lawrence University), said he had gotten to know Evans, who taught in the Yale art school. Rik and I were preparing to teach different sections of a seminar on great books in American culture, and he said, "I'm assigning *Famous Men*. Why don't you assign it, and we'll get Evans to come talk to our classes?"

2

Walker Evans (1903–75) was to be my book's unannounced hero, but for a long time I didn't know this. Though I learned a good deal from

his question-and-answer session with Rik's and my classes on April 9, 1970, we didn't become friends then. At coffee afterwards, he was tired and remote. I gathered he was in the throes of separating from his second wife. I made sappy attempts to win his attention; his eyes blinked with indifference, like an owl's. I though I'd get no more help from him.

Nine months later, I read about his retrospective at the Museum of Modern Art. The master of Yale's Calhoun College, R. W. B. Lewis, and his wife, Nancy, invited my wife, Jane, and me to a cocktail honoring Evans, and for once I did something smart: I went to New York and saw the retrospective *before* the cocktail.

Among the *Let Us Now Praise Famous Men* pictures in the show were a number never seen before, including the family portrait of the Gudgers that is the next-to-last picture in this book. I looked at this picture, then moved down the line looking at the two or three next pictures without really seeing them, then came back and stared at the Gudger picture, my head wafting with astonishment. I knew the picture had never been published or exhibited, yet I somehow felt it *had* to exist: it was what *Let Us Now Praise Famous Men* was really about.

At the cocktail party Dick Lewis introduced me to Evans, explaining that my dissertation involved his and Agee's book. Evans turned me his grim face, eyes half closed. I didn't tell him we had met before. Instead I said I had seen his retrospective and been particularly struck by the portrait of the Gudgers. "I think it sort of explodes the book," I said.

Evans's eyes opened slowly, and I felt that for the first time he saw me. "Really?" he said. "I hadn't thought about it. What do you mean?"

I was afraid I had gone too far, suggesting that a picture not in the book called the book into question, but I had no choice. I gave an early version of the argument I give here on page 286.

"That's very interesting," Evans said. "Not that I intended it. Still, you see it—it must be there."

I asked him the history of the picture, how it had come to be made.

"It was the sharecropper fellow. He was constantly after me . . ."

Other people had come up to talk with Evans. "We should discuss it."
 "I'd love to," I said.

Three months later Walker came to dinner, and after dinner he,
Jane, and I took our conversation into the living room and turned on a
taperecorder I'd borrowed from Yale's audio-visual office.

Walker's mood that night was elated and energetic. He was de-
tached from his marriage, off alcohol, and on an anti-depressant.
These changes, and his increasing celebrity, made his last years in
many ways the best ("This is really my youth!" he once told us). His
conversation that night and later taught me about much more than his
photography and *Let Us Now Praise Famous Men*. It taught me how
to evaluate all documentary work. It taught me how to be dispas-
sionate toward the passions of the thirties. It taught me that the right
way to live with what other people call success is as indifferently as
one lives with what they call failure.

3

Here is a small anthology of Walker's comments on matters relevant
to this book. He made most of these comments during his visit to
Austin in March 1974, six months after the first edition of this book
appeared, but there are some earlier comments I kept out of the book
because I thought Walker would prefer they not be published in his
lifetime. I publish his remarks on James Agee now because recent
Agee biographies have implicated Evans in Agee's bizarre sexual
behavior.

*On the lifestyles of the intelligensia in the 1930s compared with
1970.* "Ten o'clock and we're sober! If this were thirty years ago, we'd
all be drunk by this time."

*On Agee's saying that he and Evans comtemplated having group
sex with the sharecropper women.* "I blush and squirm every time I
read that. God! In the first place, it wasn't in my mind at all. Agee
never mentioned it. But my God, the enormity of such a suggestion!

 "But that has to do with Agee and the fashion of the time. This was
part of the first sexual revolution, and the violation, the innocent

violation, reached enormous proportions. Everybody by rote went to bed with everybody else, and the result was an emotional desert and confusion.

"I say 'everybody': I mean all the 'advanced' people—always. All the *sophisticated* and *emancipated* and *educated* people."

On writing a biography of Agee. "I would like to spend five years on a book not to be published for one hundred years. It would contain things unthinkable—but the man."

On Agee's commitment to truth. "He had an outsized combativeness and an immoderate supply of moral indignation, not stopping short of violence—in fact, capping it with violence. I once saw him hit a woman over the head with a chair because he said she faked an orgasm. He was shocked by this dishonesty of the woman and her naïveté, not knowing what she was doing. He was drunk. He could have killed her."

On his FSA work. "I was interested, selfishly, in the opportunity it gave me to go around and use the camera. I did anything I pleased and *ignored* what I was expected to do. If I got an order from anybody saying, 'There's a development out here, go and photograph it,' I'd tear it up and put it away. Such a bore: I wouldn't touch it."

On being shown a picture of an FSA housing development for relocated sharecroppers in Georgia and told the picture was by him. "No! Is it? . . . Well, you know, I was expected to do that, and once in a while I would. And then—it's the reason I was dropped—I just said, 'I won't do that anymore. If you want to record government housing and toot it up, I won't do it.' "

On whether he was "trying to be a journalist" on the Let Us Now Praise Famous Men project. "No, I was trying to be myself. I certainly didn't want to be what anybody else wanted me to be."

On Roy Stryker, head of the FSA photography unit. "Stryker was a politician, although he was a little hypocritical or self-deluded: he thought he was doing something idealistic, too. There was an ideal-

istic atmosphere in the New Deal, and a lot of people felt they were doing some sort of 'uplifting' work. He had me in a rage all the time, because I was working for a man whose intelligence I didn't respect.

"Well, there is always going to be someone over us who's an ass. The thing is to ignore him."

On his retaining possession of some of the pictures he made while working for the FSA. "I laid it down. I said I'm going to do it. Stryker knew that I had his number and could see through him, and he was very insecure. I took mean advantage of that.

"Well, he got his revenge. Finally one day he got a little sorry for himself and threw me out."

On "manipulating" things or people to make a better documentary photograph. "I find a howling error in composition, because something is in the wrong place, and I leave it there. God arranged that; I wouldn't touch it."

On his sociopolitical views. "The problem is one of staying out of Left politics and still avoiding Establishment patterns.

"I would not politicize my mind or work, in spite of the fact that this is now a very political time, as the thirties were. The apostles can't have me. I don't think an artist is directly able to alleviate the human condition. He's very interested in *revealing* it."

On photographing the disadvantaged. "I do have a weakness for the disadvantaged, for poor people, but I'm suspicious of it. I have to be, because that should not be the motive for artistic or aesthetic action. If it is, your work is either sentimental or motivated toward 'improving society,' let us say. I don't believe an artist should do that with his work. If he does, if you weep over a picture or a piece of writing, that's bad. Jean Cocteau of all people—you may not admire him very much—but he once said, 'Real feeling is drawn from us not by a sad spectacle but by the miracle of something done perfectly.' You want to hear it in French? 'Les bonnes larmes ne nous sont pas tirées par une page triste, mais par le miracle d'un mot en place.' "

<div align="center">4</div>

Much as it had been thirty years before, documentary was fashionable in the 1960s and early 1970s. In photographs, dispatches, and television reports, it exposed America's racism and called into doubt our war in Southeast Asia.

I remember I started writing this book late one morning in June 1970, as rain was falling from New Haven's milky sky. Yale had been shut down by the killings at Kent State and the trial of Black Panther leader Bobby Seale. Everyone expected violence. A curfew was in effect. Rumor ran that a black man opposing the Panthers had been beaten up. A bomb was found near an elementary school.

Some Yale students on the streets outside my window had hoped to goad the police into an attack; they got a few whiffs of tear gas. A much larger number of students on the streets, in T-shirts and faded jeans, carried expensive cameras; they wanted an attack so they could take its picture. These students believed in documentary. They believed a vivid firsthand record would tell the world something important—even, perhaps, transforming. Many of us believed this then.

Do we believe it now? I don't think so. Most documentary now is of the 60 Minutes sort: facts presented as entertainment, presented not for their importance but for our amusement. Since 1970, television has invented a documentary form even less responsible than what appears on 60 Minutes and its clones: the docudrama. In a docudrama, reality is taken over by actors, who turn actual event into soap opera.

Thanks to 60 Minutes and the docudrama, two of the theoretical points I labored to make in this book—that documentary deals with the emotions and that a documentary can be manipulated in the way a fiction can—are now clichés taught in high school.

Reading this book now, I am proud and sad. Proud because it is better than I had any right to expect. Sad because I left stones unturned (I still see the places where I cheated, usually by pretending to more knowledge than I had). Sad because of Walker's

death, and because Jane and I didn't respond as thoroughly as we should have to his friendship. Sad because the young man who wrote this book is a better person than I am now: harder working, more patient, more vulnerable.

I could not now write a book like this as good as this.

Notes

To keep these notes as brief as possible, I give reference only for works actually quoted in the text (unless a work mentioned in passing is hard to locate) and group citations to one source. The following abbreviations are used:

AM	*The American Mercury*	NYHT	New York *Herald Tribune*
Atlantic	*The Atlantic Monthly*		
CC	*The Christian Century*	NYT	*The New York Times*
Harper's	*Harper's Magazine*	PR	*The Partisan Review*
Nation	*The Nation*	RD	*Reader's Digest*
NM	*New Masses*	SG	*Survey Graphic*
NR	*The New Republic*	SR	*The Saturday Review of Literature*
NY	*The New Yorker*		

Epigraph

Walt Whitman, "A Backward Glance o'er Travel'd Roads," *Complete Poetry and Selected Prose*, ed. James E. Miller, Jr. (Boston, 1959), p. 445.

Preface

1. Roy E. Stryker, "Documentary Photography," *The Complete Photographer*, ed. Willard D. Morgan (10 vols., New York, 1942–43), IV, 1364. Warren I. Susman, "The Thirties," *The Development of an*

American Culture, ed. Stanley Coben and Lorman Ratner (Engle-wood Cliffs, N.J., 1970), p. 212.

PART ONE
Documentary

1. Hallie Flanagan and Margaret Ellen Clifford, *Can You Hear Their Voices?* (Poughkeepsie, N.Y., 1931). Whittaker Chambers, "You Can Make Out Their Voices," *NM,* Mar. 1931, pp. 7–16; reprinted as "Can You Hear Their Voices?", International Pamphlets Series, No. 26 (New York, 1932), prefaced by *NYT* dispatch of Jan. 4, 1931. Hallie Flanagan, *Dynamo* (New York, 1943), pp. 106–7.
2. Alfred Kazin, *On Native Grounds* (Garden City, N.Y., 1956), pp. 383, 384.

CHAPTER 1
What Is Documentary?

1. *The Random House Dictionary of the English Language* (New York, 1967). Duncan N. Morris, letter to *Harper's,* Aug. 1971, p. 8.
2. J. Saunders Redding, *On Being Negro in America* (Indianapolis, 1951), p. 9. *The American Heritage Dictionary of the English Language* (New York, 1969). Fred K. Hoehler, Foreword to Benjamin Glassberg, "Across the Desk of a Relief Administrator" (Chicago, 1938), n.p.
3. Elizabeth Janeway, review, *NYT Book Review,* July 26, 1970, p. 5. Judith Crist, review, *New York,* Oct. 19, 1970, p. 58. John Crowe Ransom, *The World's Body* (New York, 1938), pp. 59, 60, 61. Hartley Howe, "U.S. Film Service Presents," *U.S. Camera,* June–July 1940; cited in Robert L. Snyder, *Pare Lorentz and the Documentary Film* (Norman, Okla., 1968), p. 60. Arthur Rothstein, "Direction in the Picture Story," *Complete Photographer,* IV, 1359. Dale Carnegie, *How To Win Friends and Influence People* (New York, 1936), p. 27. George Biddle, *An American Artist's Story* (Boston, 1939), p. 266. Marquis W. Childs, *I Write from Washington* (New York, 1942), p. 126.
4. Herman Clarence Nixon, *Possum Trot: Rural Community, South* (Norman, Okla., 1941), p. 21. Arthur Knight, review, *SR,* May 29, 1971, p. 54; see also Malcolm Cowley, review, *NR,* May 4, 1932, p. 333. Malcolm Cowley, *Exile's Return* (New York, 1934), p. 248.
5. Childs, p. 126.

Documentary: The Primacy of Feeling
6. Beaumont Newhall, *The History of Photography* (New York, 1964), p. 142. Susman, p. 191.

7. John Grierson, *Grierson on Documentary*, ed. Forsyth Hardy (London, 1966), pp. 207, 193, 13 (see also 145), 225, 18, 136, 153, 215 (the text reads, in obvious error, "no earth"), 193, 194, 145.

8. Edward Steichen, "The F.S.A. Photographers," *U.S. Camera 1939*, ed. T. J. Maloney (New York, 1938), p. 44. Edwin Rosskam, afterword to Sherwood Anderson, *Home Town* (New York, 1940), p. 144. What I call the Photography Unit of the FSA was actually, confusingly, named the Historical Section of the FSA's Information Division.

9. Grierson, p. 42.

10. Henry Adams, *Mont-Saint-Michel and Chartres* (Garden City, N.Y., 1959), pp. 2, 117, 16, 108, 141, 62, 215, 357.

The Two Documents and How They Work

11. E. Wight Bakke, *The Unemployed Worker* (New Haven, 1940), p. 161.

12. W. H. Auden, "Squares and Oblongs," in *Poets at Work*, ed. Charles D. Abbott (New York, 1948); reprinted as "Poetry as a Game of Knowledge," in *The Modern Tradition*, ed. Richard Ellmann and Charles Feidelson, Jr. (New York, 1965), p. 210. AP dispatch, *NYT*, Dec. 16, 1967, p. 50.

13. Stryker, p. 1369. Grierson, pp. 250, 18. Mordecai Gorelik, *New Theatres for Old* (New York, 1962), p. 398.

14. Henry Thoreau, *The Portable Thoreau*, ed. Carl Bode (New York, 1964), p. 347.

15. The complete AP dispatch was in the Washington *Post*, Dec. 18, 1967, p. 1; the *Post* carried a photo inside. *Time* (Dec. 29, 1967, p. 13) gave the story a column and a half, and two photos.

16. James Agee, *Letters to Father Flye* (New York, 1962), p. 229. Ernest Dichter, *The Strategy of Desire* (New York, 1960), pp. 176, 196.

17. Ronald Berman, *America in the Sixties* (New York, 1968), p. 95.

CHAPTER 2
Social Documentary

1. Luis Buñuel, *Las Hurdes* (Spain/France, 1932); the narrator of the English version, *Land without Bread*, is very British, a tenor, and reads his words as though they were commentary for a rushed and insipid Sunday afternoon radio concert. On the form of *Las Hurdes*, see Ado Kyrou, *Luis Buñuel* (Paris, 1962), p. 38.

2. On Safer's report, see Erik Barnouw, *A History of Broadcasting in the United States* (3 vols., New York, 1966–70), III, 275. The unattributed pro-Israeli pamphlet was distributed in the lobby of the Yale University Library in June 1970.

3. John Grierson, "The Documentary Idea," *Complete Photographer*, IV, 1377. Advertisement, *NYT*, Oct. 24, 1970, p. 29.

4. Herbert Hoover, "Address Opening the Bicentennial of the Birth of George Washington" (Washington, D.C., 1932); see also Edmund Wilson, *The American Jitters* (New York, 1932), p. 147. Pare Lorentz, *The Roosevelt Year* (New York, 1934), p. 80; William Leuchtenburg, "The New Deal and the Analogue of War," reprinted in *Change and Continuity in Twentieth Century America*, ed. John Braeman and others (Columbus, 1964), pp. 81–143. Arthur M. Schlesinger, Jr., *The Crisis of the Old Order, 1919–1933* (Boston, 1957), p. 178. Franklin D. Roosevelt, *The Public Papers and Addresses* (13 vols., New York, 1938–50), I, 657; II, 15.

5. Grierson, *Grierson on Documentary*, p. 250. Arthur Siegel, *Photographers on Photography*, ed. Nathan Lyons (Englewood Cliffs, N.J., 1966), p. 90.

6. Grierson, *Complete Photographer*, IV, 1376. John Dos Passos, "Anacostia Flats," *NM*, June 1932; reprinted in *Proletarian Literature in the United States*, ed. Granville Hicks and others (New York, 1935), p. 215. Granville Hicks, "Writers in the Thirties," *As We Saw the Thirties*, ed. Rita James Simon (Urbana, 1967), p. 99.

7. Alexander Kendrick, *Prime Time: The Life of Edward R. Murrow* (Boston, 1969), p. 479. Steichen, p. 43. Dixon Wecter, *The Age of the Great Depression, 1929–1941* (New York, 1948), p. 304; for an example of "propaganda against propaganda," see O. W. Riegel, *Mobilization for Chaos: The Story of the New Propaganda* (New Haven, 1934). Cowley, *Exile's Return*, p. 294. Roosevelt, V, 569. Archibald MacLeish, *A Time To Act* (Boston, 1943), p. 151.

8. Harold D. Lasswell, *Propaganda Technique in the World War* (New York, 1927), and Leonard W. Doob, *Propaganda: Its Psychology and Technique* (New York, 1935), p. 200. Kendrick, p. 467; for examples of "black" propaganda, see Barnouw, II, 158, 162, 201.

9. Lewis Mumford, *Values for Survival* (New York, 1946), p. 39. Snyder, *Pare Lorentz and the Documentary Film*, pp. 43–44.

10. L. F. Gittler, "Nazi Propaganda at Work," *Current History*, Dec. 1937, p. 38. Joseph North, "Reportage," *The American Writers' Congress*, ed. Henry Hart (New York, 1935), p. 8. N. B. Cousins, review, *Current History*, Dec. 1937, p. 8. Malcolm Cowley, review, *NR*, Nov. 24, 1937, p. 78. Pare Lorentz, "Dorothea Lange, Camera with a Purpose," *U.S. Camera 1941*, ed. T. J. Maloney (2 vols., New York, 1940), I, 96. Murray Kempton, *Part of Our Time* (New York, 1967), p. 122. "Art Is a Weapon!" *NM*, Aug. 1931, pp. 11–12. Cowley, *Exile's Return*, pp. 295, 296.

11. See, for example, Susman, p. 214. Robert Warshow, *The Immediate Experience* (Garden City, N.Y., 1962), p. 34.

12. James Agee and Walker Evans, *Let Us Now Praise Famous Men* (Boston, 1960), p. 245.

CHAPTER 3
The Two Persuasions

1. Franklin D. Roosevelt, *Selected Speeches, Messages, Press Conferences, and Letters,* ed. Basil Rauch (New York, 1957), pp. 241, 355. On Roosevelt's hatred of propaganda, see Richard W. Steele, "Preparing the Public for War: Efforts To Establish a National Propaganda Agency, 1940–41," *American Historical Review,* Oct. 1970, pp. 1640–53.

Direct

2. Advertisement, *NY,* Nov. 22, 1972, p. 115. Heywood Broun, *It Seems to Me* (New York, 1935), p. 147.
3. MacLeish, p. 161. Richard Wright, *12 Million Black Voices* (New York, 1941), p. 146. Dorothy Parker, "Incredible, Fantastic . . . and True," *NM,* Nov. 23, 1937; reprinted in *New Masses: An Anthology of the Rebel Thirties,* ed. Joseph North (New York, 1969), pp. 174, 177. *The City* (U.S.A., 1939), directed by Willard Van Dyke and Ralph Steiner, script by Lewis Mumford (from an outline by Pare Lorentz), produced by the American Institute of Planners (on a grant from the Carnegie Corp.), music by Aaron Copland. Ernest Hemingway, "Who Murdered the Vets? (A First-Hand Report on the Florida Hurricane)," *NM,* Sept. 17, 1935; reprinted in *New Masses: An Anthology,* pp. 186, 187.
4. Stryker, p. 1364. *Agee on Film* (2 vols., Boston, 1958), I, 326. Rothstein, p. 1357. Dorothea Lange and Paul Schuster Taylor, *An American Exodus* (New York, 1939), p. 6.
5. Newhall, pp. 137, 139. Helmut and Alison Gernsheim, *The History of Photography from the Camera Obscura to the Beginning of the Modern Era* (London, 1969), p. 447. Michel F. Braive, *The Photograph: A Social History,* trans. David Britt (New York, 1966), p. 237. Robert H. Bremner, *From the Depths* (New York, 1956), p. 196. Judith Mara Gutman, *Lewis W. Hine and the American Social Conscience* (New York, 1967), p. 19.
6. Susman, p. 193. Charles Childs (text), Co Rentmeester (photographs), "From Vietnam to a VA Hospital: Assignment to Neglect," *Life,* May 22, 1970, pp. 24D–33 (quotation on 26). John L. Spivak, *A Man in His Time* (New York, 1967), p. 170.
7. Leo Gurko, *The Angry Decade* (New York, 1947), p. 177. *Agee on Film,* I, 329. Newhall, p. 142; Lange and Taylor, p. 6.
8. May Cameron, "Margaret Bourke-White Finds Plenty of Time

To Enjoy Life along with Her Camera Work," New York *Post*, 1937;
reprinted in Agee and Evans, p. 453. *The First World War*, ed. Lau-
rence Stallings (New York, 1933).

9. Edmund Wilson, *The American Earthquake* (Garden City, N.Y.,
1958), pp. 194, 12. *The Collected Essays, Journalism, and Letters of
George Orwell*, ed. Sonia Orwell and Ian Angus (4 vols., New York,
1968), I, 313.

Vicarious

10. John L. Spivak, "On the Chain Gang," International Pamphlets
Series, No. 32 (New York, 1932). C. Hartley Grattan, "Red Opinion in
the United States," *Scribner's Magazine*, Nov. 1934, p. 304. "Dictators
Dissected," *Time*, May 25, 1936, p. 17; as long as Spivak was laying
bare foreign evils he was welcome in almost all American magazines:
see his "Hitler's Racketeers," *RD*, Mar. 1936, pp. 52–54. Prospectus to
the first issue of *Ken*, Apr. 7, 1938, n.p. James Rorty, review, *Nation*,
Aug. 7, 1935, p. 163. North, "Reportage," p. 122; "Prologue," *New
Masses: An Anthology*, p. 27. John L. Spivak, personal communica-
tion.

11. "Between Ourselves," *NM*, Apr. 21, 1936, p. 30.

12. Benjamin DeMott, "The Sixties: A Cultural Revolution," *NYT
Magazine*, Dec. 14, 1969, p. 122. "Pakistan: When the Demon Struck,"
Time, Nov. 30, 1970, p. 19. Preface to John Steinbeck, "Their Blood Is
Strong" (San Francisco, 1938). Roosevelt, *Public Papers*, XIII, 577.

13. Kempton, p. 144. Whitman, "Song of Myself," *Complete Poetry
and Selected Prose*, p. 51. James Rorty, *Where Life Is Better* (New
York, 1936), p. 217. Tom Kromer, *Waiting for Nothing* (New York,
1935). Edward Anderson, *Hungry Men* (Garden City, N.Y., 1935).
Clara Weatherwax, *Marching! Marching!* (New York, 1935).

14. James Thurber's blurb, which was written for one of his early
books, appears on the jacket of the 1958 British Penguin edition of his
My Life and Hard Times (Helen Thurber, personal communication).
John Gassner, Foreword to Morgan Y. Himelstein, *Drama Was a
Weapon* (New Brunswick, N.J., 1963), p. vx.

15. "Contributors," *NR*, Apr. 15, 1931, p. 256. Maxine Davis, *The
Lost Generation* (New York, 1936), p. ix. Rorty, *Where Life Is Better*,
p. 9. Louis Adamic, *My America* (New York, 1938), p. xiii.

16. Roosevelt, *Selected Speeches*, p. 238. Philip Rahv, "The Cult of
Experience in American Writing," *Literature in America*, ed. Rahv
(New York, 1957), pp. 360, 361. Federal Art Project, *New Horizons in
American Art* (New York, 1936), panels 44, 32, 8; on Newell's mural,
see *The New Deal Arts Projects: An Anthology of Memoirs*, ed. Fran-
cis V. O'Connor (Washington, D.C., 1972), p. 73.

17. Lillian Ross and others, *The "Argonauts"* (New York, 1940),
dedication, pp. 1, 4.

18. On the pulps in the 1930s, see Russel Nye, *The Unembarrassed Muse* (New York, 1970), pp. 215, 213, 400. On testimonial ads, see Otis Pease, *The Responsibilities of American Advertising* (New Haven, 1958), pp. 51–59. See typical Lucky Strike ads: *Life*, Sept. 18, 1939, back cover; June 27, 1938, back cover. Charlotte T. Muret, "On Becoming French," *Harper's*, July 1934, pp. 222–34. Barnouw, II, 96; I, 224. Anonymous, "The Aftermath of Divorce," *Harper's*, Aug. 1934, pp. 365–73. Vincent G. Burns, Introduction to Robert E. Burns, *I Am a Fugitive from a Georgia Chain Gang!* (New York, 1932), p. 31.

19. Burns, pp. 34, 250. Spivak, *A Man in His Time*, p. 132; see also Simon Michael Bessie, *Jazz Journalism* (New York, 1938), pp. 185, 202.

20. *I Am a Fugitive from a Chain Gang* (U.S.A., 1932), directed by Mervyn LeRoy, Warner Brothers. Burns, pp. 14, 251, 5, 257. Obituary, *NYT*, June 7, 1955, p. 33.

21. Federal Writers' Project, *These Are Our Lives* (Chapel Hill, 1939), p. 31.

22. Burns, pp. 71, 77, 80 (question marks added). James M. Cain, *Cain x 3* (New York, 1969), p. 9.

<div align="center">

CHAPTER 4

What Documentary Treats

</div>

1. N. Scott Momaday, review, *NYT Book Review*, Nov. 15, 1970, pp. 66, 67.

2. Howard Zinn, *The Politics of History* (Boston, 1970), p. 39.

3. Agee and Evans, p. xiv. W. T. Couch, Preface to *These Are Our Lives*, pp. ix, x.

4. Couch, p. xiii. Louise V. Armstrong, *We Too Are the People* (Boston, 1938), p. 473. Editorial, *Life*, May 28, 1971, p. 4. Donald H. Broderick, letter to *Life*, Dec. 4, 1970, p. 24A.

5. Frances Perkins, *The Roosevelt I Knew* (New York, 1946), pp. 92, 97. Herbert Agar, *Who Owns America?* (Boston, 1936), p. vii.

6. Frances Perkins, *People at Work* (New York, 1934), pp. 160–61.

7. Alfred Kazin, *Starting Out in the Thirties* (Boston, 1965, p. 104.

8. Edward Bliss, Jr., *In Search of Light: The Broadcasts of Edward R. Murrow, 1938–1961*, ed. Bliss (New York, 1967), p. 6. Edward R. Murrow, "A Report to America," in Archibald MacLeish, Murrow, and William S. Paley, *In Honor of a Man and an Ideal* (n.p., Columbia Broadcasting System, [1942]), p. 19. *Photographers on Photography*, pp. 69–70, 92.

9. Federal Writers' Project, *American Stuff* (New York, 1937); "American Stuff," *Direction*, I:3 (1938).

10. *The Random House Dictionary*. Margaret Bourke-White, afterword to Erskine Caldwell and Bourke-White, *Say, Is This the U.S.A.*

(New York, 1941), p. 176. Rorty, *Where Life Is Better*, p. 9. Sherwood Anderson, *Puzzled America* (New York, 1935), p. 240. Adamic, p. xiii. Stuart Chase, *Rich Land, Poor Land* (New York, 1936), p. 5.

11. Nathan Asch, *The Road* (New York, 1937), p. 7.

12. Zinn, pp. 113, 26, 103, 113. Harold Stearns, *Rediscovering America* (New York, 1934). Archibald MacLeish, *New Found Land* (New York, 1930).

13. Stryker, *Complete Photographer*, IV, 1370–71.

14. Marcus Klein, "The Roots of Radicals," *Proletarian Writers of the Thirties*, ed. David Madden (Carbondale, Ill., 1968), p. 150. Robert Bendiner, *Just around the Corner* (New York, 1967), p. 220. Margaret Bourke-White, *Portrait of Myself* (New York, 1963), p. 95. William E. Leuchtenburg, *Franklin D. Roosevelt and the New Deal, 1932–1940* (New York, 1963), p. 341. *Inventory: An Appraisal of the Results of the Works Progress Administration* (Washington, D.C., 1938). Gorelik, p. 399. [Joseph North] "Reportage," *Proletarian Literature in the United States*, p. 211; "Reportage," *American Writers' Congress*, p. 121. Spivak, personal communication. Matthew Josephson, "The Role of the Writer in the Soviet Union," *American Writers' Congress*, ed. Hart, pp. 41, 42.

15. Waldo Frank, "Values of the Revolutionary Writer," *American Writers' Congress*, p. 73. Hart, Introduction to *American Writers' Congress*, p. 15. Sherwood Anderson, "I Want to Be Counted," *Harlan Miners Speak*, ed. Theodore Dreiser (New York, 1932), p. 307. Caroline Bird, *The Invisible Scar* (New York, 1966), p. 158. William Saroyan, "Prelude to an American Symphony," *NM*, Oct. 23, 1934; reprinted in *New Masses: An Anthology*, p. 92.

16. Roosevelt, *Selected Speeches*, pp. 65–69. Orwell, *Collected Essays*, I, 390. Lange and Taylor, p. 6. Oscar Lewis, *The Children of Sanchez* (New York, 1961), pp. xx, xxi. "Editors' Note," *Life*, Dec. 4, 1970, p. 5. Zinn, p. 40.

17. Perkins, *People at Work*, pp. 161, 249. Josephson, pp. 41, 42.

18. Steichen, "The F.S.A. Photographers," p. 44. Lorentz, "Dorothea Lange," p. 98.

19. Lorentz, pp. 95, 96. Lusha Nelson, "Friendless," *U.S. Camera 1939*, p. 135.

20. See another photo of the woman with her raffish husband in Lange's "Desperation," Farm Security Administration, *The Bitter Years, 1935–1941*, ed. Edward Steichen (New York, 1962), n.p.

21. Bourke-White, *Portrait of Myself*, pp. 137, 126. Margaret Bourke-White, "Notes on Photographs," in Erskine Caldwell and Bourke-White, *You Have Seen Their Faces* (New York, 1937), p. 187.

22. Nancy Newhall, Introduction to Paul Strand, *Photographs 1915–1945* (New York, 1945), p. 4.

23. Rothstein, *Complete Photographer*, IV, 1356, 1357. Archibald MacLeish, *Land of the Free* (New York, 1938), plate 14.

24. Hartley E. Howe, "You Have Seen Their Pictures," *SG*, Apr. 1940, p. 238. Forrest Jack Hurley, "To Document a Decade," Tulane University Ph.D. dissertation, 1971, pp. 117–26. Curtis D. MacDougall, *Hoaxes* (New York, 1958), pp. 94–95.

25. Karin Dovring, *Road of Propaganda: The Semantics of Biased Communication* (New York, 1959). Lorentz, "Dorothea Lange," p. 98.

26. Cowley, review, *NR*, Nov. 24, 1937, p. 78. Stryker, p. 1364.

PART TWO

The Documentary Motive and the Thirties

1. *Hard Times*, ed. Studs Terkel (New York, 1970), p. 57.

2. Frederick Lewis Allen and Agnes Rogers, *I Remember Distinctly* (New York, 1947), p. 126. *Life*, Apr. 4, 1938, pp. 9–13. Bird, p. 22. [Archibald MacLeish] "'No One Has Starved,'" *Fortune*, Sept. 1932, pp. 19–29, 80–88. [James Thurber] "New York in the Third Winter," *Fortune*, Jan. 1932, p. 41. Mauritz Hallgren, "Mass Misery in Philadelphia," *Nation*, Mar. 9, 1932, p. 275. Childs, *I Write from Washington*, p. 25.

3. Bird, pp. 59, 71. William E. Leuchtenburg, ed., *The New Deal* (Columbia, S.C., 1968), p. xiv; Gilbert Seldes says that Americans in the early thirties "were not permitted for many months to confront the reality of our situation"; see his *Years of the Locust: America, 1929–32* (Boston, 1933), pp. 11–12. Edward Angly, ed., *Oh Yeah?* (New York, 1931). Barnouw, I, 17, 273.

4. *Unemployment Relief, Hearings before a Subcommittee of the Committee on Manufactures of the United States Senate*, 71 Cong. (1st Sess.), on S. 174 and S. 262, Dec. 28, 1931–Jan. 9, 1932 (Washington, D.C., 1932), p. 311. George S. Kaufman and Morris Ryskind, *Of Thee I Sing* (New York, 1932), p. 177.

5. *Unemployment Relief*, pp. 314, 319, 323, 312.

6. William Hodson, *Unemployment Relief*, p. 11. Irving Bernstein, *A History of the American Worker* (Boston, 1960), I, 268. "Unemployed Arts," *Fortune*, May 1937, p. 109. Harry L. Hopkins, "The Realities of Unemployment" (Washington, D.C., WPA, 1936), p. 7.

7. Mauritz Hallgren, *Seeds of Revolt* (New York, 1933), p. 5.

8. Walter Morris, "America in Search of a Way" (mimeographed, Gloversville, N.Y., 1940). Marquis W. Childs, *Sweden: The Middle Way* (New Haven, 1936). Jack Conroy, *The Disinherited* (New York, 1933), p. 239. Thomas L. Stokes, *Chip off My Shoulder* (Princeton, 1940), p. 259. Rexford G. Tugwell, "Behind the Farm Problem: Rural Poverty," *NYT Magazine*, Jan. 10, 1937; reprinted in *The New Deal*,

ed. Carl Degler (Chicago, 1970), pp. 171–72. *The Journals of David E. Lilienthal* (5 vols., New York, 1964–71), I, 80.

9. Adamic, *My America*, p. 506. In his "travel book of American personalities" *Roots of America* (New York, 1936), Charles Morrow Wilson says that traditional Americans, the people who are the "roots" of the country, "naturally . . . are inclined to measure the world, first and last, with the yardstick of their own senses. To them seeing, feeling, hearing, smelling are the best roads to believing" (pp. 2, 14). Carnegie, *How To Win Friends and Influence People*, pp. 179–80; for an example of the kind of "demonstration" Carnegie meant, see the documentary reconstruction of what a car accident does to "you" in J. C. Furnas, "—And Sudden Death," *RD*, Aug. 1935, pp. 21–26. Furnas' article, reputedly the most widely read of all time, was followed up with one equally graphic by an embalmer, A. J. Bracken, "The Aftermath of Sudden Death," *RD*, Dec. 1935, pp. 52–54.

<div align="center">

CHAPTER 5

The Central Media

</div>

1. Henry Mayhew, *London Labour and the London Poor* (4 vols., London, 1851–62). Adolph Smith and John Thompson, *Street Life in London* (London, 1877; reprinted New York, Benjamin Blom, 1969).

2. Mary McCarthy, *On the Contrary* (New York, 1961), pp. 250, 257, 263, 259. Many of the fiction categories are borrowed from the end-pages of the Arena Publishing Company's 1891 edition of Hamlin Garland, *Main-Travelled Roads* (Boston). John Fischer, *The Stupidity Problem, and Other Harassments* (New York, 1964), p. 107; John Fischer and Dan A. Lacy, personal communication.

3. Agee and Evans, p. 11. *Agee on Film*, I, 296–97. Kazin, *On Native Grounds*, pp. 386, 387. Christopher Isherwood, *The Berlin Stories* (n.p., New Directions, 1945), p. 1.

4. Kazin, p. 387.

5. Robert S. Allen and Drew Pearson, *Washington Merry-Go-Round* (New York, 1931), p. 321. Roosevelt, *Public Papers*, VII, 284. Archibald MacLeish, *The American Cause* (New York, 1941), p. 17.

6. Roosevelt, *Public Papers*, VII, 278–80.

7. Editorial, *CC*, Nov. 18, 1936, p. 1519. Robert T. Elson, *Time Inc.* (New York, 1968), p. 322. George Seldes, statement of purpose on beginning his newsletter *In Fact*, May 20, 1940; reprinted in his *Never Tire of Protesting* (New York, 1968), p. 21.

8. George Seldes, *Lords of the Press* (New York, 1938), p. 331. Stokes, pp. 449–50. Editorial, *CC*, Nov. 18, 1936, pp. 1518, 1519.

9. Elson, pp. 224, 443. "The Press and the People—A Survey," *Fortune*, Aug. 1939, pp. 70, 65, 70.

10. "The Press and the People," pp. 70, 72, 65, 70.

11. Paul F. Lazarsfeld, *Radio and the Printed Page* (New York, 1940), pp. 232, 218, 141–43.

12. Lazarsfeld, pp. 201, 181. Barnouw, II, 62. Jonathan Yardley, review, *NR*, Feb. 6, 1971, p. 33.

13. Barnouw, II, 8.

14. Hadley Cantril and others, *The Invasion from Mars* (Princeton, 1940), p. 70. Archibald MacLeish, Foreword to *The Fall of the City* (New York, 1937), pp. x, xi; see Ruth Lechlitner, "The 1930's: A Symposium," *Carleton Miscellany*, winter 1965, p. 81. Barnouw, II, 69. Warshow, p. 255.

15. Edward R. Murrow, *This Is London*, ed. Elmer Davis (New York, 1941), p. 13; see Kendrick, p. 103. Columbia Broadcasting System, "Crisis: September 1938: A Complete and Verbatim Transcript of What America Heard over the Columbia Broadcasting System during the 20 Days of the Czechoslovakian Crisis" (10 vols., mimeographed, n.p., C.B.S., 1938), I, Sept. 12, p. 4; IV, Sept. 19, p. 26; IV, Sept. 21, p. 36.

16. C.B.S., "Crisis," IV, Sept. 21, pp. 27, 44–45 (Maxim Litvinoff was Stalin's foreign minister).

17. Frederick Lewis Allen, *Since Yesterday* (New York, 1940), p. 316.

18. C.B.S., "Crisis," IV, Sept. 20, p. 47. Murrow, *This Is London*, pp. 172, 204–5, 129, 174–75.

19. Murrow, *This Is London*, p. viii, 172, 173. Kendrick, pp. 107, 246, 247. Edward R. Murrow and Fred W. Friendly, *See It Now* (New York, 1955), p. 55.

20. Kendrick, p. 207. Murrow, *This Is London*, pp. 179–80; part of this broadcast is reprinted in Kendrick, pp. 207–8, and I have adopted some of his punctuation.

21. Kendrick, pp. 246, 208, 221. Barnouw, I, 151.

22. Irving Settel, *A Pictorial History of Radio* (New York, 1967), p. 122; for furthering Anglo-American friendship, Murrow was twice decorated by the British: see Kendrick, p. 512. To avoid the term "progagandist," Murrow has been called a "reporter-preacher": see Robert Lewis Shayon, "The Two Men Who Were Murrow," *Columbia Journalism Review*, fall 1969, p. 51. Grierson, *Complete Photographer*, IV, 1380. MacLeish, *A Time To Act*, p. 159.

23. Murrow, *This Is London*, p. 150, 51, 177, 178.

CHAPTER 6
The New Deal

1. Childs, *I Write from Washington*, p. 24. Bird, *The Invisible Scar*, p. 130.

2. Robert Forsythe (Kyle S. Crichton), *Redder Than the Rose* (New York, 1935), p. 224.

FDR

3. Henry F. Pringle, "The President," *NY*, June 16, 1934, p. 20, Roosevelt, *Public Papers*, VII, 283. George E. Reedy, *The Twilight of the Presidency* (New York, 1970), p. 96. "Decade's End," *Time*, Jan. 8, 1940, p. 13; see also *The Strenuous Decade*, ed. Daniel Aaron and Robert Bendiner (Garden City, N.Y., 1970), pp. 65–134. Arthur A. Ekirch, *Ideology and Utopias* (Chicago, 1969), p. 73.

4. Perkins, *The Roosevelt I Knew*, pp. 92, 97, 30.

5. Robert Sherwood, *Roosevelt and Hopkins* (New York, 1948), p. 831. Frank Kingdon, *As FDR Said* (New York, 1950), p. 64; on Eleanor Roosevelt as reporter, see also Lorena Hickok, *Reluctant First Lady* (New York, 1962), p. 22, and Eleanor Roosevelt, *This I Remember* (New York, 1949), pp. 4, 56, 67, 72, 125, 133. Robert S. Allen and Drew Pearson, "How the President Works," *Harper's*, June 1936, pp. 11–12. Perkins, p. 69.

6. Perkins, p. 70. Roosevelt, *This I Remember*, p. 134. Roosevelt, *Selected Speeches*, p. 119. H. G. Wells, *Experiment in Autobiography* (New York, 1934), p. 682. Richard Hofstadter, *The American Political Tradition* (New York, 1948), pp. 313, 323–24.

7. Perkins, p. 71. Degler, *The New Deal*, p. 6. Sherwood, pp. 213, 826, 217. Leuchtenburg, *The New Deal*, pp. 112, 218. Roosevelt, *Public Papers*, VI, 408–9; see Allen Guttmann, *The Wound in the Heart* (New York, 1962). *F.D.R.: His Personal Letters*, ed. Elliott Roosevelt and Joseph P. Lash (4 vols., New York, 1950), III, 734.

8. See John Morton Blum, "'That Kind of Liberal': Franklin D. Roosevelt after Twenty-five Years," *Yale Review*, autumn 1970, p. 23. On the fanaticism of "moderates" in the 1930s, see Frank A. Warren III, *Liberals and Communism* (Bloomington, Ind., 1966). Perkins, p. 332. A. A. Berle Jr., "The Social Economics of the New Deal," *NYT Magazine*, Oct. 29, 1933, p. 4. Mumford, *Values for Survival*, p. 80.

9. Roosevelt, *Public Papers*, I, 774–75.

10. Corliss Lamont, *American Writers' Congress*, ed. Hart, p. 172. Mauritz A. Hallgren, *The Gay Reformer* (New York, 1935), p. 30.

11. Edward Robb Ellis, *A Nation in Torment* (New York, 1970), p. 231; see also Joseph Freeman, *An American Testament* (New York, 1936), p. 595, and Kempton, *Part of Our Time*, p. 194. Leslie A. Fiedler, *No! in Thunder* (Boston, 1960), p. 163. Perkins, pp. 71, 72. Arthur M. Schlesinger, Jr., *The Age of Roosevelt* (3 vols., Boston, 1957–60), II, 571, 572. Gene Smith, *The Shattered Dream* (New York, 1970), p. 174.

12. Roosevelt, *Selected Speeches*, pp. 229–31. On Roosevelt's military plans for Greenland, see Mark Skinner Watson, *Chief of Staff: Prewar Plans and Preparations* (Washington, D.C., 1950), pp. 485–86.

13. Perkins, pp. 76, 330, 76. "The Situation in American Writing," *PR*, summer 1939; reprinted in *The Partisan Reader*, ed. William Phillips and Philip Rahv (New York, 1946), p. 620.

WPA

14. David M. Potter and William H. Goetzmann, *The New Deal and Employment* (New York, 1960), p. 47. U.S. Federal Works Agency, *Final Report on the WPA Program, 1935–43* (Washington, D.C. [1947]), p. 122. "Unemployed Arts," *Fortune*, May 1937, p. 112. I use the phrase "arts projects" to refer to the five WPA programs grouped under Federal Project Number One ("Federal One," as it was commonly called): art, music, theater, writing, and historical records; see William F. McDonald, *Federal Relief Administration and the Arts* (n.p., Ohio State University Press, 1969), p. ix.

15. Reuel Denney, "The Discovery of the Popular Culture," *American Perspectives*, ed. American Studies Association (Cambridge, Mass., 1961), p. 170. Susman, p. 184. Cowley, *Exile's Return*, pp. 287–96. "Between Ourselves," *NM*, Apr. 24, 1934, p. 30. Alfred Hayes and Aaron Copland, "Into the Streets May First," *NM*, May 1, 1934, pp. 16–17. "For the People," *Time*, June 5, 1939, p. 60. Aaron Copland, *Our New Music* (New York, 1941), pp. 229–30. Milton W. Brown, *American Painting from the Armory Show to the Depression* (Princeton, 1970), p. 185. John Mason Brown, *The Worlds of Robert E. Sherwood* (New York, 1965), p. 337.

16. "Unemployed Arts," pp. 112, 114, 111. "For the People," p. 60. Copland, p. 229.

17. "Unemployed Arts," p. 168. Biddle, *An American Artist's Story*, p. 279.

18. Matthew Josephson, *Infidel in the Temple* (New York, 1967), p. 378; see also Bendiner, p. 182. *Federal Theater Plays* (2 vols., New York, 1938), II, 20–21.

19. Hallie Flanagan, *Arena* (New York, 1940), p. 65. *Federal Theater Plays*, II, 20, 37, 54, 43, 70, 37, 91. John Gassner, ed., *Best American Plays, Supplementary Volume, 1918–1958* (New York, 1961), p. 454.

20. Gassner, p. 454. Gorelik, p. 335. Flanagan, *Arena*, p. 184. Kazin, *Starting Out in the Thirties*, pp. 81–82.

21. *Federal Theater Plays*, II, 13; the text I quote is from the prompt script: see Willson Whitman, *Bread and Circuses* (New York, 1937), p. 89.

22. "Unemployed Arts," pp. 117, 116. Federal Writers' Project,

"Check-list of Recorded Songs in the English Language in the Ar-
chive of American Folk Songs to July, 1940" (2 vols., mimeographed,
Washington, D.C., 1942). Searle F. Charles, *Minister of Relief: Harry
Hopkins and the Depression* (Syracuse, N.Y., 1963), p. 71; see also
Sherwood, p. 596. Federal Writers' Project, *The Armenians in Massa-
chusetts* (Boston, 1937); *The Negroes of Nebraska* (Lincoln, 1940);
Jewish Families and Family Circles in New York (New York, 1939).
WPA, *Norwegian Word Studies*, by Einar Ingvald Haugen (Madison,
1942); *The Pattern of Internal Mobility in Texas*, by Walter Gordon
Browder (Austin, 1944). Couch, *These Are Our Lives*, p. x. Holger
Cahill, Introduction to [Federal Art Project] *The Index of American
Design*, ed. Erwin O. Christensen (New York, 1950), p. xii. "The In-
dex of American Design: A Portfolio," *Fortune*, June 1937, p. 103.

23. Grace Overmyer, *Government and the Arts* (New York, 1939),
p. 112. "The Index of American Design," p. 104. Holger Cahill,
Introduction to *New Horizons in American Art*, p. 30. Wecter, *The
Age of the Great Depression*, p. 154. Howard W. Odum and Harry
Estill Moore, *American Regionalism* (New York, 1938), pp. 3, 4. WPA,
Inventory, p. 82. Jane DeHart Matthews, *The Federal Theatre, 1935–
1939* (Princeton, 1967), p. 29. Flanagan, *Arena*, p. 231. Robert C.
Brinkley, "The Cultural Program of the W.P.A.," *Harvard Educational
Review*, Mar. 1939, p. 161.

24. Ellis, *A Nation in Torment*, p. 513. Lewis Mumford, "Writers'
Project," *NR*, Oct. 20, 1937, p. 306. "Work of the Federal Writers'
Project of the WPA," *Publishers' Weekly*, Mar. 18, 1939, p. 1132. Kath-
erine Kellock, "The WPA Writers: Portraitists of the United States,"
American Scholar, autumn 1940, p. 474. Mabel S. Ulrich, "Salvaging
Culture for the WPA," *Harper's*, May 1939, p. 656.

25. Kellock, p. 473. Mumford, p. 307. Robert Cantwell, "America
and the Writers' Project," *NR*, Apr. 26, 1939, pp. 323, 324.

26. "Mirror to America," *Time*, Jan. 3, 1938, p. 56. Federal Writers'
Project, *Connecticut: A Guide to Its Roads, Lore, and People* (Bos-
ton, 1938), pp. 427.

27. Cantwell, p. 325. *Connecticut*, pp. 222, 225.

28. *Connecticut*, pp. 512, 425–26.

29. Cantwell, p. 324. *Connecticut*, pp. 226, 424–25.

30. *Connecticut*, pp. 228–53.

31. Jacques Barzun, *The House of Intellect* (New York, 1959), p.
29. Cantwell, p. 325. For a very different evaluation of the American
Guide Series, see Harold Rosenberg, "Anyone Who Could Write En-
glish," *NY*, Jan. 20, 1973, pp. 99–102.

32. "The Index of American Design," p. 103. Cahill, *New Horizons
in American Art*, pp. 17, 18. Hilton Kramer, review, *NYT*, Apr. 14,
1970, p. 52.

CHAPTER 7
A Documentary Imagination

1. Helen Dreiser, *My Life with Dreiser* (Cleveland, 1951), p. 271. Ruth Epperson Kennell, *Theodore Dreiser and the Soviet Union, 1928–1945* (New York, 1969), p. 275. Wallace Stevens, *Letters*, ed. Holly Stevens (New York, 1966), p. 309; *The Palm at the End of the Mind*, ed. Holly Stevens (New York, 1972), pp. 188, 206; *Opus Posthumous*, ed. Samuel French Morse (New York, 1957), p. 165.

2. Daniel Aaron, *Writers on the Left* (New York, 1961), p. 393. William Phillips, "What Happened in the 30's," *Commentary*, Sept. 1962, p. 212.

3. David Madden, Introduction to *Proletarian Writers of the Thirties*, p. xxi. Jack Conroy, "The 1930's, a Symposium," *Carleton Miscellany*, winter 1965, p. 39. Newhall, *A History of Photography*, p. 144.

4. John Dos Passos, *U.S.A.* (New York, 1939), p. 100. Weatherwax, p. 211.

5. Gorelik, p. 435. Malcolm Cowley, *Think Back on Us*, ed. Henry Dan Piper (Carbondale, Ill., 1967), p. 350. "Speaking of Pictures," *Life*, Feb. 19, 1940, pp. 10–11. " 'The Grapes of Wrath,' " *Life*, June 5, 1939, pp. 66–67.

6. Leslie Fiedler, "The Two Memories," *The Thirties*, ed. Morton J. Frisch and Martin Diamond (DeKalb, Ill., 1969), p. 51. Walter B. Rideout, *The Radical Novel in the United States, 1900–1954* (Cambridge, Mass., 1956), p. 12. William Z. Foster, *The History of the Communist Party in the United States* (New York, 1952), pp. 334, 330; Irving Howe and Louis Coser, *The American Communist Party* (Boston, 1957), p. 330. Advertisement, *NM*, Nov. 1, 1938, back cover.

7. George Beiswanger, "Martha Graham: A Perspective," in Barbara Morgan, *Martha Graham: Sixteen Dances in Photographs* (New York, 1941), p. 144. LeRoy Leatherman, *Martha Graham* (New York, 1966), p. 34. Louis Horst and Robert Sabin, "Complete Chronological List of Dances Composed by Martha Graham from April 1926 to April 1961," in *Martha Graham*, ed. Karl Leabo (New York, 1961), n.p.; see also pp. 12–15, 158 in Morgan, *Martha Graham*.

8. Morgan, pp. 145, 15, 128–39, 145–46. Owen Burke, review, *NM*, Oct. 18, 1938, p. 29. John Martin, review, *NYT*, Oct. 10, 1938, p. 14.

9. Morgan, p. 147. Leatherman, p. 37.

10. The film of *Appalachian Spring* was made in the 1950s for a Pennsylvania TV station and is available from the Media Extension Center of the University of California at Berkeley.

11. Barnouw, I, 277, 271; II, 94, 96–97. Elson, pp. 251, 270, 297, 352, 337, 352. Dichter, p. 187. Bendiner, p. 43. John Gunther, *Inside Europe* (New York, 1937), pp. ix, 4, 5; I am grateful to Benjamin

Bradlee for his thoughts on Gunther's use of unattributed sources. Time Inc., *Four Hours a Year* (n.p., Time Inc., 1936), p. 27; *Photojournalism* (New York, 1971), pp. 55, 58–61. McCandlish Phillips, "Two Fathers of Photojournalism Recall Their 'Progeny,'" *NYT*, May 14, 1971, pp. 43, 83. The information on *Life*'s printing techniques comes from Carl Mydans, personal communication, and from "Life in the Making," an article in R. R. Donnelley's house organ *The Lakeside News*, Nov. 1947, pp. 329–33. Advertisement, *Life*, May 15, 1939, pp. 80–81. Carl Mydans, *More Than Meets the Eye* (New York, 1959), p. 11. "The Photograph and Good News," *The Ideas of Henry Luce*, ed. John K. Jessup (New York, 1969), pp. 43–45. "Muncie, Indiana," *Life*, May 10, 1937, pp. 15, 16. "America's Future," *Life*, June 5, 1939, p. 24.

12. F. O. Matthiessen, *American Renaissance* (New York, 1941), p. xvii. "Young Americans Study America: Springfield, Mo. Has Progressive Education," *Life*, June 5, 1939, pp. 40–42; see Boyd H. Bode, *Progressive Education at the Crossroads* (New York, 1938), p. 9. Albert Halper, *Good-bye, Union Square* (Chicago, 1970), p. 199. Louis Adamic, "Education on a Mountain," *Harper's*, Apr. 1936, pp. 516–30; abridged in *RD*, June 1936, pp. 23–27; expanded in Adamic, *My America*, quotes on pp. 617, 638. John Crowe Ransom, *The New Criticism* (Norfolk, Conn., 1941), p. 156. Mirra Komarovsky, *The Unemployed Man and His Family* (New York, 1940), pp. ix, 7.

13. "How I Came to Communism: A Symposium," *NM*, Sept. 1932, pp. 6–10. Marquis W. Childs, "They Hate Roosevelt," *Harper's*, May 1936, pp. 634–42. Elson, p. 210. [Archibald MacLeish] "Ivan Kreuger I," *Fortune*, May 1933, p. 52.

14. Frances Cooke Macgregor, "The Photographs," in Eleanor Roosevelt and Macgregor, *This Is America* (New York, 1942), n.p.

15. Kempton, *Part of Our Time*, p. 127. Kazin, *Starting Out in the Thirties*, p. 15. Copland, pp. 198, 199.

16. John Grierson, Preface to Paul Rotha, *Documentary Film* (London, 1936), pp. 10, 11. Susman, p. 191.

17. Frank Brookhouser, *These Were Our Years* (Garden City, N.Y., 1959), p. 383. Gerald Green, "Back to Bigger," *Proletarian Writers of the Thirties*, p. 36. William Saroyan, "Seventy Thousand Assyrians," *The Daring Young Man on the Flying Trapeze* (New York, 1934), pp. 40–41. Terkel, *Hard Times*, pp. 100–101.

18. Kempton, p. 83; see also Dwight Macdonald, *Memoirs of a Revolutionist* (New York, 1957), p. 14. Leslie A. Fiedler, *An End to Innocence* (Boston, 1955), p. 10. Archibald MacLeish, *A Time To Speak* (Boston, 1941), p. 88.

19. Whittaker Chambers, *Witness* (New York, 1952), p. 458. MacLeish, *A Time To Act*, p. 160.

20. Columbia Broadcasting System, *The Sound of Your Life* (New York, 1950), pp. 41, 39, 45, 3, 45. Advertisement, *Life*, Feb. 19, 1940, inside front cover. For a different and far more bitter evaluation of the temper of thirties America, see Rexford G. Tugwell, Foreword to Edward Banfield, *Government Project* (Glencoe, 1951), pp. 12–13.

21. Henry R. Luce, "The American Century," *Life*, Feb. 17, 1941, p. 65; the ideas in this influential essay echo Walter Lippmann's in "The American Destiny," *Life*, June 5, 1939, pp. 47 f.

22. *Citizen Kane* (U.S.A., 1941), directed by Orson Welles, script by Herman J. Mankewicz and Welles, Mercury/RKO. Elson, p. 463. Burke, p. 29. Bakke, *The Unemployed Worker*, p. 5. MacLeish, *A Time To Speak*, p. 293. Theodore Dreiser, *America Is Worth Saving* (New York, 1941), pp. 287, 288. In 1939 James Agee, Walker Evans, Jay Leyda, and Dwight Macdonald planned a series of short books collecting "documents." According to Agee's remarks in an unpaged manuscript notebook in the James Agee Papers at the Humanities Research Center of the University of Texas at Austin, the topics they considered included compilations of newspaper and magazine articles, advertisements, letters, "100 precious objects irrelevant to art," "sensations and things uncapturable by any technique of art or record," and "traveling in America—60 days traveling as exactly as possible recorded." Leyda says their idea was to publish "just the documents with as little commentary as possible," and remembers that one thing they wanted to print were the dying words of Dutch Schultz, which Macdonald finally published in his *Parodies: An Anthology from Chaucer to Beerbohm—and After* (New York, 1960), pp. 210–11.

23. Thornton Wilder, *Three Plays* (New York, 1966), pp. 121–22, 135, 136.

PART THREE

The Documentary Nonfiction of the Thirties

1. Grierson, *Grierson on Documentary*, p. 18.

2. James Rorty, review, *Nation*, Dec. 24, 1930, p. 712. John Dollard, *Caste and Class in a Southern Town* (New Haven, 1937), pp. 14, 2.

CHAPTER 8

Popularized Case-Worker Studies

1. Clinch Calkins, *Some Folks Won't Work* (New York, 1930), pp. 1, 2.

2. Calkins, p. 1. Paul Blanshard, review, *The World Tomorrow*, January 1931, p. 25. Marquis W. Childs, review, *NR*, Oct. 22, 1930, p. 275. Paul H. Douglas, review, *Survey*, Nov. 1, 1930, p. 166. Lionel Trilling, review, *Kenyon Review*, winter 1942, p. 99.

3. "The Gist of It," *SG*, July 1935, p. 323.

4. James Mickel Williams, *Human Aspects of Unemployment and Relief* (Chapel Hill, 1933), pp. ix, xiv, viii.

5. Calkins, pp. 16, 17.

6. Calkins, pp. 3, 32, 25, 28. Harland H. Allen, review, *CC*, Jan. 7, 1931, p. 18.

7. Calkins, p. 49. Childs, review, p. 275.

8. Calkins, pp. 145–46, 145, 127, 128, 129–30.

<div align="center">

CHAPTER 9
Social Science Writing

</div>

1. W. Lloyd Warner and Paul S. Lunt, *The Social Life of a Modern Community*, vol. I of the Yankee City Series (New Haven, 1941), pp. 5, 6. Dollard, p. 2.

2. Charles Horton Cooley, *Sociological Theory and Social Research* (New York, 1930), p. 332. E. Wight Bakke, *The Unemployed Man* (London, 1933), p. xiv. Thomas Minehan, *Boy and Girl Tramps of America* (New York, 1934), p. 247.

3. Florence Codman, review, *Nation*, Mar. 28, 1934, p. 366. Louis Adamic, review, *SR*, Nov. 9, 1935, p. 10. John Chamberlain, review, *NYT Book Review*, Apr. 17, 1932, p. 10. Childs, review, *NR*, Oct. 22, 1930, p. 275. Rorty, *Where Life Is Better*, p. 10. David L. Cohn, *God Shakes the Creation* (New York, 1935), p. xiv.

4. Dollard, pp. 17, 18. Eduard C. Lindeman, *Social Discovery* (New York, 1923), pp. 191 (note that the original meaning of the phrase is slightly different from the present), 179. Cooley, p. 333. Minehan, pp. xv, xvi.

5. Clifford R. Shaw, *The Natural History of a Delinquent Career* (Chicago, 1931), p. 18.

<div align="center">

Case Study

</div>

6. Eli Ginzberg and others, *The Unemployed* (New York, 1943).

7. Ginzberg, pp. 181, 201. Bakke, *The Unemployed Man*, pp. xiv–xv. Winona L. Morgan, *The Family Meets the Depression* (Minneapolis, 1939), p. 6.

8. Robert Cooley Angell, *The Family Encounters the Depression* (New York, 1936), pp. 15, 16, 84. Paul L. Schroeder and Ernest W. Burgess, Introduction to Ruth Shonle Cavan and Katherine Howard Ranck, *The Family and the Depression* (Chicago, 1938), p. 8.

9. Komarovsky, pp. 19, 24, 25.

10. Ginzberg, pp. ix, 175, 5, 136, 165, 166, 167, 157, 158, 201, 3, 168, 3, 170, 4, 156, 171, 201, 202.

11. Warner, p. 127. Dollard, pp. 485, 17, 299.

12. John Madge, *The Origins of Scientific Sociology* (New York, 1962), p. 53. W. I. Thomas and Florian Znaniecki, *The Polish Peasant in Europe and America* (4 vols., 1918–20), III, 1.

13. E. Wight Bakke, *Citizens without Work* (New Haven, 1940), pp. 12, v, 64, 200, 31–32; *The Unemployed Worker*, pp. 72, 26.

14. Lazarsfeld, Introduction to Komarovsky, p. xii.

Participant Observation

15. Bakke, *The Unemployed Man*, pp. xiii, xiv, xv.

16. Robert E. L. Faris, *Chicago Sociology, 1920–1932* (Chicago, 1970), pp. 64, 28. Nels Anderson, Introduction to *The Hobo* (Chicago, 1961), p. xii. Paul G. Cressey, *The Taxi-Dance Hall* (Chicago, 1932), pp. xviii, xii. Robert S. Lynd and Helen M. Lynd, *Middletown* (New York, 1929), p. 506.

17. Warner, pp. 4, 3, 48, 43. John Marquand, a resident of Newburyport, satirized Warner and the Yankee City project in his novel *Point of No Return* (1949); see Granville Hicks, "Marquand of Newburyport," *Harper's*, Apr. 1950, pp. 101–8.

18. Allison Davis and others, *Deep South* (Chicago, 1941), pp. viii, 3. Dollard, pp. 1, 17, 19, 20.

19. Bakke, *Citizens without Work*, pp. 60, 61.

20. Minehan, pp. xii–xiii, xiii, 126–27, 76, 122, 126, 129, xii (on the "cult of experience," see also pp. 117–18). Edwin H. Sutherland and Harvey J. Locke, *Twenty Thousand Homeless Men* (Chicago, 1936), pp. v, vi, v.

21. Minehan, pp. 236, xii, 9, 44–45. Nels Anderson, review, *SG*, Jan. 1935, pp. 26–27. Jay Leyda, *Kino* (London, 1960), pp. 284, 437.

22. William Foote Whyte, *Street Corner Society* (Chicago, 1943), xvii, xvii–xviii, xi (note his crediting Warner for his method), 115, 100. Whyte, "On the Evolution of *Street Corner Society*," appendix to the 1955 edition (Chicago), p. 306. See Madge, pp. 210–54.

Documentary Reportage: Radical

1. Mauritz A. Hallgren, "Panic in the Steel Towns," *Nation*, Mar. 30, 1932, p. 361. Herbert C. Pell, review, *SR*, Nov. 30, 1935, p. 6.

Exposé Quotation

2. "The Old Lefty," *Time*, Feb. 8, 1971, p. 47. See John L. Spivak, *Georgia Nigger* (New York, 1932); "On the Chain Gang"; "Wall Street's Fascist Conspiracy," *NM*, Jan. 29, 1935, pp. 9–15; *Shrine of the Silver Dollar* (New York, 1940); *A Man in His Time*, pp. 134–64, 453–63.

3. John L. Spivak, "Shady Business in the Red Cross," *AM*, Nov. 1934, pp. 257, 258, 263, 264, 265, 266. This article apparently prompted Alfred Knopf, the owner of the *American Mercury*, to drop Charles Angoff as editor and sell the magazine: see *NYT*, Jan. 23, 1935, p. 15, and George Simpson, "Mr. Knopf Makes a Sale," *NM*, Feb. 5, 1935, p. 20.

Case Study

4. Erskine Caldwell, *Some American People* (New York, 1935), pp. 230, 231–32; see "Bootleg Slavery," *Time*, Mar. 4, 1935, pp. 13–14.

5. John L. Spivak, "Letter from America to President Roosevelt," *NM*, Mar. 20, 1934, pp. 9–11 (*New Masses* had a continuing "Letter from America" rubric for documentary reportage); reprinted in *Proletarian Literature in the United States*, pp. 252–58, and *New Masses: An Anthology*, pp. 145–51. Meridel LeSueur, "Women on the Breadlines," *NM*, Jan. 1932, pp. 5–7.

6. Edmund Wilson, "Progress and Poverty," *NR*, May 30, 1931, pp. 13–16.

Participant Observer

7. "A Note about the Author," John L. Spivak, *Europe under the Terror* (New York, 1936), p. 245. R. L. Duffus, review, *NYT Book Review*, July 28, 1935, p. 1.

8. John Dos Passos, *In All Countries* (New York, 1934), pp. 222–28. Malcolm Cowley, "The Flight of the Bonus Army," *NR*, Aug. 17, 1932, pp. 13–15. Meridel LeSueur, "Cows and Horses Are Hungry," *AM*, Sept. 1934, pp. 53–56. Herbert L. Matthews, article, *NYT*, Mar. 18, 1938, pp. 1, 8.

9. Matthews, p. 8. Barrie Stavis, "Barcelona Horror," *NM*, Mar. 29, 1938, p. 7.

10. Herbert Morrison's report is on the Longines Symphonette Society's "Remember the Golden Days of Radio," vol. II (Larchmont, N.Y.); see also Barnouw, II, 109, and "Oh! the Humanity!" *Time*, May 17, 1937, pp. 35–42.

11. Tillie Lerner, "The Strike," *PR*, Sept.–Oct. 1934, p. 3.

12. John A. Fitch, review, *SG*, May 1935, pp. 554, 555.

13. John L. Spivak, "Bitter Unrest Sweeps the Nation," *AM*, Aug. 1934, p. 387; reprinted, slightly revised, in his *America Faces the Barricades* (New York, 1935), pp. 83–84. Perkins, *People at Work*, p. 156.

14. Spivak, *America Faces the Barricades*, pp. 84, 168, 268.

15. Duffus, p. 1. Spivak, pp. vii, ix.

16. Rorty, *Where Life Is Better*, pp. 12 (see Minehan, p. 58), 107, 13, 49, 92–97.

17. Wilson, *The American Jitters*, pp. 10, 284, 290, 296; *Travels in Two Democracies* (New York, 1936), pp. 150–62; *The American*

Earthquake, pp. 570, 571. Benjamin Stolberg, review, *NYHT Books*, Apr. 17, 1932, p. 7.

CHAPTER 11
Informant Narrative

1. Wilson, "Detroit Motors," *NR*, Mar. 25, 1931, pp. 147–48.
2. *NR*, May 6, 1931, pp. 322–23; *NR*, Mar. 8, 1933, pp. 92–95; *NM*, Jan. 1, 1935, pp. 20–27; *Nation*, July 3, 1937, p. 26; *NM*, Mar. 29, 1938, pp. 5–6 (reprinted from *The New Statesman and Nation* [London]).
3. Cowley, *Exile's Return*, p. 107. [Michael Gold] Editorials, *NM*, July 1928, p. 2; Aug. 1928, p. 2.
4. Aaron, *Writers on the Left*, pp. 205–13. "I'm on Relief," *Harper's*, Jan. 1936, pp. 200, 205. Caroline A. Henderson, "Letters from the Dust Bowl," *Atlantic*, Mar. 1936, pp. 542, 546, 548, 540.
5. League of Professional Groups for Foster and Ford, "Culture and Crisis" (New York, 1932); the pamphlet was drafted by James Rorty, Matthew Josephson, and Malcolm Cowley: see Josephson, *Infidel in the Temple*, p. 150. "On Being Fired," *NR*, Apr. 15, 1931, p. 230 (the author would appear to have been James Rorty: see "Contributors," *NR*, Apr. 29, 1931, p. 310). "Letter from a Hearst Striker," *NM*, Mar. 3, 1936, p. 9.
6. Couch, *These Are Our Lives*, pp. xiii–xiv.
7. Aaron, pp. 212, 211. Nelson Algren, "The 1930's, a Symposium," *Carleton Miscellany*, winter 1965, p. 104.
8. Robert Cantwell, review, *NR*, Apr. 10, 1935, p. 252. Fred T. Marsh, review, *NYHT Books*, Mar. 3, 1935, p. 2. Kromer, blurb to *Waiting for Nothing* (1935); reprinted as foreword to the 1968 edition (New York), which has the same pagination. Roland Mulhauser, review, *SR*, Mar. 30, 1935, p. 584. Kromer, pp. 16, 14, 3, 112, 113, 120, 121–22, 32. *Years of Protest*, ed. Jack Salzman and Barry Wallenstein (New York, 1967), p. 45.
9. The phrase "oral history" would appear to derive from the Greenwich Village character Joe Gould, who styled himself the "oral historian of our times"; see Horace Gregory," "Pepys on the Bowery," *NR*, Apr. 15, 1931, pp. 249–51. In 1970 Jean Stein and George Plimpton noted that over four hundred oral history projects were under way; see *American Journey*, ed. Stein and Plimpton (New York, 1970), p. viii.
10. E. W. Burgess, "Editor's Preface" and "Discussion," in Shaw, *The Natural History of a Delinquent Career*, pp. xi, 240, 241. Clifford R. Shaw, *The Jack-Roller* (Chicago, 1930). Shaw, *The Natural History of a Delinquent Career*, p. 58.
11. John Dollard, *Criteria for the Life History* (New Haven, 1937).

Robert Redfield, Foreword to Louis Gottschalk, Clyde Kluckhohn, Robert Angell, *The Use of Personal Documents in History, Anthropology, and Sociology* (New York, 1945), p. vii. *The Professional Thief*, ed. Edwin H. Sutherland (Chicago, 1937), pp. v, 116, 21, 190.

12. Aaron, p. 178. Asch, *The Road*, p. 7; see B. A. Botkin's description of "creative listening" in McDonald, *Federal Relief Administration and the Arts*, p. 713. Theodore Dreiser, *Harlan Miners Speak* (New York, 1932), pp. 200, 152–53, 181–89. For a less complimentary view of Herndon Evans, see Edmund Wilson, "Class War Exhibits," *NM*, Apr. 1932, p. 7.

13. Couch, *These Are Our Lives*, pp. ix, xi, xiii, xii (see also 417), x, 214 (the text once unaccountably changes "James" to "John"), 217, 260, 253, 258.

14. Couch and Botkin had more than methodological quarrels; see McDonald, p. 679. B. A. Botkin, Preface to Federal Writers' Project, *Lay My Burden Down*, ed. Botkin (Chicago, 1945), pp. viii, vii, xi, xii, xii–xiii, xiii, ix, 142, 172, 93, 58. Stein and Plimpton, p. viii.

15. "The Disinherited Speak: Letters from Sharecroppers" (New York, the Workers Defense League for the Southern Tenant Farmers' Union, 1937), pp. x, 20, 18, 24, 26, 14.

<div align="center">

CHAPTER 12

The Documentary Book

</div>

1. Sigmund Aaron Lavine, review, Boston *Evening Transcript*, Nov. 29, 1937, p. 3. Cowley, review, *NR*, Nov. 24, 1937, p. 78.

2. Elson, *Time*, p. 306. *Fortune*, Dec. 1935, pp. 115–20; Aug. 1935, pp. 38–47; Feb. 1936, pp. 63–68.

3. Kazin, *On Native Grounds*, p. 385. MacLeish, *Land of the Free*, n.p. Paul U. Kellogg, ed., *The Pittsburgh Survey* (6 vols., New York, 1909–14). Rexford G. Tugwell, personal communication. Ralph Henry Gabriel, ed., *The Pageant of America: A Pictorial History of the United States* (15 vols., New Haven, 1925–29). Advertisement, *AM*, Dec. 1934, p. xxiv.

4. See also C. M. Wilson, *The Roots of America*.

5. Lewis W. Hine, Foreword to *Men at Work* (New York, 1932), n.p. M. Lincoln Schuster, *Eyes on the World* (New York, 1935), p. 83.

6. James Korges, *Erskine Caldwell* (Minneapolis, 1969), p. 14. Robert Capa, *Death in the Making* (New York, 1938). Erskine Caldwell and Margaret Bourke-White, *North of the Danube* (New York, 1939); *Russia at War* (London, 1942). Margaret Bourke-White, *Shooting the Russian War* (New York, 1942). Ansel Adams, *Born Free and Equal* (New York, 1944), pp. 7, 9. Lange and Taylor, *An American Exodus*, p. 6.

7. Cowley, review, *NR*, Nov. 24, 1937, p. 78. MacLeish, *Land of the Free*, p. 89. Caldwell and Bourke-White, *You Have Seen Their Faces*, p. 168. Lange and Taylor, p. 57 (N.B., this photo does not appear in the 1969 edition of *An American Exodus* [New Haven]).

8. Newhall, *The History of Photography*, p. 150. George P. Elliott, "On Dorothea Lange," *Dorothea Lange* (New York, 1966), pp. 8, 9.

9. Erskine Caldwell, *Call It Experience* (New York, 1951), p. 163; personal communication.

10. Cameron, in Agee and Evans, p. 451. I don't know who first called Bourke-White "the poetess of the camera," but the appellation persists: see the advertisement for Young and Rubicam, *Fortune*, Feb. 1970, p. 149. Margaret Bourke-White (photographs) [and James Agee (text)], "The Drought: A Post-Mortem in Pictures," *Fortune*, Oct. 1934, pp. 76–83. Bourke-White, *Portrait of Myself*, p. 134.

11. Oren Stephens, "Revolt on the Delta," *Harper's*, Nov. 1941, p. 656. Agee and Evans, p. 455. David Eugene Conrad, *The Forgotten Farmers* (Urbana, Ill., 1965), p. 158. Howard Kester, *Revolt among the Sharecroppers* (New York, 1936), p. 69. "Bootleg Slavery," *Time*, Mar. 4, 1935, p. 13. John Herling, "Labor and Industry: Field Notes from Arkansas," *Nation*, Apr. 10, 1935, p. 419.

12. Conrad, p. 166. "Bootleg Slavery," p. 13. Frazier Hunt, *One American and His Attempt at Education* (New York, 1938), pp. 394–95. Henry A. Wallace, *NYT Magazine*, Mar. 31, 1935, p. 4. Cecil Holland, "The Tenant Farmer Turns," *SG*, May 1935, p. 233.

13. Conrad, p. 210; there is a second *March of Time* film, *Land of Cotton* (1936), on the topic. *White Bondage* (U.S.A., 1937), Warner Brothers. "Music in Films," *Films: A Quarterly of Discussion and Analysis*, winter 1940, p. 5. Mary McCarthy, "My Confession," *The Reporter*, Dec. 22, 1953, p. 32. Editorial, *NYT*, Nov. 18, 1936, p. 24.

14. Caldwell and Bourke-White, *You Have Seen Their Faces*, pp. 165, 167. *Report of the Special Committee on Farm Tenancy*, 75th Cong., 1st Sess., House Doc. No. 149 (Washington, D.C., 1937).

15. Caldwell and Bourke-White, *You Have Seen Their Faces*, pp. 108–11, 77, 165.

16. Caldwell and Bourke-White, *You Have Seen Their Faces*, p. 77. Agee and Evans, p. 134. Bourke-White, *Portrait of Myself*, pp. 125, 126–27.

17. George P. Elliott, "On Dorothea Lange," p. 9; "Photographs and Photographers," *A Piece of Lettuce* (New York, 1964), p. 92. Warshow, *The Immediate Experience*, p. 38.

18. Bourke-White, *Portrait of Myself*, p. 138; Cousins, review, *Current History*, Dec. 1937, p. 8.

19. Bourke-White, in Caldwell and Bourke-White, *You Have Seen Their Faces*, p. 187.

20. Caldwell and Bourke-White, introductory note to *You Have Seen Their Faces*, n.p.

21. Cameron, in Agee and Evans, pp. 451, 452, 451, 453. Walker Evans, in conversation with the author. Cowley, review, *NR*, Nov. 24, 1937, p. 78. Evans' dates of employment with the FSA were communicated to me by Joseph L. Wertzberger, director of the General Services Administration's National Personnel Records Center.

22. Evans, in conversation. Bourke-White, in Caldwell and Bourke-White, *You Have Seen Their Faces*, p. 187.

23. Herman Clarence Nixon, "Whither Southern Economy?", *I'll Take My Stand* (New York, 1930); *Forty Acres and Steel Mules* (Chapel Hill, 1938), pages facing 19, 26, frontispiece, facing 60, facing 45, 3, facing 35.

24. Archibald MacLeish, personal communication; *Land of the Free*, pp. 8, 46, 83 (titles on pp. 89 f.), 89, 1, 2, 88. See in particular T. K. Whipple, review, *NR*, Apr. 13, 1938, pp. 311–12.

25. Paul S. Taylor, personal communication; "Migrant Mother: 1936," *American West*, May 1970, p. 42; "Again the Covered Wagon," *SG*, p. 348.

26. Lange and Taylor, *An American Exodus* (1939), p. 6; Taylor, "Migrant Mother: 1936," pp. 43, 45.

27. Paul S. Taylor, "Nonstatistical Notes from the Field," a 1940 Department of Agriculture report reprinted in *An American Exodus* (1969), pp. 136, 137. Taylor, personal communication.

28. Dorothea Lange, "The Making of a Documentary Photographer," interview with Suzanne Riess (mimeographed, Berkeley, University of California Regional Oral History Office, 1968), pp. 144–49. Beaumont Newhall, "Commentary," *Dorothea Lange Looks at the American Country Woman* (Fort Worth, 1967), p. 5. Taylor, "Again the Covered Wagon," p. 351; this article was the germ of *An American Exodus:* the book's dust jacket had a photo of a pickup truck covered like a conestoga wagon and the caption "Covered Wagon—1939 style"; Paul Kellogg, *Survey Graphic*'s editor, offered advice on the book and actually titled it (Taylor, personal communication). Lange and Taylor, pp. 39–40. Carey McWilliams, review, *NR*, Feb. 12, 1940, p. 218.

29. Lange and Taylor, pp. 6, 14, 92, end papers, 101, 35, 142, 129. Elliott, "Photographs and Photographers," pp. 96, 97. Elliott, "On Dorothea Lange," p. 13.

30. Dorothea Lange, "The Assignment I'll Never Forget," *Popular Photography*, Feb. 1960; reprinted in *American West*, May 1970, p. 46. Lange and Taylor, pp. 101 (1939 edition), 81 (1969 edition).

31. *Dorothea Lange*, pp. 38, 39. Lorentz, "Dorothea Lange," p. 98. Taylor, personal communication.

32. Taylor, Preface to *An American Exodus* (1969), p. 13. Edwin Rosskam, *Washington: Nerve Center* (New York, 1939), p. 7; *San Francisco* (New York, 1939), p. 50.

33. Rosskam, *Washington*, p. 7. Wright, *12 Million Black Voices*, pp. 9, 18. Anderson, *Home Town*, p. 66. Evans, in conversation.

34. Anderson, pp. 3, 4, 6, 4, 17, 72, 91, 102, 17–18.

35. Wright, pp. 14–15, 13. I am indebted to Robert Crunden for help in formulating the argument in this paragraph. Redding, *On Being Negro in America*, p. 9.

36. Roosevelt and Macgregor, *This Is America*, n.p.

37. Roosevelt and Macgregor. *Life* magazine was itself each week an emblem of unity in diversity and no doubt the most important American periodical of the war years; Henry Luce said, "Though we did not plan *Life* as a war magazine, it turned out that way" (Elson, p. 306; see also p. 485).

38. Roosevelt and Macgregor, *This Is America*.

Documentary Reportage: "Conservative"

1. Nathan Asch, review, *NR*, Sept. 4, 1935, p. 108. Ferner Nuhn, review, *Nation*, Oct. 30, 1935, p. 518.

2. *NM*, Feb. 1932, pp. 16–18; *Harper's*, May 1931, pp. 738–60; *NR*, Feb. 25, 1931, pp. 37–41. Wilson, *American Jitters*, pp. 297, 309, 310. Rorty, *Where Life Is Better*, p. 169. In the early thirties, despair over democracy was endemic and calls for a dictator frequent; see Warren, *Liberals and Communism*, and Seldes, *The Years of the Locust*, pp. 224–26. Donald Davidson, review, *American Review*, May 1935, p. 237. Kazin, *On Native Grounds*, p. 390.

3. Nathan Asch, review, *NR*, Feb. 26, 1936, p. 86. Jay Allen, Preface to Capa, *Death in the Making*, n.p. Nuhn, p. 518.

4. On the average American as "conservative," see C. M. Wilson, *Roots of America*, p. 8. Adamic, *My America*, p. 662.

5. Waldo Frank, *Our America* (New York, 1919), p. 10. Anita Brenner, review, *Nation*, Feb. 12, 1936, p. 194. *As F.D.R. Said*, ed. Kingdon, p. 63; Frank Kingdon, personal communication.

6. The first edition of *On the Road* aired Oct. 26, 1967; its subject was the fall leaves in New England (Louise G. Colon, letter on behalf of Charles Kuralt). Caldwell, *Some American People*, pp. 3, 4, 5, 8, 9.

7. Caldwell, *Some American People*, pp. 265, 88, 147, 151.

8. Caldwell, "Our Garden of Eden," *Some American People*, pp. 49–51.

9. Sherwood Anderson and Raymond Moley, letters, *Today*, Dec. 2, 1933, p. 3. Moley says that he conceived the idea of sending Anderson

out to document America because "Anderson's book *Winesburg, Ohio* indicated to me how much he knew of the people and the town in my home state of Ohio" (personal communication).

10. Hamilton Basso, review, *NR*, May 1, 1935, p. 348. Review, *CC*, May 29, 1935, p. 732; see also Louis Adamic, review, *SR*, Apr. 13, 1935, p. 631. Anderson, *Puzzled America*, p. x. Davidson, pp. 237, 234.

11. Anderson, pp. xvi, 11, xv, 165–66, 241, ix, x.

12. Robert Cantwell, review, *NR*, May 10, 1939, p. 27. Harvey Swados, ed., *The American Writer and the Great Depression* (Indianapolis, 1966), p. 221. Anderson, p. 113.

13. E. B. White, in William Strunk, Jr., and White, *The Elements of Style* (New York, 1959), p. 70. Sherwood Anderson, "At the Mine Mouth," *Today*, Dec. 30, 1935, p. 5.

14. Basso, p. 348. Anderson, *Puzzled America*, p. 5.

15. Asch, *The Road*, pp. 15–16, 195, 269. Cowley, *Think Back on Us*, p. 387. Review, *Time*, May 24, 1937, p. 74.

16. Otis Ferguson, review, *NR*, June 30, 1937, p. 231.

17. Christopher Lazare, review, *Nation*, July 3, 1937, p. 24. John C. Cort, review, *Commonweal*, Sept. 12, 1941, p. 500. Asch, *The Road*, pp. 81, 252, 85.

18. Jonathan Daniels, *A Southerner Discovers the South* (New York, 1938), pp. 9–10. Adamic, *My America*, p. xi.

19. John Hersey, *Into the Valley* (New York, 1943), p. 74. Malcolm Cowley, review, *NR*, June 8, 1938, p. 135. Cowley, *Think Back on Us*, pp. 195, 196.

20. Dreiser, *America Is Worth Saving*, pp. 225, 285, 259. John Strachey, *Hope in America* (New York, 1938), p. 163. Rollo Walter Brown, *I Travel by Train* (New York, 1939), p. 299.

21. Benjamin Appel, *The People Talk* (New York, 1940), p. 497. Clifton Fadiman, review, *NY*, Apr. 15, 1939, p. 103. George Leighton, *Five Cities* (New York, 1939), p. 7.

22. Irving Berlin, letter, "Let's Waive 'The Star-Spangled Banner,' " *Fact*, Jan.–Feb. 1965, pp. 8–9. Barnouw, II, 155. Henrietta Yurcheno and Marjorie Guthrie, *A Mighty Hard Road: The Woody Guthrie Story* (New York, 1970), back cover. Childs, *I Write from Washington*, pp. 318, 319.

23. Caldwell and Bourke-White, *Say, Is This the U.S.A.*, pp. 10–12.

PART FOUR

Let Us Now Praise Famous Men

1. Agee and Evans, p. 13. Robert Fitzgerald, "Memoir," *The Collected Short Prose of James Agee*, ed. Fitzgerald (Boston, 1968), p. 49. Susman, "The Thirties," p. 217.

2. Evans, in conversation.

3. James Agee, typed draft manuscript to *Let Us Now Praise Famous Men*, the James Agee Papers, Humanities Research Center, the University of Texas at Austin, p. 352. [James Agee] " 'This Project Is Important,' " *Fortune*, Oct. 1933, pp. 81–97; "TVA I: Work in the Valley," *Fortune*, May 1935, pp. 92–96. Evans, in conversation. According to Joseph Wertzberger, director of the General Services Administration's National Personnel Records Center, Evans was on leave without pay from the Photography Unit from July 16, to Sept. 15, 1936. During this time Evans was not directly an employee of Time Inc.; Robert Elson informs me that Evans first appears on Time Inc.'s personnel roster in 1943, when he joined *Time* as a book reviewer. It seems that Evans was paid a flat sum for the tenant project, as had apparently been done for the photos he took to accompany such earlier articles as "The Communist Party," *Fortune*, Sept. 1934, pp. 69–74, 154–62. Indeed, his "wages" may have come from money Agee was advanced on the project; David DeJong, a friend of Agee's, recalls that Agee and Evans were paid handsomely for their work—he implies as much as $8,000 to $12,000 (DeJong, "The 1930's, a Symposium," p. 52; note, however, that DeJong's memory is unreliable: he thinks the project took place at the end of the decade, after Agee had resigned from *Fortune*). Evans is not sure why his photographs of the tenants became the property of the FSA, but he thinks this arrangement may have been necessary to get him time off from the Photography Unit. T. S. Matthew, "James Agee—'Strange and Wonderful,' " *SR*, Apr. 16, 1966, p. 22.

4. Evans, in conversation. Macdonald, *Memoirs of a Revolutionist*, p. 262. Robert Fitzgerald, personal communication.

5. "Success Story," *Fortune*, Dec. 1935, p. 115. Agee and Evans, p. 7.

6. Evans, in conversation. Agee, *Letters*, p. 94. Matthews, p. 22. Agee manuscript notebook with draft paragraphs of the Preface to *Let Us Now Praise Famous Men*, in the Agee Papers, n.p. Fitzgerald, "Memoir," p. 34. Robert Elson, personal communication. Louis Kronenberger, *No Whippings, No Gold Watches* (Boston, 1970), pp. 68–69. Ralph Ingersoll, personal communication.

7. Beulah Hagen, letter to the author on behalf of Cass Canfield. Evans, in conversation.

8. Hagen, letter to the author. In cancelling the contract for Agee and Evans' book, Harpers stipulated that if the book were later published Harpers should recover the cost of the photoengravings and of Agee's advance; Harpers did recover these costs (Hagen letter). Agee, manuscript notebook. Agee and Evans, p. xv. Evans, in conversation.

9. Agee and Evans, pp. xiv, 455. Agee, typed draft manuscript, p.

348. Evans, in conversation. When Houghton Mifflin accepted *Let Us Now Praise Famous Men*, Edward Aswell wrote to Paul Brooks: "Let me tell you now how greatly I envy you the privilege of publishing this book. It was a great blow to me personally that things turned out as they did. Agee is certainly one of the most remarkable writers I have even known and the only one now living who, I feel sure, is an authentic genius" (Hagen letter). Paul Brooks, personal communication.

10. Paul Brooks, personal communication. Agee and Evans, p. 208. Donald Crichton Alexander, *The Arkansas Plantation, 1920–1942* (New Haven, 1943), p. 67.

11. Agee and Evans, p. xiv.

12. Evans, in conversation. MacLeish, personal communication. Agee and Evans, p. 13.

13. Henry James, Preface to the New York edition of *The Portrait of a Lady* (New York, 1908), III, x.

14. Agee and Evans, pp. xv, xiv. Evans, in conversation. Hilton Kramer, review, *NYT*, Feb. 7, 1971, II, 27; see also Elliott, "Photographs and Photographers," *A Piece of Lettuce*, p. 95.

CHAPTER 14
The Photographs

1. Hilton Kramer, review, *NYT*, Jan. 28, 1971, p. 42. John Szarkowski, Introduction to *Walker Evans* (New York, 1971), p. 20. A. D. Coleman, review, *NYT*, Feb. 14, 1971, II, 38. Walter McQuade, review, *Life*, Mar. 5, 1971, p. 12.

2. *Walker Evans: His Time, His Presence, His Silence* (U.S.A., 1969), directed Sedat Pakay, distributed Film Images. *C.B.S. Evening News*, Apr. 17, 1971. "Gallery," *Life*, Aug. 14, 1970, pp. 6–9. Tom Maloney, *U.S. Camera 1961* (New York, 1960), p. 6.

3. Ruth Lechlitner, review, *NYHT Books*, Aug. 24, 1941, p. 10. Lincoln Kirstein, in Walker Evans, *American Photographs* (New York, 1938), p. 197.

4. Agee and Evans, p. 76. Evans, in conversation.

5. See Szarkowski, in *Walker Evans*, p. 12. Evans, in conversation. In *James Agee* (Minneapolis, 1971), Erling Larsen suggests that Evans moved the Gudger's bed to photograph it better (p. 29).

6. Trilling, review, *Kenyon Review*, winter 1942, p. 100. Richard Warch called my attention to the bizarre angles from which Bourke-White took her photographs. Evans used flashes for all the interiors, including the interior portraits of people, in *Let Us Now Praise Famous Men;* but he took care to use the device as little as he could

and still get the light he needed. He says he developed his pictures with great care so as to *hide* the fact that flashes had been used.

7. "The Art of Seeing," *NY*, Dec. 24, 1966, p. 27.

8. Agee and Evans, pp. 203, 134. Evans, in conversation. Coleman, p. 38. Elliott, "Photographs and Photographers," p. 94. James Agee, essay in Helen Levitt and Agee, *A Way of Seeing* (New York, 1965), p. 4.

9. Agee and Evans, pp. 9, 7, 203, 9. Szarkowski, p. 15. Glenway Wescott, essay in *U.S. Camera Magazine*, No. 1 (1938), p. 67; quoted in Newhall, *The History of Photography*, p. 148.

10. Van Gogh's painting *Les Souliers* (Boots with Laces) is in Amsterdam's Stedelijk Museum.

11. Evans, in conversation.

12. Agee and Evans, pp. 143, 61, 367, 369.

13. Barzun, *The House of Intellect*, pp. 30, 29. Edward Steichen, ed., *The Family of Man* (New York, 1955), pp. 125, 5.

14. Agee, *A Way of Seeing*, p. 7. Agee and Evans, pp. 134, 204, 156, 207–08. Coleman, p. 38.

15. William Carlos Williams, review, *NR*, Oct. 12, 1938, p. 284. *Walker Evans*, pp. 165, 179. The third photograph was displayed in Evans' Jan. 30–Feb. 25, 1971 exhibit at the Robert Schoelkopf Gallery in New York City.

16. Trilling, pp. 100–101. Evans, in conversation. Susman, p. 217.

17. Evans, in conversation. Photo 22 in the first section of *American Photographs* has a different image of this hymn-sing, showing Margaret, Fred, Sadie, and Katy Ricketts, and Paralee in her splendid dress (see Agee and Evans, pp. 283–84).

18. Kirstein, in *American Photographs*, p. 191.

19. Evans, in conversation.

20. The photo of Sadie Ricketts and her seven children is in the 1960 edition but not the earlier.

21. Evans, in conversation; foreword to *American Photographs*, n.p.

22. Agee, *A Way of Seeing*, p. 3. The range of Evans' taste is demonstrated in the series of photographs he chose for the "Photography" section in Louis Kronenberger, *Quality* (New York, 1969), pp. 169–211. Evans, in conversation; "People and Places in Trouble," *Fortune*, Mar. 1961, p. 110.

23. Evans, in conversation.

24. Walker Evans, "James Agee in 1936," in Agee and Evans, p. xi. *Walker Evans*, p. 93. Evans, in conversation. Agee and Evans, pp. 273, 89.

25. *Walker Evans*, p. 89. Evans, in conversation. Agee and Evans, p. 369.

26. "Master of the brood," is Evans' description.

27. Evans, in conversation.

28. On the smiles of society's "victims," see Brendan Gill, review, *NY*, Dec. 25, 1971, pp. 66–68.

29. Evans, in conversation.

30. On "terror," "nostalgia," and "infinite sadness" in Evans' work, see, for example, Coleman, review, *NYT*, Feb. 14, 1971, II, 38.

31. On Evans' work as "timeless," see, for instance, John Gruen, review, *New York*, Feb. 15, 1971, p. 59. Susan Sontag, "The Aesthetics of Silence," *Styles of Radical Will* (New York, 1969), p. 16.

32. Evans, *American Photographs*, pp. 47 (first section), 30 (second section).

33. Coleman, p. 38.

CHAPTER 15
The Text

1. Agee and Evans, pp. xv, xvi, 236. Kazin, *On Native Grounds*, p. 387.

2. Blurb to the 1966 paperback edition of *Let Us Now Praise Famous Men* (New York). W. M. Frohock, "James Agee—The Question of Wasted Talent," *The Novel of Violence in America* (Dallas, 1957), pp. 212–30. George Barker, review, *Nation*, Sept. 27, 1941, p. 282. Harvey Breit, review, *NR*, Sept. 15, 1941, p. 348. Review, *Time*, Oct. 13, 1941, p. 104. Review, *NY*, Sept. 13, 1941, p. 75.

3. Agee and Evans, pp. 100, 60–61, xiii, xix, 8, xxii, 20, 321, 307, 249, 14, 217, 307, 439, 392 (see also p. 91). Agee, manuscript notebook. Agee, *Letters*, pp. 114–15. Review, *Time*, Oct. 13, 1941, p. 104. Selden Rodman, review, *SR*, Aug. 34, 1941, p. 6. Agee, carbon copy of a typed draft manuscript of "Work," in the Agee Papers, p. 4a. Susman, p. 217.

4. Agee and Evans, pp. 111, 169, 161. Hart Crane, *The Collected Poems*, ed. Waldo Frank (New York, 1938), p. 65.

5. Agee and Evans, pp. 237, 134, 218, 196.

6. Agee and Evans, pp. 322, 11, 238. Kenneth Seib, *James Agee: Promise and Fulfillment* (Pittsburgh, 1968), p. 51.

7. Agee and Evans, pp. 237, 238, 234, 230, 150–51. Agee's inventory of the tenants' lives was recognized as a unique accomplishment when it appeared: "an almost unbelievably exact physical inventory" (*The New Yorker*), "come[s] as close to reproducing the actual as words . . . can" (*Time*), "Agee is not only a poet but a corking good journalist" (Ruth Lechlitner, the New York *Herald Tribune*).

8. Agee and Evans, pp. 469, 234.

9. Review, *Time*, Oct. 13, 1941, p. 104. Breit, p. 348. Trilling, p. 102.

10. Agee and Evans, pp. 7, xi, 16, 239. Agee, carbon copy of a typed draft manuscript of "Education," in the Agee Papers, p. 19.

11. Agee and Evans, p. 100.

12. Agee and Evans, pp. 26, 41, 42, 365, 413–14, 417.

13. Agee and Evans, pp. 115, 415, 396, 415, 58, 271, 89–90.

14. Agee and Evans, pp. 371, 370, 400. Evans, in conversation. William Christenberry, in conversation with the author.

15. Leo R. Etzkorn, review, *Library Journal*, Aug. 1941, p. 667. Henry Roth, "No Longer at Home," *NYT*, Apr. 15, 1971, p. 43. Agee and Evans, pp. 66, 371.

16. Agee and Evans, p. 62. Evans, in conversation.

17. Agee and Evans, pp. 382, 79, 80, 79, 80, 78.

18. Paul Goodman, review, *PR*, Jan.–Feb. 1942, p. 86. Agee and Evans, pp. 77, 80, 81 (N.B., the "how were we caught" section occurs between the tenants' dreams and Louise's interior monologue, both of which are acknowledged fabrications).

19. Evans, in conversation. Agee, typed draft manuscript, p. 356. Agee and Evans, pp. 468 f.

20. Agee, *A Way of Seeing*, p. 78. Evans, in conversation.

21. Trilling, pp. 102, 99, 102. See for example Victor Anthony Kramer, "James Agee's 'Dissonant Prologue': A Study of *Let Us Now Praise Famous Men*" (unpublished M.A. thesis; the University of Texas at Austin, 1963), p. 49. Agee and Evans, pp. 15, 445, 216–17. Agee, *A Way of Seeing*, p. 74.

22. Agee and Evans, p. 392; James McIntosch brought this passage to my attention.

23. Agee and Evans, pp. 235, 234, 356, 351, 357.

24. Agee and Evans, pp. 62, 99, 242, 471.

25. Agee and Evans, p. 244. Agee, manuscript notebook.

26. Macdonald, *Memoirs of a Revolutionist*, p. 264. Peter H. Ohlin, "James Agee: A Critical Study," a 1964 dissertation at the University of New Mexico [later published as *Agee* (New York, 1966)], p. 80 (Ohlin makes the more suggestive comparison of Agee's prose to "action painting," pp. 90 f.). Kramer, pp. 40 f.; Ohlin, p. 243; Seib, p. 48; Alfred T. Barson, *A Way of Seeing: A Critical Study of James Agee* (n.p., University of Massachusetts Press, 1972), pp. 86–95. Agee and Evans, pp. 243, 421, 302, 220, 445, 439, 81–82, 360, 162, 103, 212, 361, 393, 370, xiv, 3, 443, 2. Eric Wensberg, review, *Nation*, Nov. 26, 1960, pp. 417–18.

27. Macdonald, p. 266. Agee and Evans, p. 439.

28. Agee and Evans, pp. 64, 110, 183, 319, 372, 202, 308, 447. Agee, *Letters*, pp. 104–5; typed draft manuscript, pp. 3, 353; typed carbon of a draft manuscript of "Inductions," p. 16. Agee collected and arranged the chapters in *Let Us Now Praise Famous Men* on an undated scrap of paper which is among the

Harmon & the reviews —

Part One : (County Letter) (missing) (part one)

Colors (missing)

Part Two : Shelter ✓ (part two) On the Porch
 Education ✓
 Work ✓

Intermission (Pastors & Reviews — missing)

Part Three etc. ✓

Shady Grove ✓
2 images ✓

Notes & Appendices (missing)

(part 3)

Agee manuscripts at the University of Texas. His list is repro-
duced here with the kind permission of the Humanities Re-
search Center of the University of Texas at Austin and of David
McDowell, Trustee of the James Agee Trust.

29. Trilling, p. 101. Agee and Evans, pp. xiv, 245, 99, 110.
Agee, typed draft manuscript, p. 354.

30. Agee and Evans, pp. 101, xiv, 225–26, 294, 320, 295. In a
draft of the 1941 Preface, Agee wrote: "The [recording] instru-
ment is individual human consciousness. (It is also the subject.)"
(typed draft manuscript, p. 352).

31. Agee and Evans, p. 439. Priscilla Robertson, review, *The
Progressive*, Jan. 1961, pp. 44, 45.

32. Robert Coles, *Children of Chaos* (3 vols., Boston, 1967–72).
Robert Coles and Al Clayton, *Still Hungry in America* (New
York, 1969). Paul Good, *The American Serfs* (New York, 1968).

33. Christenberry, in conversation; Evans, in conversation.
Agee and Evans, p. 78.

34. Coleman, p. 38. Agee and Evans, pp. 392, 16. Agee be-
lieved that suffering in human life was both constant and inevita-
ble; when the Second World War began he claimed that it was
no more than was always going on: "Not one peacetime breath is
drawn that does not contain a dreadfulness to equal the whole of
war" (manuscript notebook).

Bibliography

This brief bibliographic essay discusses the sources that most usefully treat the themes of this book.

There are no books or articles on documentary as a genre. On documentary film, John Grierson's *Grierson on Documentary*, ed. Forsyth Hardy (London, 1966), a collection of reviews and essays written over several decades, is spirited, suggestive, and influential. Paul Rotha's *Documentary Film* (London, 1936) has little of Grierson's messianic and speculative fervor. Robert L. Snyder's *Pare Lorentz and the Documentary Film* (Norman, Okla., 1968) is a torpid study of this important filmmaker's career. Lewis Jacobs' *Documentary Tradition* (New York, 1971) collects articles on documentary films from *Nanook* to *Woodstock*, and G. Roy Levin's *Documentary Explorations* (Garden City, N.Y., 1971) transcribes interviews with fifteen documentary filmmakers. Beaumont Newhall's writing on documentary photographs pauses to reflect on documentary per se; see his *History of Photography* (New York, 1965) and his "Commentary" in *Dorothea Lange Looks at the American Country Woman* (Fort Worth, 1967). George P. Elliott makes valuable remarks on documentary in "Photographs and Photographers," an essay in his *Piece of Lettuce* (New York, 1964), and in his introduction to *Dorothea Lange* (New York, 1966). *U.S. Camera* regularly treats documentary expression; two early articles are of particular interest: Edward Steichen, "The F.S.A. Photographers," *U.S. Camera 1939*, ed. T. J. Maloney (New York,

1938), pp. 43–65; and Pare Lorentz, "Dorothea Lange, Camera with a Purpose," *U.S. Camera 1941*, ed. Maloney (2 vols., New York, 1940), I, 93–98. *Photojournalism* and *Documentary Photography*, volumes in *Life's* Library of Photography (New York, 1971), are informative. Several documentary photographers analyze their craft in *Photographers on Photography*, ed. Nathan Lyons (Englewood Cliffs, 1966), and Judith Mara Gutman examines Lewis Hine's work in her *Lewis W. Hine and the American Social Conscience* (New York, 1967). To understand the attitudes toward documentary in the 1930s, the entries by Roy Stryker, Arthur Rothstein, and John Grierson in *The Complete Photographer*, ed. Willard D. Morgan (10 vols., New York, 1942–43) are indispensable; the 1963–65 revision of this series omits or alters these articles. Despite its title, J. A. V. Chapple's *Documentary and Imaginative Literature, 1880–1920* (n.p., Barnes and Noble, 1970) is a study of British fiction. Despite *its* title, A. William Bluem's *Documentary and American Television: Form, Function, Method,* a Hastings House Communication Arts book (New York, 1965), has a broad comprehension of documentary in various media. Tom Wolfe's article "Why They Aren't Writing the Great American Novel Anymore" (*Esquire,* Dec. 1972, pp. 152–59, 272–80) analyzes "New Journalism" and suggests correspondences between it and documentary reportage.

On thirties America, the literature is forbiddingly ample. The magazines that provide the richest image of the period are *The New Republic, New Masses, Fortune, The Nation, Survey Graphic, Time,* and *Life.* Two commentaries are acknowledged classics: Edmund Wilson's *American Jitters: A Year of the Slump* (New York, 1932) and Malcolm Cowley's *Exile's Return: A Narrative of Ideas* (New York, 1934); these editions are to be preferred to Wilson's reworking of the same material in *The American Earthquake* (Garden City, N.Y., 1958) and Cowley's many revisions of *Exile's Return.* Quite as valuable as these books are John L. Spivak's *America Faces the Barricades* (New York, 1935), Erskine Caldwell's *Some American People* (New York, 1935), and Marquis W. Childs' *I Write from Washington* (New York, 1942). Mauritz A. Hallgren's *Seeds of Revolt: A Study of American Life and the Temper of the American People during the Depression* (New York, 1933), his *Gay Reformer: Profits before Plenty under Franklin D. Roosevelt* (New York, 1935), Gilbert Seldes' *The Years of the Locust: America, 1929–1932* (Boston, 1933), Sherwood Anderson's *Puzzled America* (New York, 1935), James Rorty's *Where Life Is Better: An Unsentimental American Journey* (New York, 1936), Nathan Asch's *The Road: In Search of America* (New York, 1937), and Louis Adamic's *My America* (New

York, 1938) also reward attention. For contemporary perspective on thirties cultural life, *The American Writers' Congress*, ed. Henry Hart (New York, 1935), George Biddle's *An American Artist's Story* (Boston, 1939), Mordecai Gorelik's *New Theatres for Old* (New York, 1940), Hallie Flanagan's *Arena* (New York, 1940) and *Dynamo* (New York, 1943), and Harold Clurman's *The Fervent Years* (New York, 1945) are all excellent, as is "Unemployed Arts," *Fortune*, May 1937, pp. 108–17, 168–72. The most insightful analyses of thirties art and expression done at the time were by Edmund Wilson and Malcolm Cowley in their *New Republic* reviews and articles (some of them are republished in Wilson's *The Shores of Light* [New York, 1952] and Cowley's *Think Back on Us*, ed. Henry Dan Piper [Carbondale, Ill., 1967]); by Archibald MacLeish in his several books of the period; and, especially, by Alfred Kazin in the final chapters to *On Native Grounds* (New York, 1942). Among the anthologies on the 1930s, three are outstanding: *The Strenuous Decade*, ed. Daniel Aaron and Robert Bendiner (Garden City, 1970), *Years of Protest*, ed. Jack Salzman and Barry Wallenstein (New York, 1967), and *New Masses: An Anthology of the Rebel Thirties*, ed. Joseph North (New York, 1969).

The following memoirs of the 1930s are lively and informative: John L. Spivak, *A Man in His Time* (New York, 1967); Alfred Kazin, *Starting Out in the Thirties* (Boston, 1965); Matthew Josephson, *Infidel in the Temple* (New York, 1967); and Albert Halper, *Good-Bye, Union Square* (Chicago, 1970). None of these has the haunted conviction of Whittaker Chambers' *Witness* (New York, 1952). Perhaps the finest memoir of the time is— appropriately—a collective one: *Hard Times: An Oral History of the Great Depression*, ed. Studs Terkel (New York, 1970). "The 1930's, a Symposium," *Carleton Miscellany*, winter 1965, pp. 9–114, gathers memories of the decade's cultural life. Arthur M. Schlesinger, Jr.'s *The Age of Roosevelt* (3 vols., Boston, 1957–60) and William E. Leuchtenburg's *Franklin D. Roosevelt and the New Deal, 1932–1940* (New York, 1963) are as much general histories of the period as biographies of Roosevelt. Dixon Wecter's general history *The Age of the Great Depression, 1929–1941* (New York, 1948) is still of value. Other general histories, though popularized, offer important insights: Frederick Lewis Allen's *Since Yesterday* (New York, 1940) is particularly good on the period's mass entertainments; Caroline Bird's *The Invisible Scar* (New York, 1966) is excellently written and poorly annotated; Robert Bendiner's *Just around the Corner* (New York, 1967) is most useful when most autobiographical; Edward Robb Ellis' *A*

Nation in Torment (New York, 1970) is overlong, unannotated, awkwardly written, and full of significant facts. Murray Kempton's *Part of Our Times: Some Monuments and Ruins of the Thirties* (New York, 1955) and Robert Warshow's essays on the thirties in *The Immediate Experience* (Garden City, N.Y., 1962) are perceptive social history, though Kempton tends to sentimentalize his heroes and neither man has any charity toward his villains. Robert M. Crunden's *From Self to Society* (Englewood Cliffs, N.J., 1972) uses pithy biographies to examine the social and intellectual life of the 1920s and 1930s. The most suggestive intellectual history of the thirties is Warren I. Susman's essay "The Thirties," in *The Development of an American Culture*, ed. Stanley Coben and Lorman Ratner (Englewood Cliffs, N.J., 1970), pp. 179–218; Susman's theme is kaleidoscopic, hard to pin down, but his attention to documentary media encouraged me to believe I was not traveling down a blind alley. Susman's student Richard H. Pells has written an intellectual history of the 1930s, *Radical Visions and American Dreams* (New York, 1973), that promises to be influential.

A host of books treat particular aspects of thirties America. On Franklin Roosevelt, in addition to the Schlesinger and Leuchtenburg books mentioned above, Ernest K. Lindley's *Half Way with Roosevelt* (New York, 1937) and Robert Sherwood's *Roosevelt and Hopkins* (New York, 1948) are useful; more revealing than any of these are Frances Perkins' *The Roosevelt I Knew* (New York, 1946) and Eleanor Roosevelt's *This I Remember* (New York, 1949). On the trials of the intellectual Left, Daniel Aaron's *Writers on the Left* (New York, 1961) is essential. Frank A. Warren III, studies the influence of Communism on moderates in his important *Liberals and Communism* (Bloomington, Ind., 1966). On Proletarian literature, David Madden's critical anthology *Proletarian Writers of the Thirties* (Carbondale, Ill., 1968) is excellent. Leslie Fiedler's evaluation of thirties fiction, scattered through his various books (there is a fine essay in Madden's anthology), is the most plausible we have. On thirties theater, Morgan Y. Himelstein's *Drama Was a Weapon* (New Brunswick, N.J., 1963) is narrow-spirited. On radio, Erik Barnouw's *History of Broadcasting in the United States* (3 vols., New York, 1966–70) is lively and authoritative; Alexander Kendrick's *Prime Time: The Life of Edward R. Murrow* (Boston, 1969) is the first biography of a newsman of radio's golden age. The films of the thirties are limply surveyed in Andrew Bergman's *We're in the Money* (New York, 1971); Pauline Kael's "Raising Kane," in *The Citizen Kane Book* (Boston, 1971) is a classic of popular culture analysis.

Robert T. Elson's *Time Inc.: The Intimate History of a Publishing Enterprise* (New York, 1968) provides important information. On the WPA arts projects, William F. McDonald's *Federal Relief Administration and the Arts* (n.p., Ohio State University Press, 1969) gives Washington's view of the projects, but little on their content and nothing about their effect nor—surprisingly—their cost. Jane DeHart Matthews' *The Federal Theatre, 1935–1939* (Princeton, 1967) and Jerre Mangione's *The Dream and the Deal: The Federal Writers' Project, 1935–1943* (Boston, 1972) are valuable, though both steadily ignore the works their projects produced. The FSA photography project is the subject of F. Jack Hurley's *The Portrait of a Decade: Roy Stryker and the Development of Documentary Photography in the Thirties* (Baton Rouge, 1973). Some of the FSA pictures by Ben Shahn and Walker Evans are to be published in *Ben Shahn, Photographer*, ed. Margaret R. Weiss (New York, 1972) and *Walker Evans: Photographs from the Farm Security Administration, 1935–1938* (New York, 1972). Sean Callahan's introduction to *The Photographs of Margaret Bourke-White*, ed. Callahan (Greenwich, Conn., 1972) provides a guide to her career, and Bourke-White's *Portrait of Myself* (New York, 1963) is revealing. Dorothea Lange's interview with Suzanne Riess, "The Making of a Documentary Photographer" (mimeographed, Berkeley, University of California Regional Oral History Office, 1968) recounts her career. On industrial labor, Irving Bernstein's *History of the American Worker, 1920–1941* (2 vols., Boston, 1960, 1970) is thorough. Bernstein's work is usefully supplemented by David Eugene Conrad, *The Forgotten Farmers: The Story of the Sharecroppers in the New Deal* (Urbana, Ill., 1965), and Donald H. Grubbs, *Cry from the Cotton: The Southern Tenant Farmers' Union and the New Deal* (Chapel Hill, 1971). John Madge's *Origins of Scientific Sociology* (New York, 1962) and Robert E. L. Faris' *Chicago Sociology, 1920–1932* (Chicago, 1970) helped inform my discussion of social science writing.

Walker Evans' photography has always inspired superb prose, beginning with James Agee's reflections in *Let Us Now Praise Famous Men* (Boston, 1941). The articles on Evans by Lincoln Kirstein, Glenway Westcott, William Carlos Williams, and Lionel Trilling, which I quote in the text and cite in the Notes, are perceptive and eloquent. John Szarkowski, the director of Evans' triumphal 1971 retrospective at the Museum of Modern Art, contributes a judicious introduction to *Walker Evans* (New York, 1971). The retrospective was sensitively reviewed, above all by the *New York Times* art critics Hilton Kramer and A. D. Coleman; their reviews, cited in the text and Notes, are searching aes-

thetic and social criticism. Unlike the writing on Evans, the writing on Agee isn't very helpful, no doubt because Agee himself covered the topic so brilliantly. Three scholarly books have appeared: Peter H. Ohlin, *Agee* (New York, 1966), which I have seen only in its earlier incarnation as a 1964 University of New Mexico Ph.D. dissertation; Kenneth Seib, *James Agee: Promise and Fulfillment* (Pittsburgh, 1968); and Alfred T. Barson, *A Way of Seeing: A Critical Study of James Agee* (n.p., University of Massachusetts Press, 1972). These studies, which draw on Victor A. Kramer's unpublished M.A. thesis (1963) and Ph.D. dissertation (1966) at the University of Texas at Austin, attempt New Critical analyses of Agee's writing and are tangential to his greatness. Three memoirs of Agee come closer to the mark: Evans' "James Agee in 1936" in the 1960 edition of *Let Us Now Praise Famous Men* (Boston); Dwight Macdonald's "James Agee," in *Against the American Grain* (New York, 1965); and Robert Fitzgerald's introduction to Agee's *Collected Short Prose* (Boston, 1968). The Agee issue of the *Harvard Advocate* (Feb. 1972) is handsome and hagiographic. What we need most is a biography tracing the continuities and discontinuities between Agee's moral vision and his life; such a book, which could only be written by an intimate, seems likely never to be done.

Throughout my work I have been assisted by conversation and correspondence with people interested in what this book discusses. I will welcome further opinions or corrections that readers have.

Index